To Christmas
Music! "!"
Love Andrew 2012

DEAR KEITH

PLEASE ENJOY!

THANKS FOR THE
INTRO TO ANDREW!
HE'S GENIUS!

Darren x

in loving memory of

Natalie Sattler Esposito
1973-2008

Louise Uphoff
1947 - 2011

Justin Daley
1980 - 2010

All the monies raised from The Beauty Book will be divided between :
SNOG (Sydney Neurology Oncology Group) www.snog.org.au
HEADRUSH www.headrushwisconsin.org

foreword

THE BEAUTY BOOK for BRAIN CANCER was born after I lost one of my best friends to this disease, Natalie Sattler Esposito. After Natalie's funeral her family asked for donations to go to SNOG (Sydney Neurology Oncology Group) in lieu of flowers. After donating on behalf of my family, SNOG emailed me a thank you letter. I then flew back to the US on the 14-hour flight and I started to think about what could I do to bring awareness and further research for brain cancer and keep Natalie's memory alive. Using all my connections and friend's support, I embarked on this wonderful project called THE BEAUTY BOOK for BRAIN CANCER, after more than 2 years of photographing some of the biggest celebrities in the world – this project is now finished and ready for everyone to enjoy.

I grew up with Natalie. We attended the same high school, shared many friends (Jordan, Alesha, Ginny) and we all remained amazing friends through adulthood. I even introduced Natalie to her husband, Leonardo Esposito, in our early 20's.

Natalie battled with brain cancer for 4 years. She was diagnosed on the 2nd December 2004 with a stage 3 tumor, showing to be Anaplastic Astrocytoma after having symptoms of headaches, visual disturbances and memory loss. Throughout the four years, Natalie completed radiation, chemotherapy and had a tumor surgically removed. She fought hard and sought natural therapies as well.

Natalie lost her battle with brain cancer in September 2008.

Natalie had a stunning big smile and a cheeky laugh that filled the room with joy. Natalie loved fashion and 80's supermodels, she worked in the fashion industry as a pattern maker and eventually had her own label called "White Lion". I shared so many great times with her, a trip to Hong Kong at 19, getting our high school results, her wedding and many of our birthdays celebrated together with our group of friends. This project, I wouldn't do for many people, but Natalie meant the world to me as she did to her family Mom, Bev, Dad, Ian, sister Christine and husband Leonardo. Her beautiful life deserves to be remembered and the story of what she went through with brain cancer needs to be told.

During the course of this project I've been so fortunate to photograph and meet many talented and amazing people, not just the mega star celebrities, but so many creatively gifted hair, makeup and just down right generously big hearted people. That brings me to my now dear friend "Pantera" Sarah Uphoff.

When I shot Mehcad Brooks, for the book, he realized that Sarah, not only could help, but was passionate about the cause. Her mother, Louise, was diagnosed with Stage 4 Glioblastoma Mulitforme on January 8, 2010.

Louise was passionate about so many things. She loved Broadway musicals, knitting, garage sales and the Green Bay Packers. She was incredibly passionate about politics and progressive causes. Up until her illness, she was an accountant for WEAC (Wisconsin's teachers union). Her family is incredibly grateful for her Union insurance, that thankfully covered most of her medical expenses. But mostly, Louise was passionate about her family. Her husband of 41 years, Charles, her kids Jennifer, Sarah and James and her five grandchildren, Jamie, Seeger, Madison, Arden and Alex.

Louise had surgery at UW-Hospital in Madison, Wisconsin, on January 12, 2010 followed by chemo, radiation, clinical drug trials, another surgery to install a shunt, steroids and anti-seizure meds. In addition to that she tried acupuncture, increased her vitamins and switched to an organic diet. Sadly, after such a courageous fight, Louise lost her battle with brain cancer on July 21, 2011 in Hospice, surrounded by her family, singing union songs and showtunes.

Sarah's biggest frustration in this whole process was constantly hearing from doctors "We don't know",…so we came together for one common goal – to raise money for research.

Brain Cancer now has a voice called THE BEAUTY BOOK and raising money for research is so vital. There are still so many unknowns with this disease and the battle is often intensely hard and intrusive. Brain Cancer doesn't discriminate against age, race or gender – it attacks all. Together we can and will make a difference.

Darren Tieste

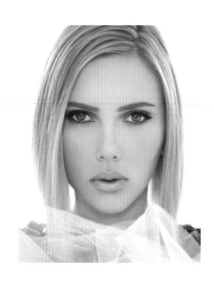

SCARLETT JOHANSSON
wears dress by **GEORGE HOBEIKA**
Makeup **MAI QUYNH**
Hair **DAVID BABAII**
Manicure **JENNA HIPP**
Retouching **JUDITH CAINGAT**
shot at www.concreteloft.com

DARREN TIESTE
exec producer + photographer

DOUGLAS VANLANINGHAM
fashion director

"PANTERA" SARAH UPHOFF
senior producer + event producer

LUIS RODRIGUEZ
co-producer

JANE NEGLINE
co-producer

GLENN NUTLEY
co-producer

SAMANTHA BAILEY
sydney event producer

KAT ANDREWS
digital tech producer

LEONARDO ESPOSITO
shoot producer

GEOFF KATZ
HUGO REYES
serial placement/cpi

MANUEL VILLAFANIA
cover design

MARCEL SARMIENTO
art director

ANDREW RYAN
photo assistant

JUDITH CAINGAT
retouching

KRISTEN LAUBER
retouching

contact@thebeautybook.org

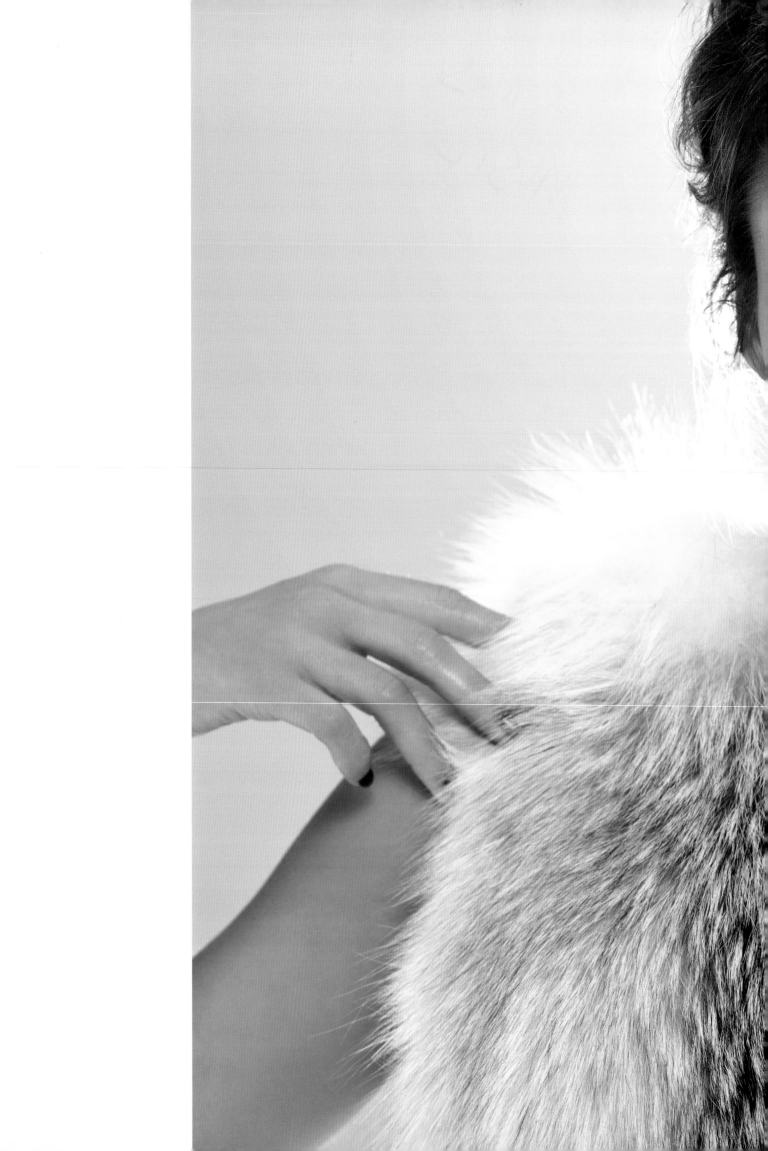

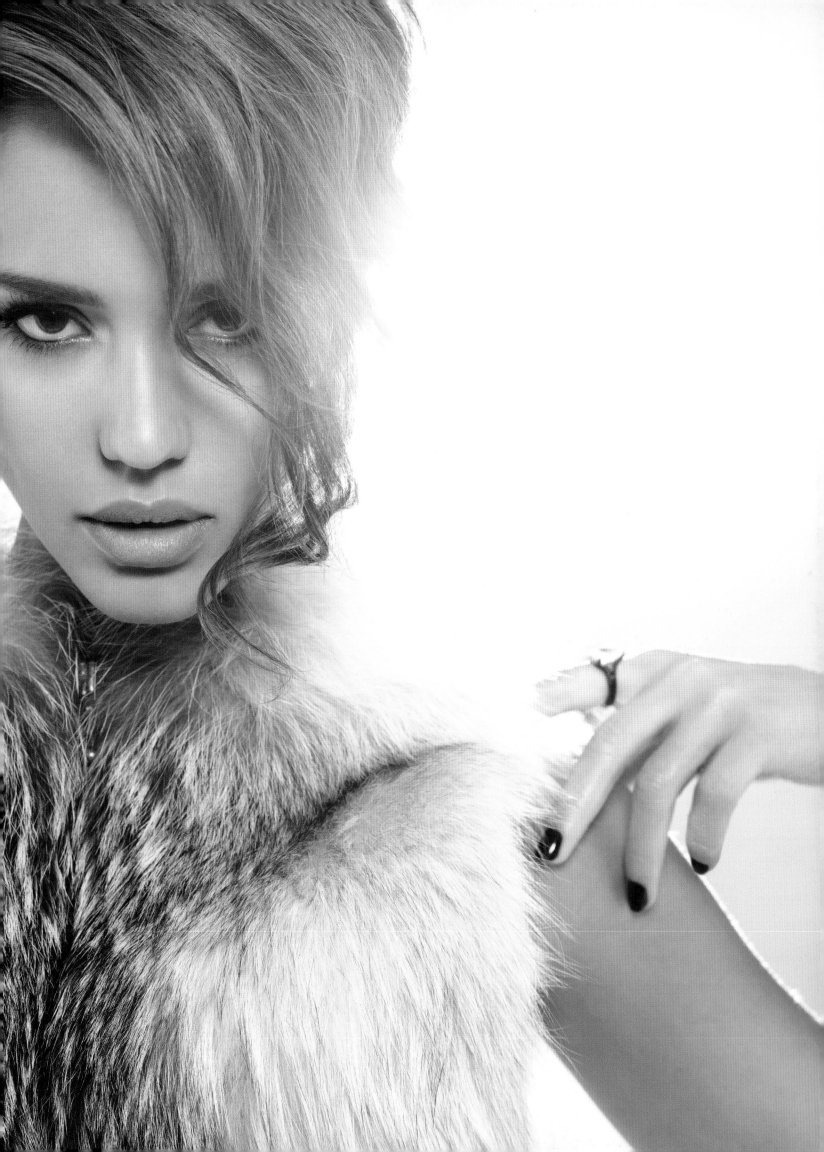

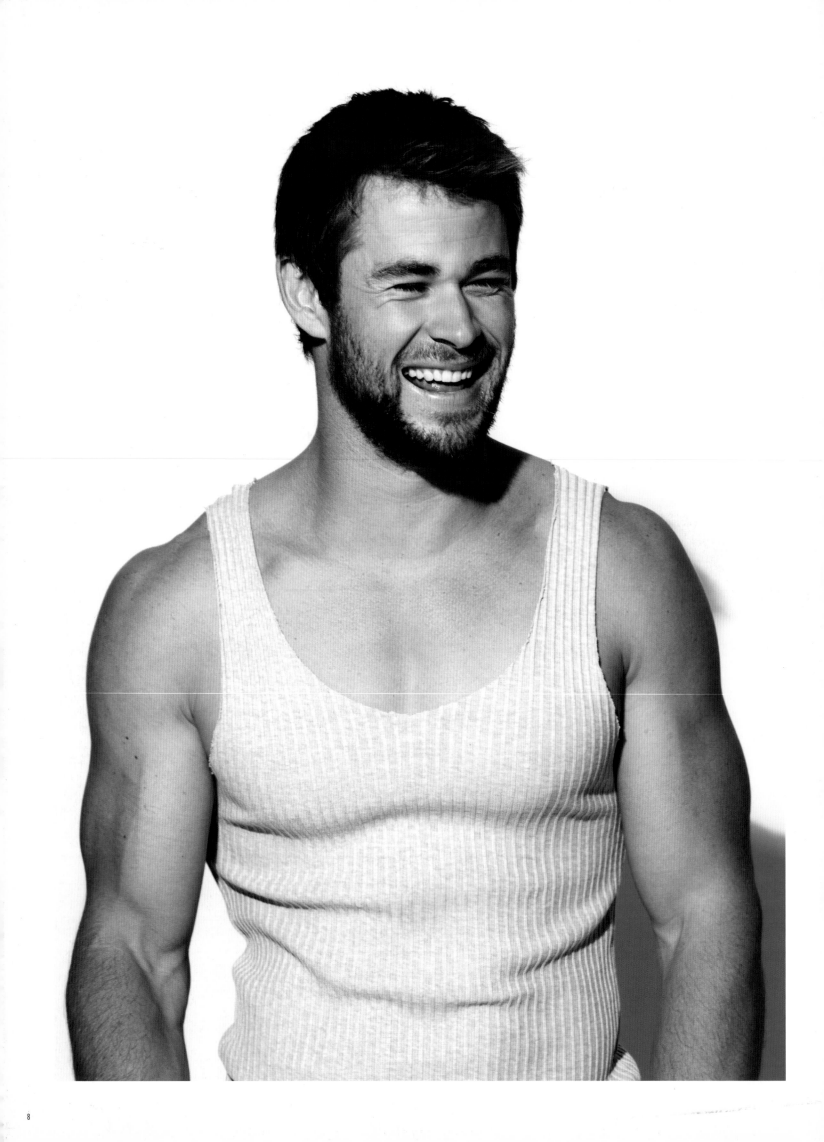

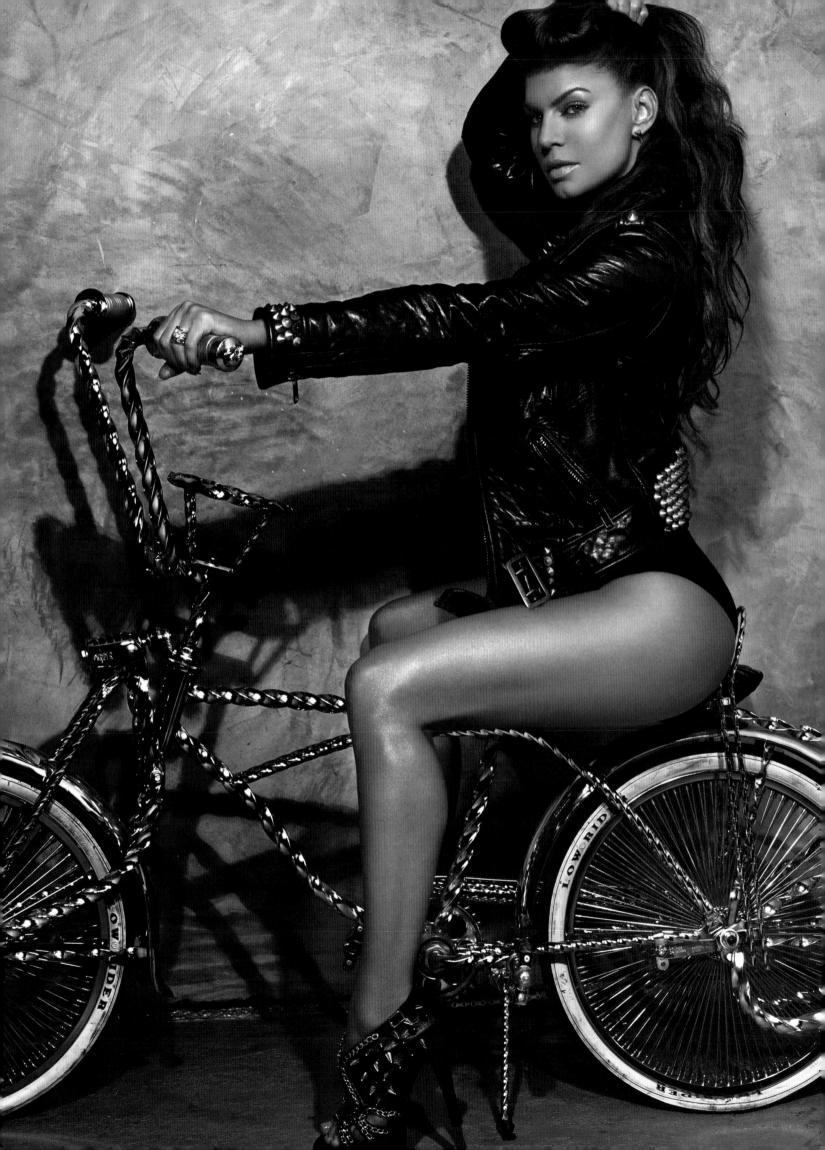

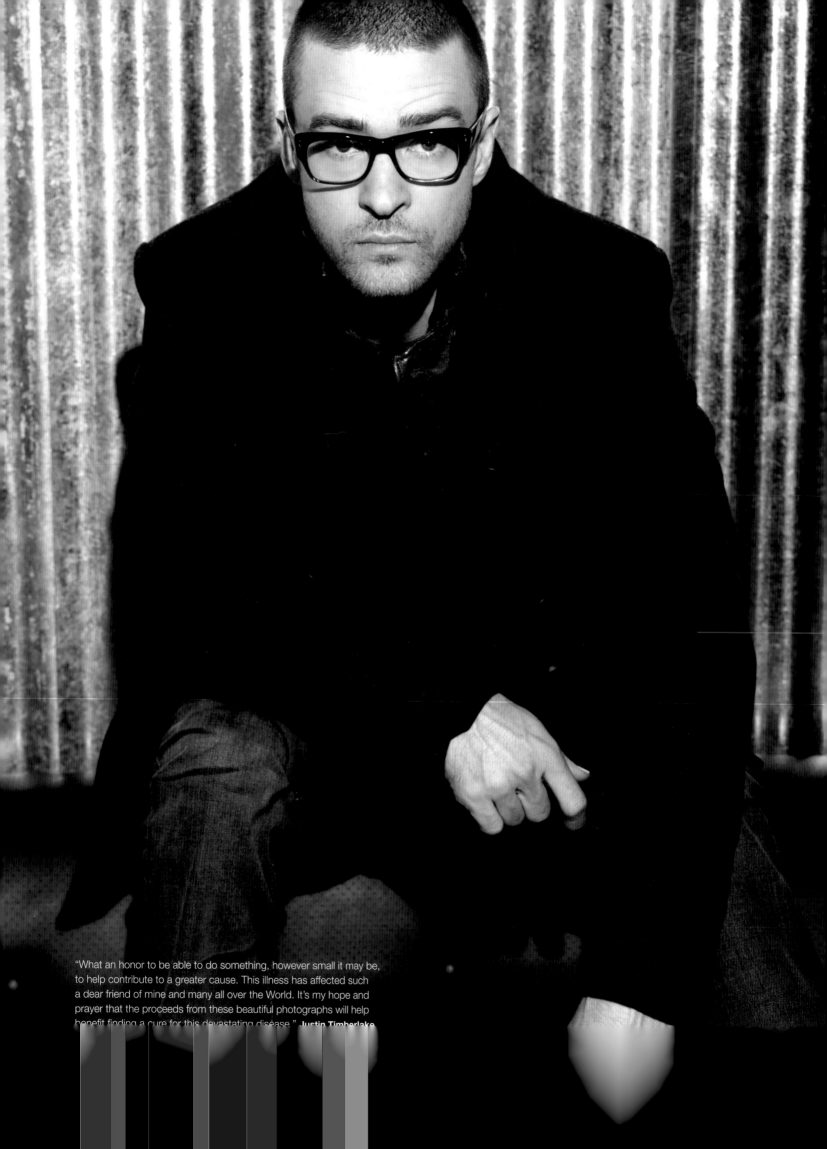

"What an honor to be able to do something, however small it may be, to help contribute to a greater cause. This illness has affected such a dear friend of mine and many all over the World. It's my hope and prayer that the proceeds from these beautiful photographs will help benefit finding a cure for this devastating disease." **Justin Timberlake**

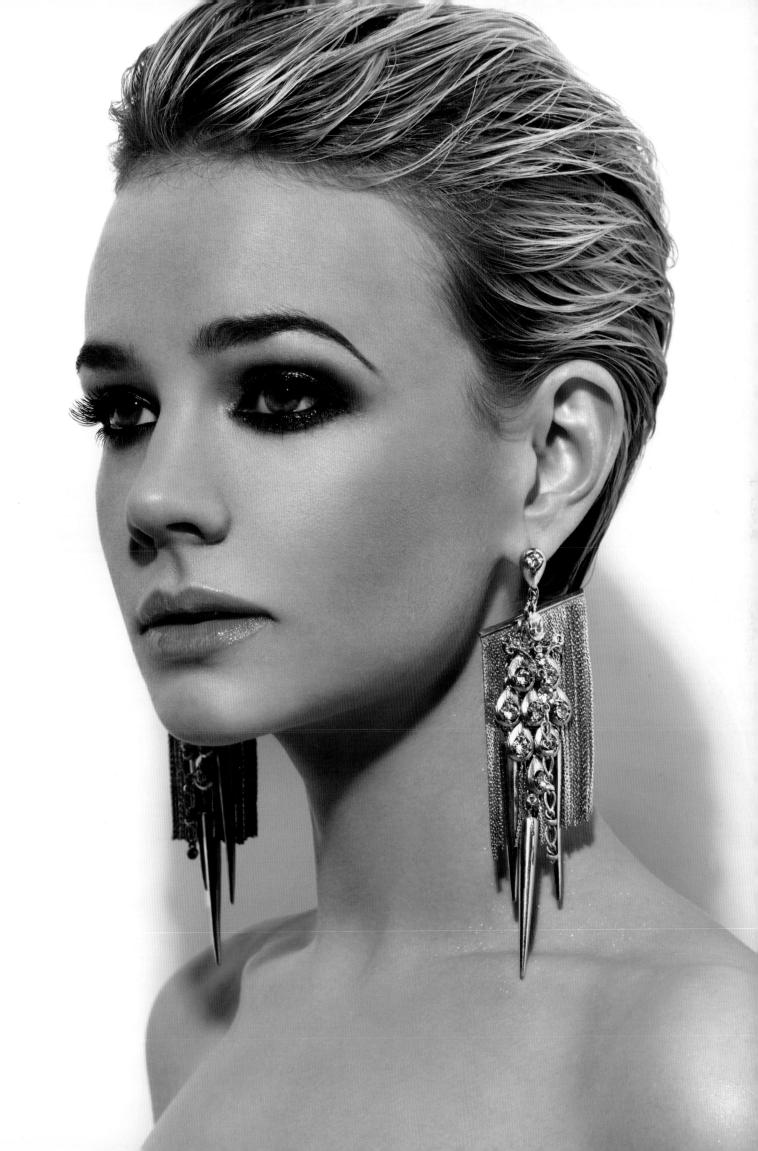

"This cause is important to me because its personal. Awareness and Research saved my little brothers life as an infant with brain cancer." **Leighton Meester**

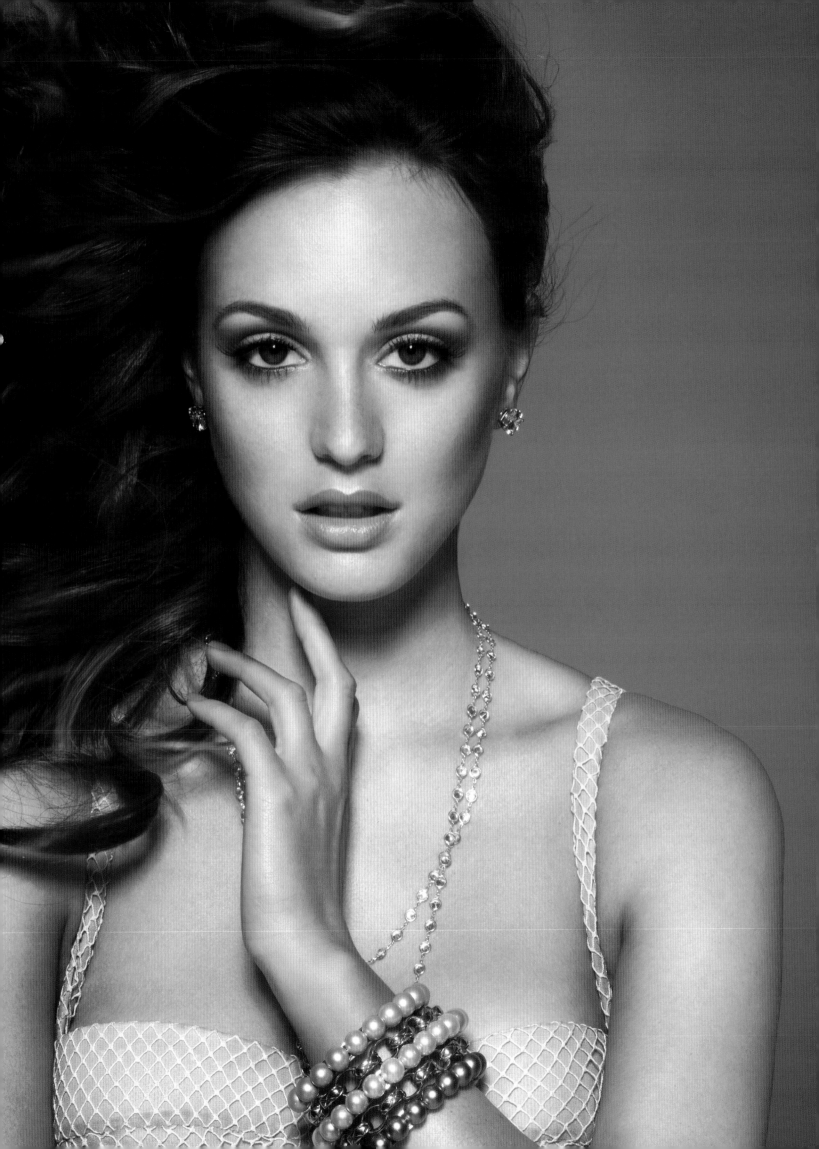

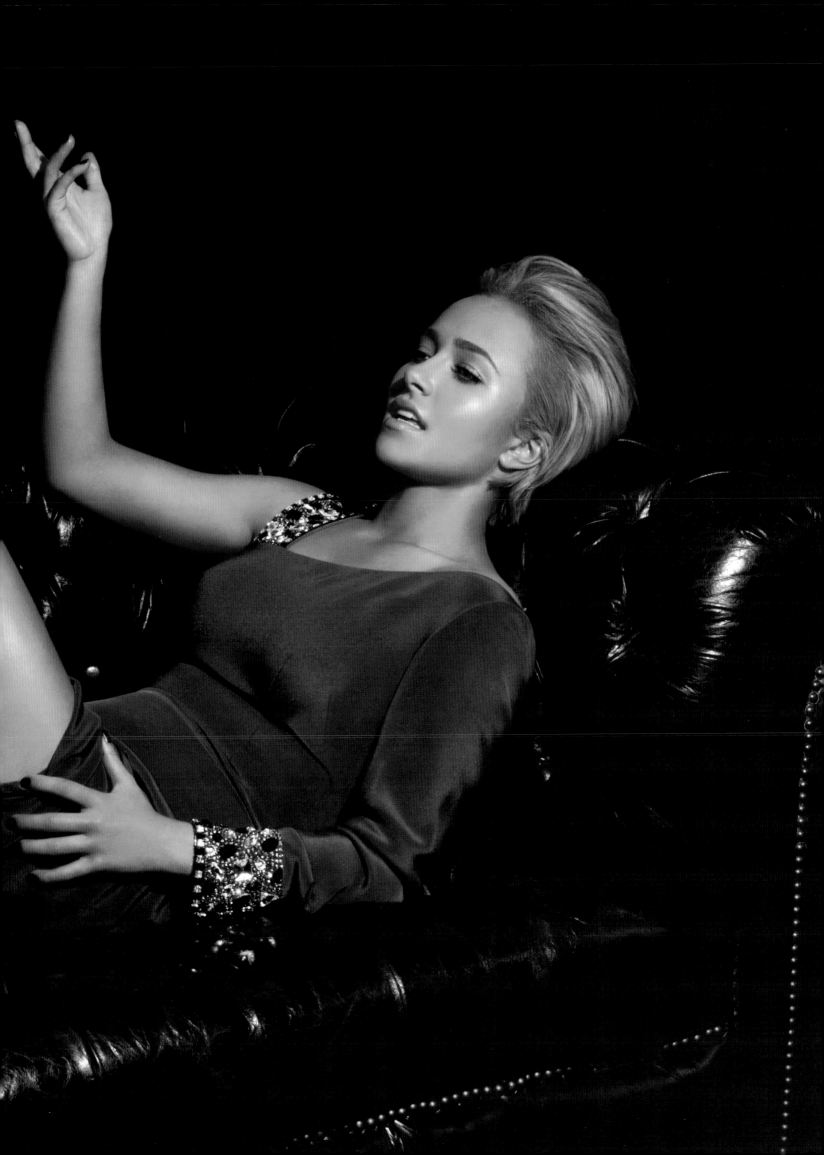

"I am honored and excited to be a part of Darren's vision and supporting Brain Cancer Awareness." **Channing Tatum**

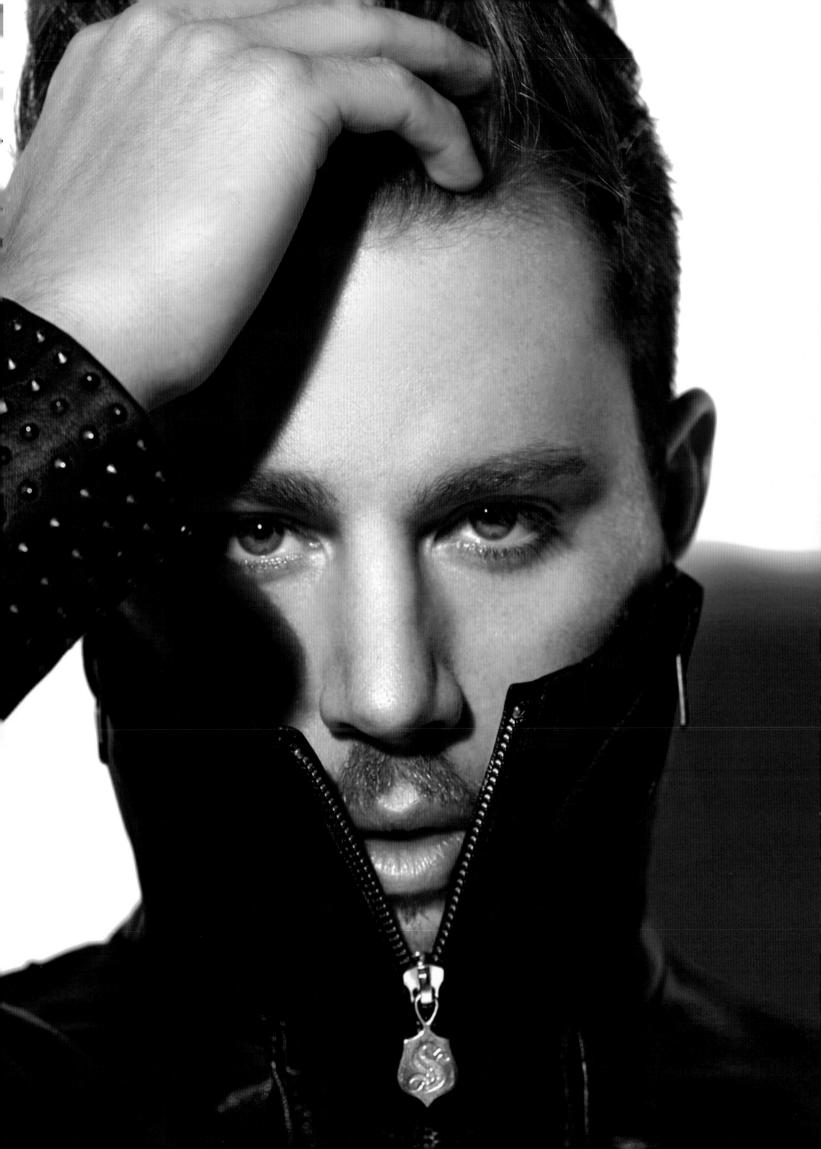

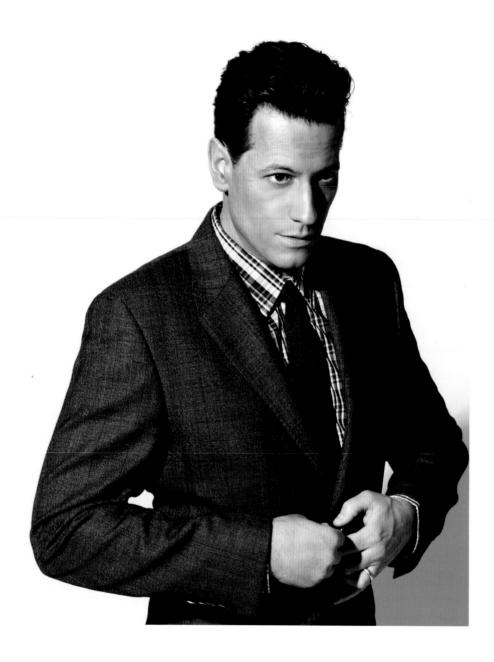

"I didn't hesitate when my dear friend Pantera Sarah asked me to be part of this special book. Its vitally important for us to raise funds to help research and ultimately find a cure for a disease that affects the lives of so many people." **Ioan Gruffudd**

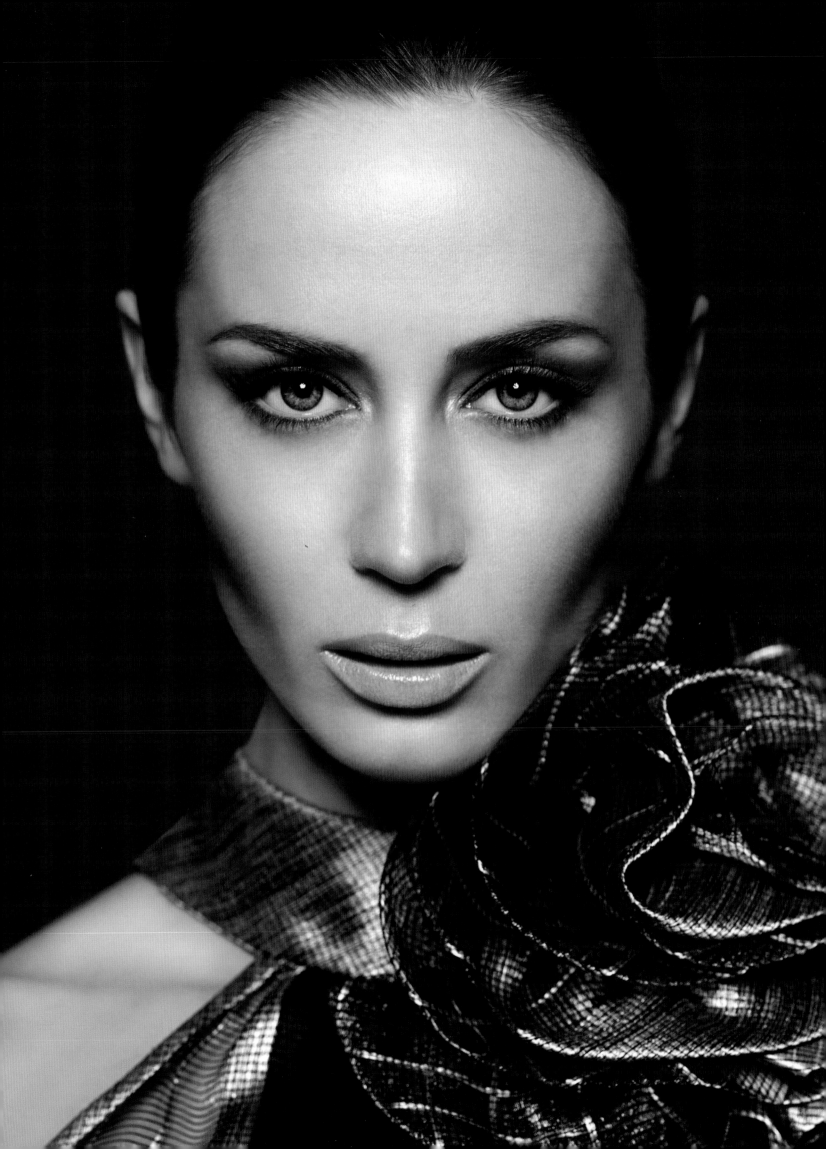

FIVE

Living Under Glass

JANE TRESIDDER &
STAFFORD CLIFF

THE WORLD ATLAS OF ARCHITECTURE

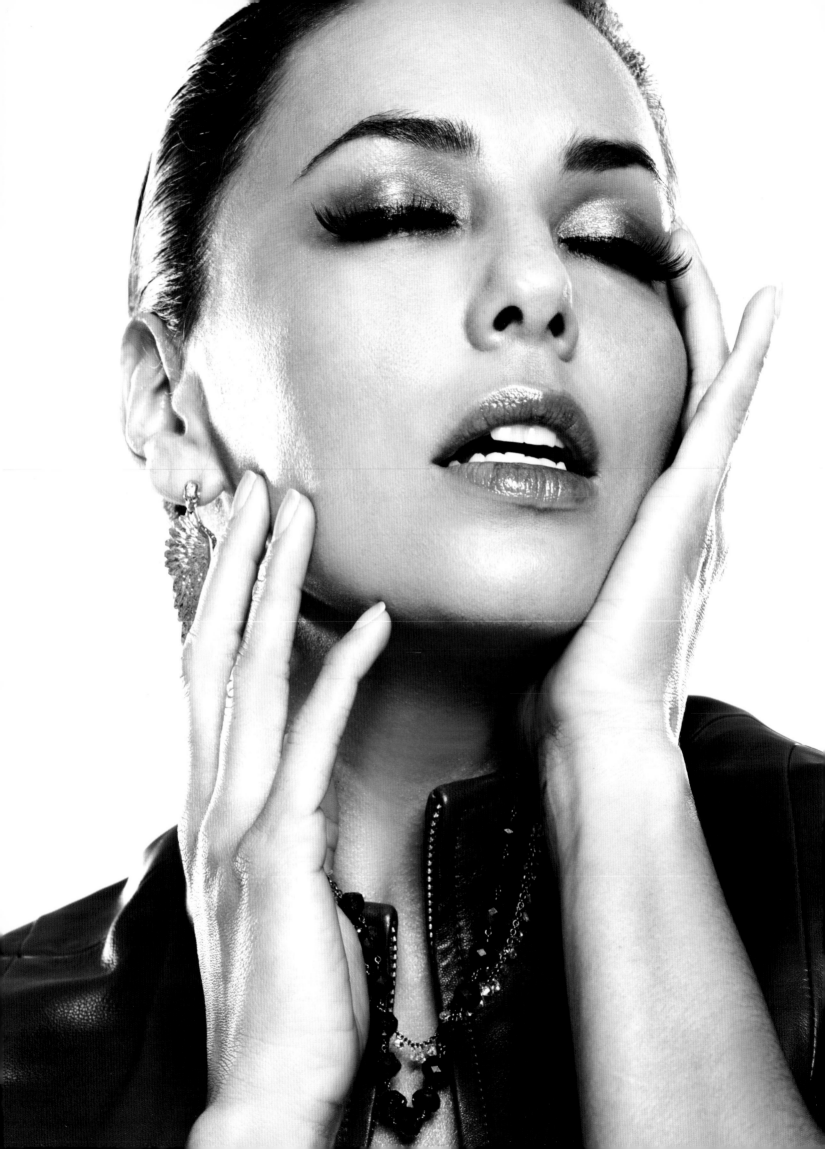

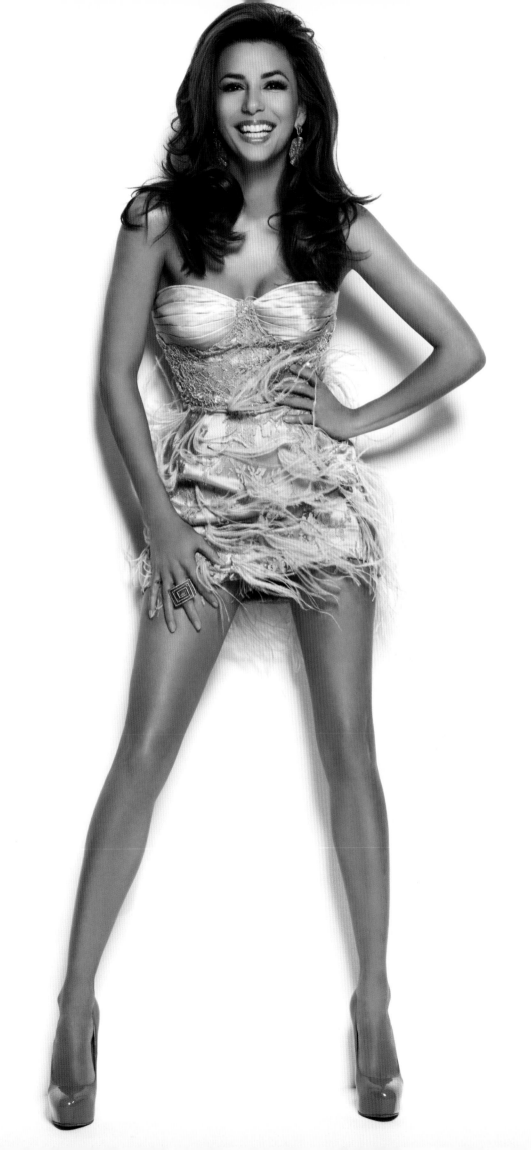

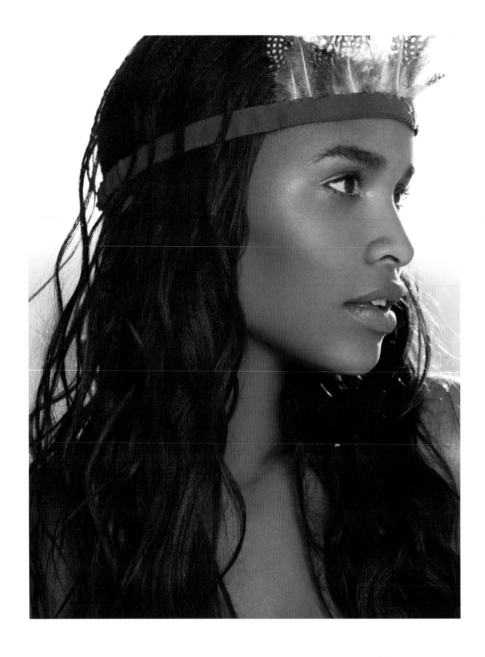

"I've never met Sarah's mother, but if her daughter is any indication, she's an extraordinary woman. It's easy to feel helpless when a loved one is going through something like this, but instead of being helpless, Sarah decided to be helpful to those suffering the same fate as her mother and the family and loved ones beside them. This is the reason that I am involved." **Joy Bryant**

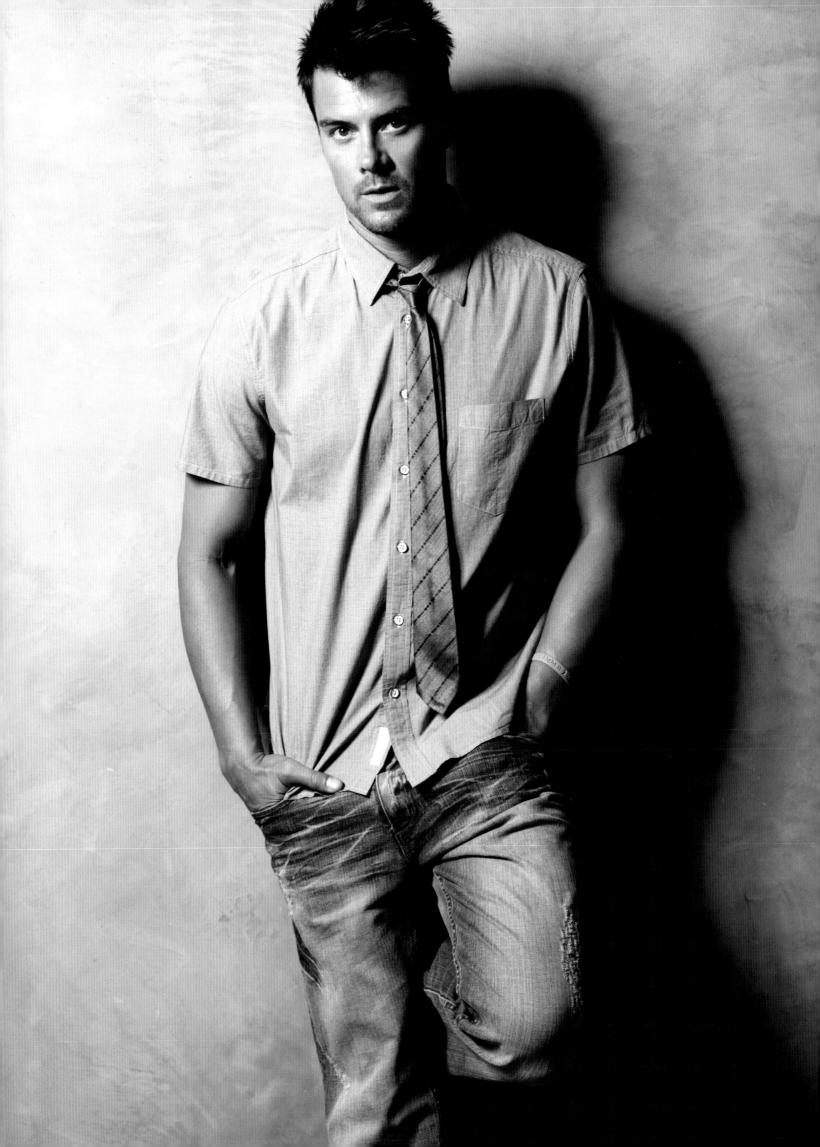

"I admire and respect Darren Tieste's drive, ambition and talent in helping bring funds and awareness to the fight against cancer." **Hugh Jackman**

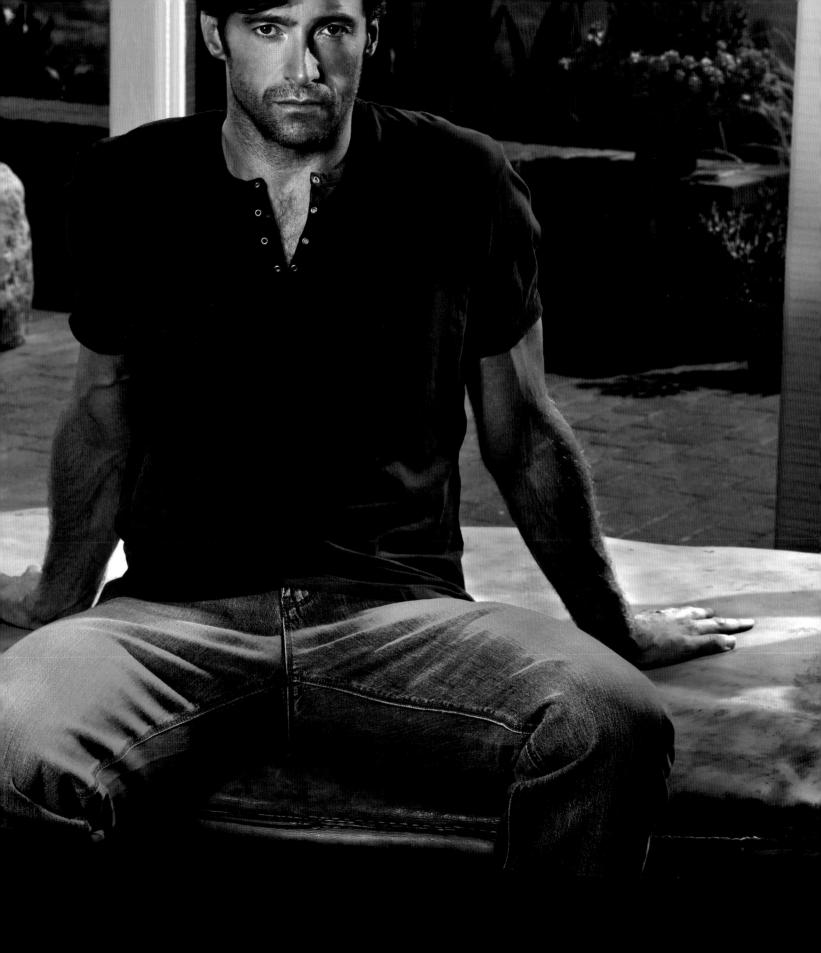

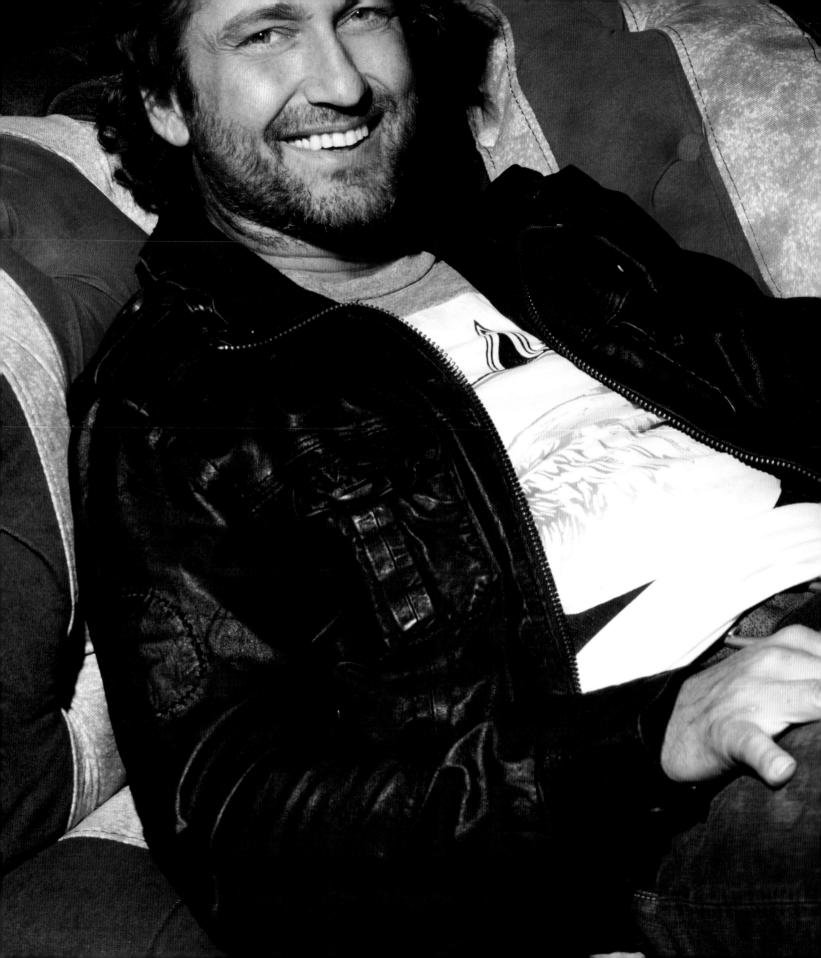

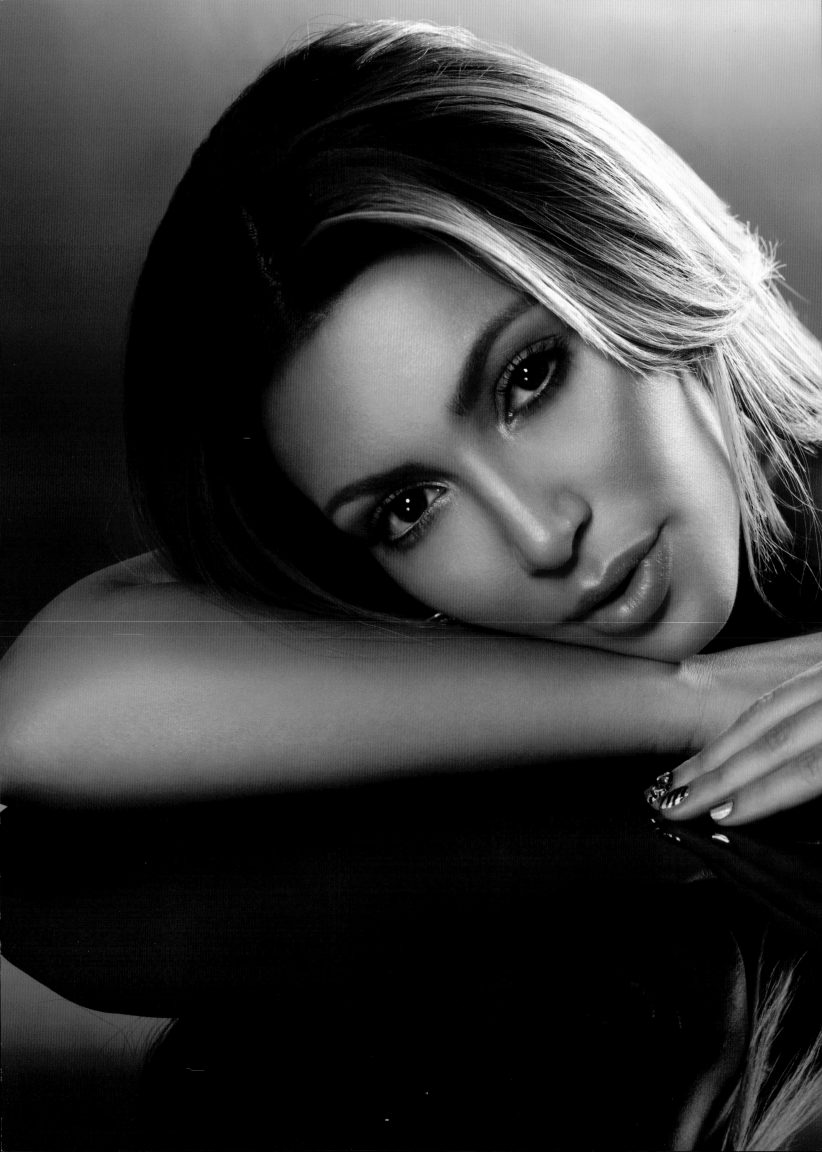

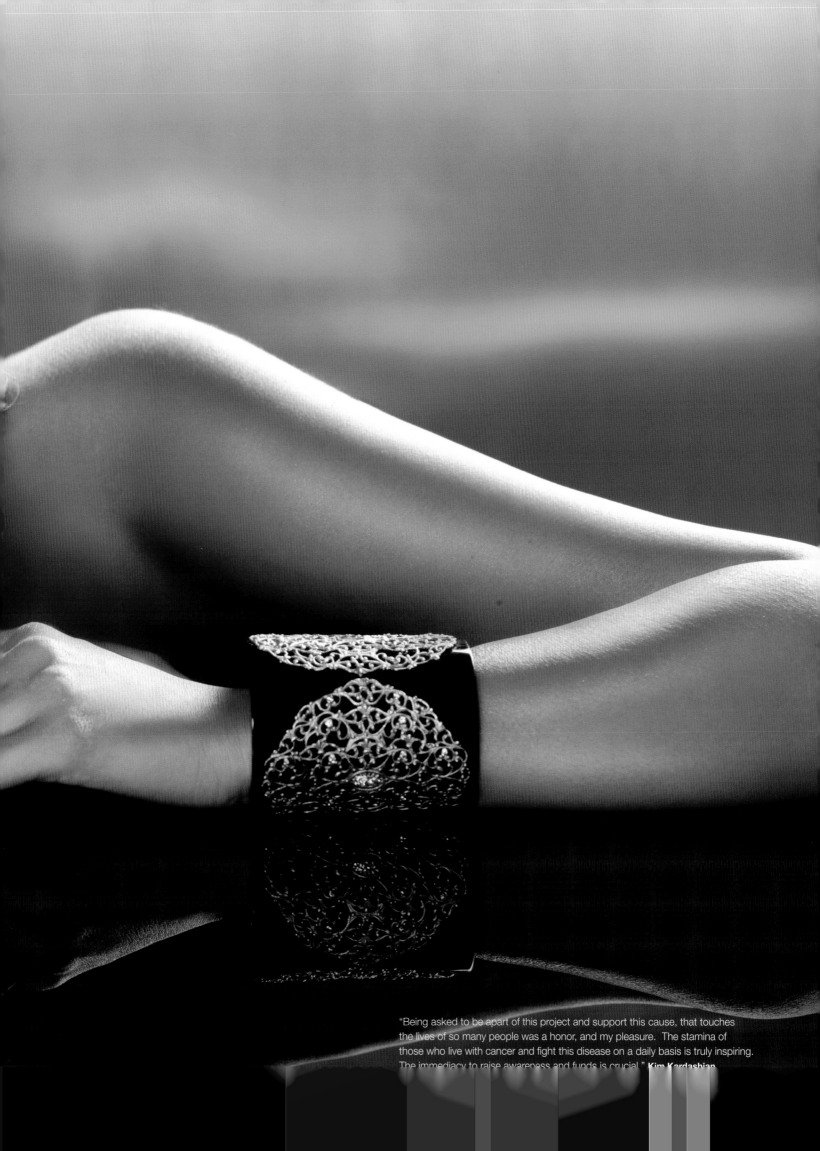

"Being asked to be apart of this project and support this cause, that touches the lives of so many people was a honor, and my pleasure. The stamina of those who live with cancer and fight this disease on a daily basis is truly inspiring. The immediacy to raise awareness and funds is crucial." **Kim Kardashian**

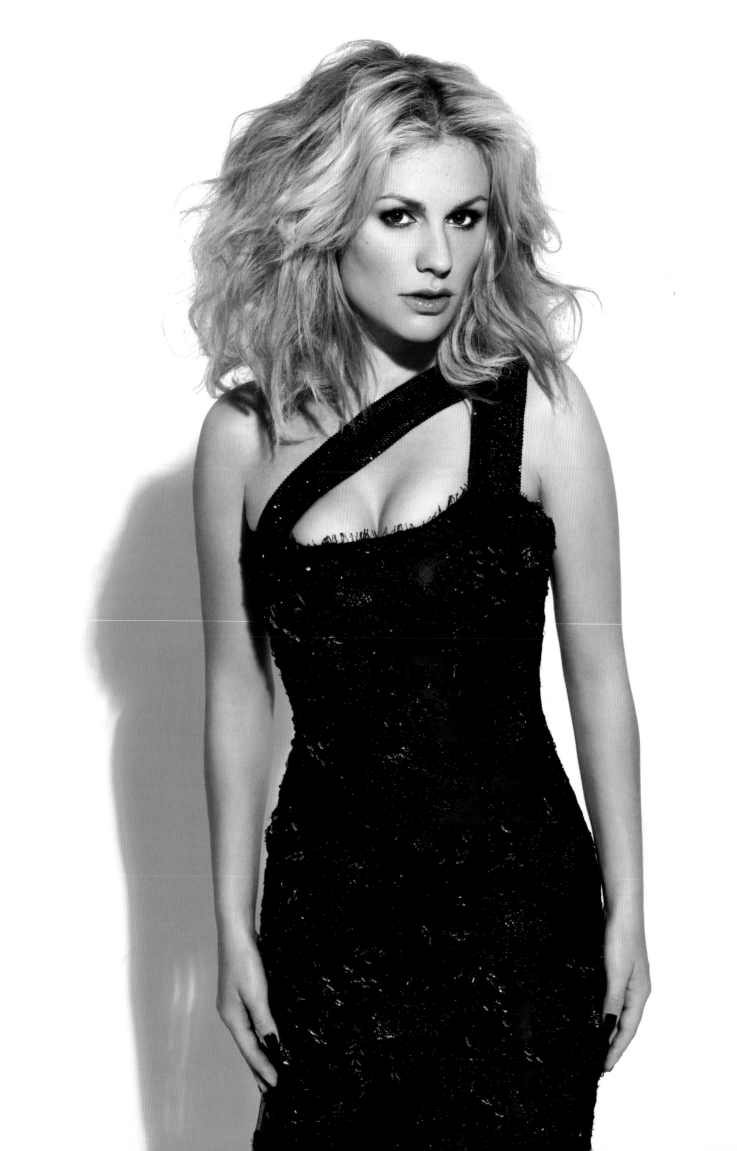

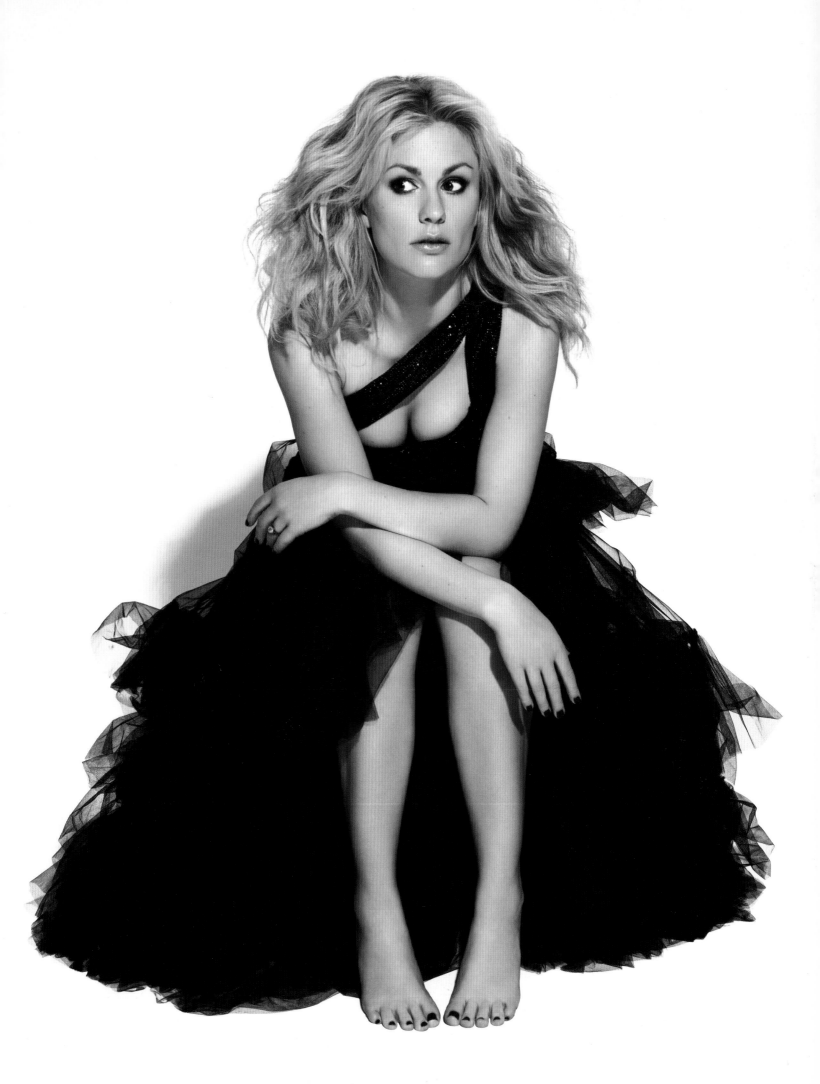

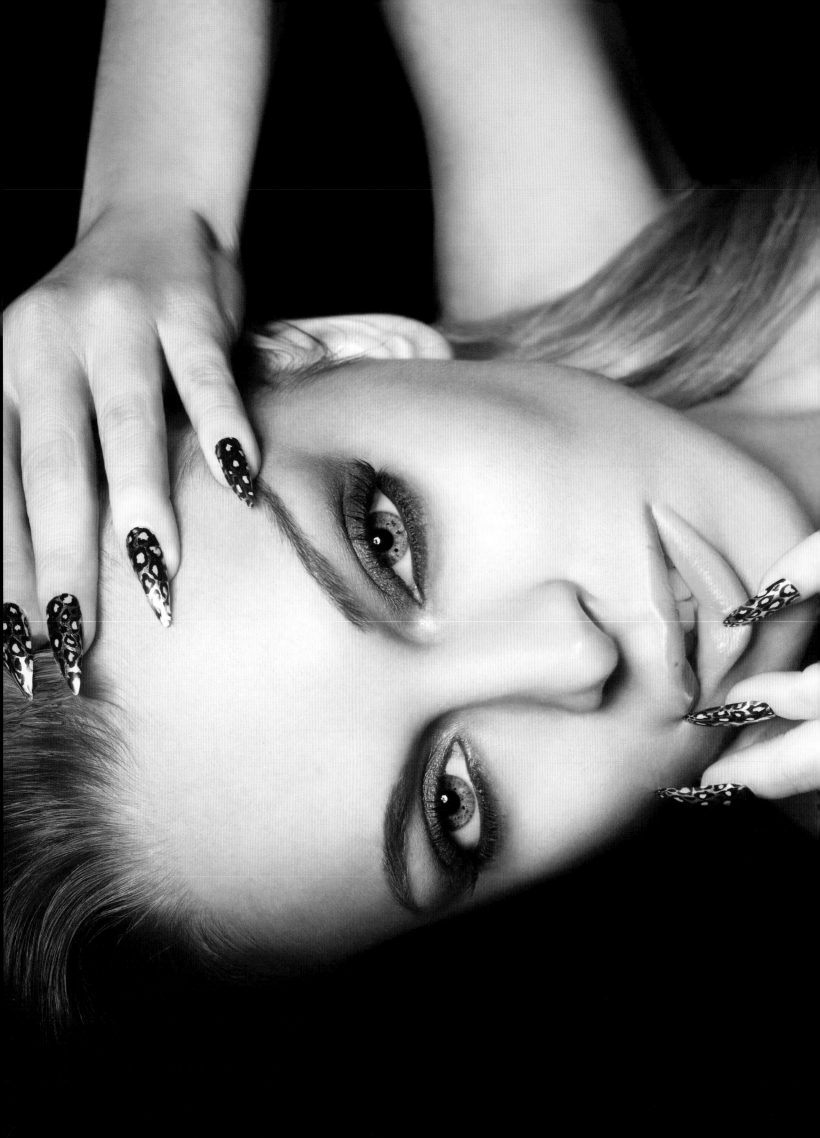

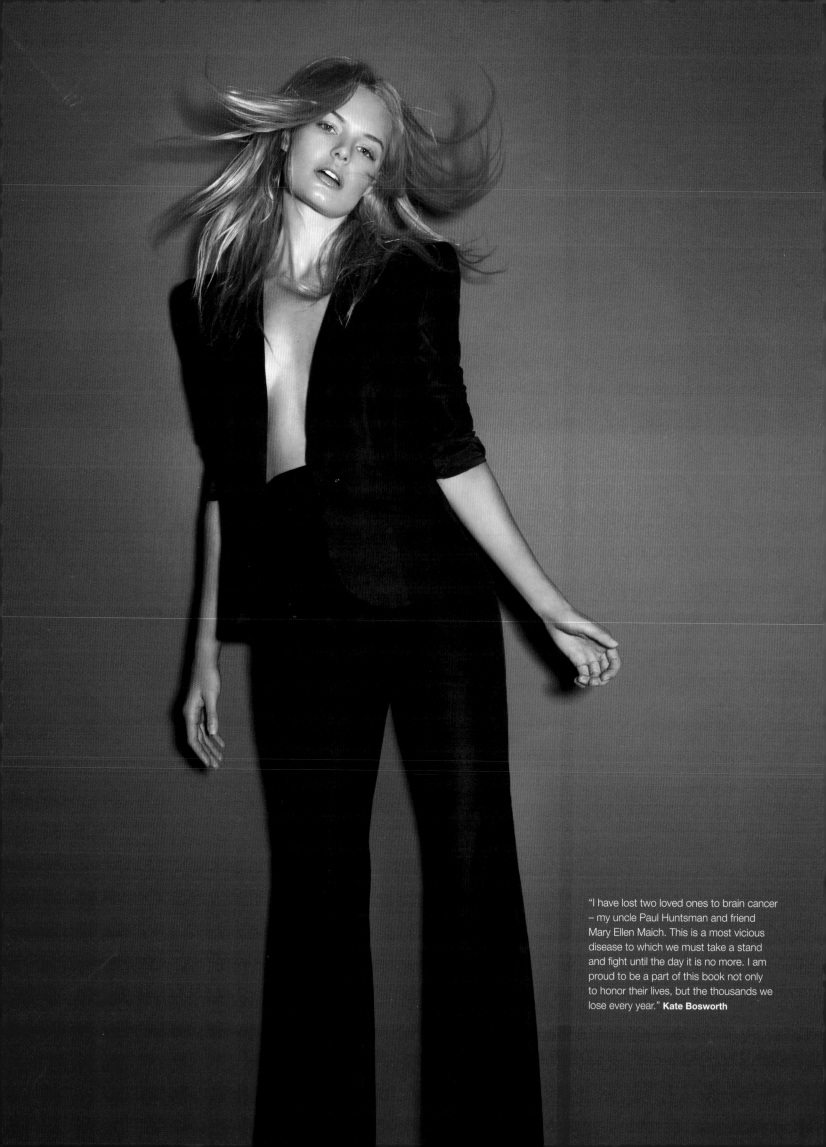

"I have lost two loved ones to brain cancer – my uncle Paul Huntsman and friend Mary Ellen Maich. This is a most vicious disease to which we must take a stand and fight until the day it is no more. I am proud to be a part of this book not only to honor their lives, but the thousands we lose every year." **Kate Bosworth**

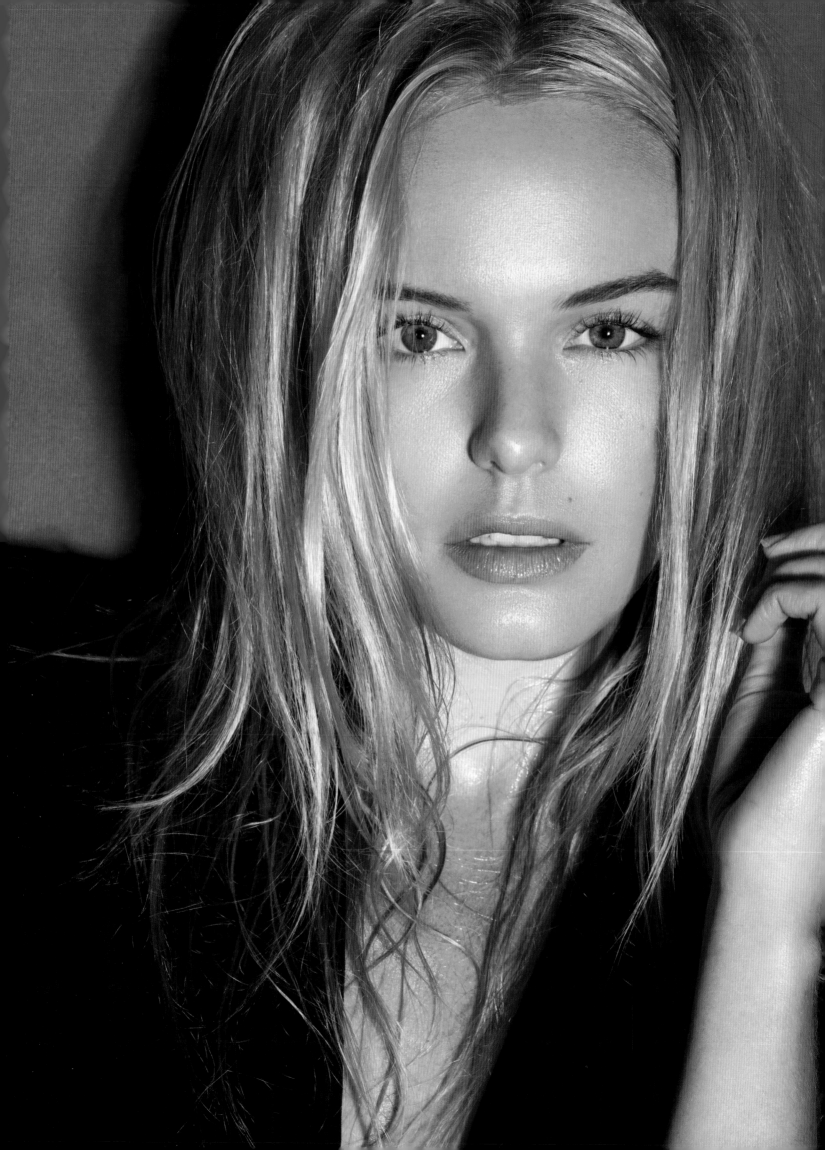

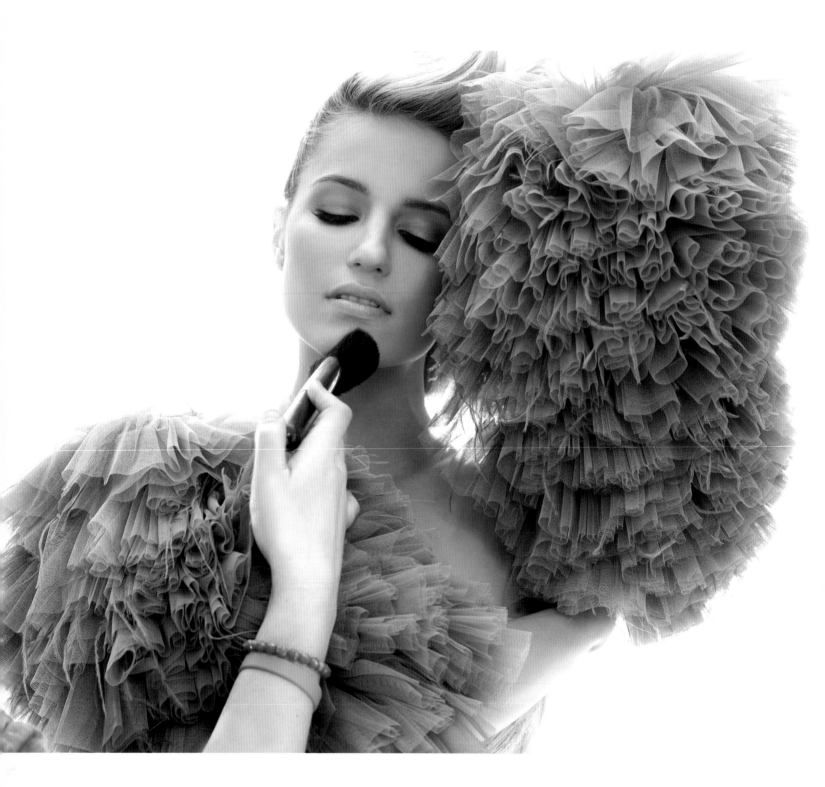

"To one of the most beautiful people I never really knew. Luckily his daughter, my mother, kept him and his spirit alive. My Grandfather would always say, "Without your health and your happiness, you have nothing." We can strive to be beautiful by acknowledging that beauty is only skin deep, and recognizing that being a beautiful person provides the most rewards. We can strive to be happier by equally acknowledging the successes and joys, no matter the size. We can strive be healthy by living well, perhaps in moderation, yet disease and illness can strike despite it all, sometimes far before one is truly ready. Thank you Sarah for bringing me on board, your beauty and passion is deep. As is everyone involved in this book. To those that we've lost along the way, this is for you." **Dianna Agron**

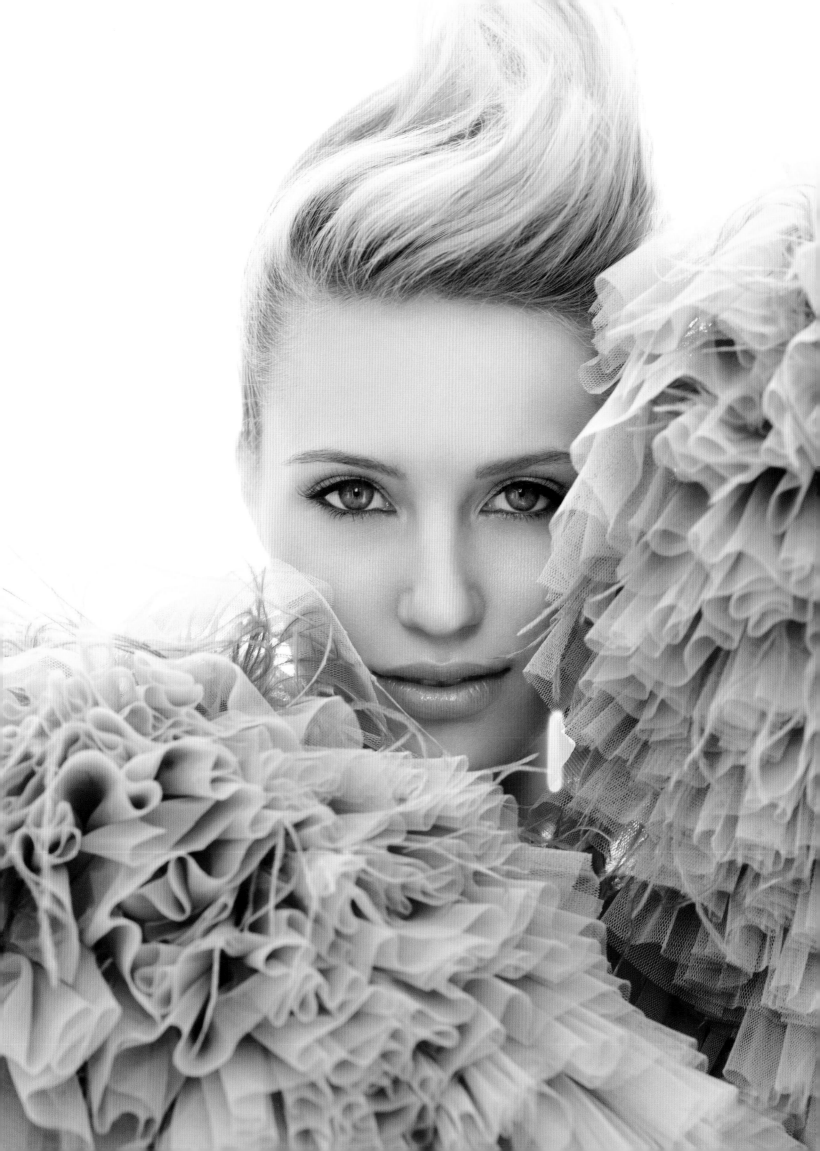

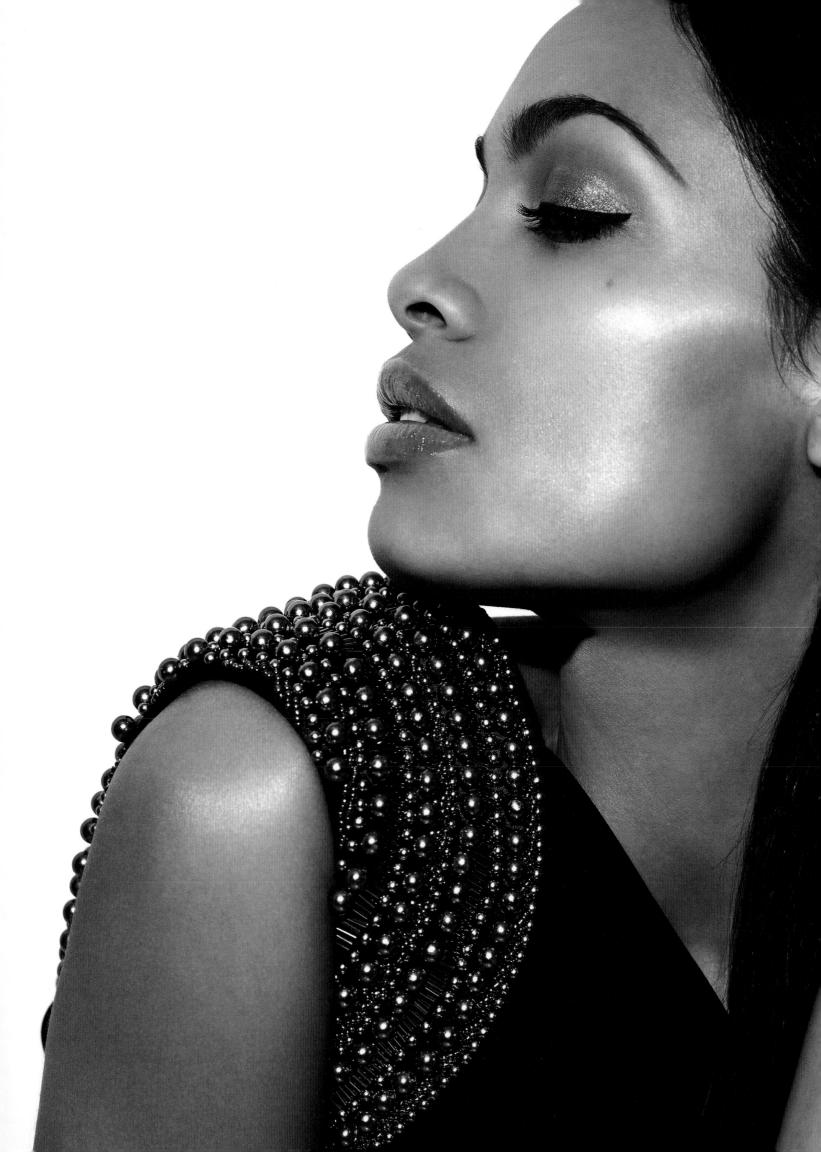

"This was one of the most wonderful shoots ever.
Knowing the awareness & funds we could achieve
through collaborating together was exciting & humbling.
I admire Darren's vision & commitment. Thank you for
allowing me to participate." **Rosario Dawson**

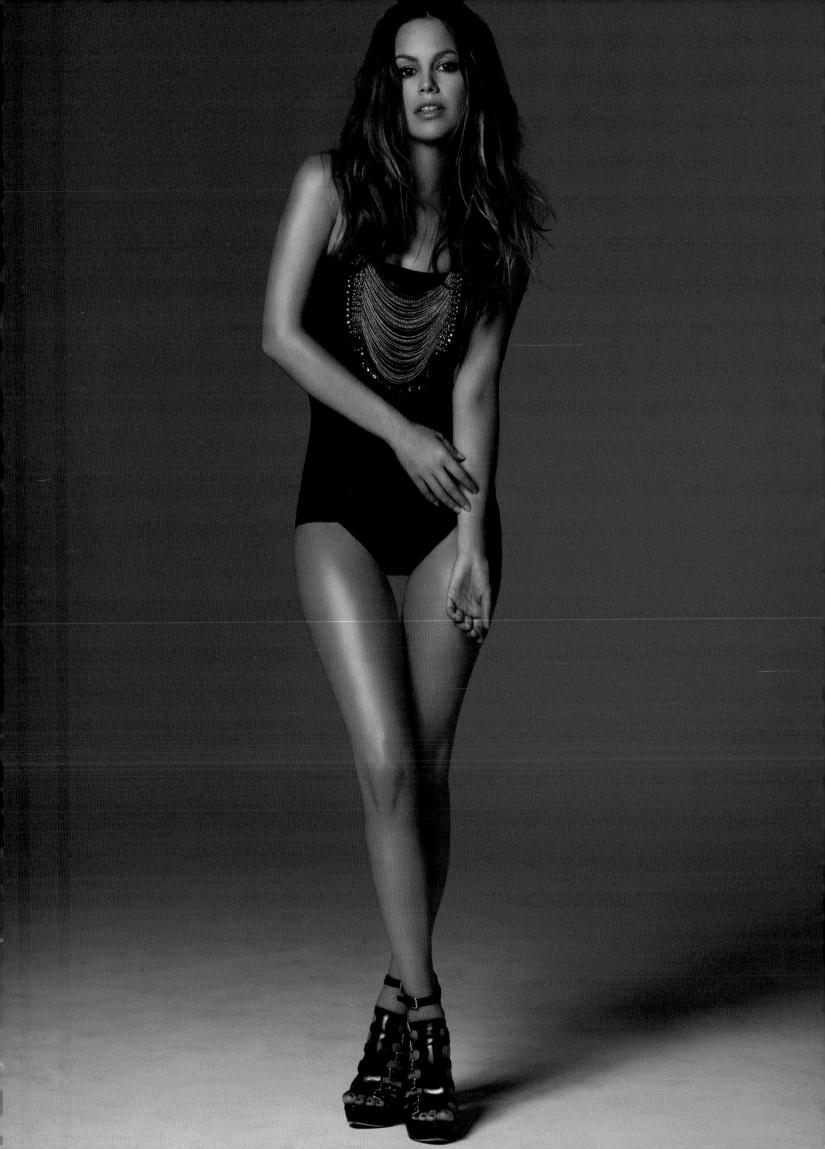

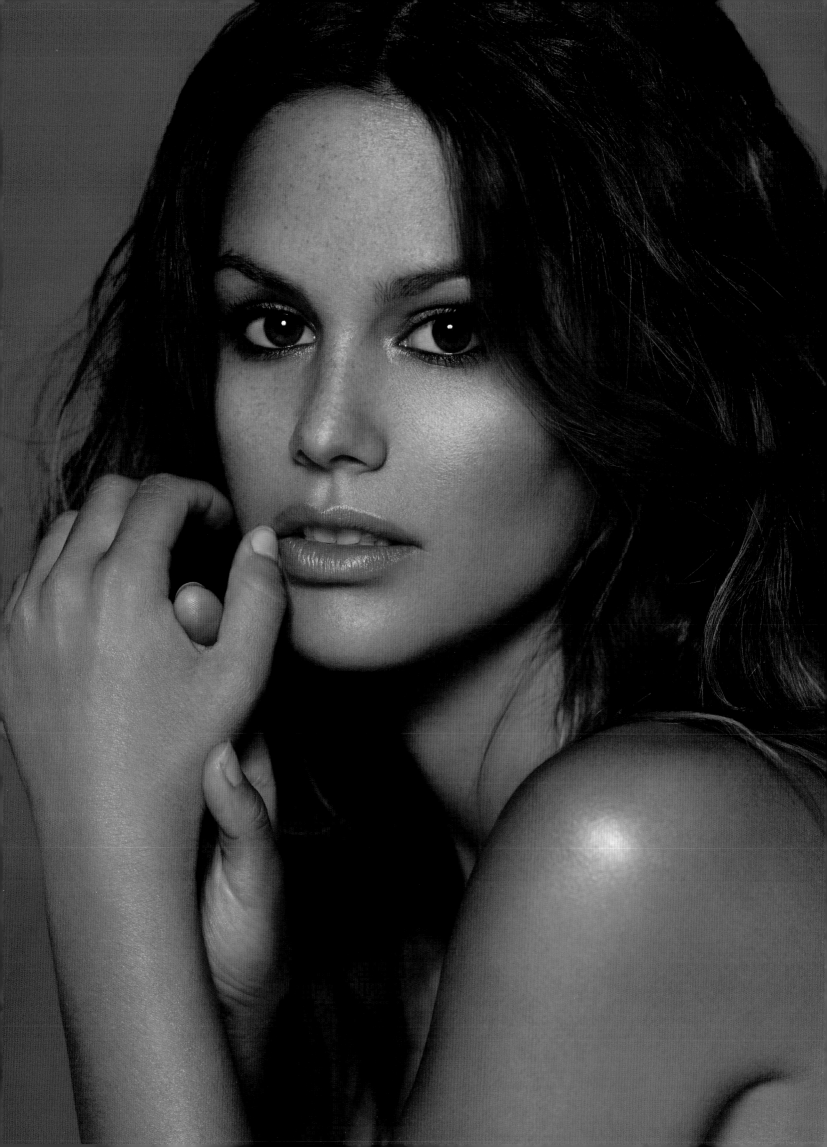

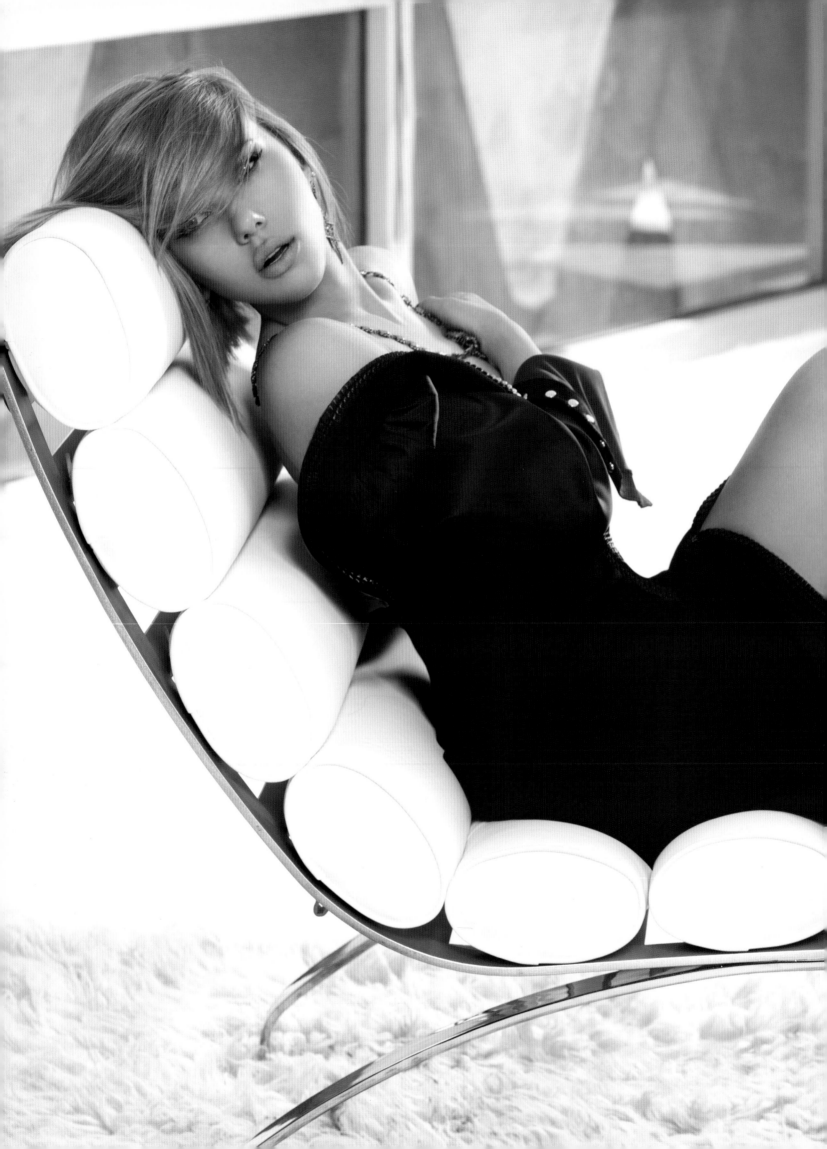

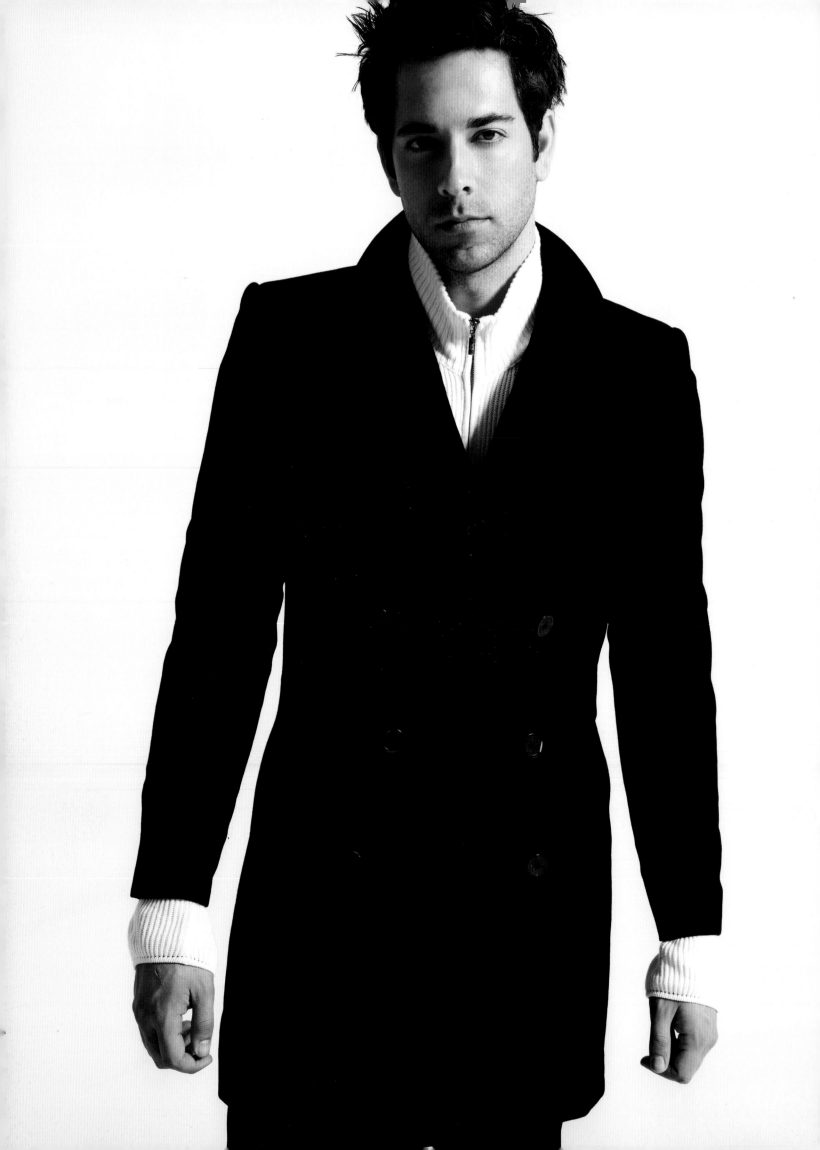

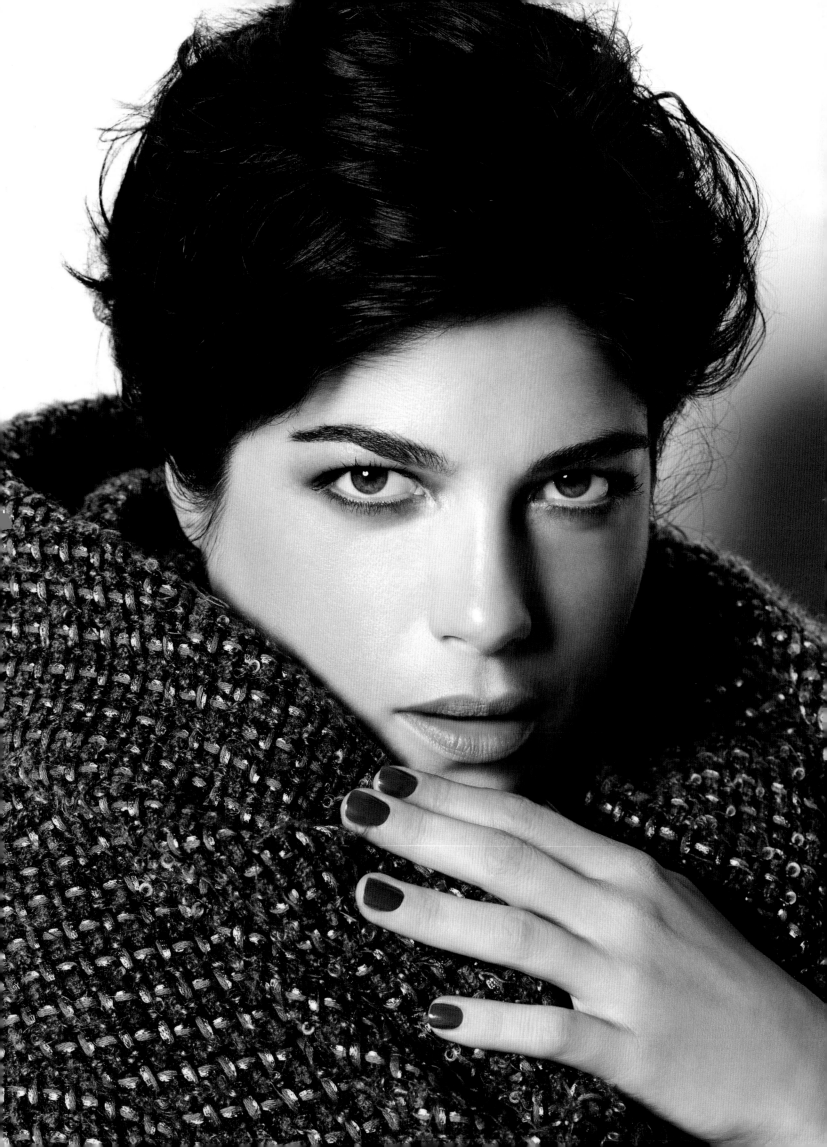

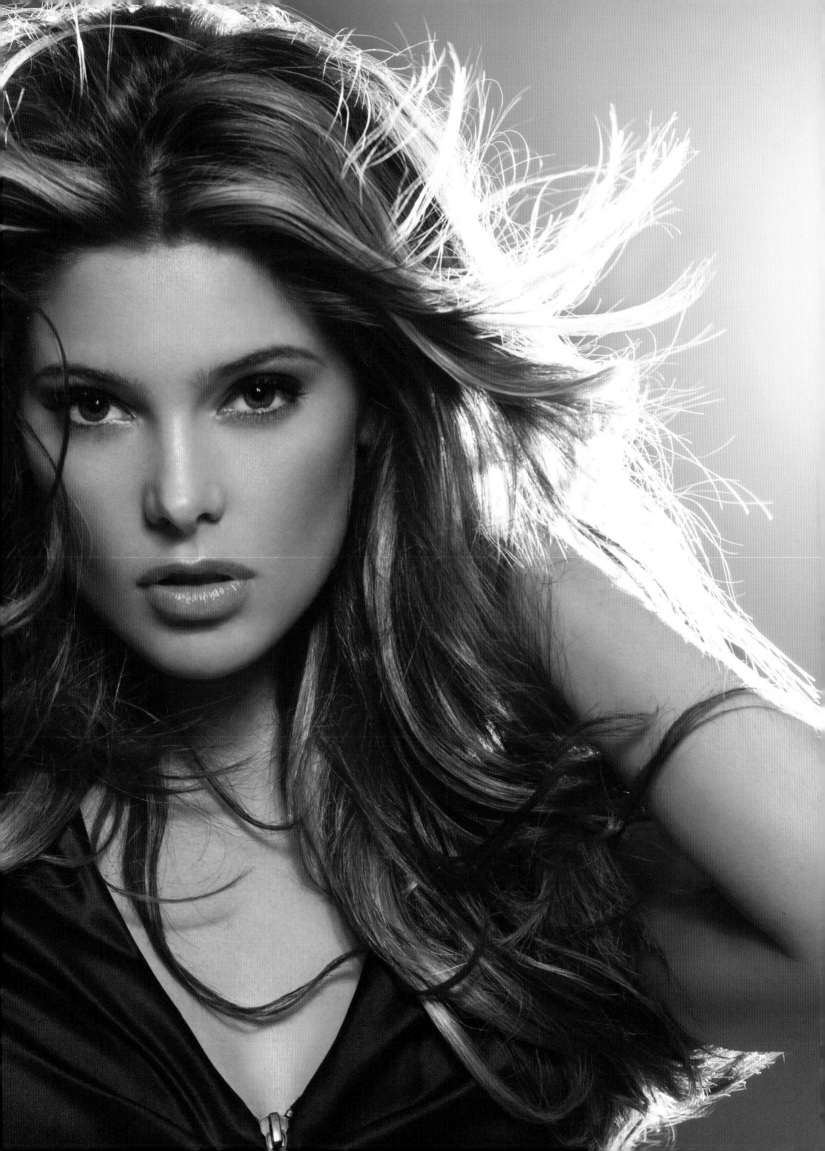

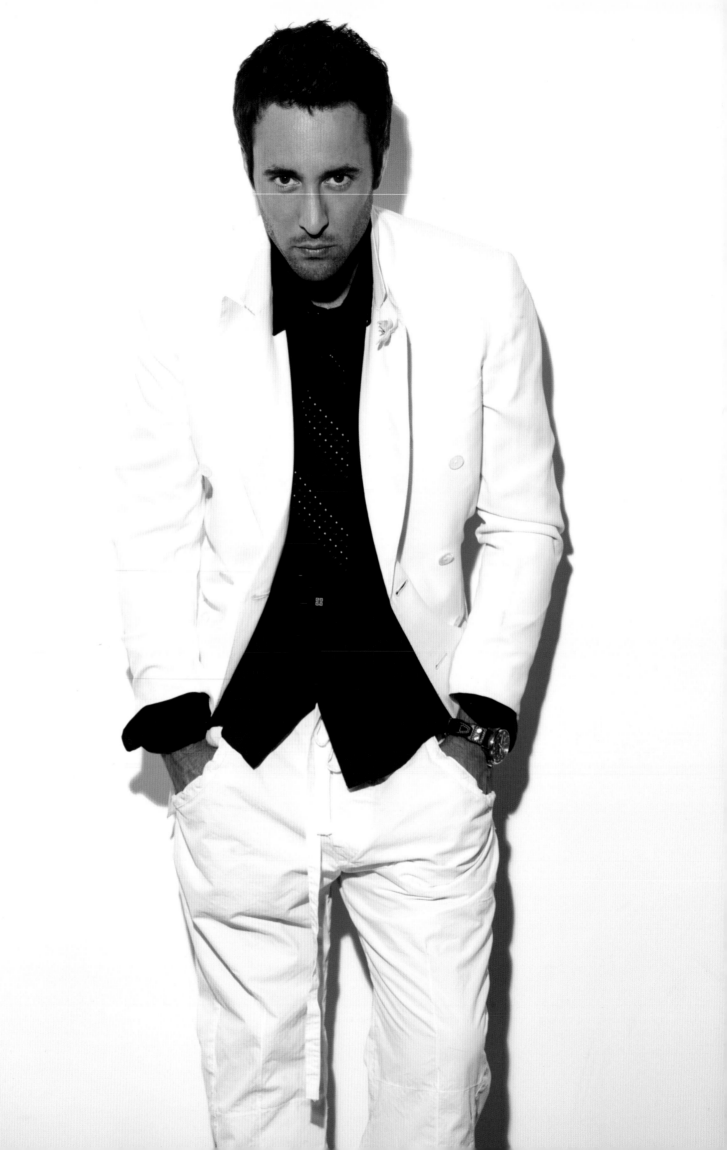

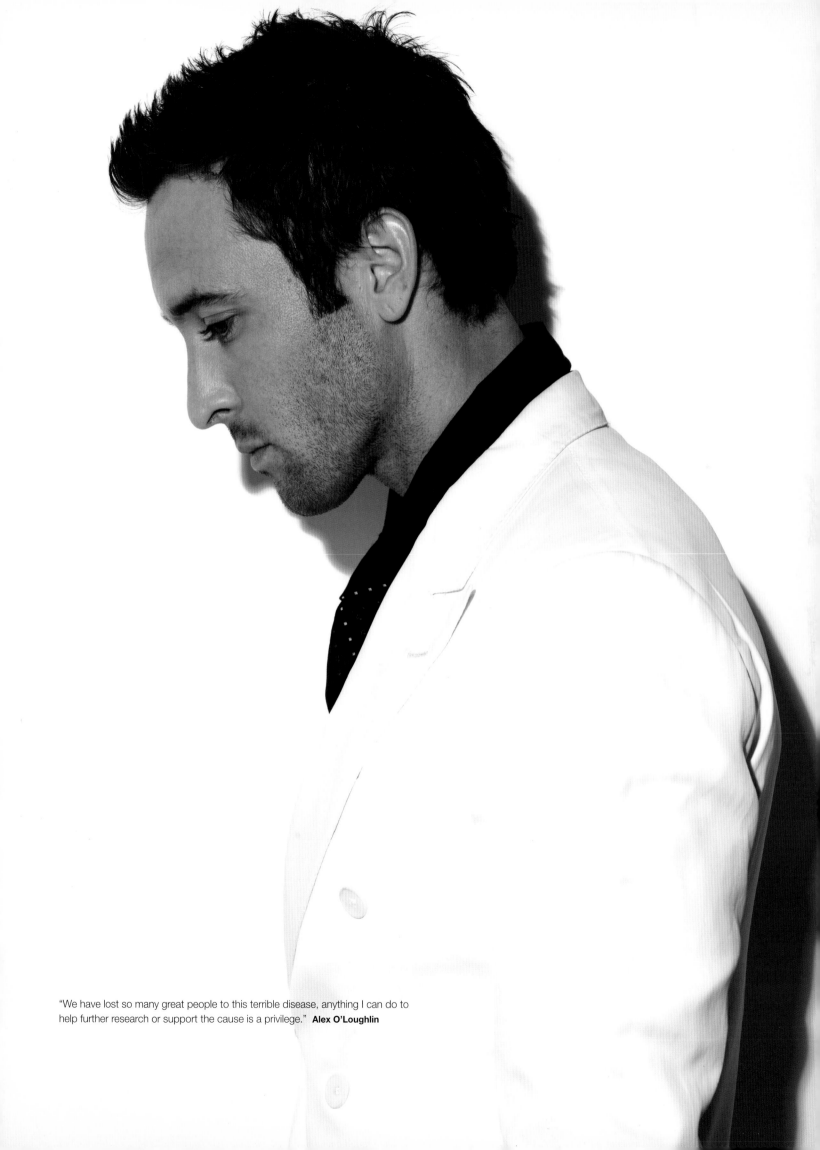

"We have lost so many great people to this terrible disease, anything I can do to help further research or support the cause is a privilege." **Alex O'Loughlin**

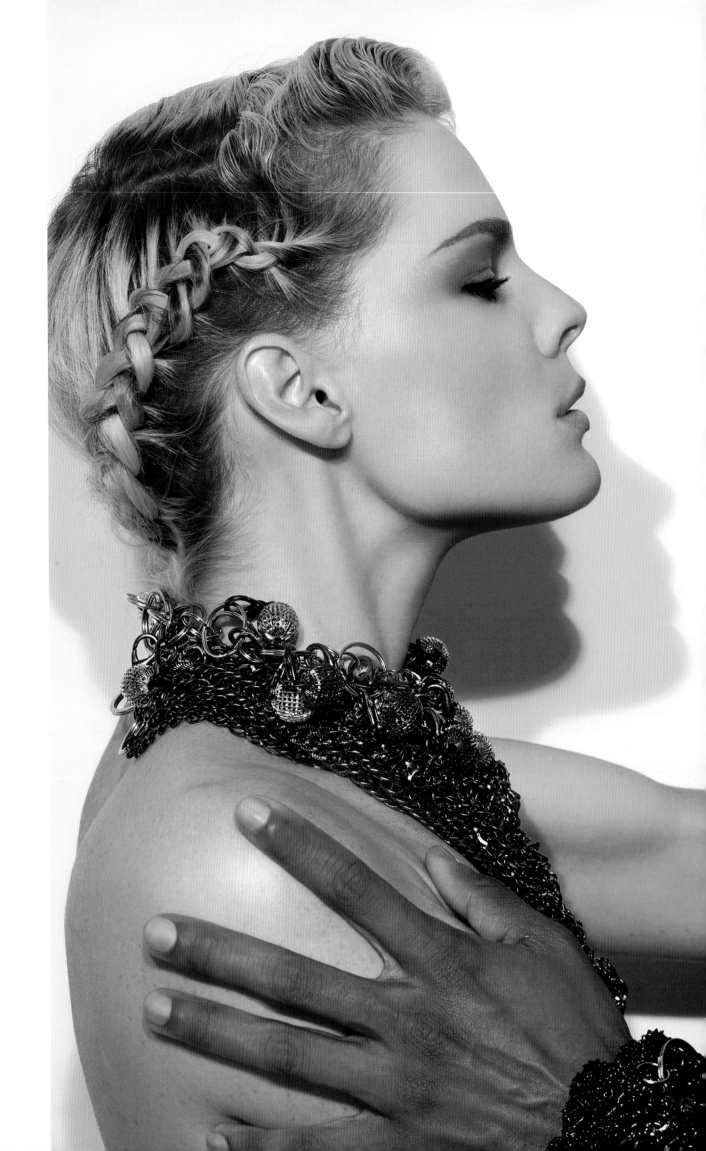

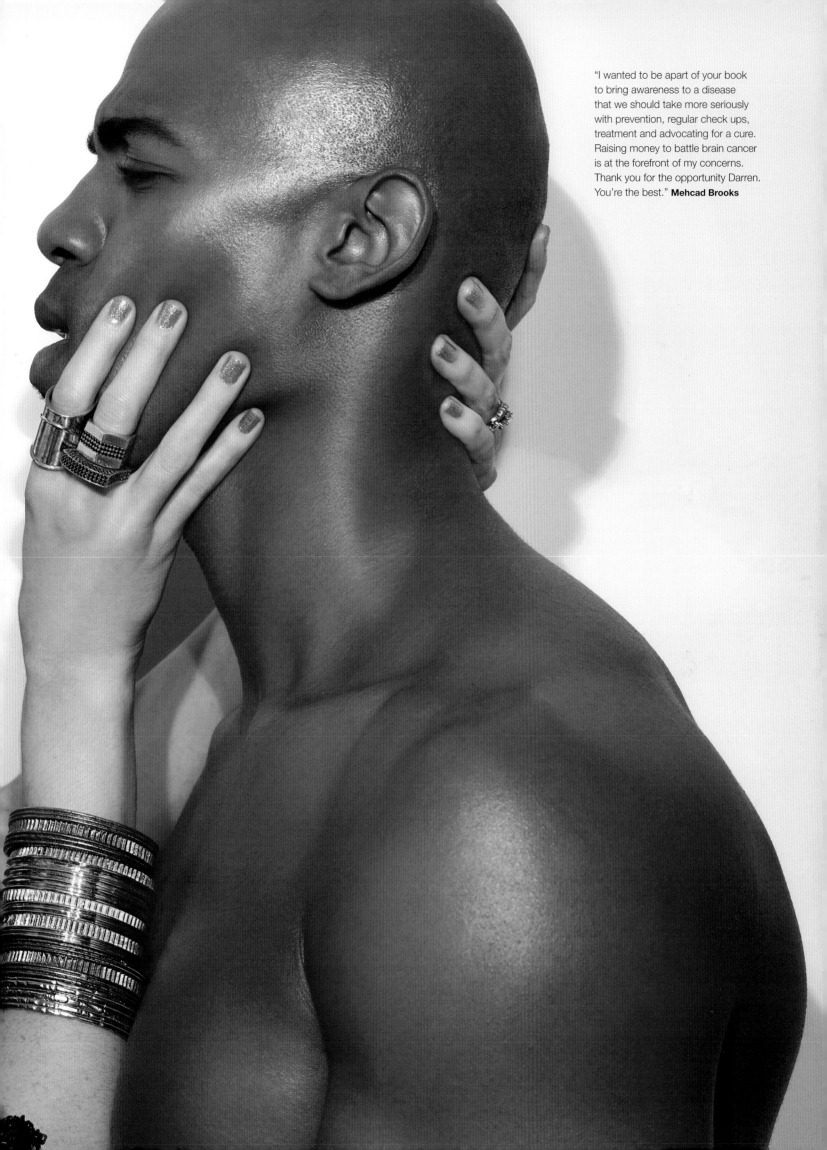

"I wanted to be apart of your book to bring awareness to a disease that we should take more seriously with prevention, regular check ups, treatment and advocating for a cure. Raising money to battle brain cancer is at the forefront of my concerns. Thank you for the opportunity Darren. You're the best." **Mehcad Brooks**

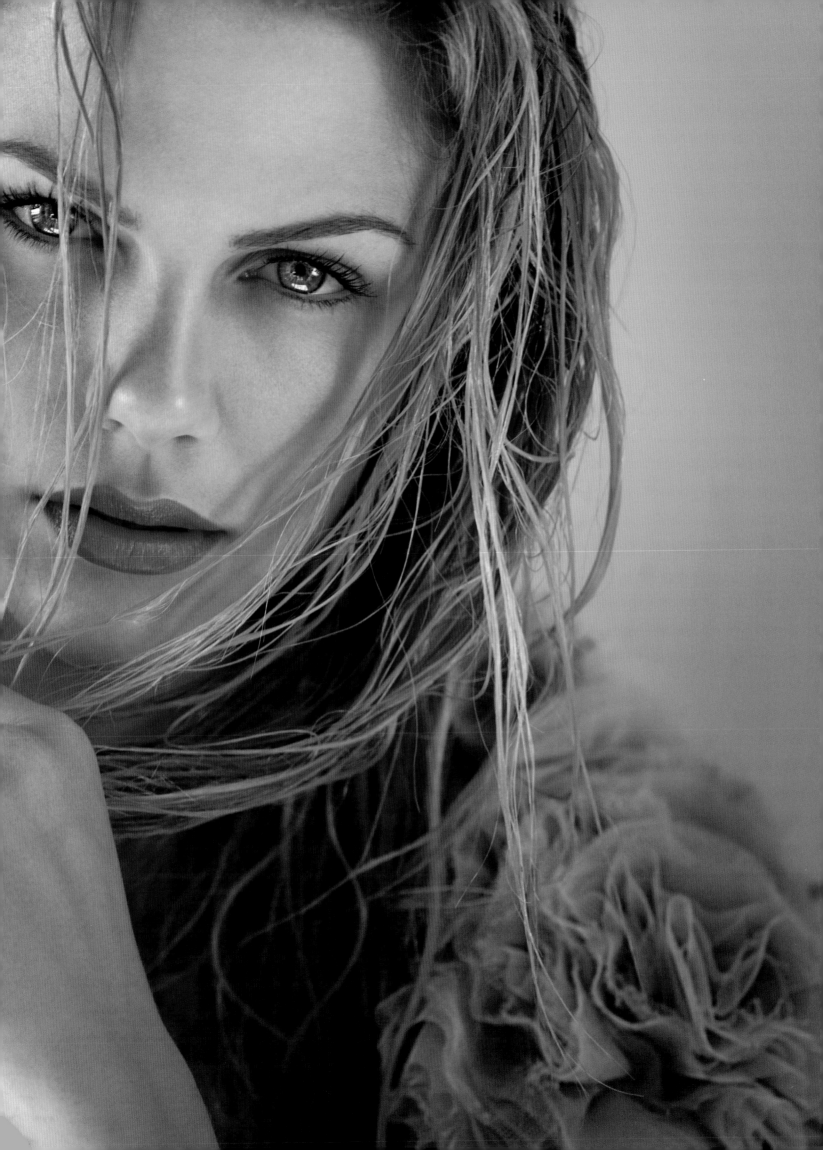

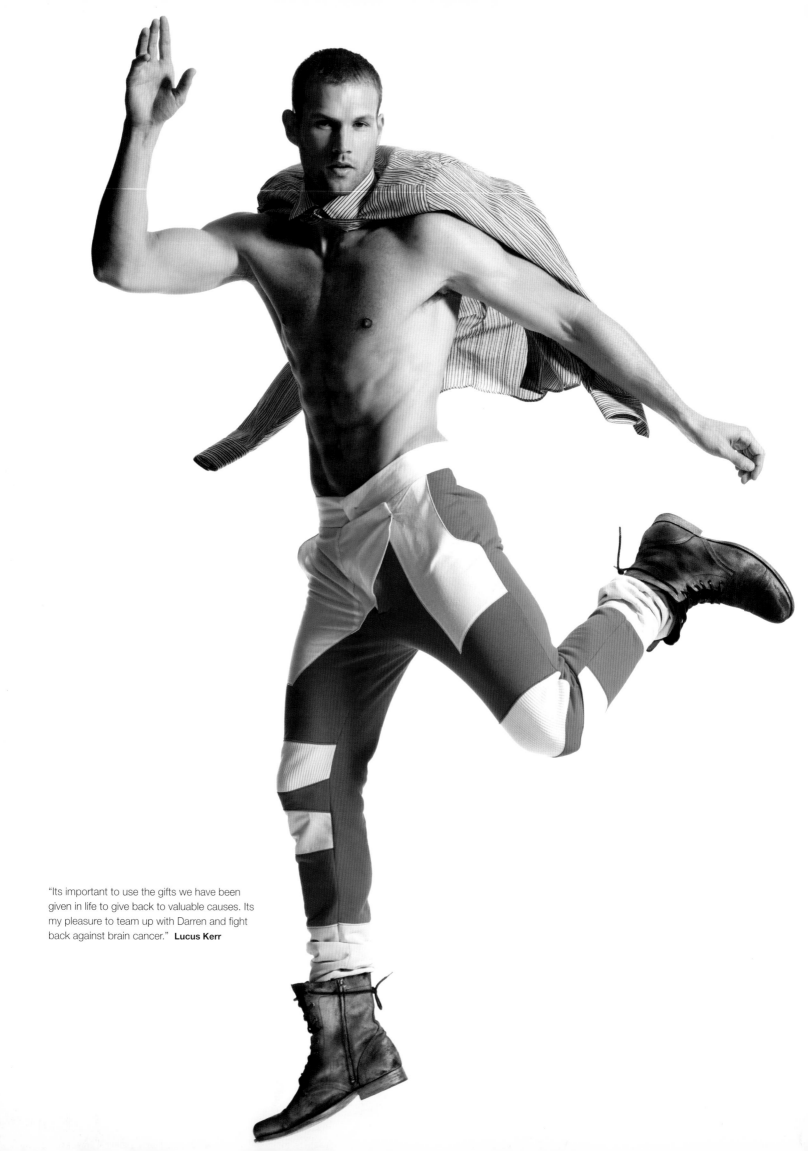

"Its important to use the gifts we have been given in life to give back to valuable causes. Its my pleasure to team up with Darren and fight back against brain cancer." **Lucus Kerr**

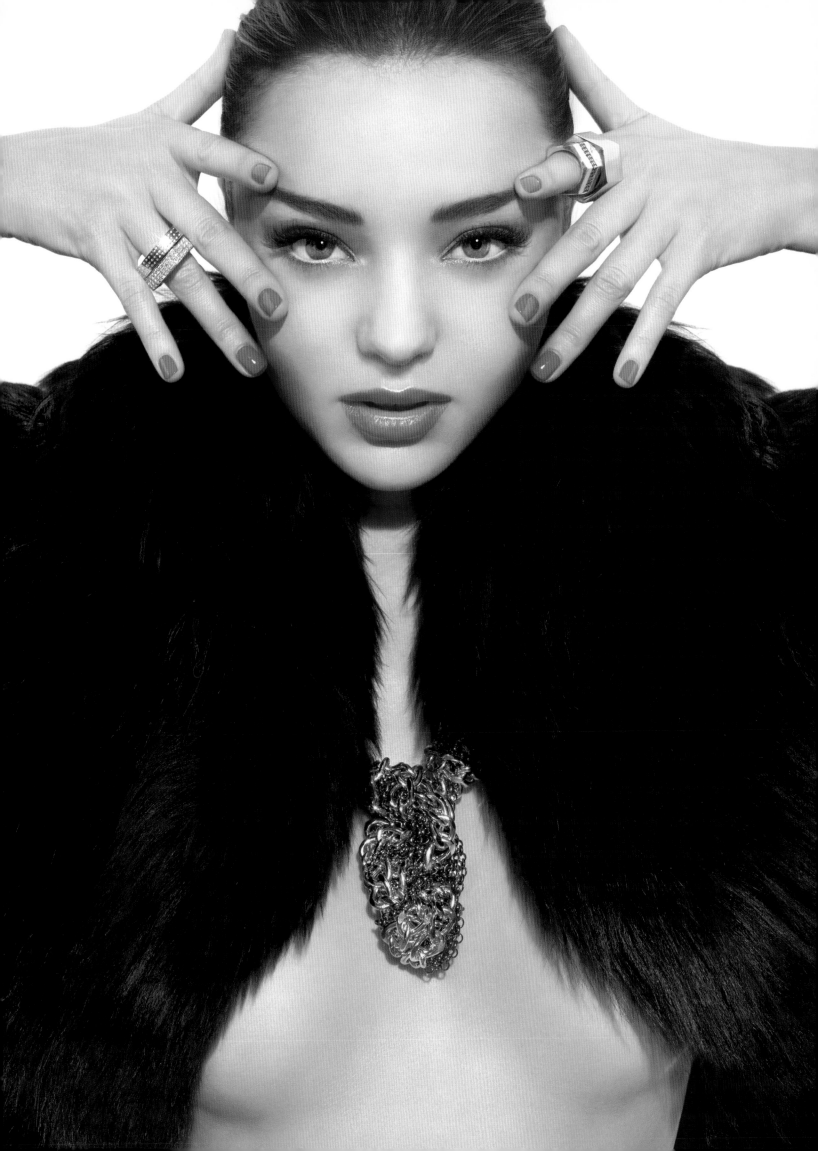

"This cause is very near and dear to my heart. I feel honored to be part of this book supporting the fight against brain cancer." **Denise Richards**

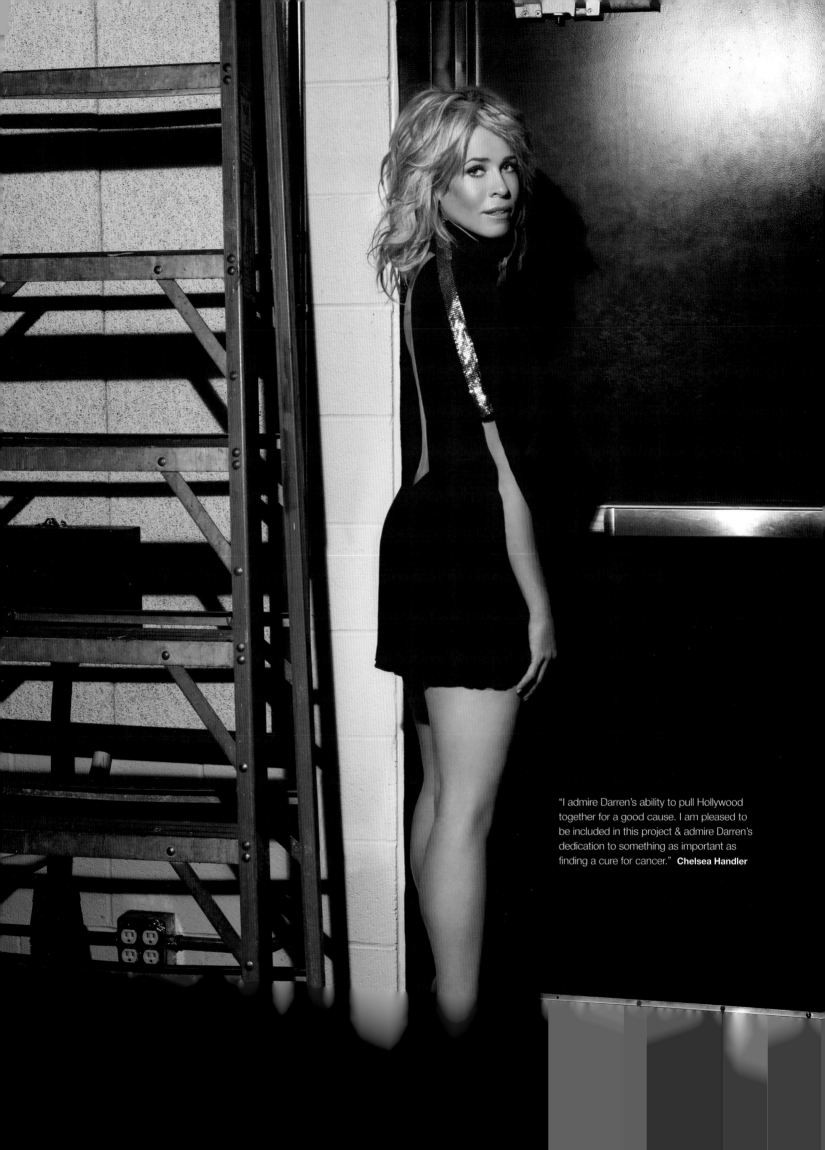

"I admire Darren's ability to pull Hollywood together for a good cause. I am pleased to be included in this project & admire Darren's dedication to something as important as finding a cure for cancer." **Chelsea Handler**

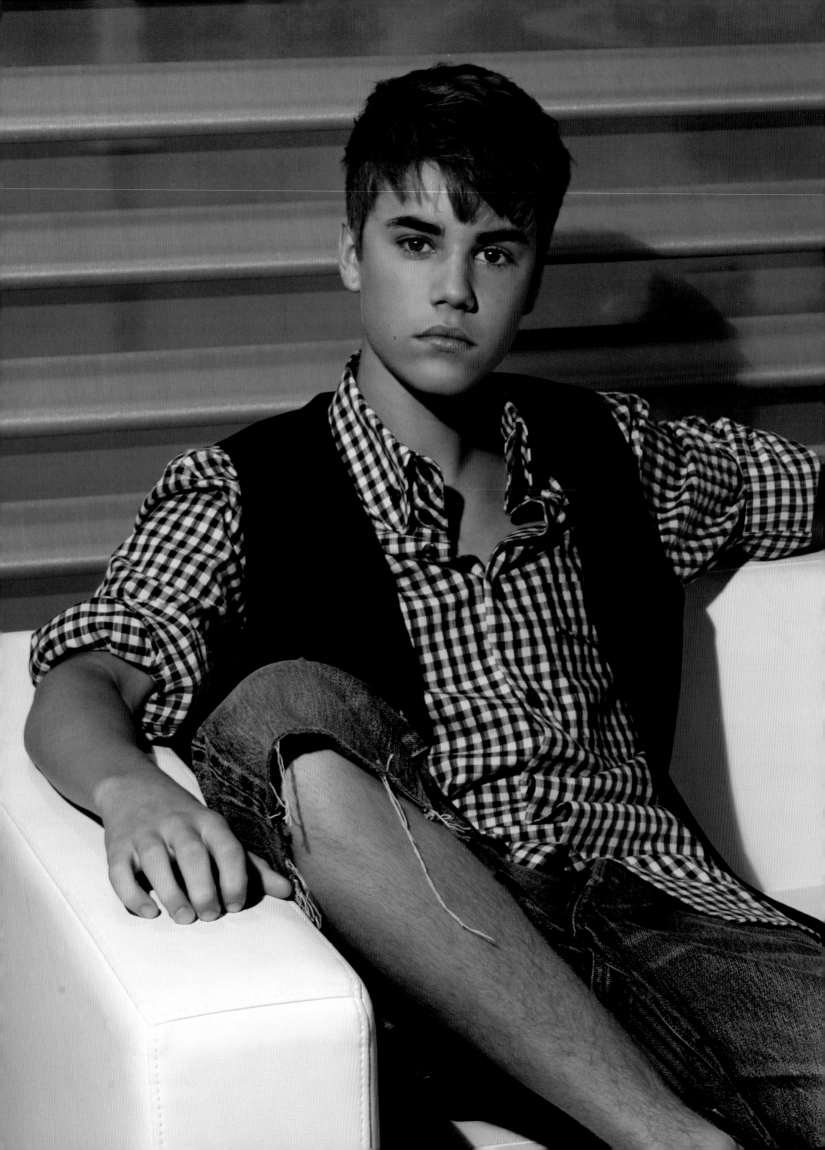

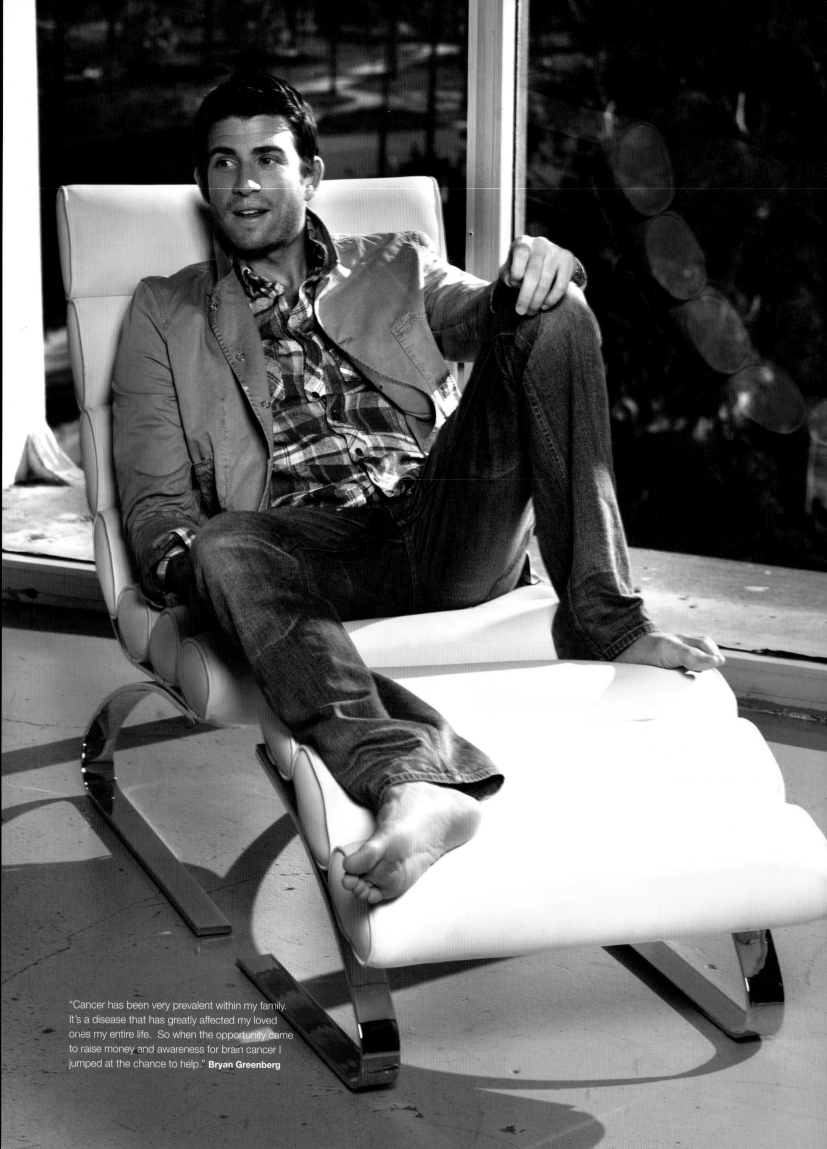

"Cancer has been very prevalent within my family. It's a disease that has greatly affected my loved ones my entire life. So when the opportunity came to raise money and awareness for brain cancer I jumped at the chance to help." **Bryan Greenberg**

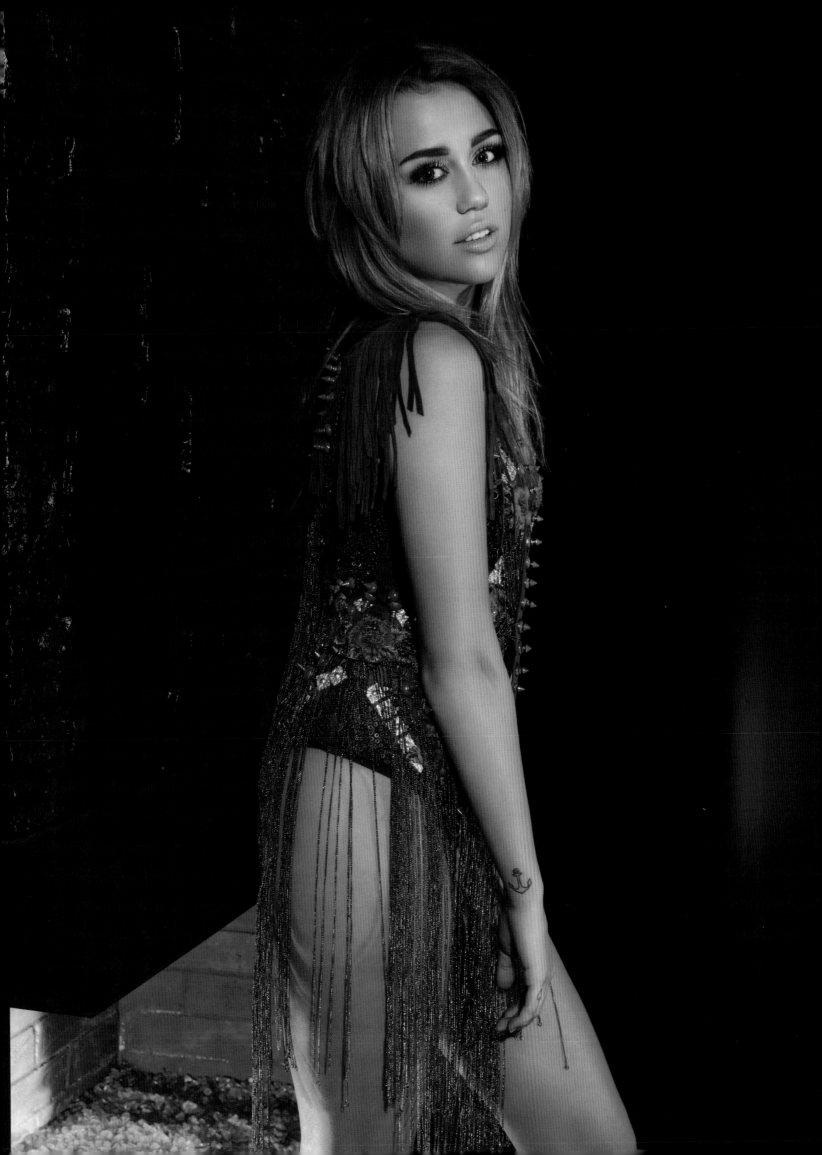

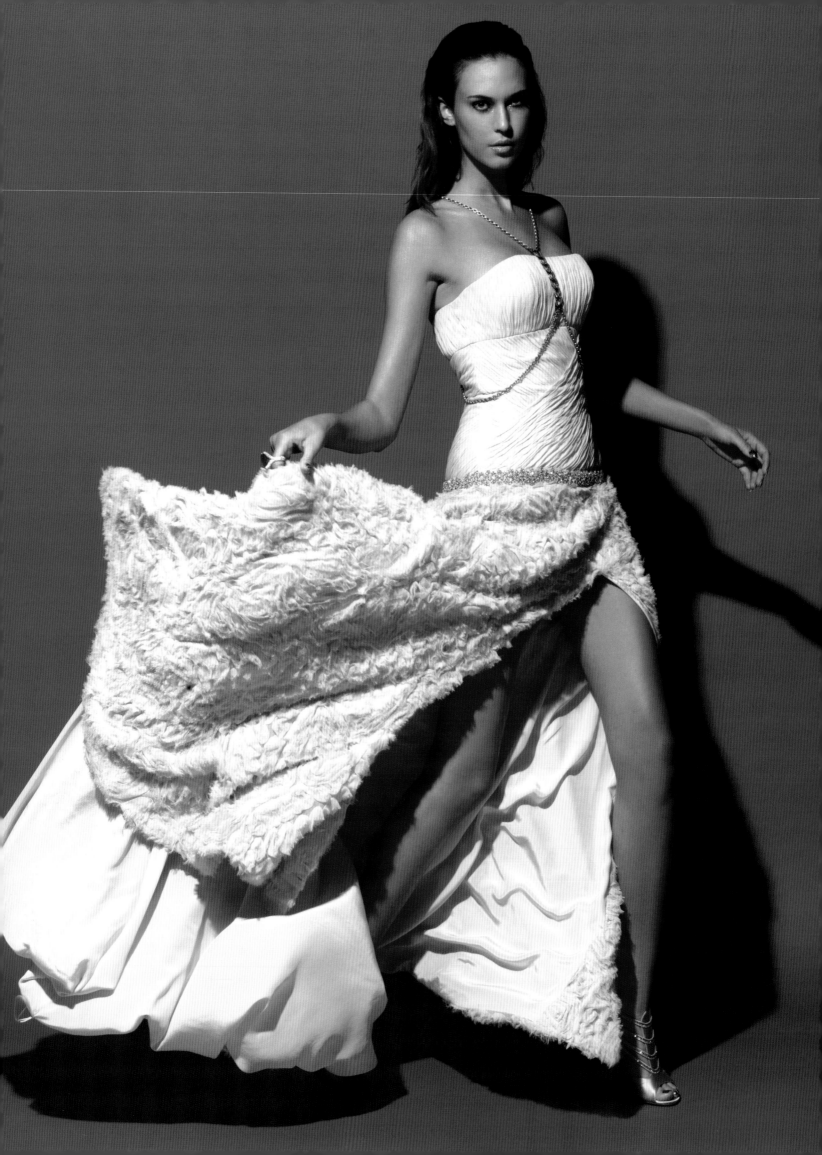

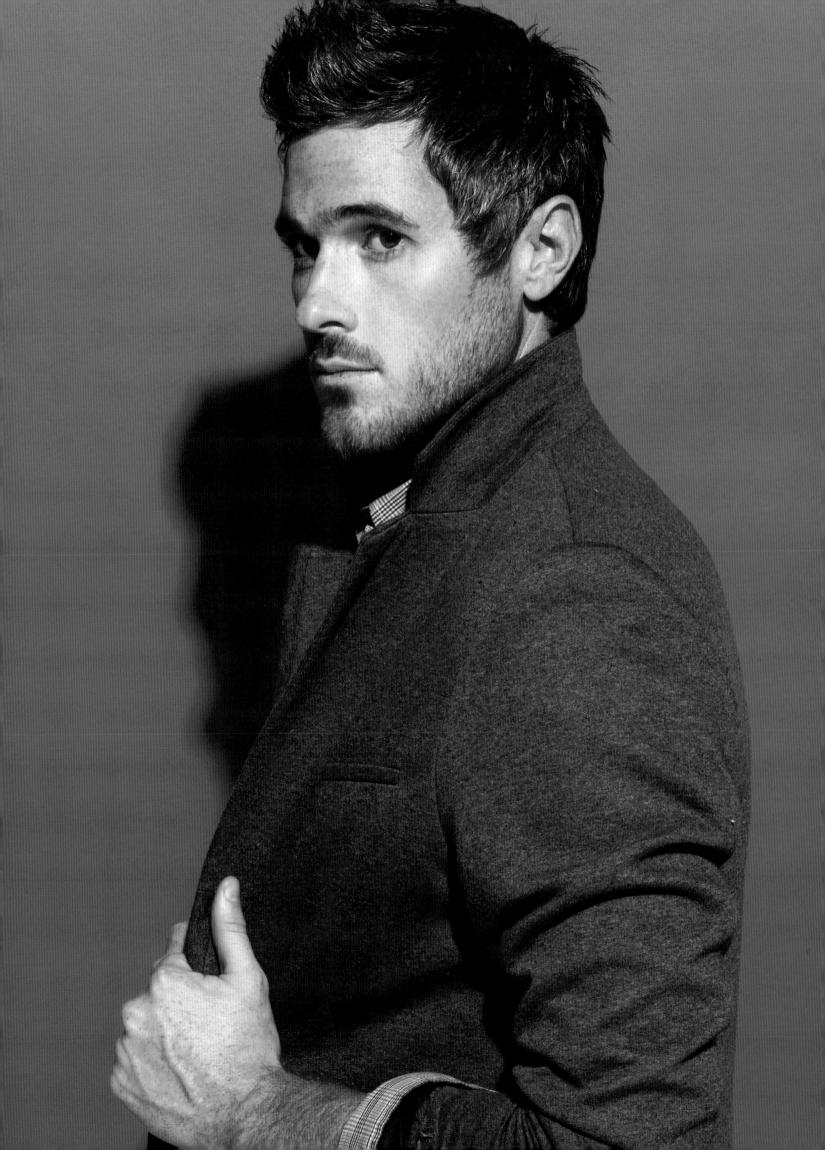

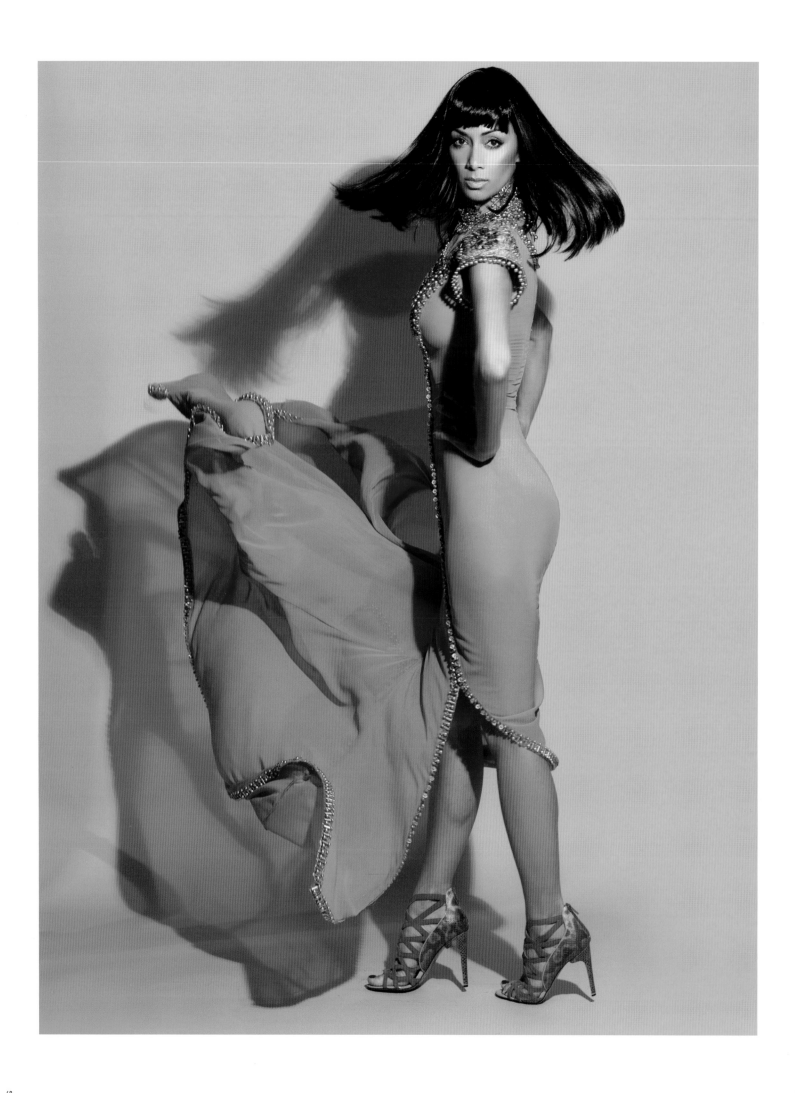

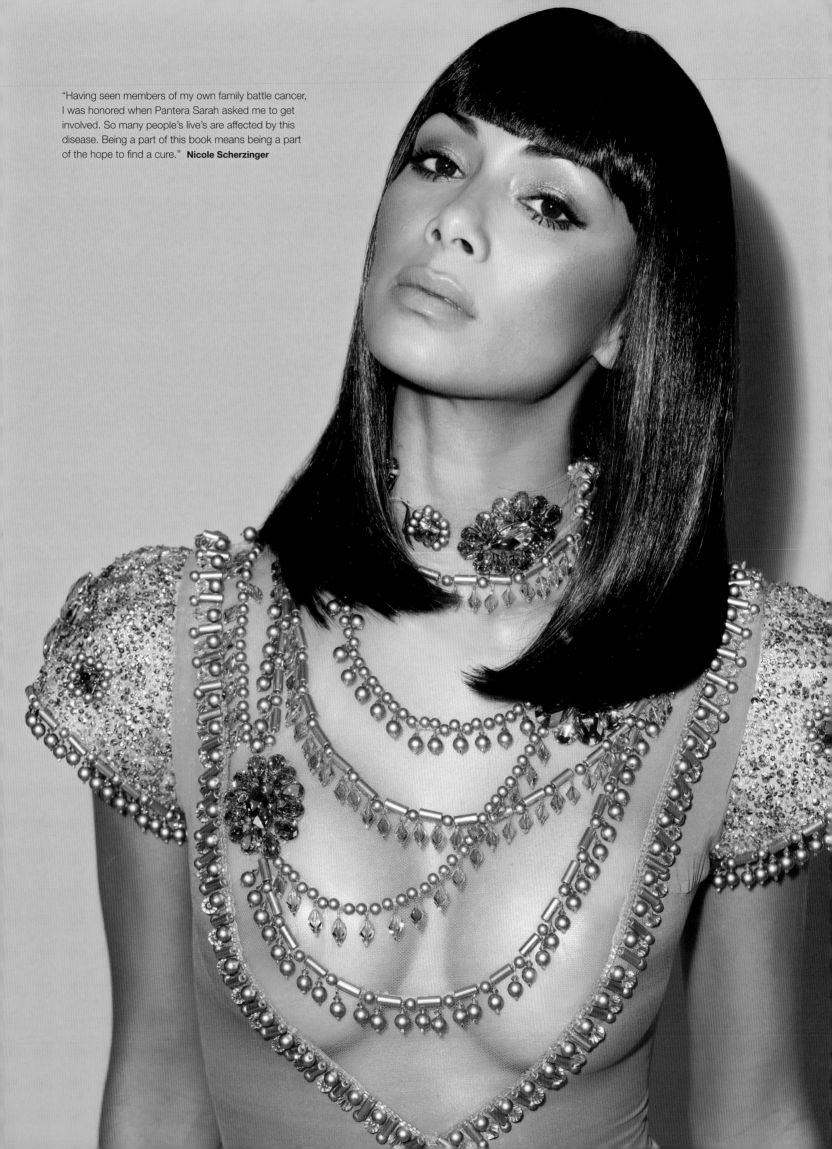

"Having seen members of my own family battle cancer, I was honored when Pantera Sarah asked me to get involved. So many people's live's are affected by this disease. Being a part of this book means being a part of the hope to find a cure." **Nicole Scherzinger**

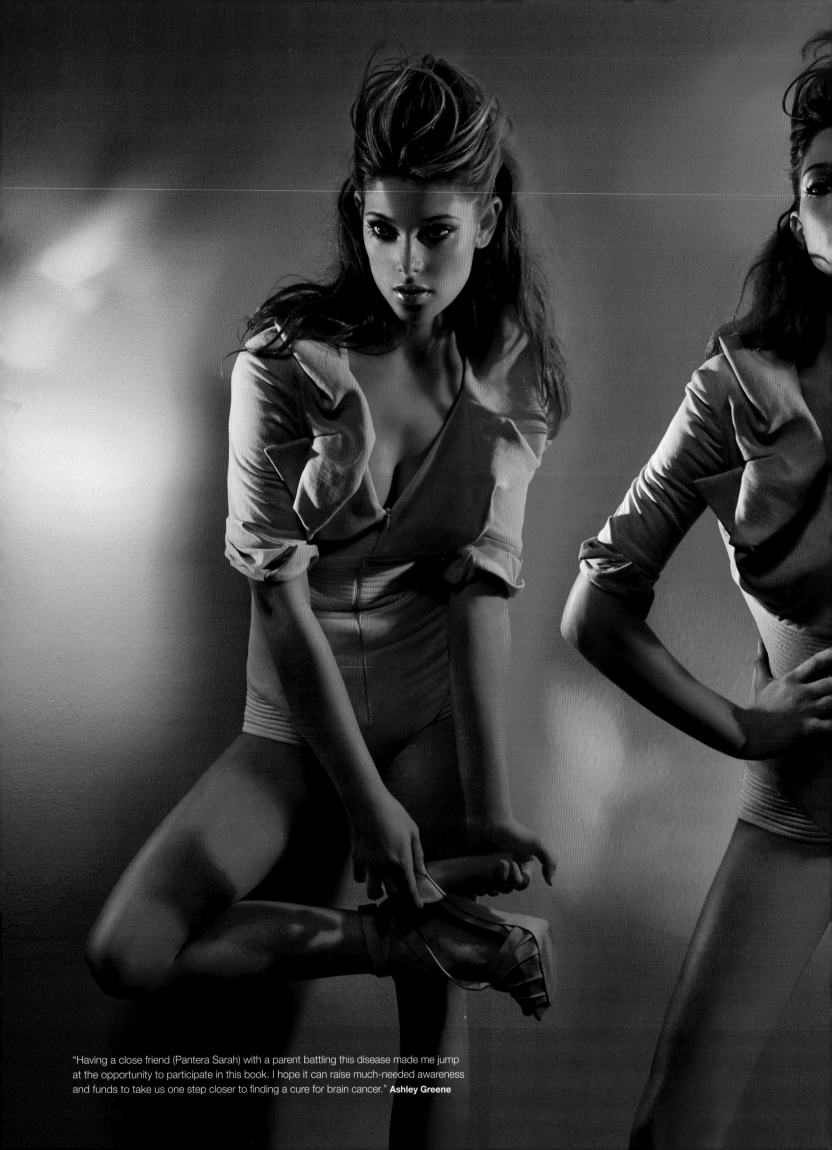

"Having a close friend (Pantera Sarah) with a parent battling this disease made me jump at the opportunity to participate in this book. I hope it can raise much-needed awareness and funds to take us one step closer to finding a cure for brain cancer." **Ashley Greene**

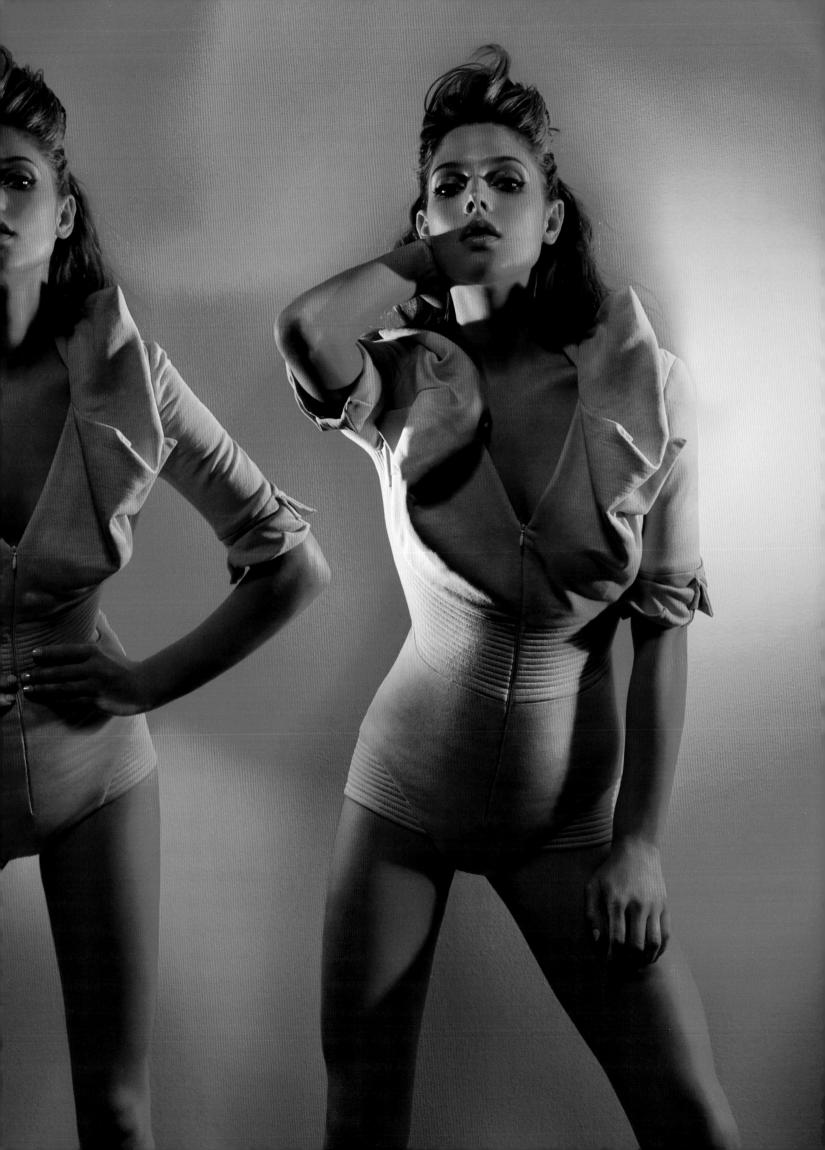

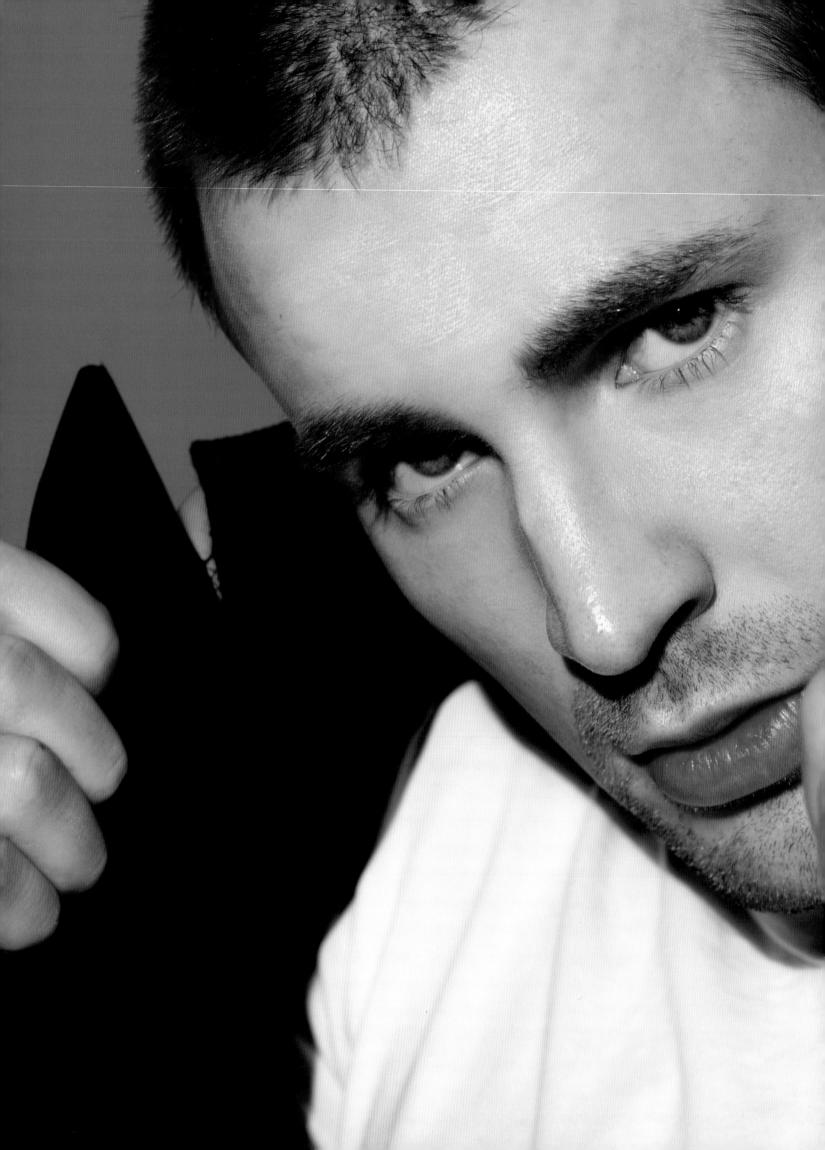

"I participated in the book because I believe in solutions, taking action, and seeking alternatives to disease. Its never about a fight against cancer its all about re generating healthy cells and preventing mutations, if research is the step to a solution then count me in." **Michelle Rodriguez**

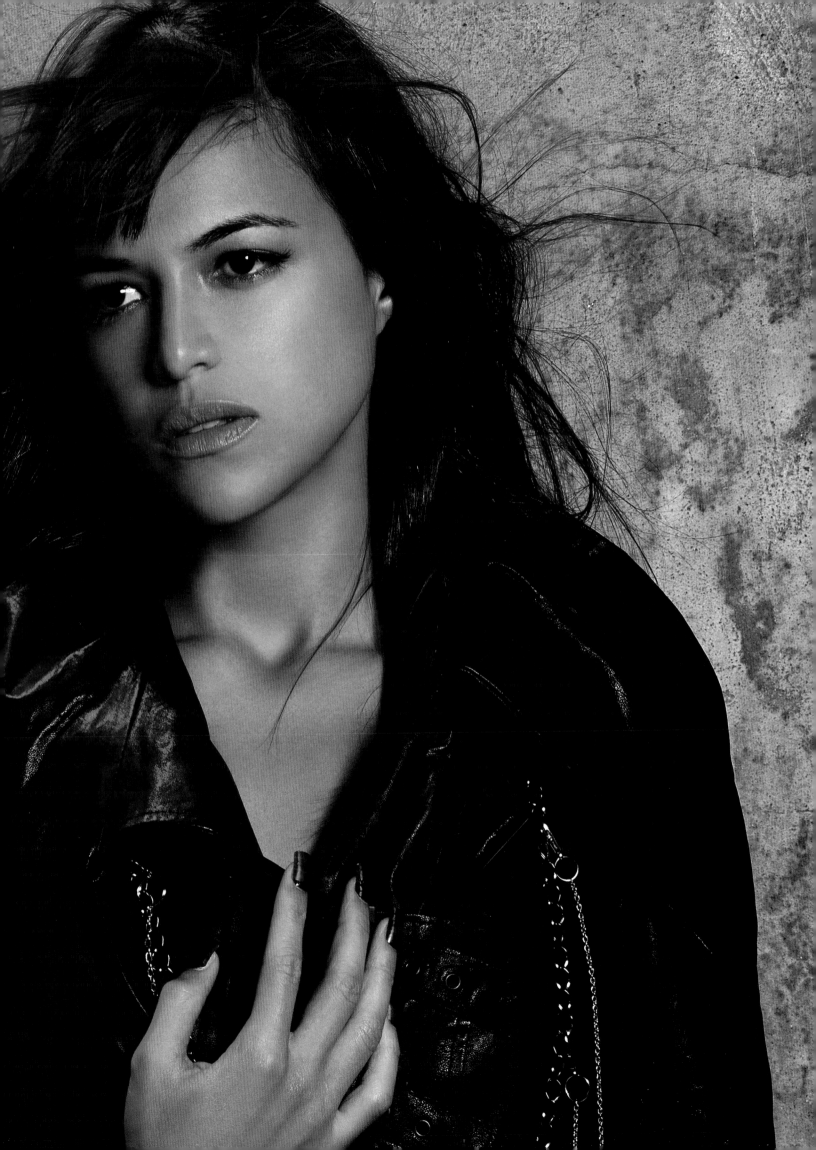

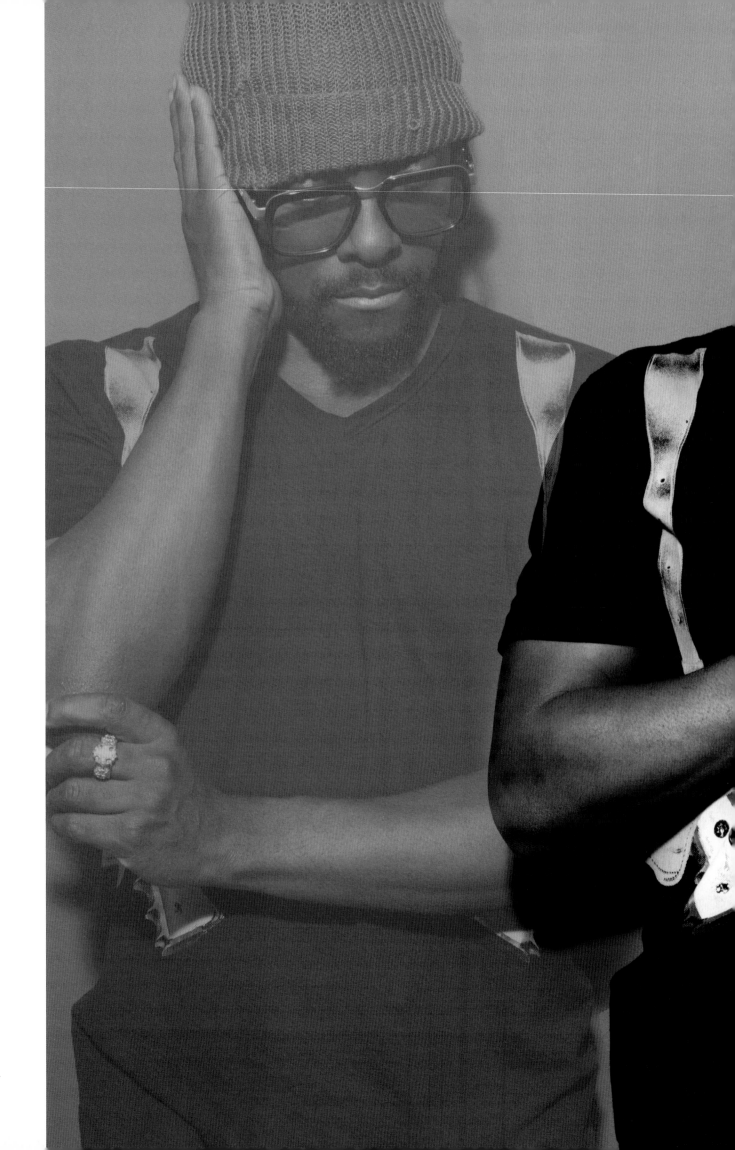

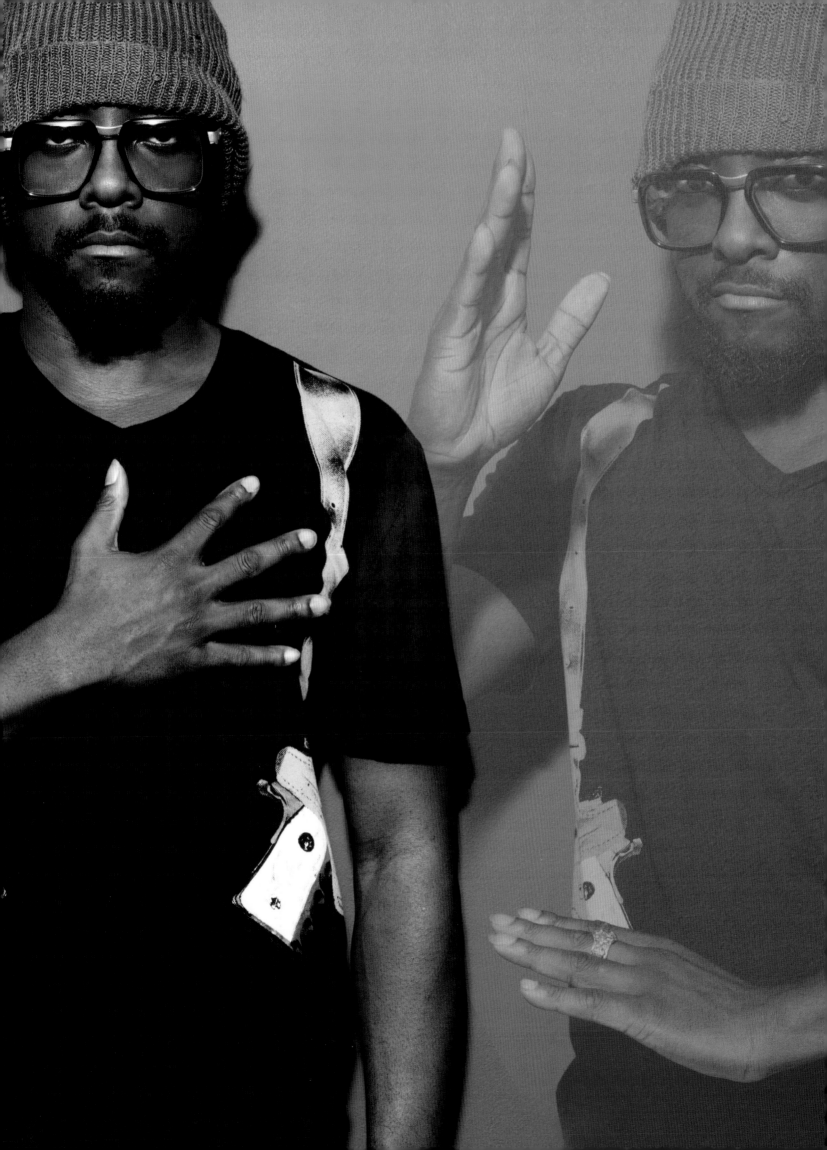

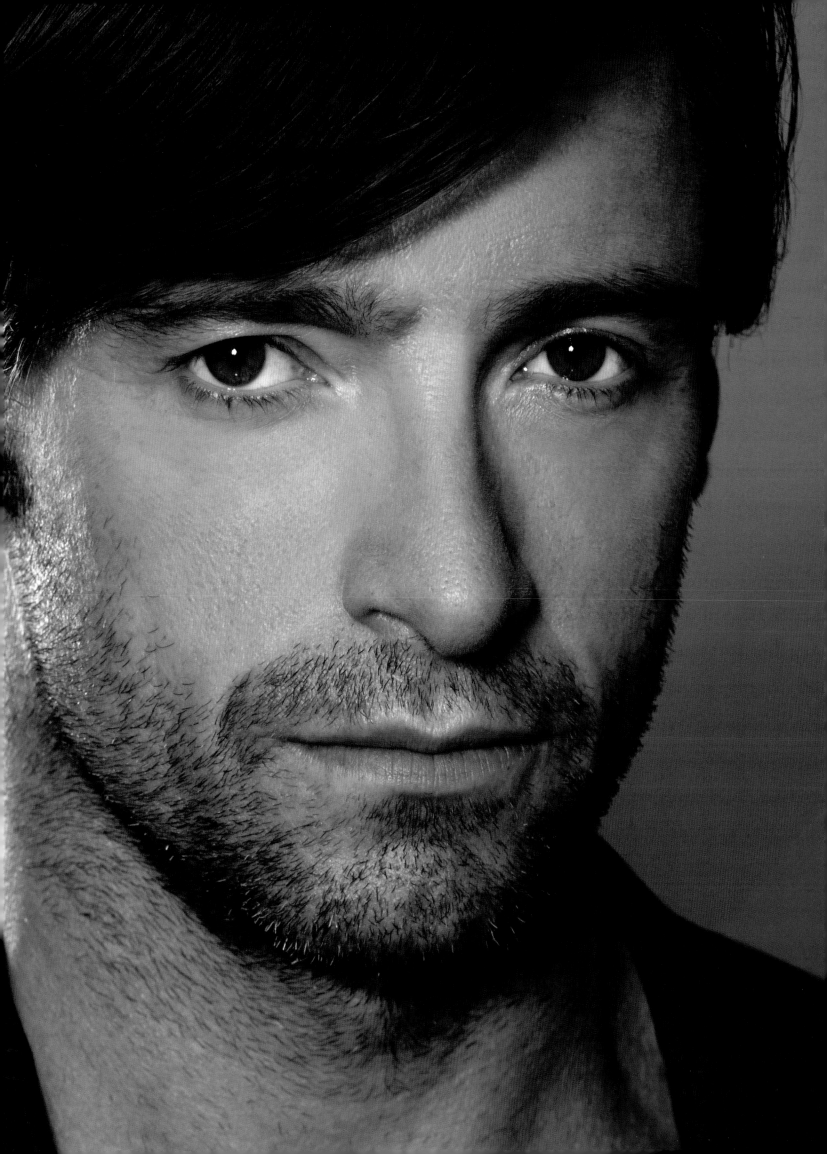

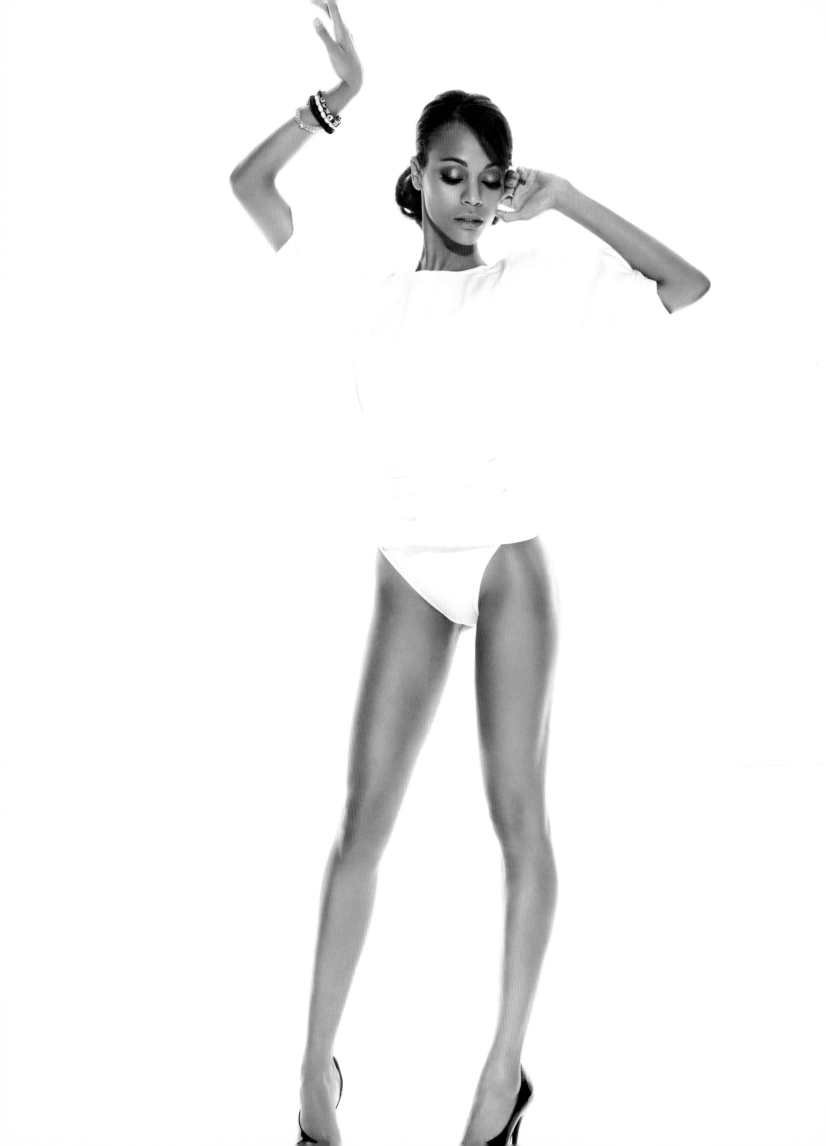

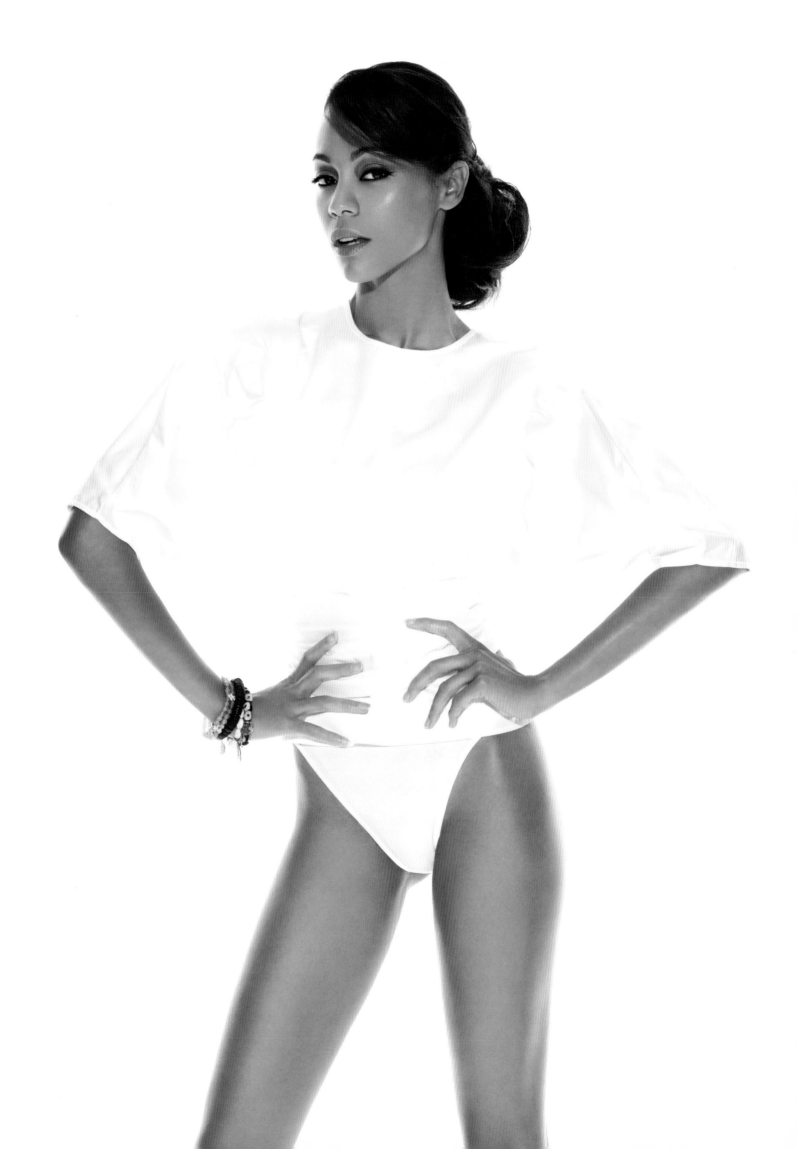

"Cancer affects us all regardless of age, race, religious background and/or lifestyle choice. This disease leaves many feeling hopeless and helpless. By purchasing this book you are taking action: helping to fund vital research programs searching for a cure. I'm proud to be a part of this project which helps to affect positive change in the face of the epic battle against brain cancer." **Scarlett Johansson**

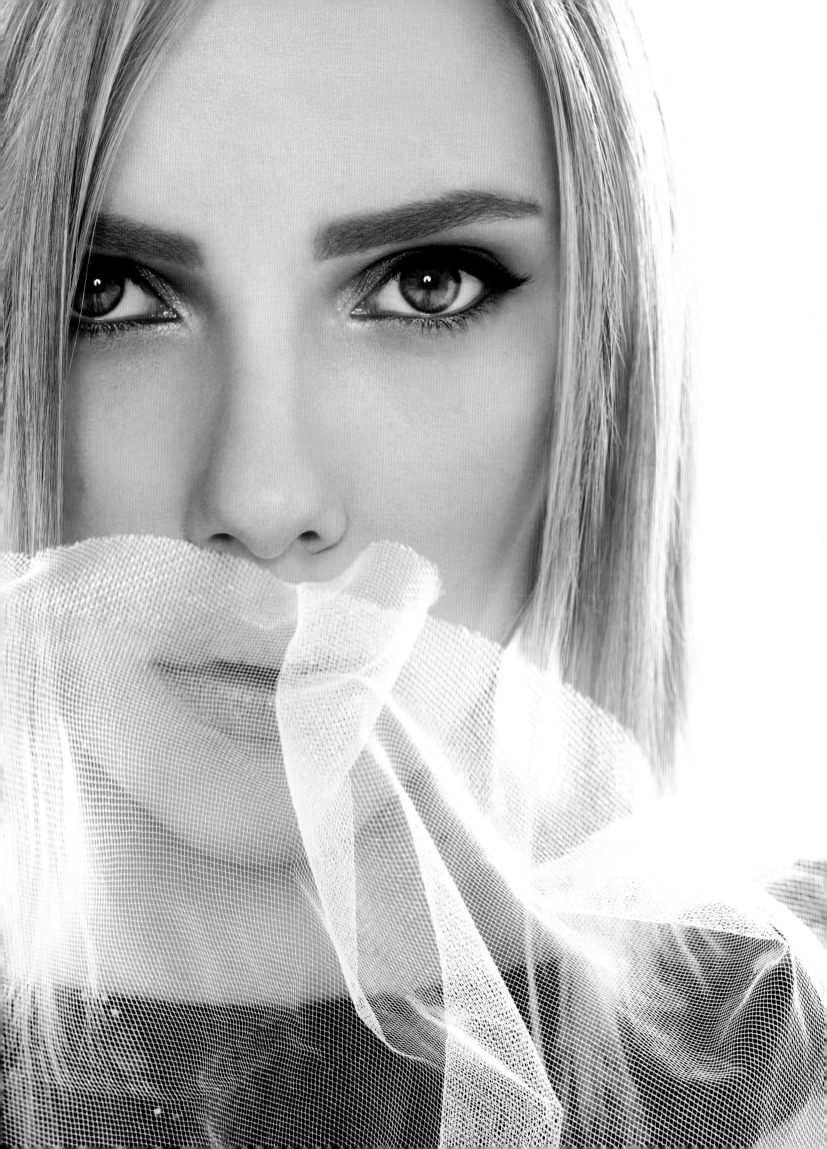

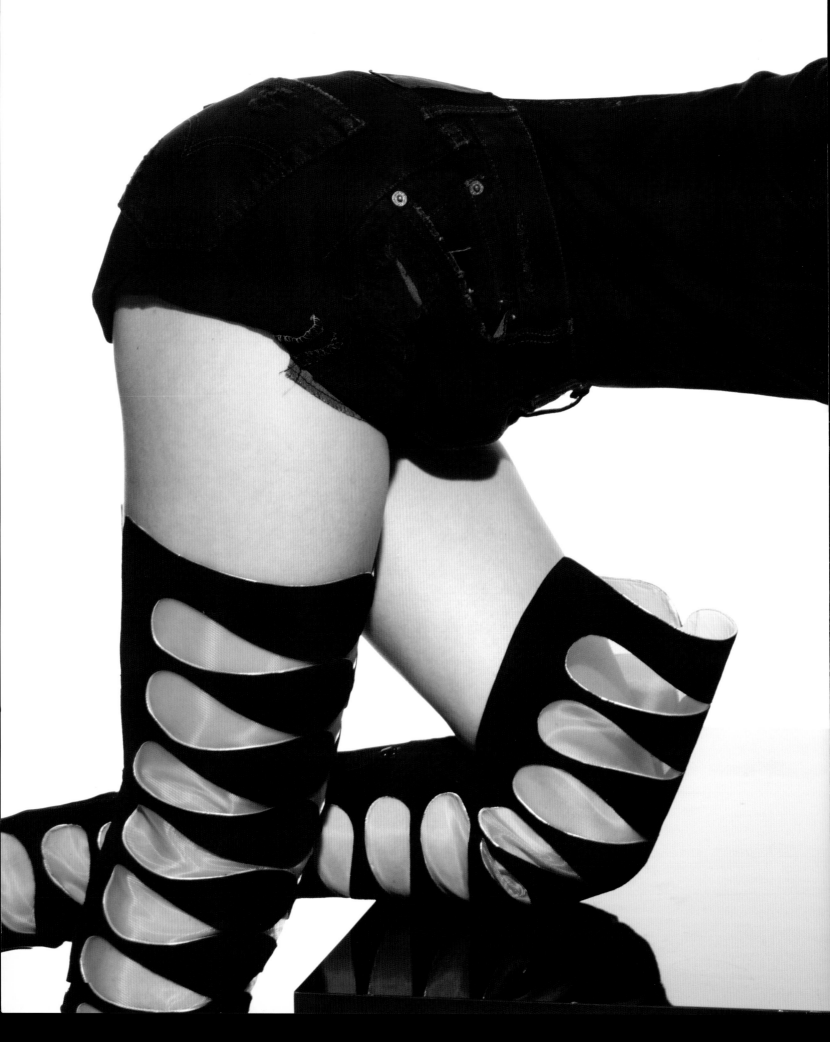

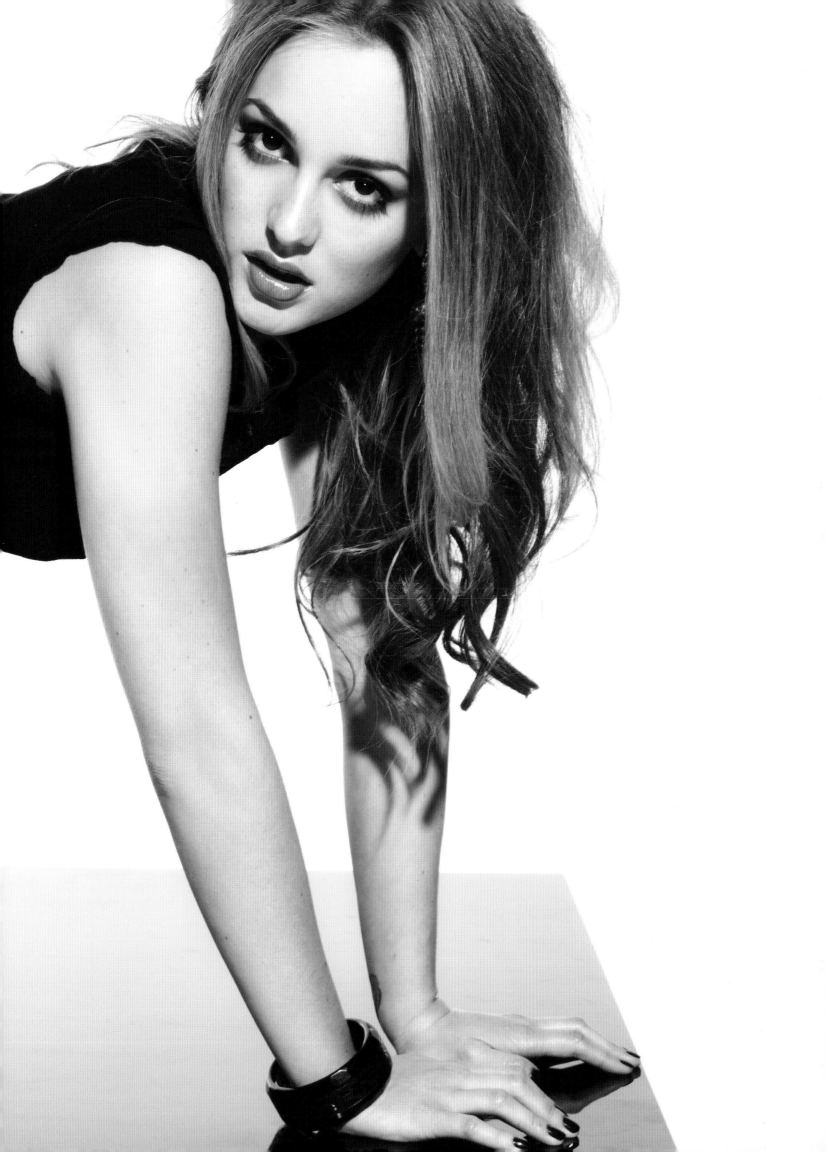

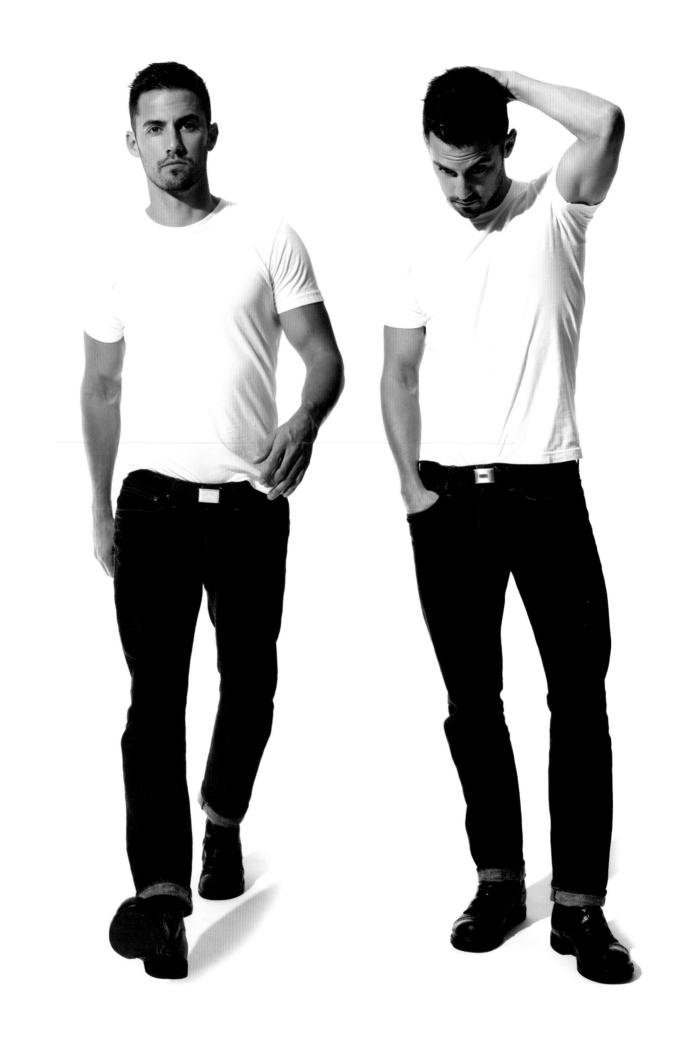

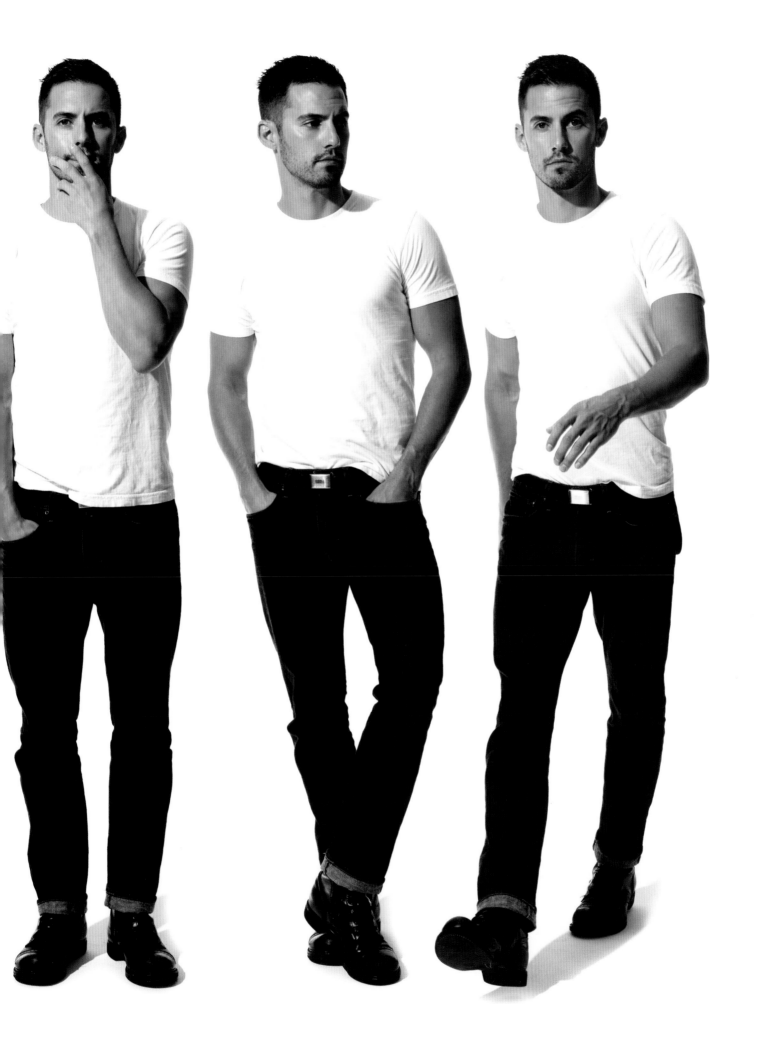

"Cancers of all kinds impact so many. But it hit closer to home when my friend fought and beat brain cancer over some long years. I saw the bravery in dealing with this adverse enemy and the joy in knowing it was possible to defeat it." **Milo Ventimiglia**

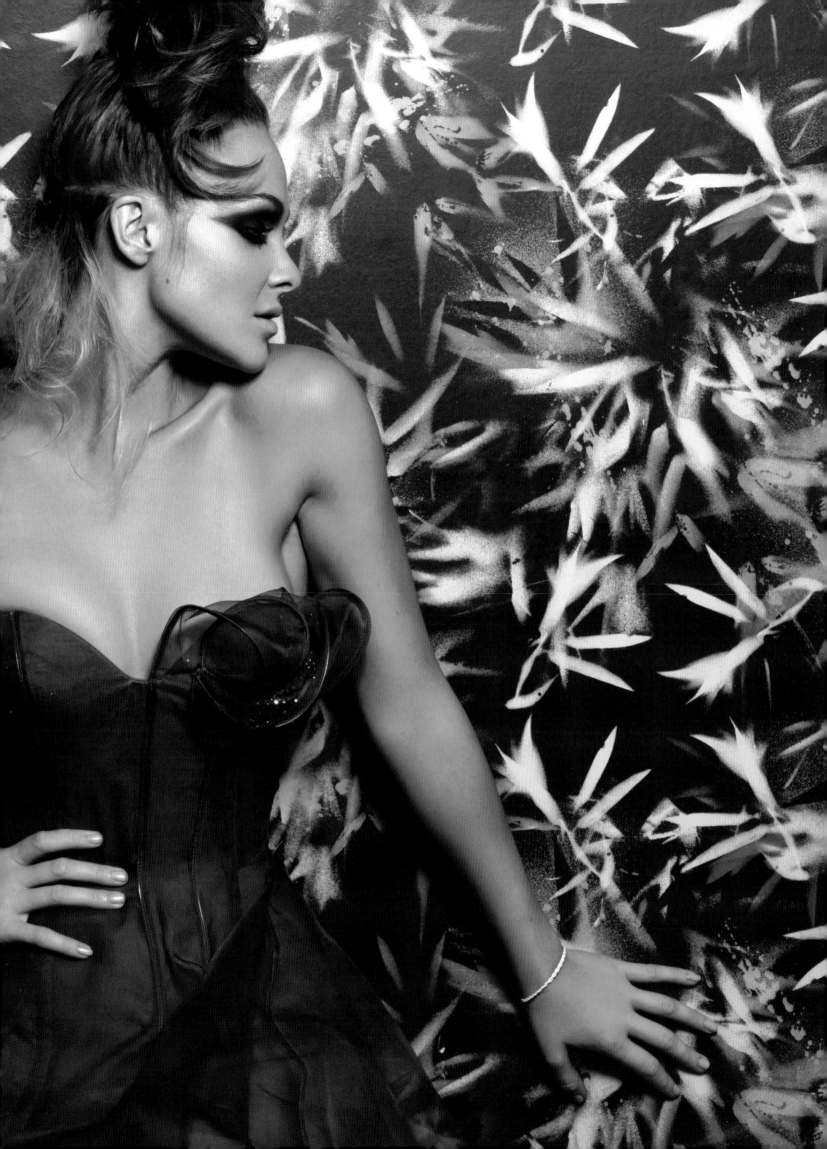

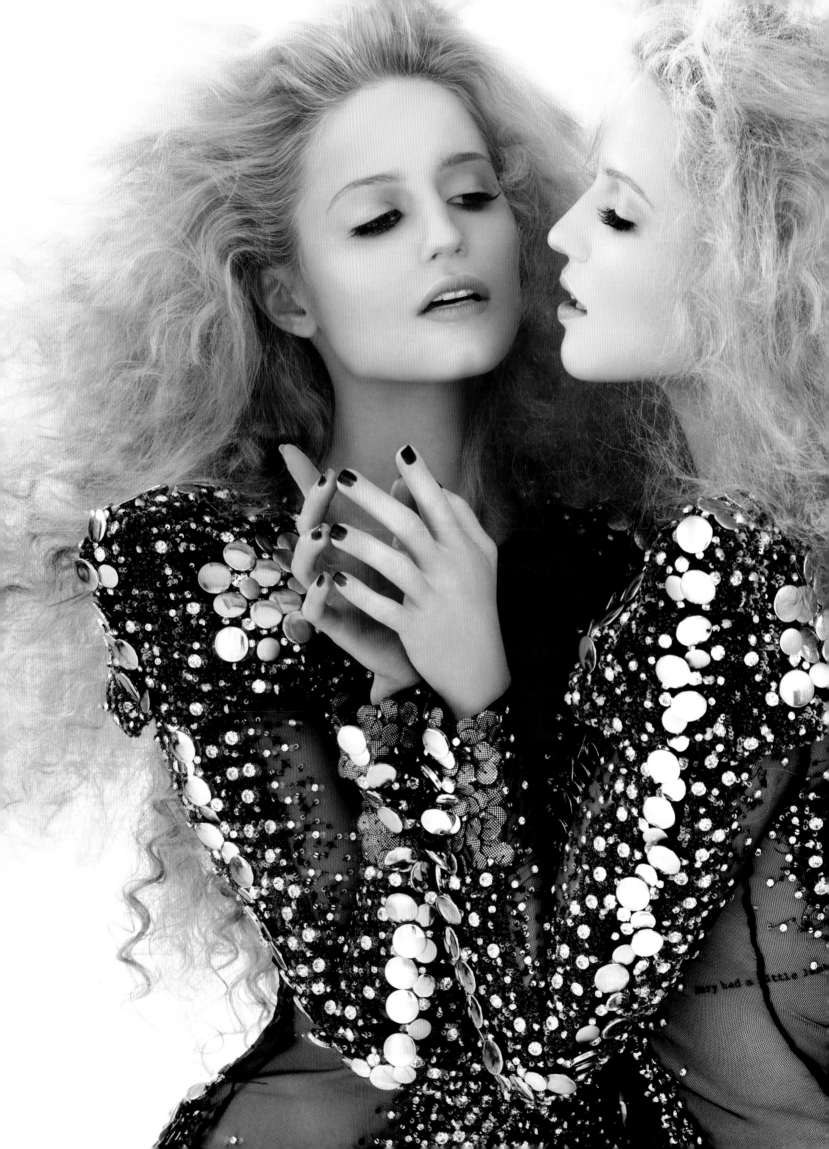

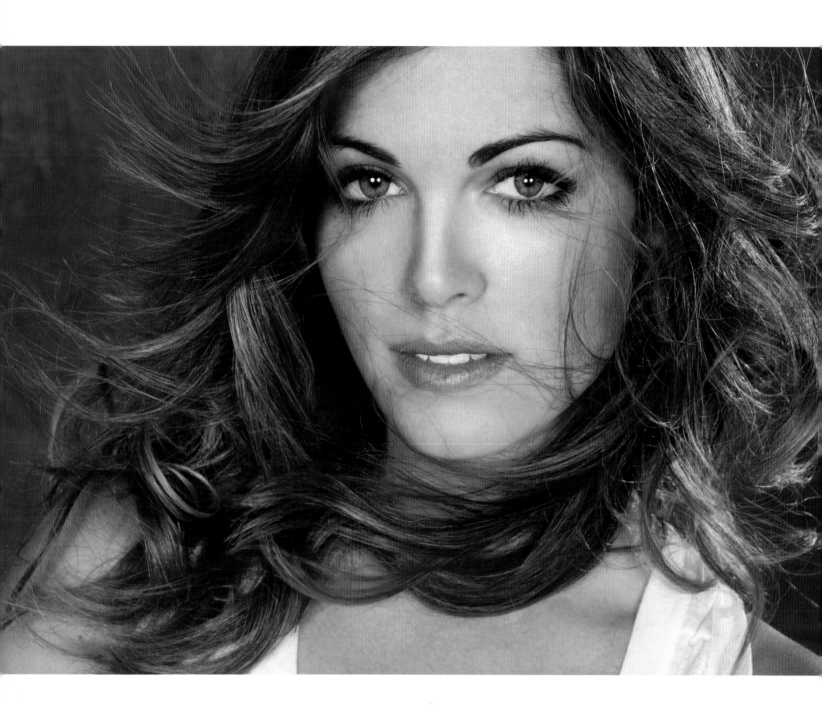

"Cancer touches the lives of so many, whether it be family, friends or oneself. As with any battle, there is power in numbers and knowledge. I hope Darren's book will help increase our chances in this fight." **Kate French**

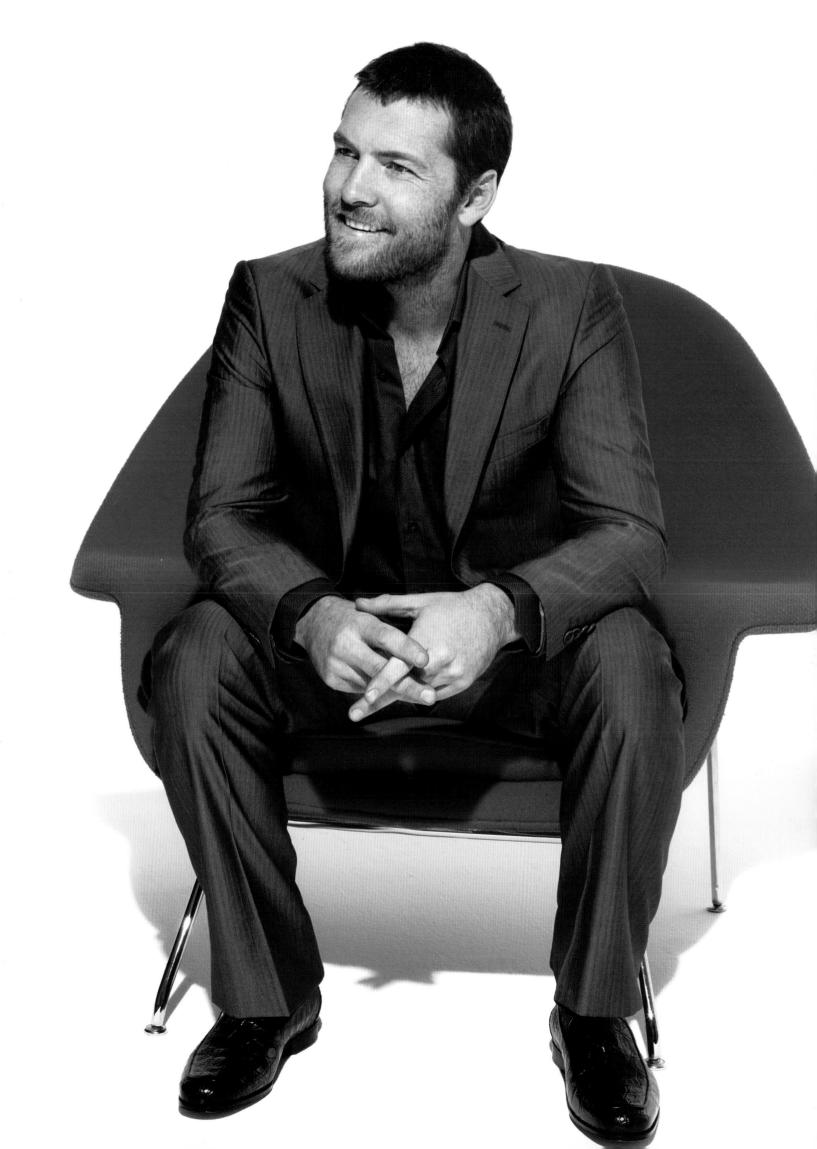

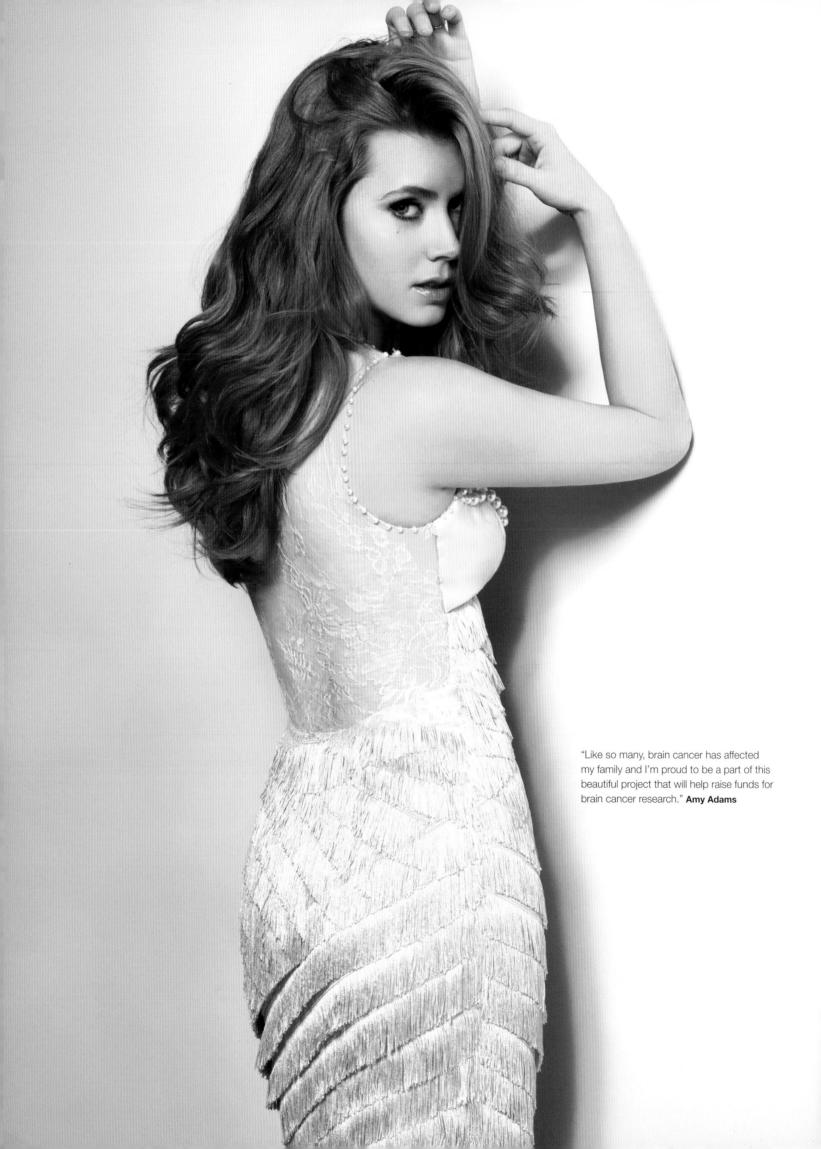

"Like so many, brain cancer has affected my family and I'm proud to be a part of this beautiful project that will help raise funds for brain cancer research." **Amy Adams**

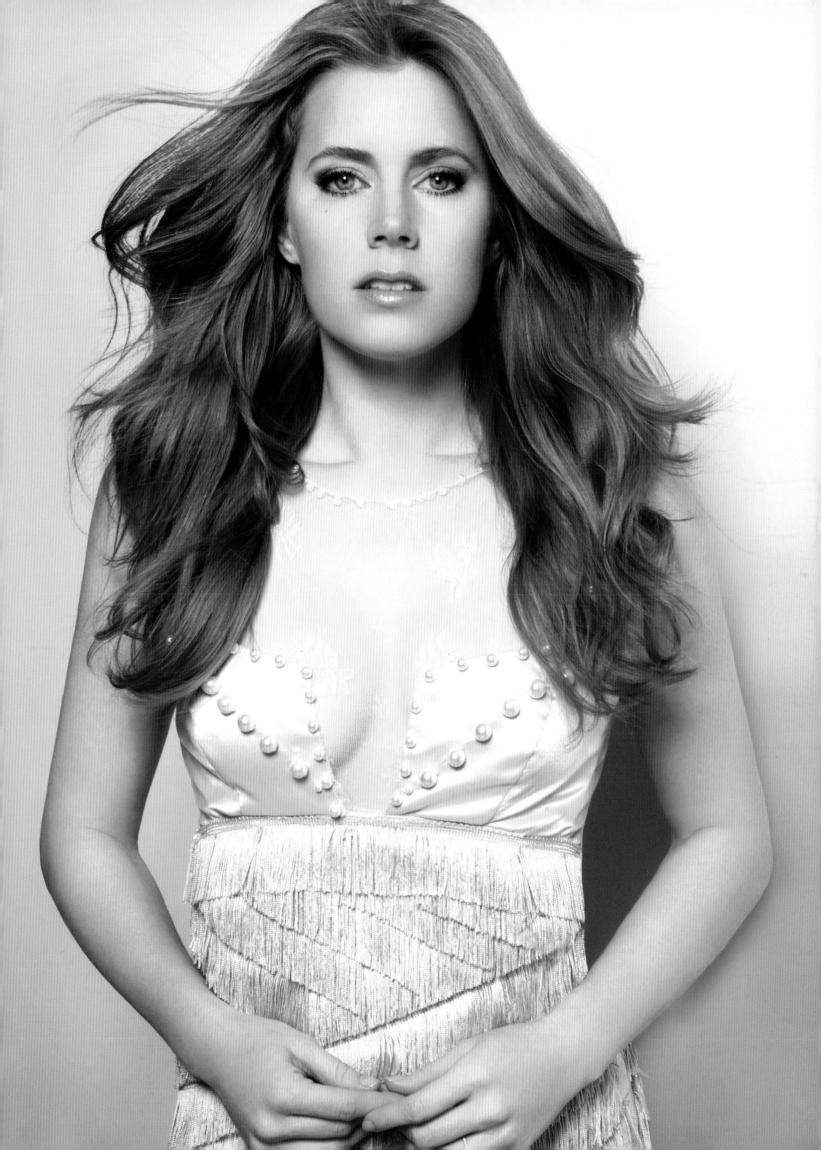

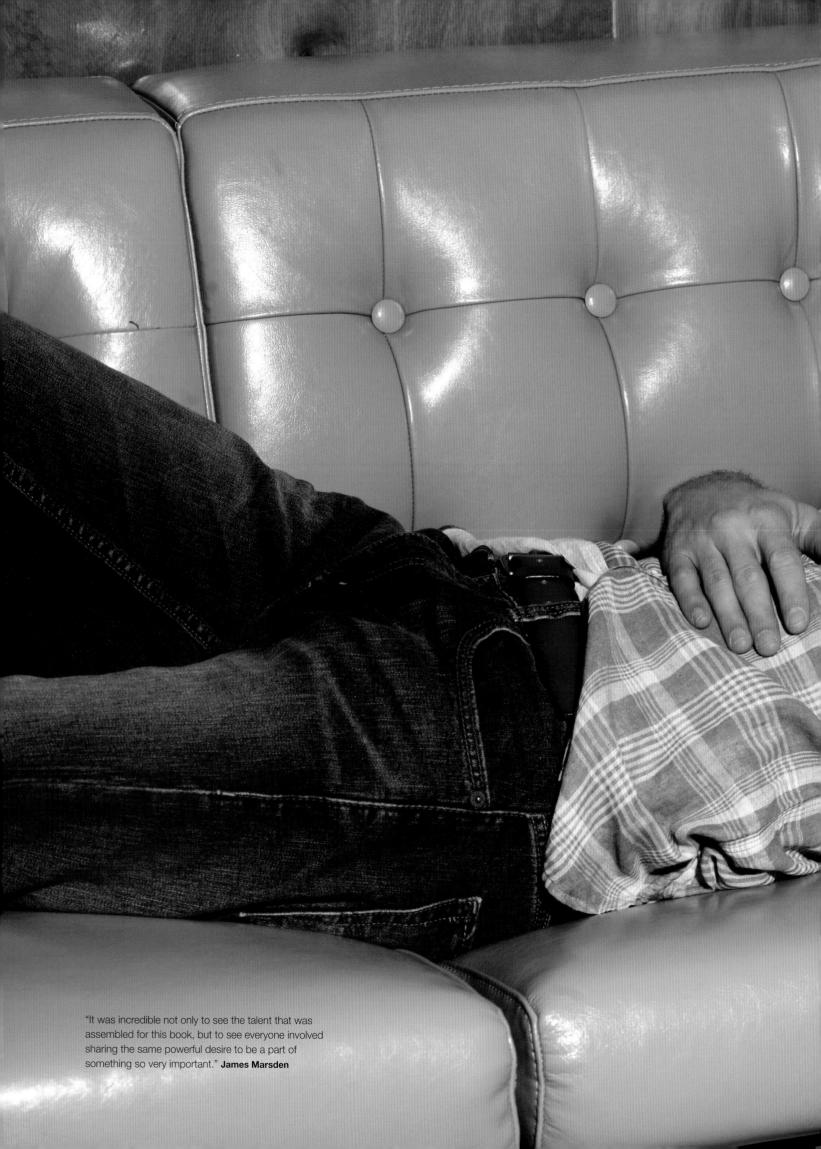

"It was incredible not only to see the talent that was assembled for this book, but to see everyone involved sharing the same powerful desire to be a part of something so very important." **James Marsden**

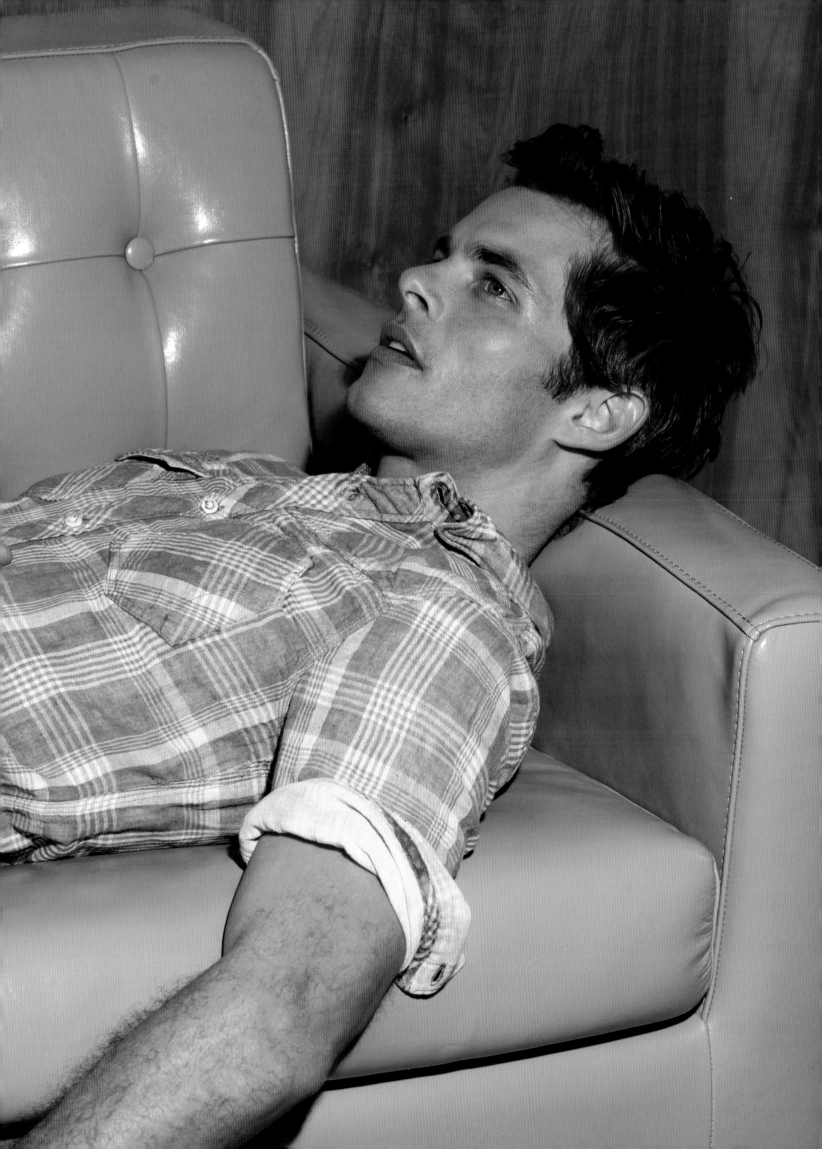

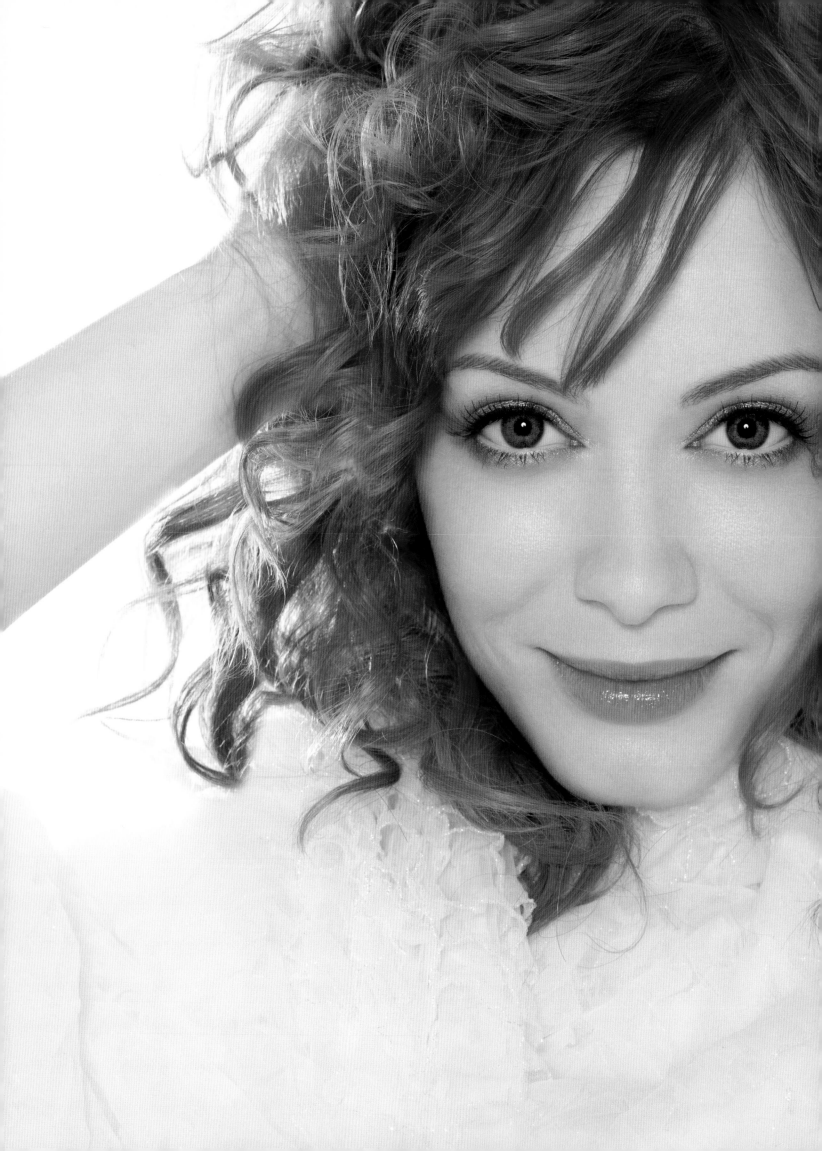

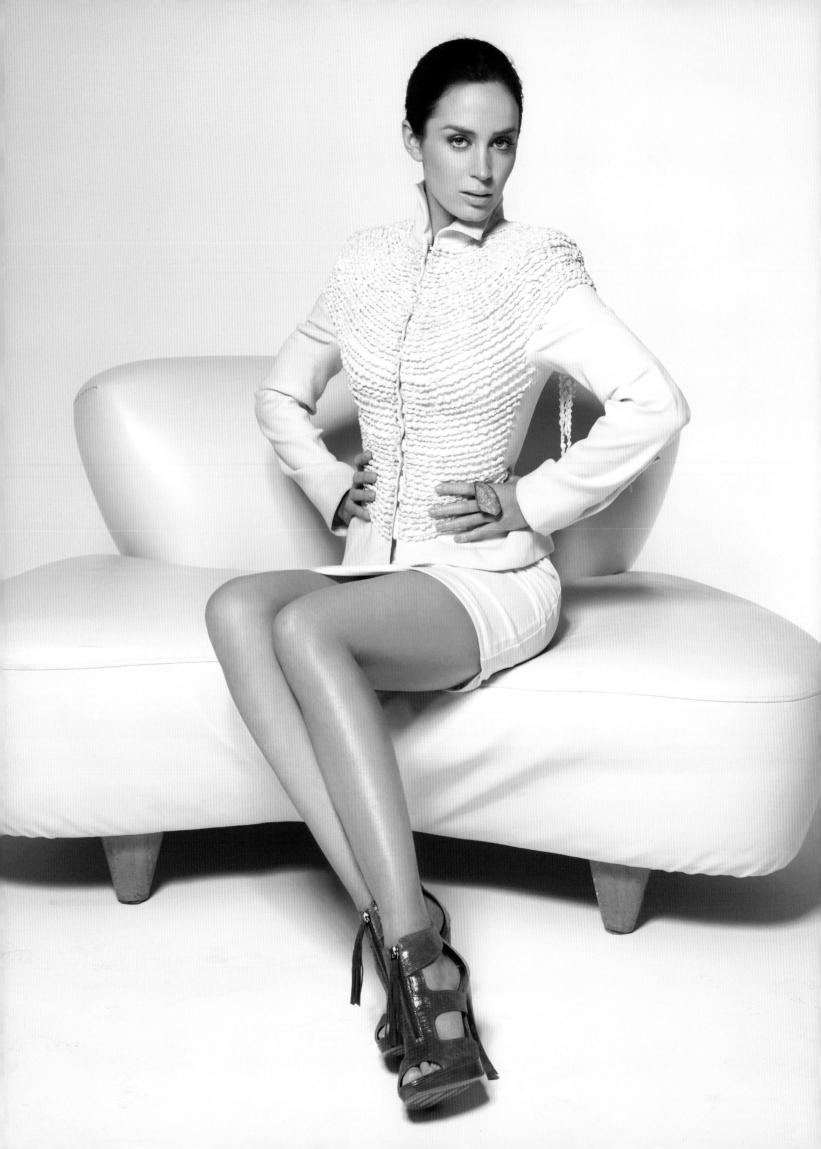

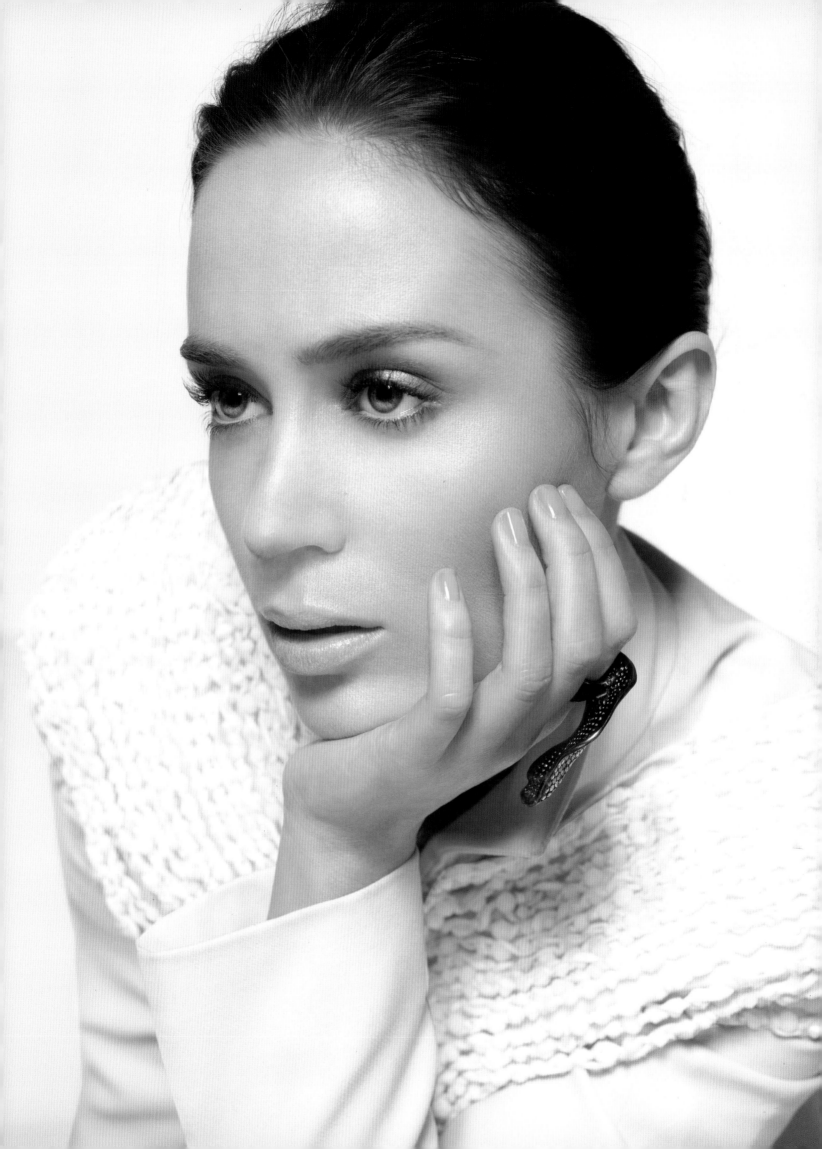

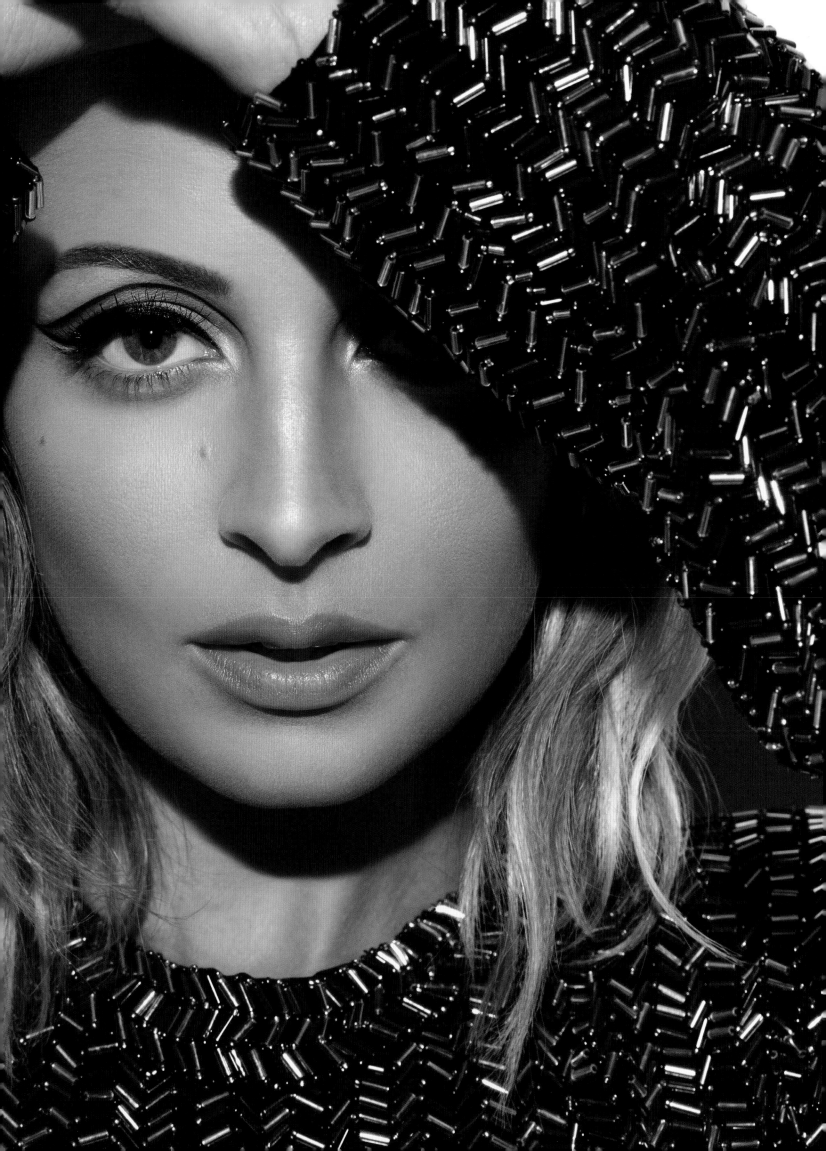

"It was important for me to get involved with this cause because cancer affects everyone, not just the diagnosed. Tieste had a beautiful vision, bringing to light the story of survival rather than defeat through his photography."
Daren Kagasoff

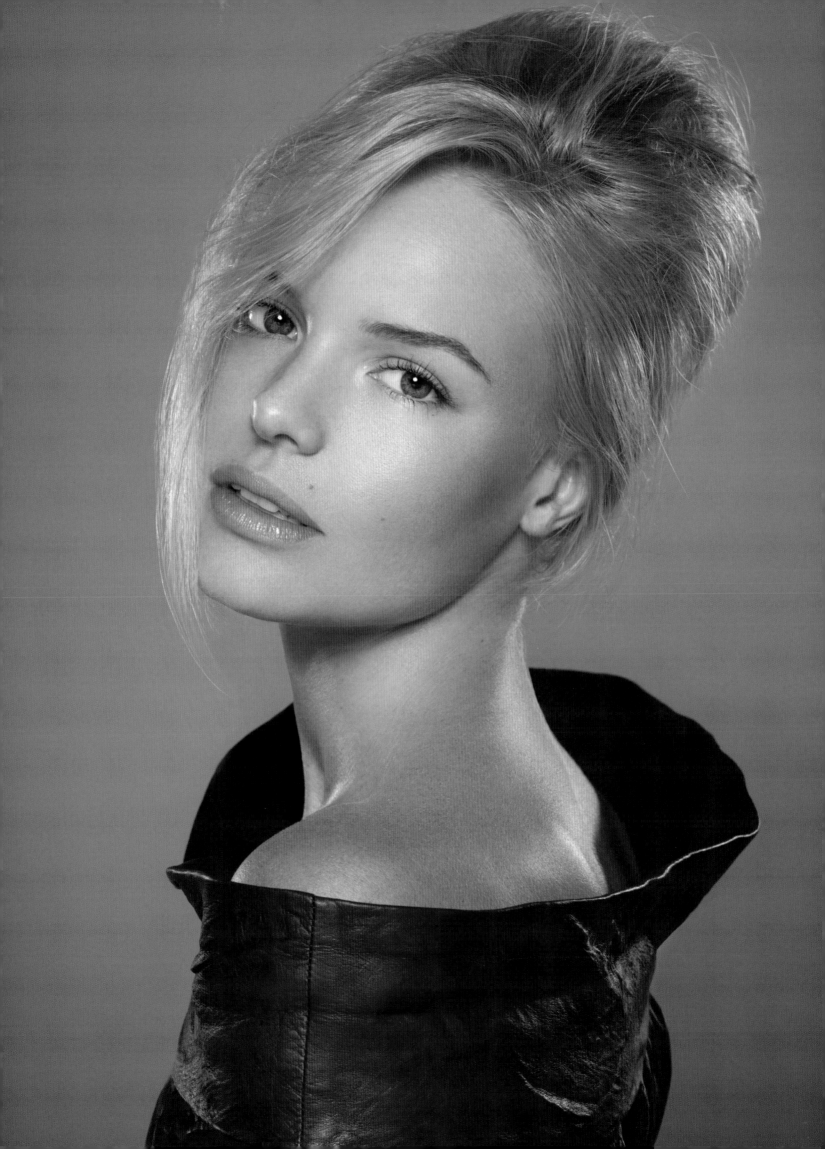

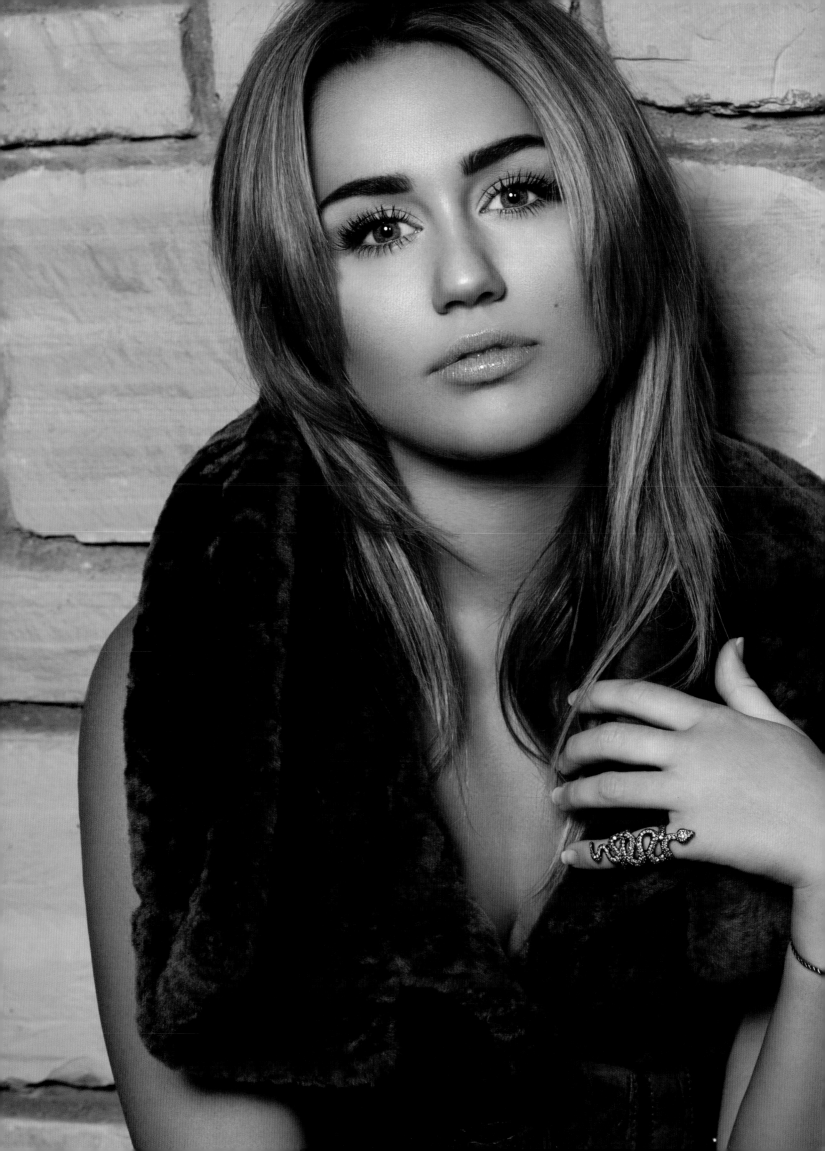

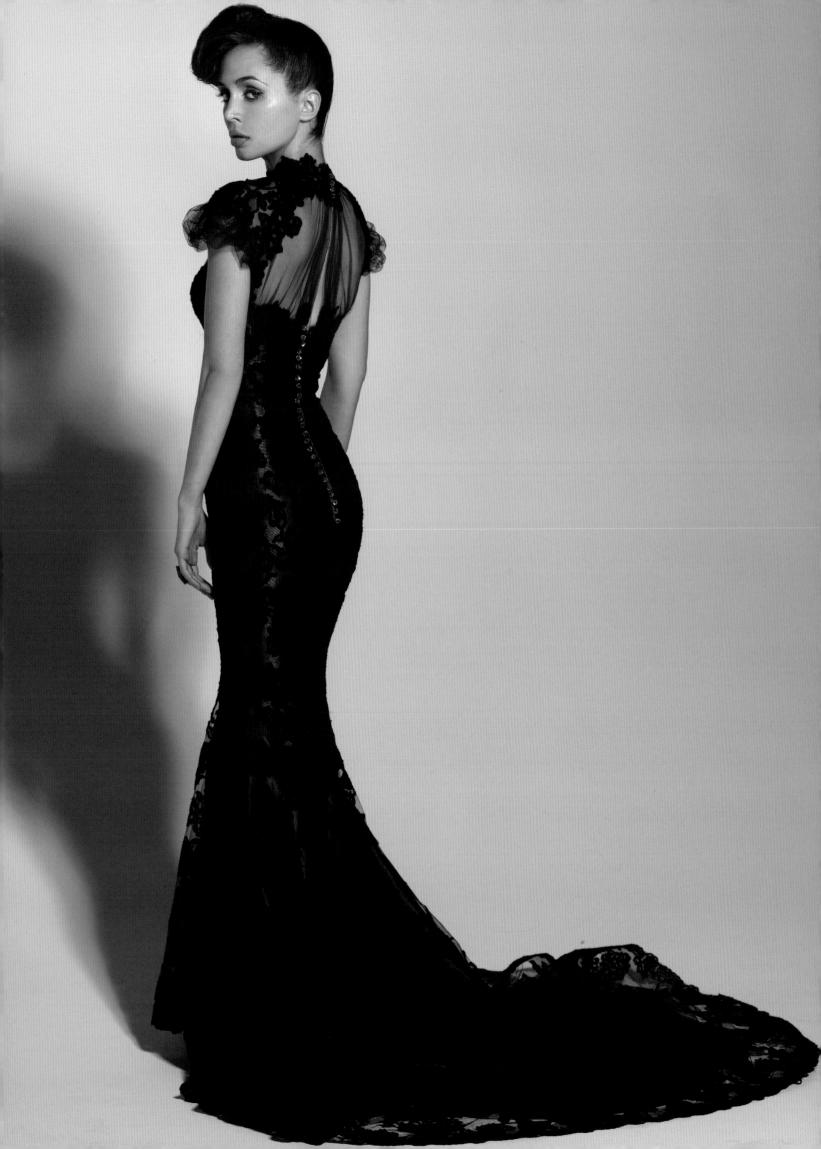

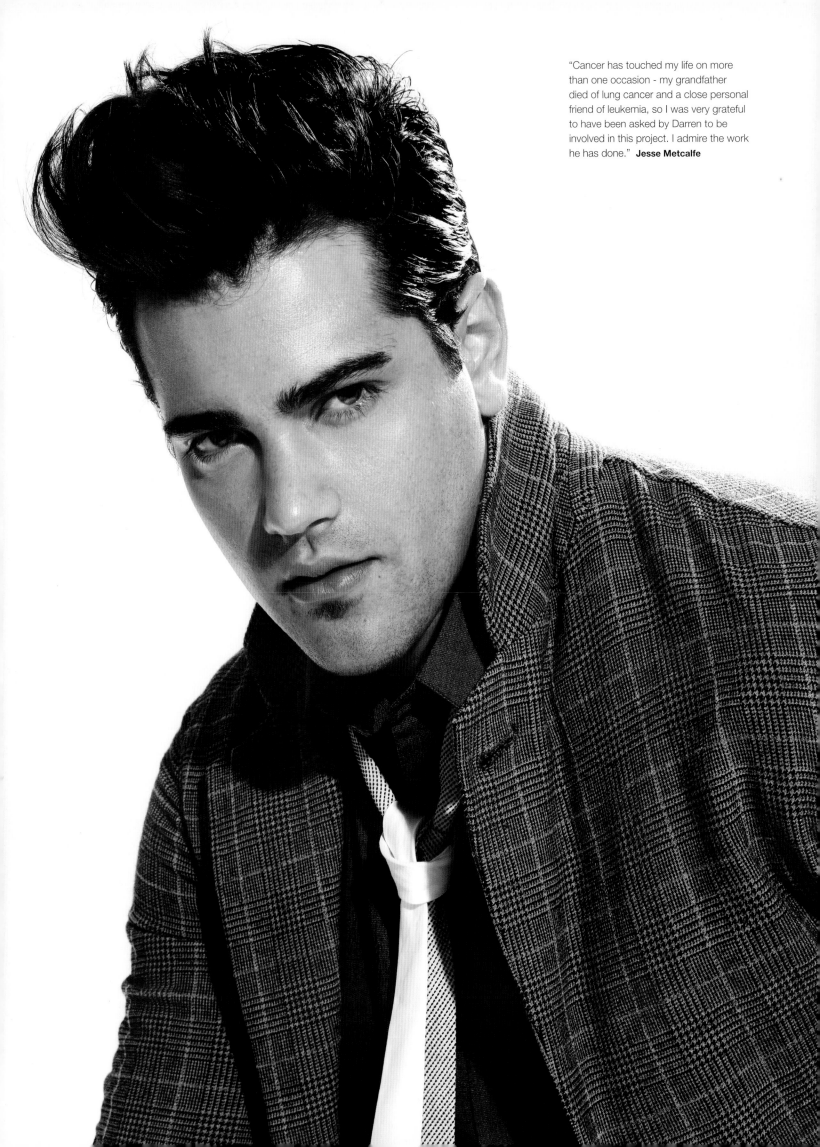

"Cancer has touched my life on more than one occasion - my grandfather died of lung cancer and a close personal friend of leukemia, so I was very grateful to have been asked by Darren to be involved in this project. I admire the work he has done." **Jesse Metcalfe**

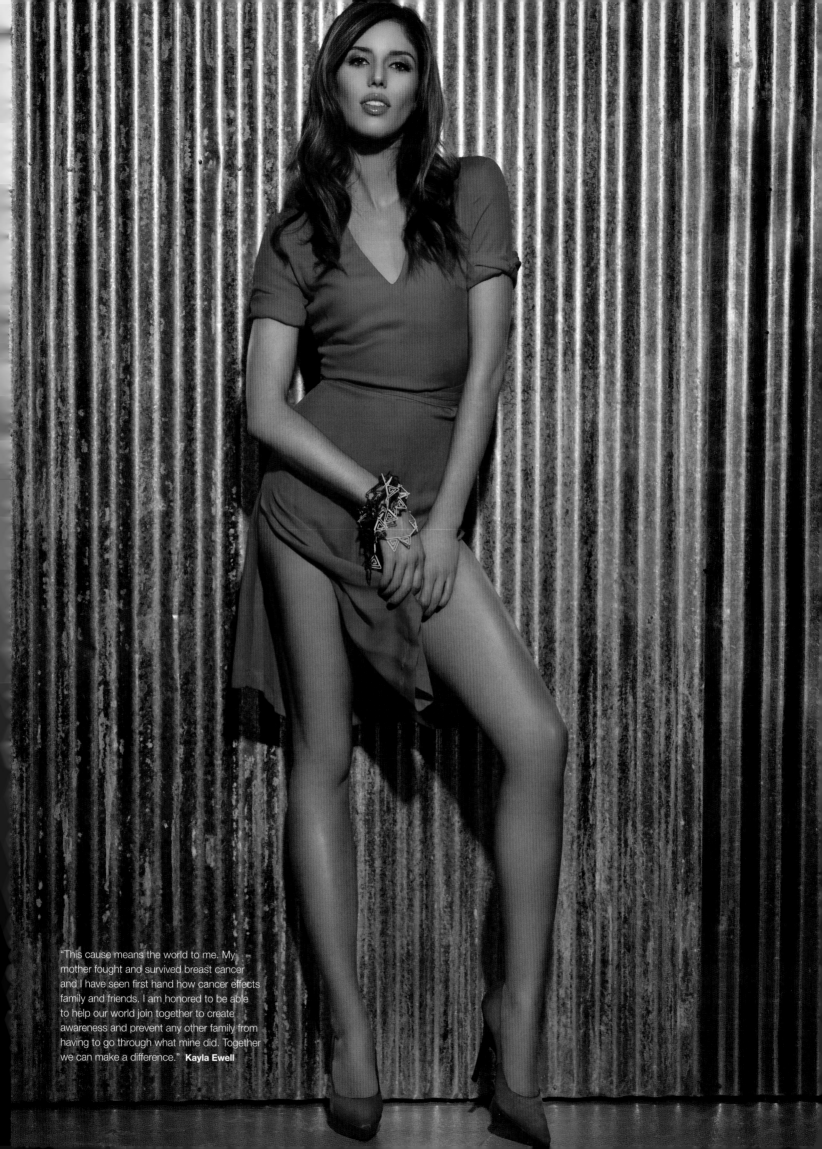

"This cause means the world to me. My mother fought and survived breast cancer and I have seen first hand how cancer effects family and friends. I am honored to be able to help our world join together to create awareness and prevent any other family from having to go through what mine did. Together we can make a difference." **Kayla Ewell**

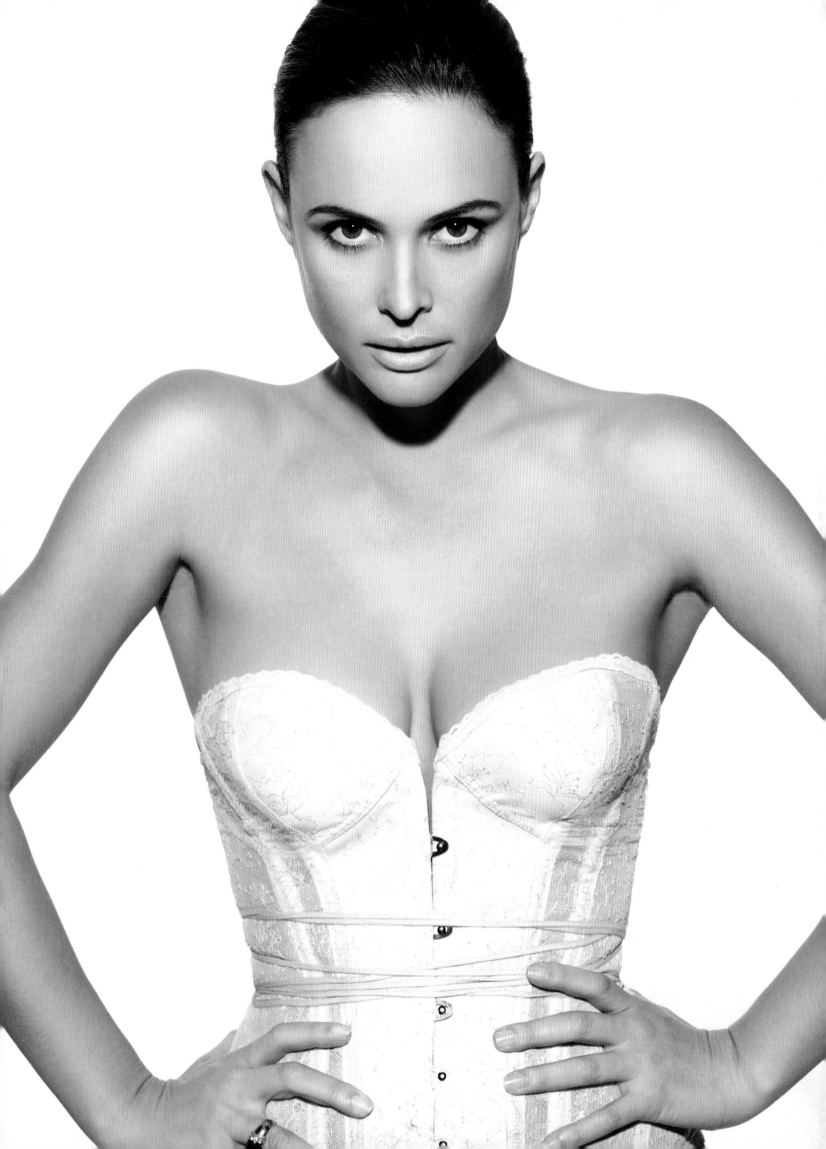

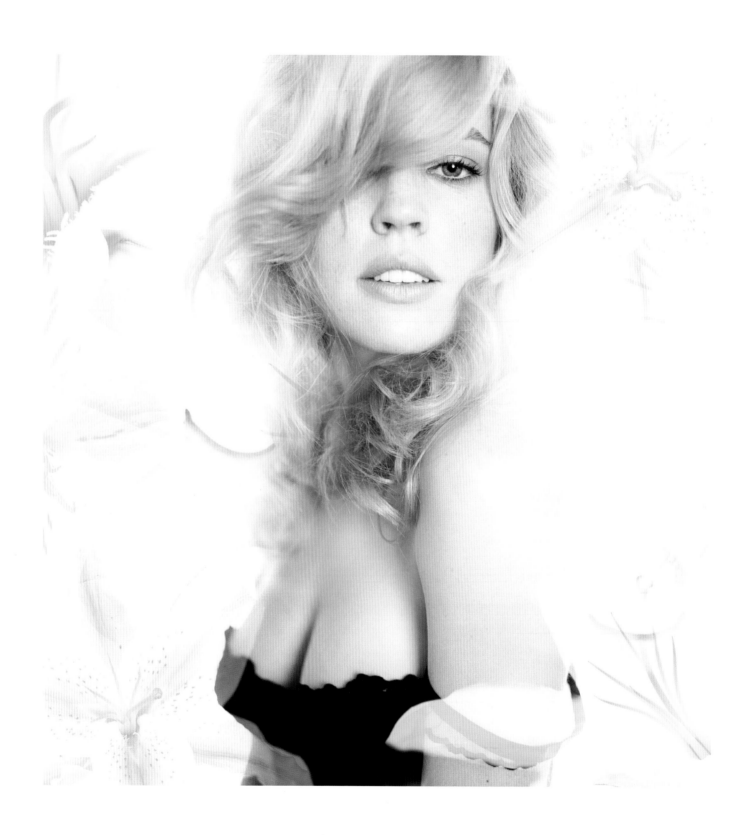

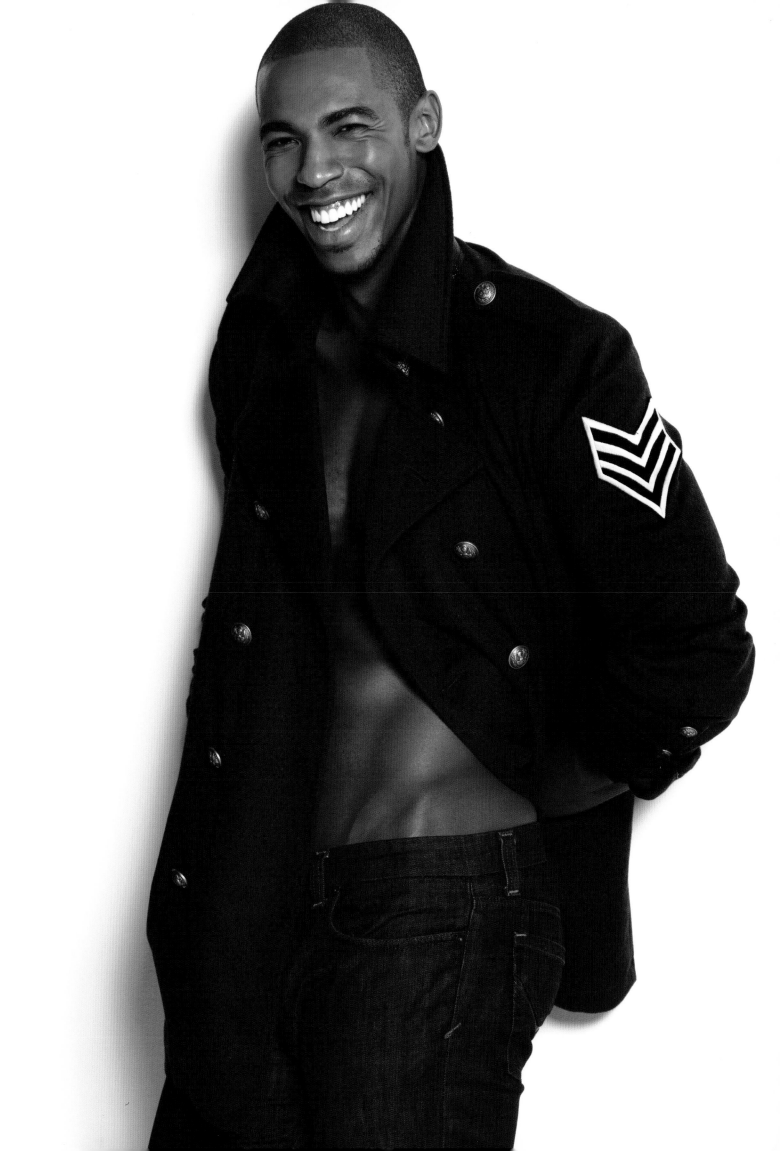

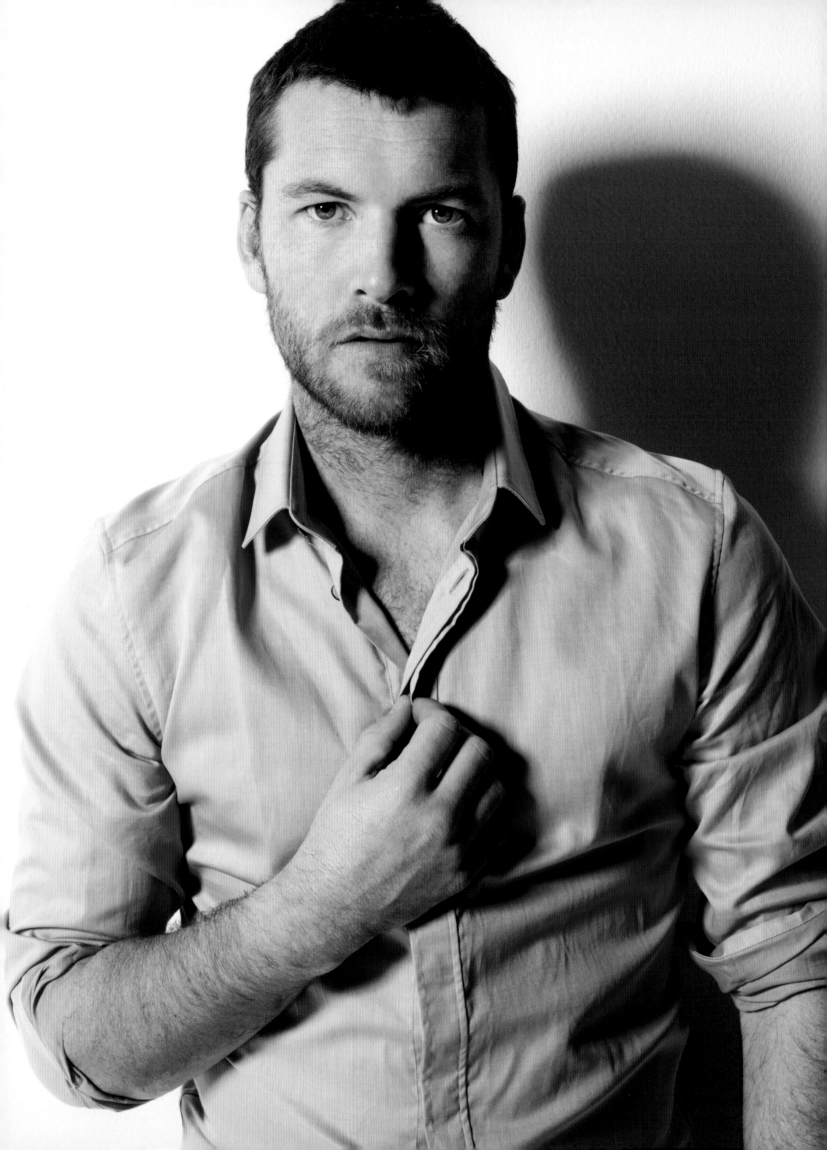

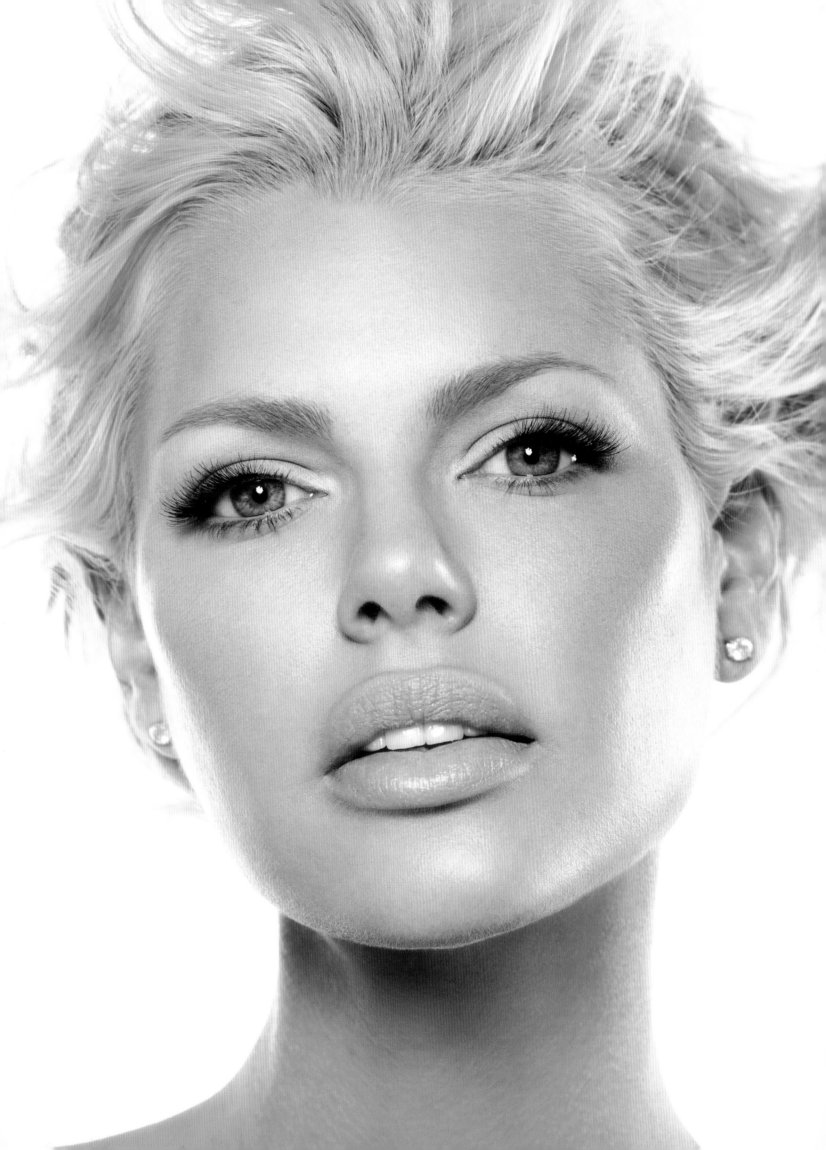

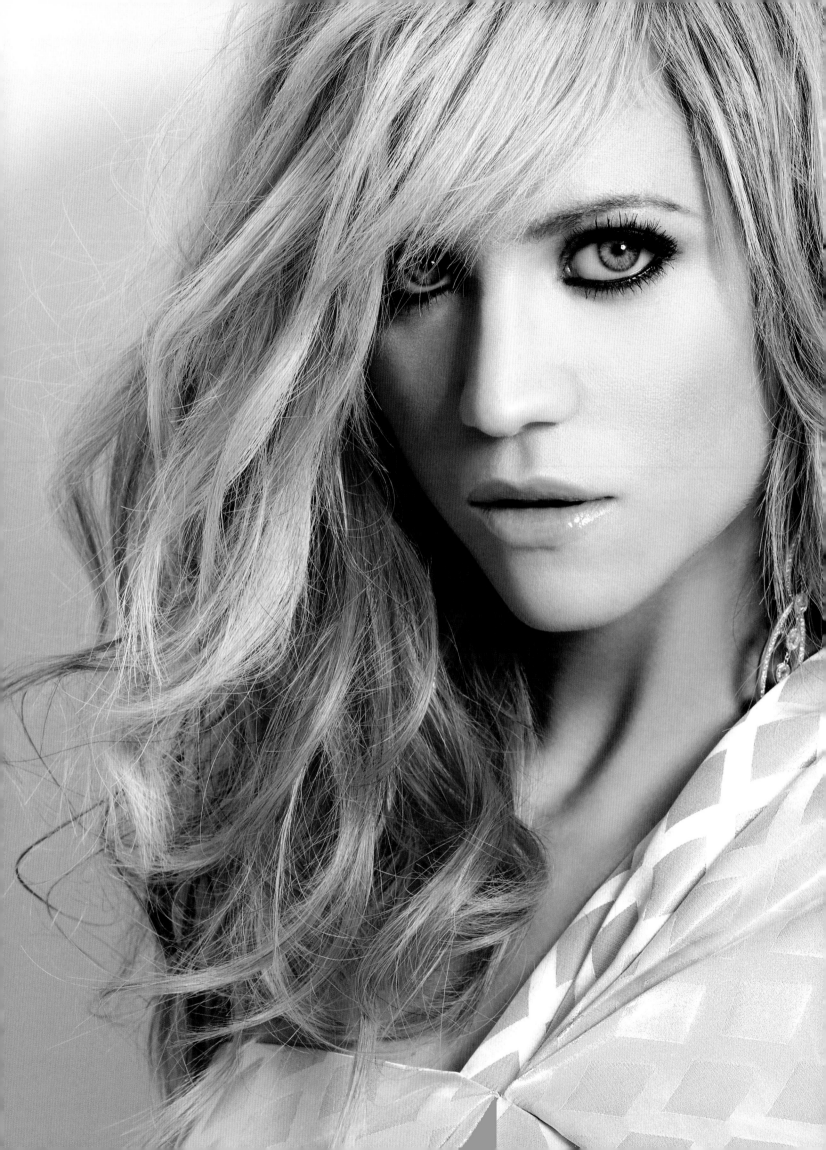

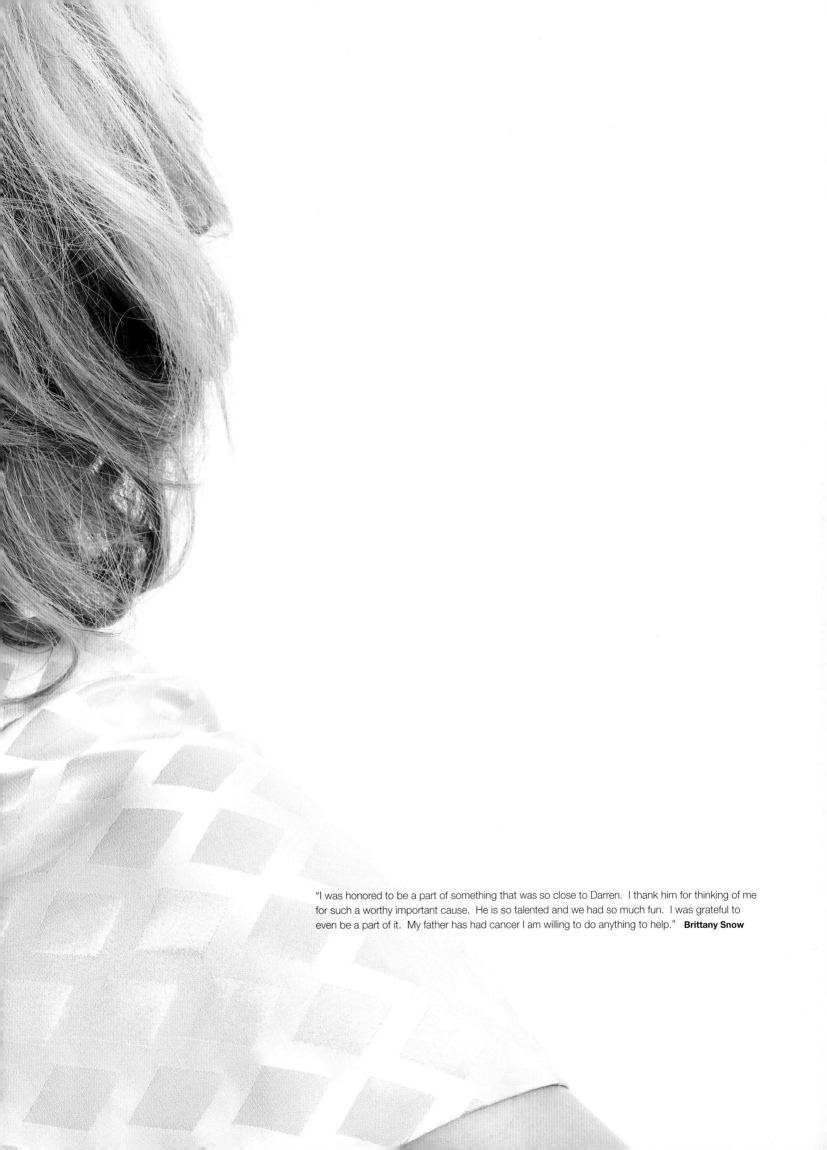

"I was honored to be a part of something that was so close to Darren. I thank him for thinking of me for such a worthy important cause. He is so talented and we had so much fun. I was grateful to even be a part of it. My father has had cancer I am willing to do anything to help." **Brittany Snow**

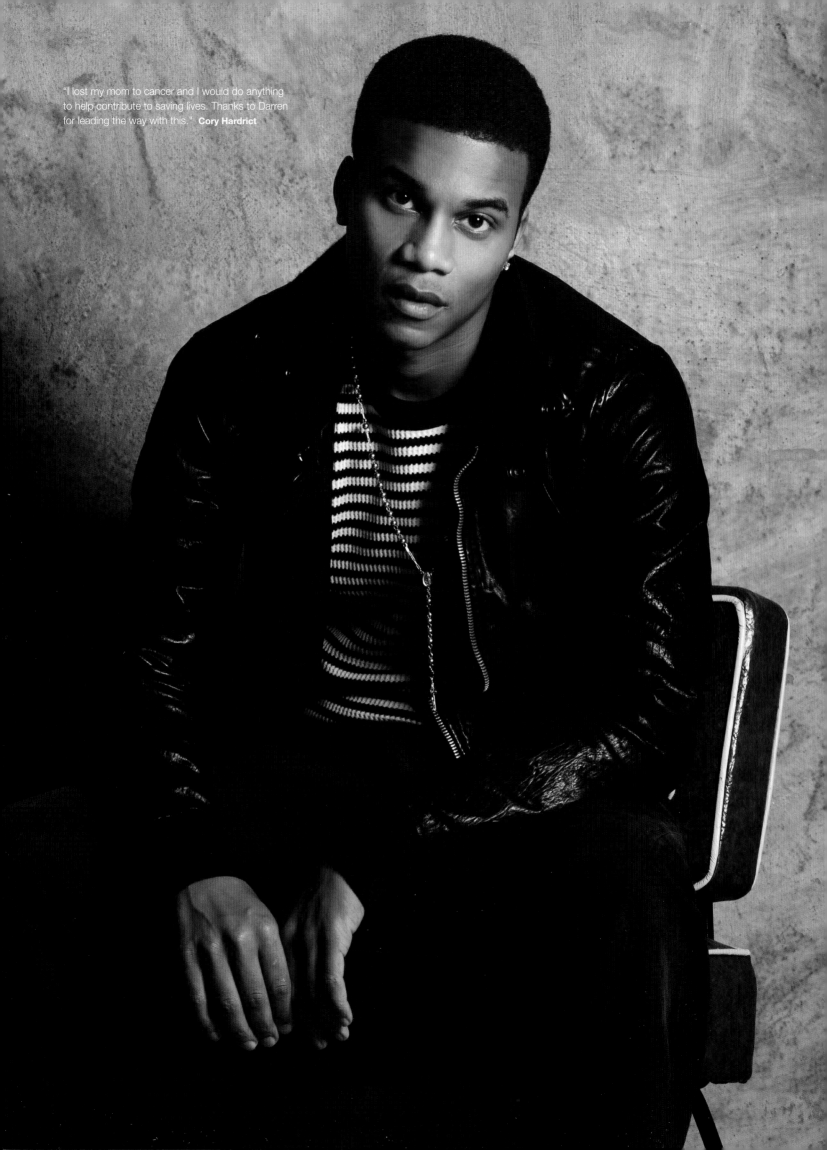

"I lost my mom to cancer and I would do anything to help contribute to saving lives. Thanks to Darren for leading the way with this." **Cory Hardrict**

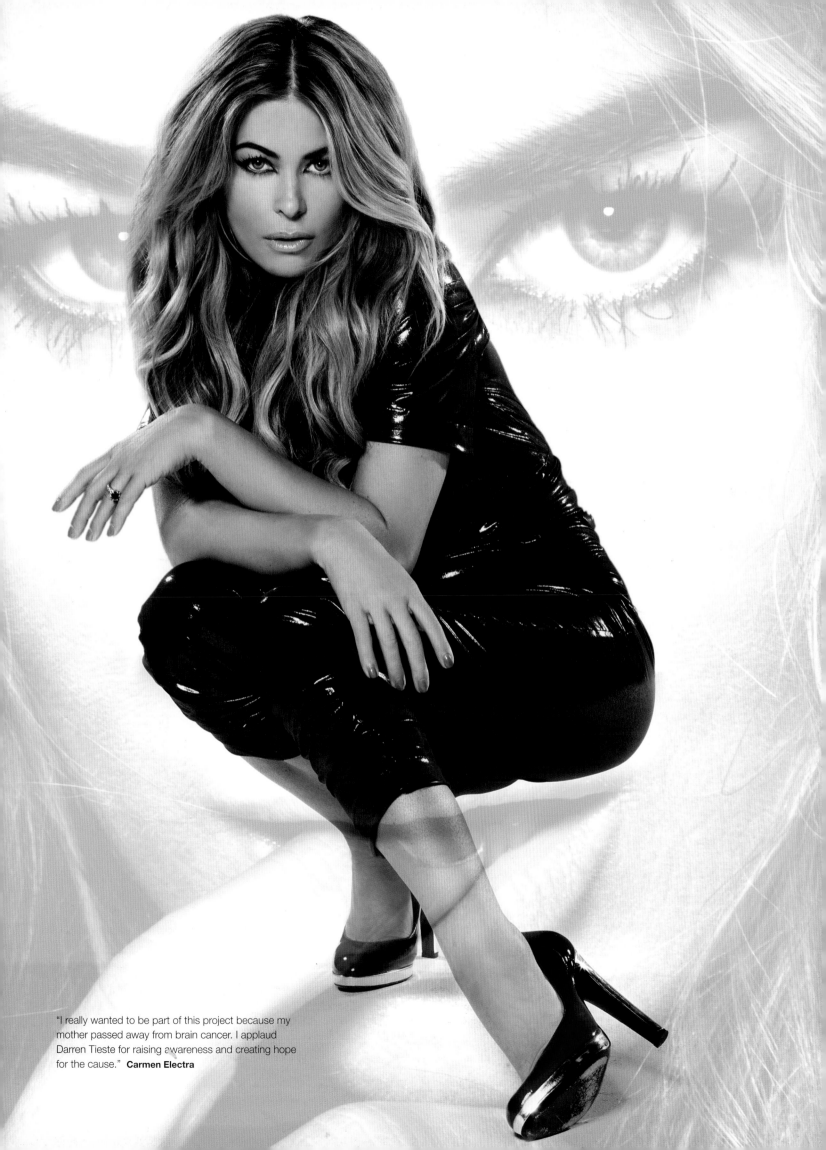

"I really wanted to be part of this project because my mother passed away from brain cancer. I applaud Darren Tieste for raising awareness and creating hope for the cause." **Carmen Electra**

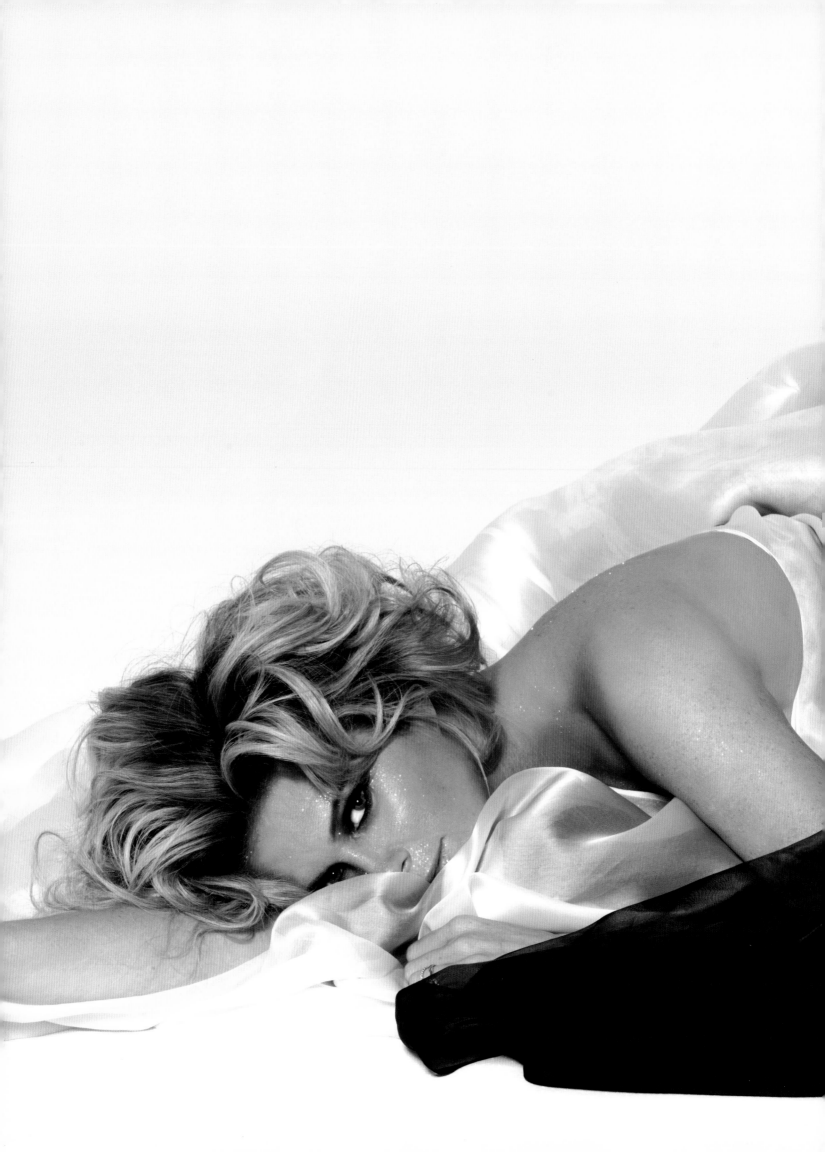

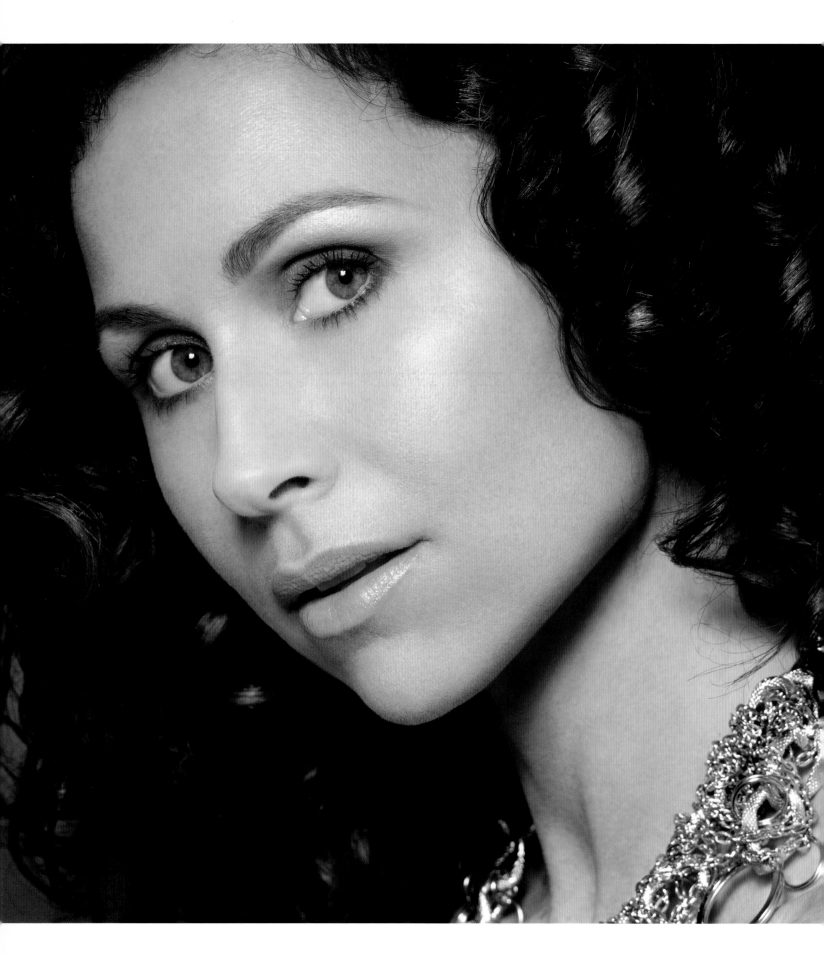

"I'm very happy I could be part of something that raises money for research for this pernicious disease." **Minnie Driver**

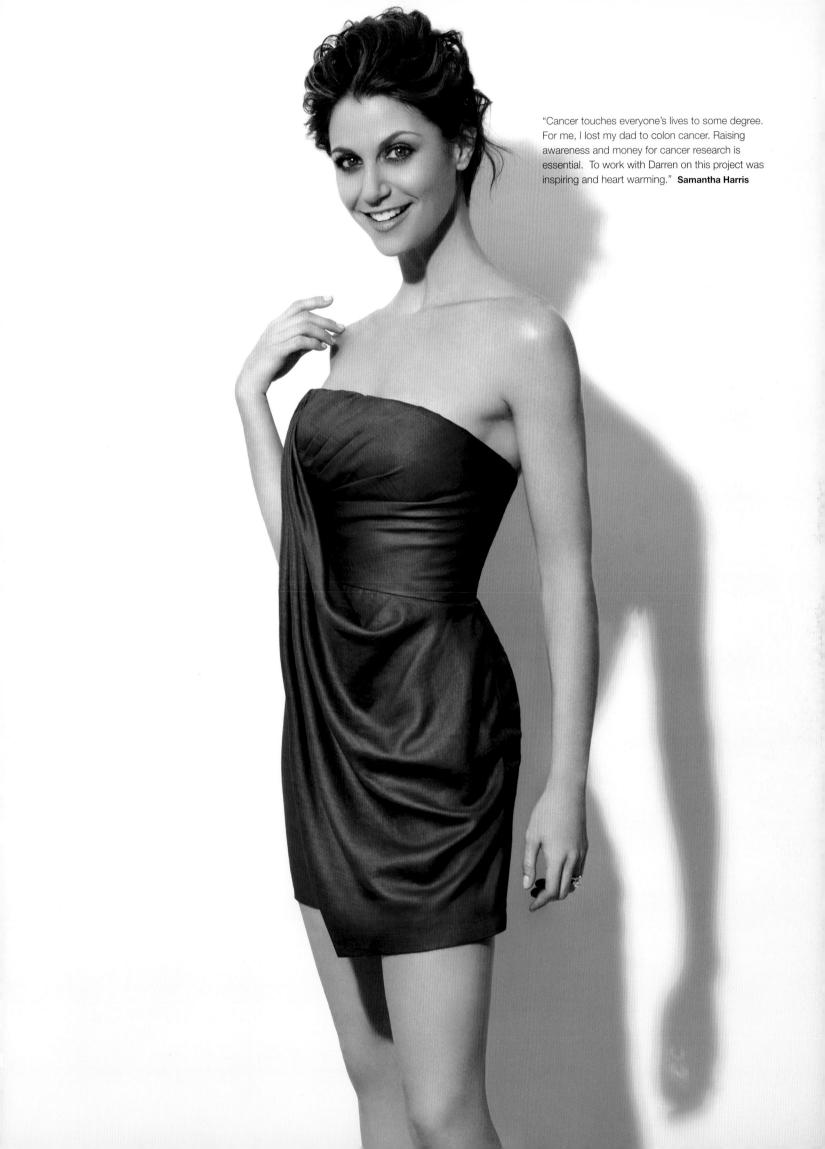

"Cancer touches everyone's lives to some degree. For me, I lost my dad to colon cancer. Raising awareness and money for cancer research is essential. To work with Darren on this project was inspiring and heart warming." **Samantha Harris**

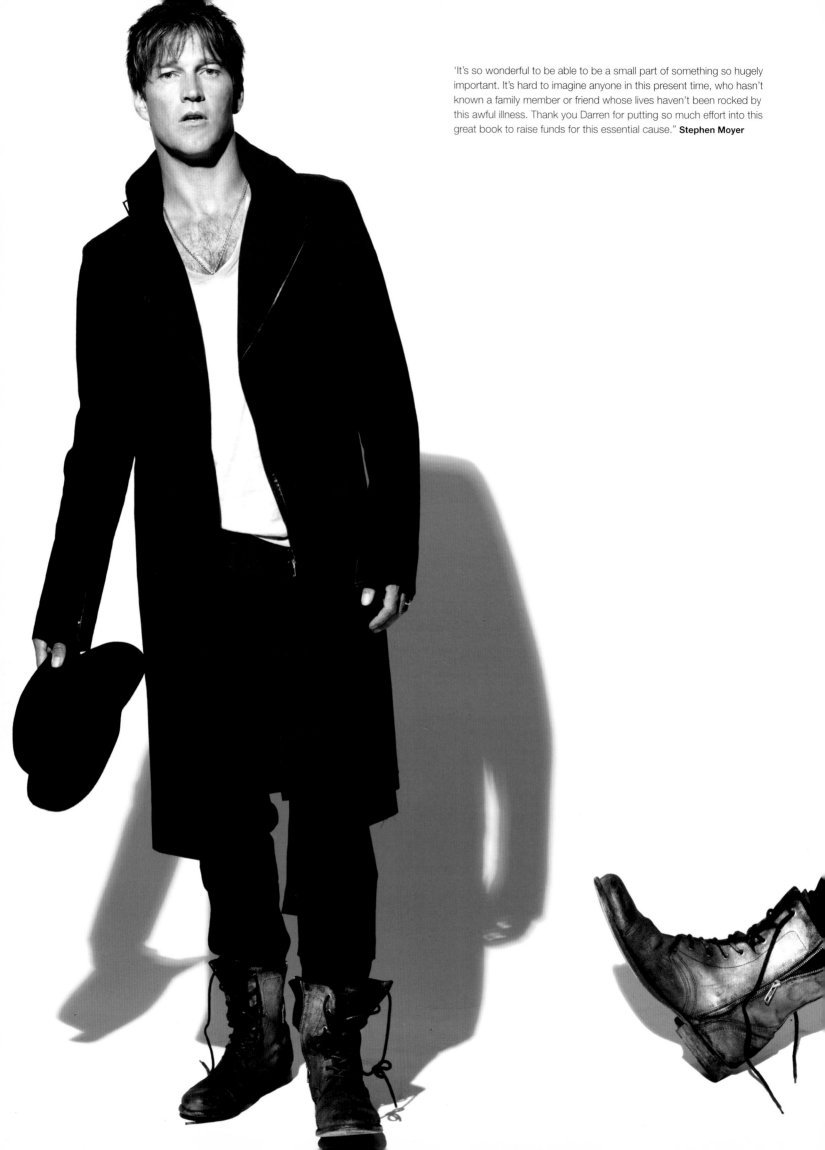

'It's so wonderful to be able to be a small part of something so hugely important. It's hard to imagine anyone in this present time, who hasn't known a family member or friend whose lives haven't been rocked by this awful illness. Thank you Darren for putting so much effort into this great book to raise funds for this essential cause." **Stephen Moyer**

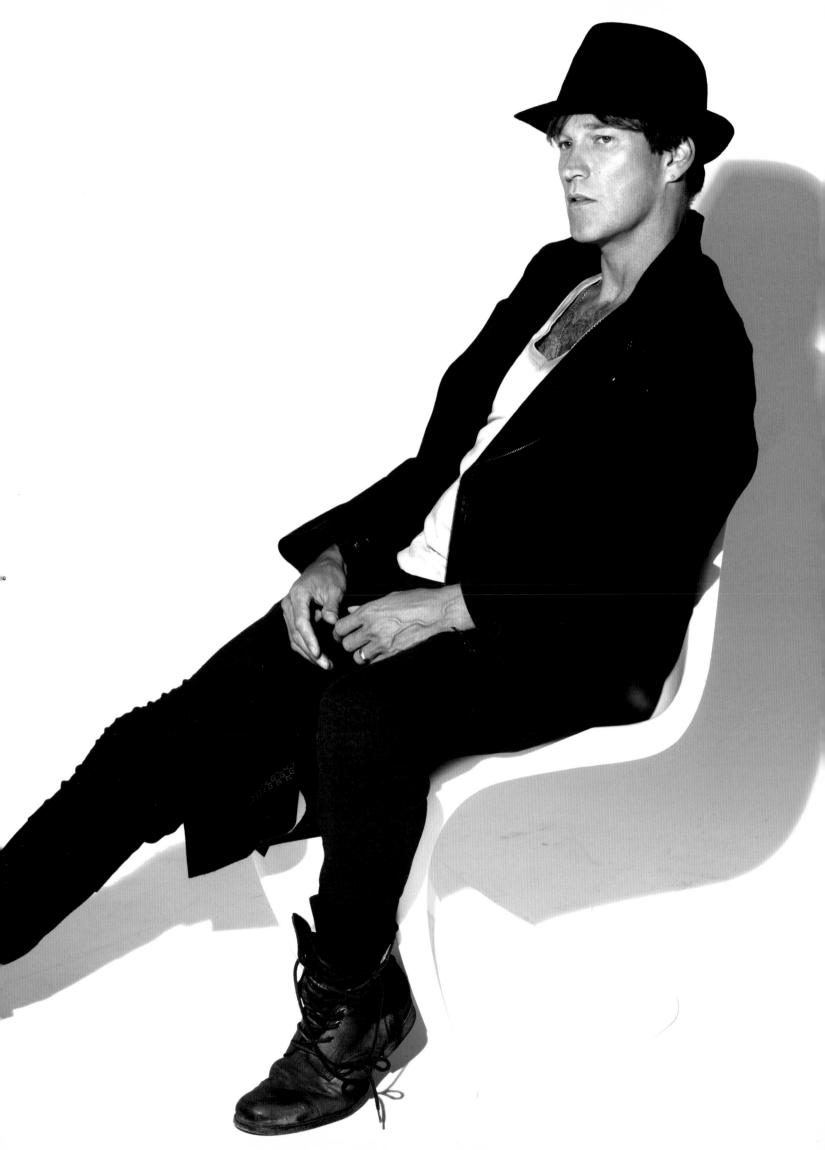

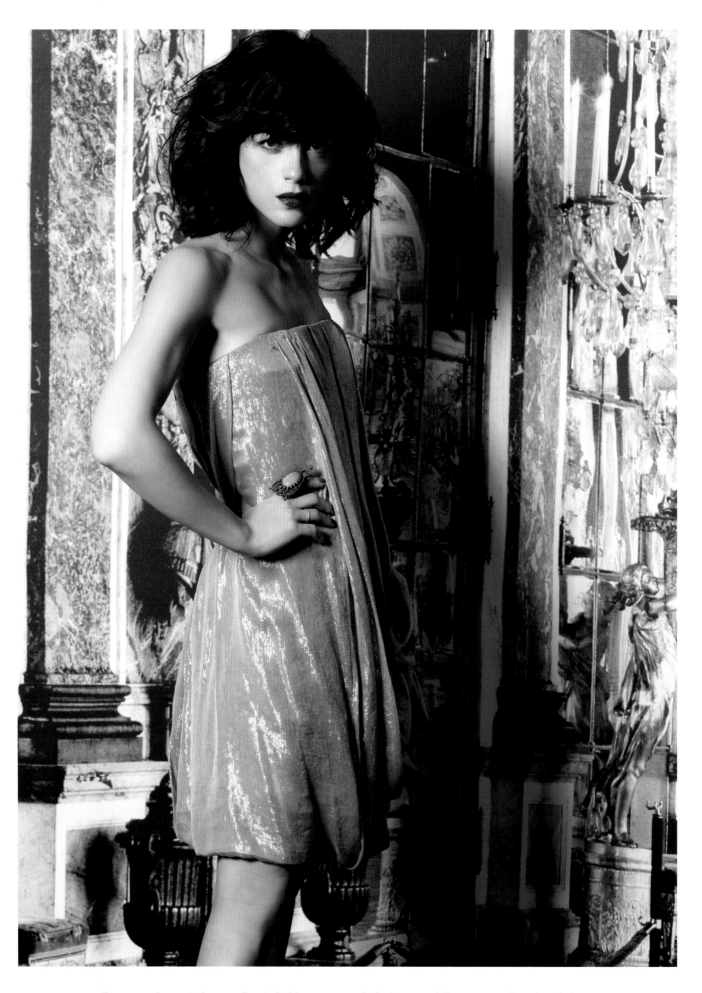

"It was my pleasure to be a small part of raising awareness for brain cancer. I, like so many others, have lost a family member to this very cancer and so it was a special honor to sit for Darren Tieste's generous contribution in the campaign to gain hope against this disease. His talents and drive are so appreciated." **Selma Blair**

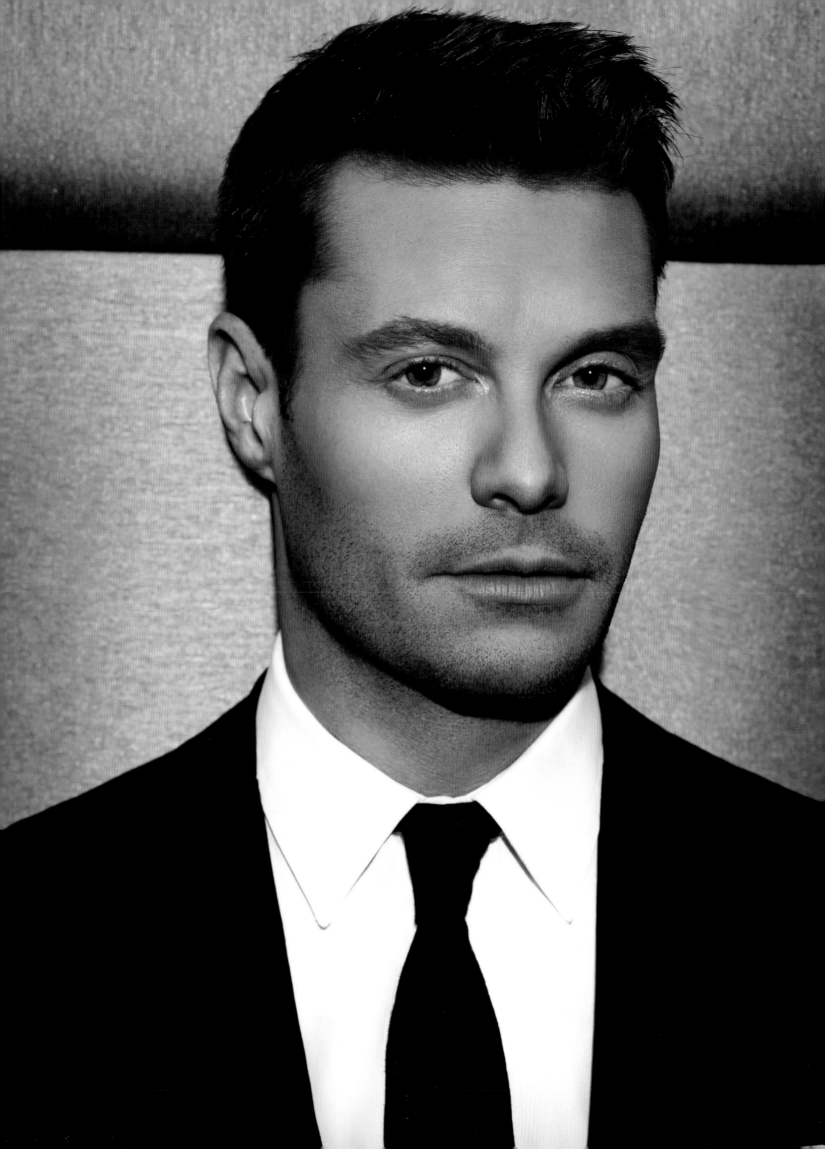

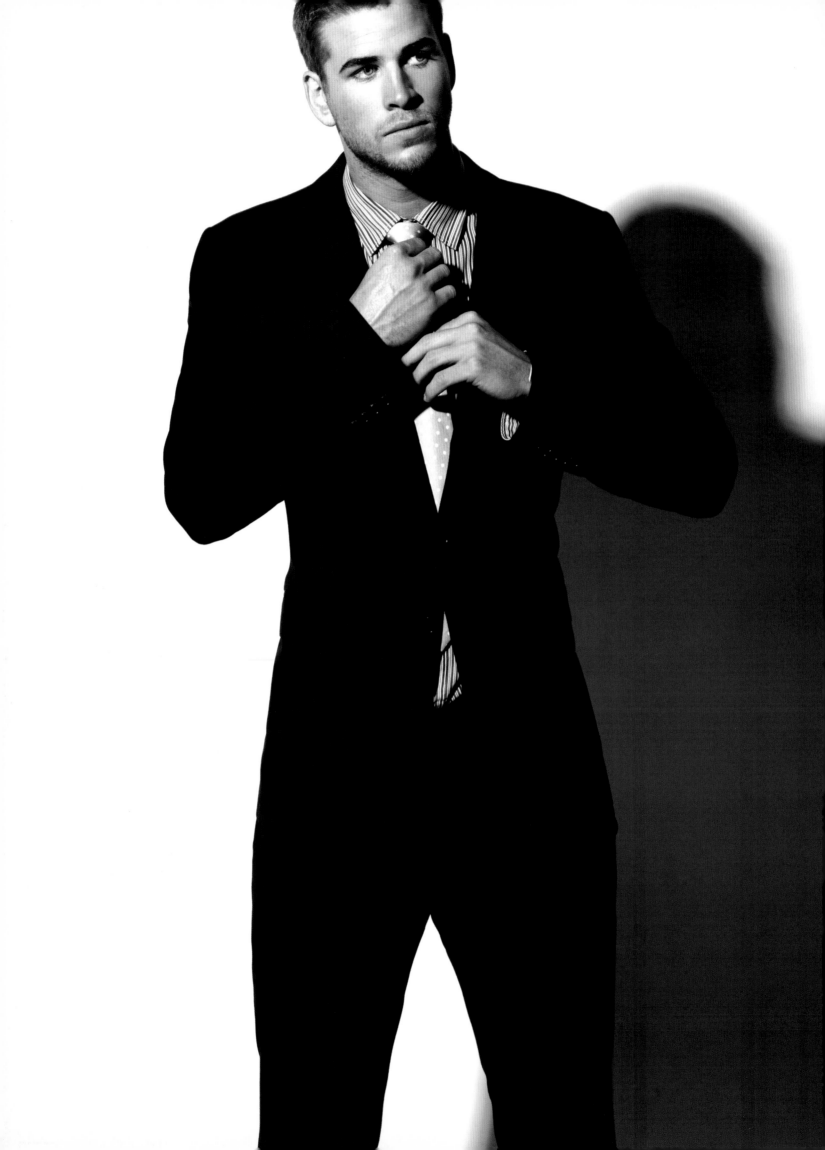

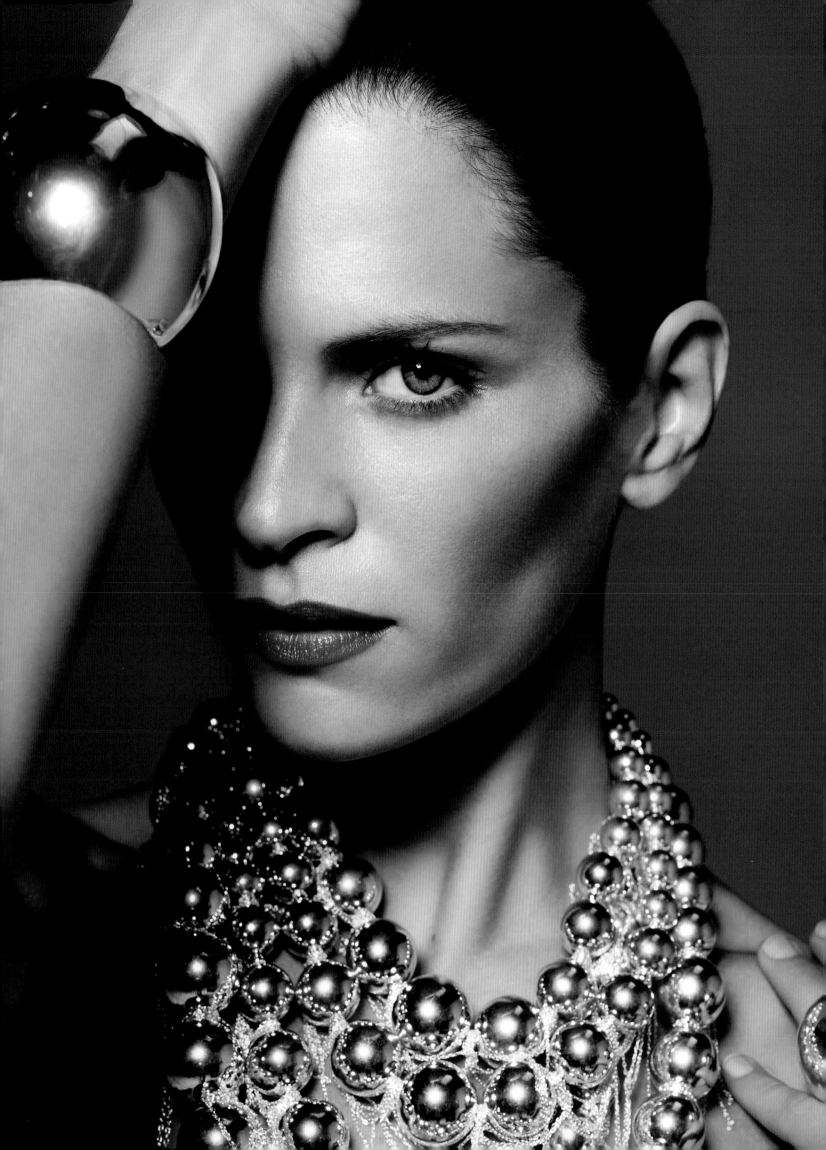

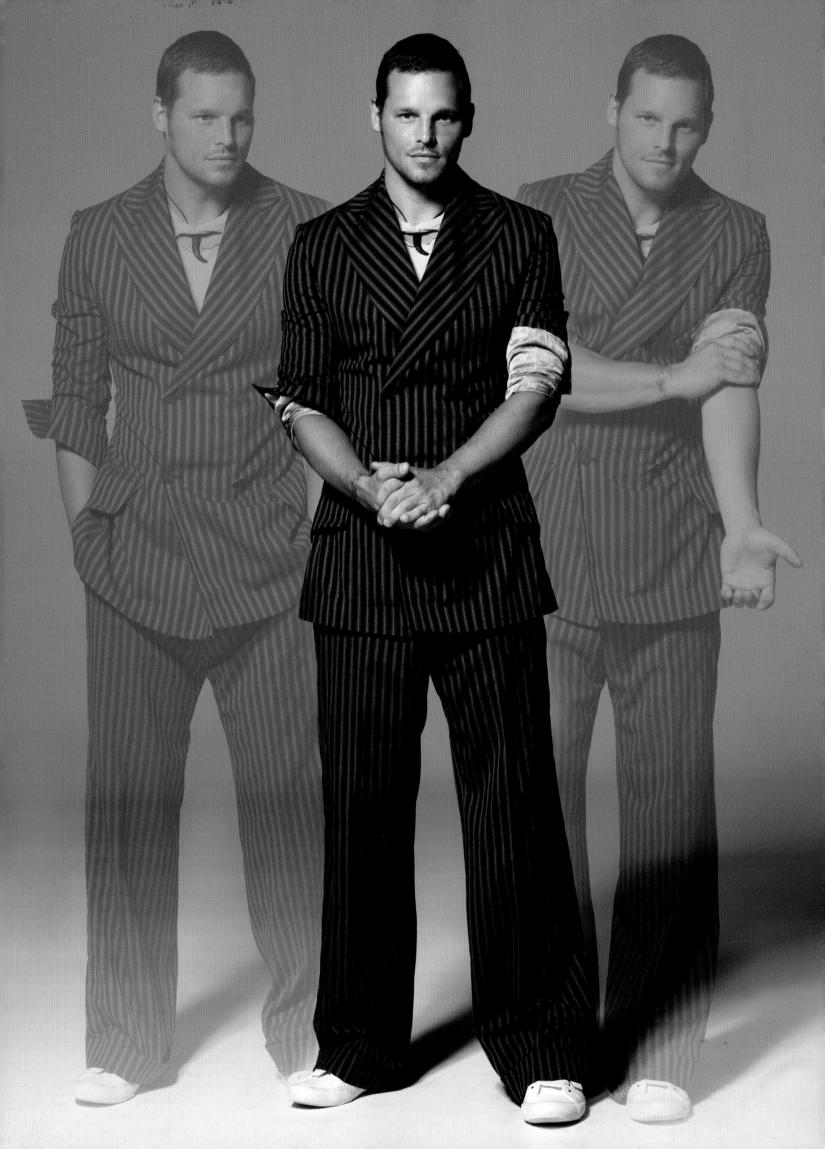

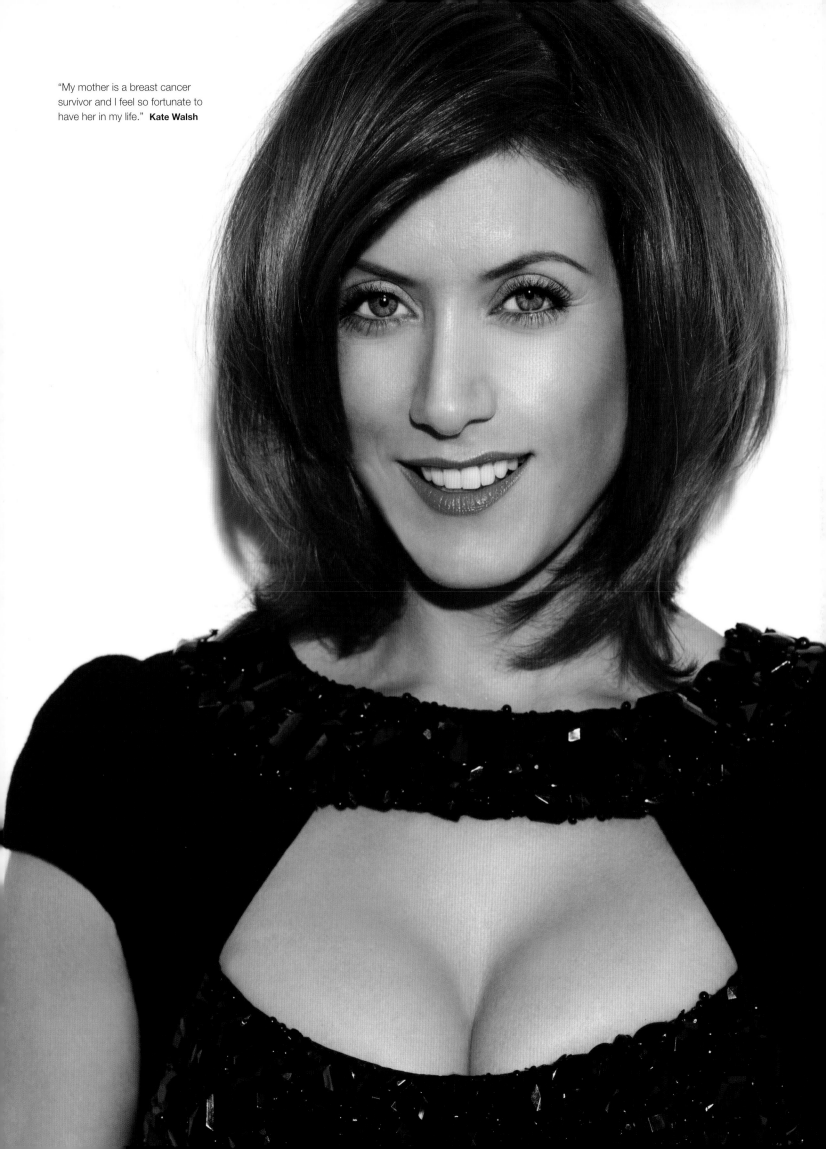

"My mother is a breast cancer survivor and I feel so fortunate to have her in my life." **Kate Walsh**

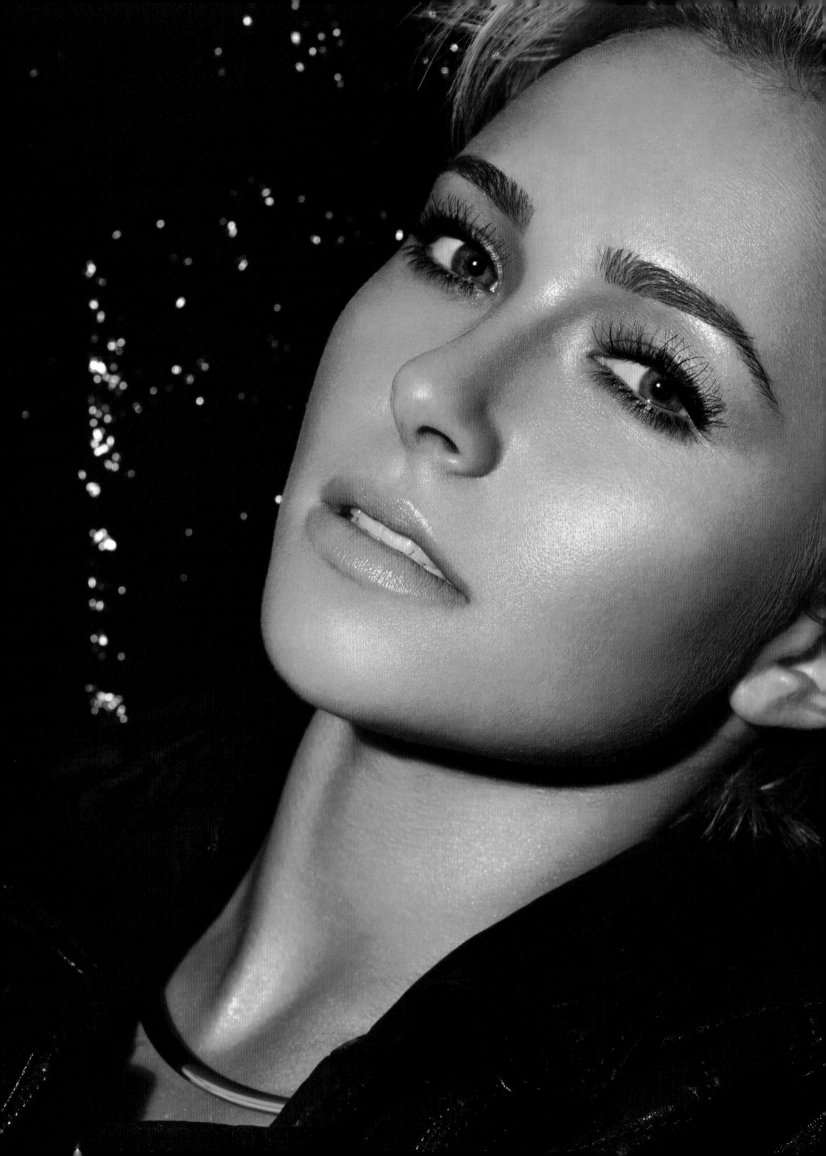

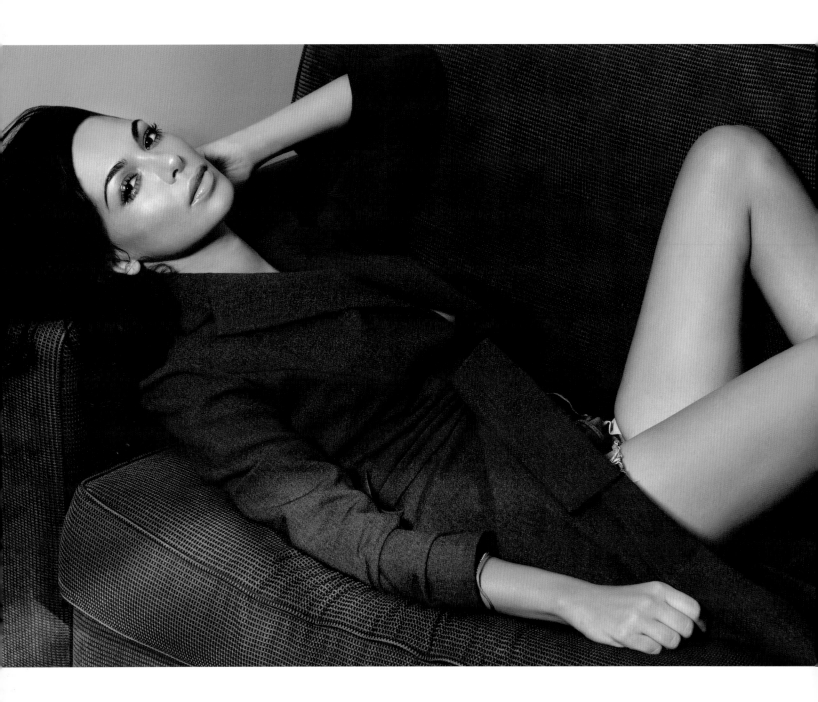

"This project is giving a voice to a cause that is very close to me and I am sure close to many other people. It was my pleasure and my honor to be asked to share my voice and pose for a photo in this beautiful book." **Moran Atias**

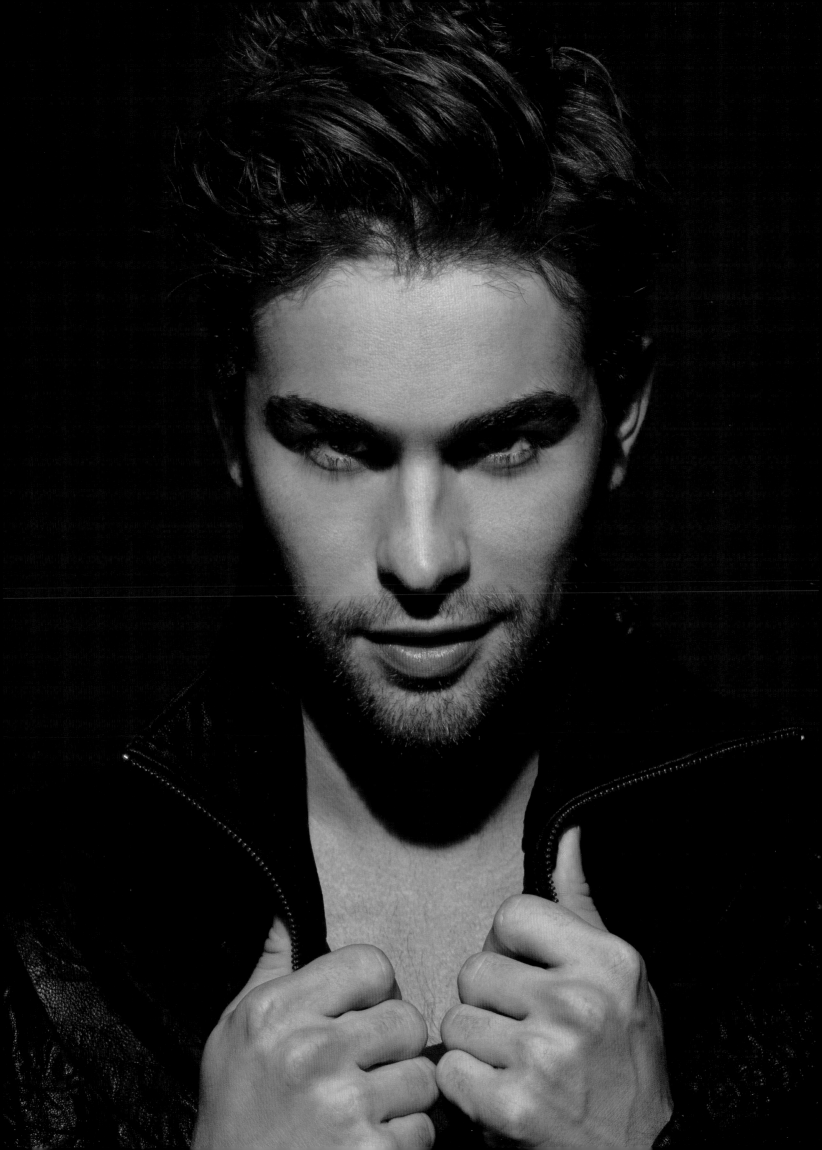

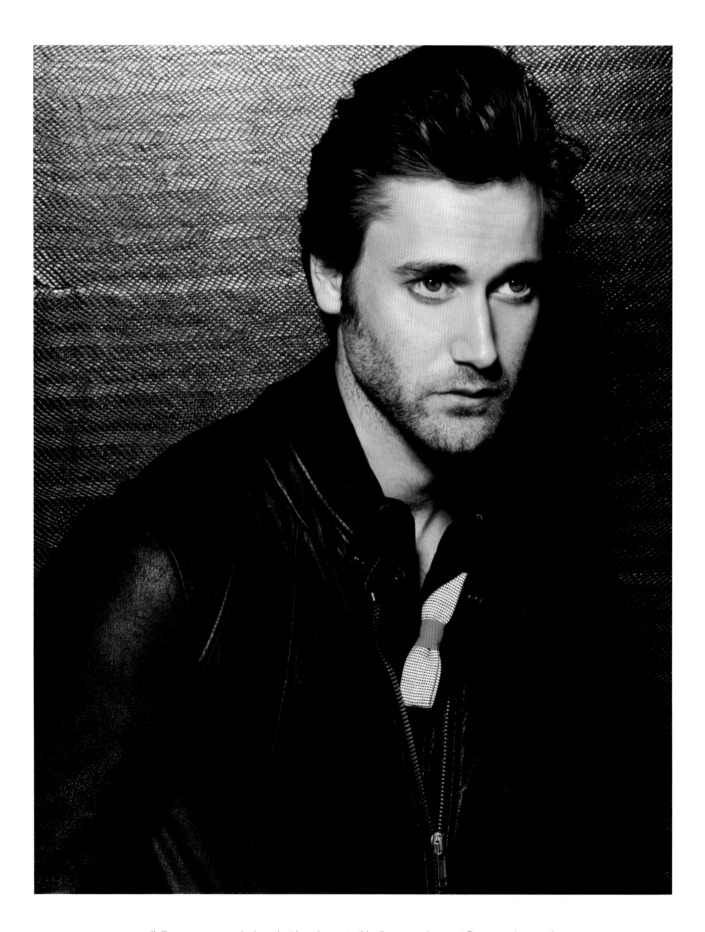

"I, like so many people, have lost loved ones to this disease and respect Darren and anyone's efforts to raise awareness, through their art, about the need to keep fighting." **Ryan Eggold**

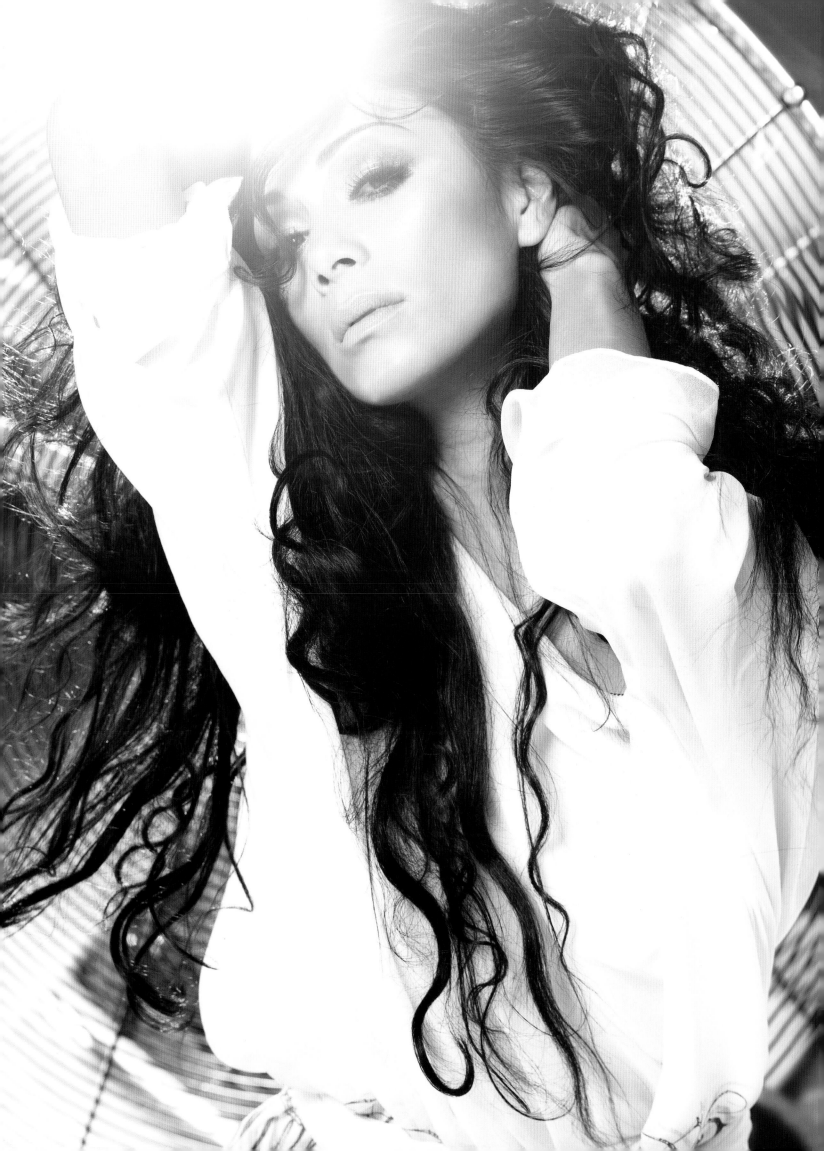

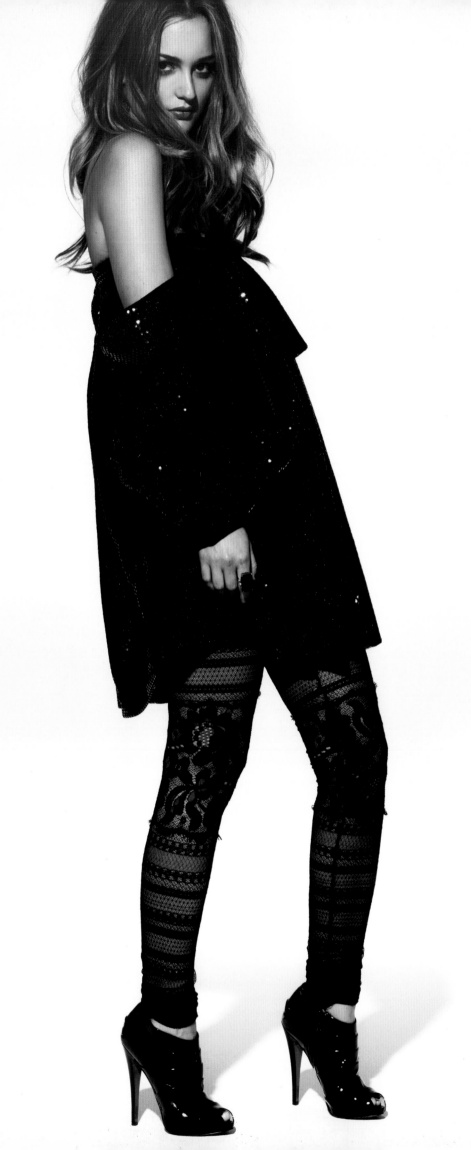

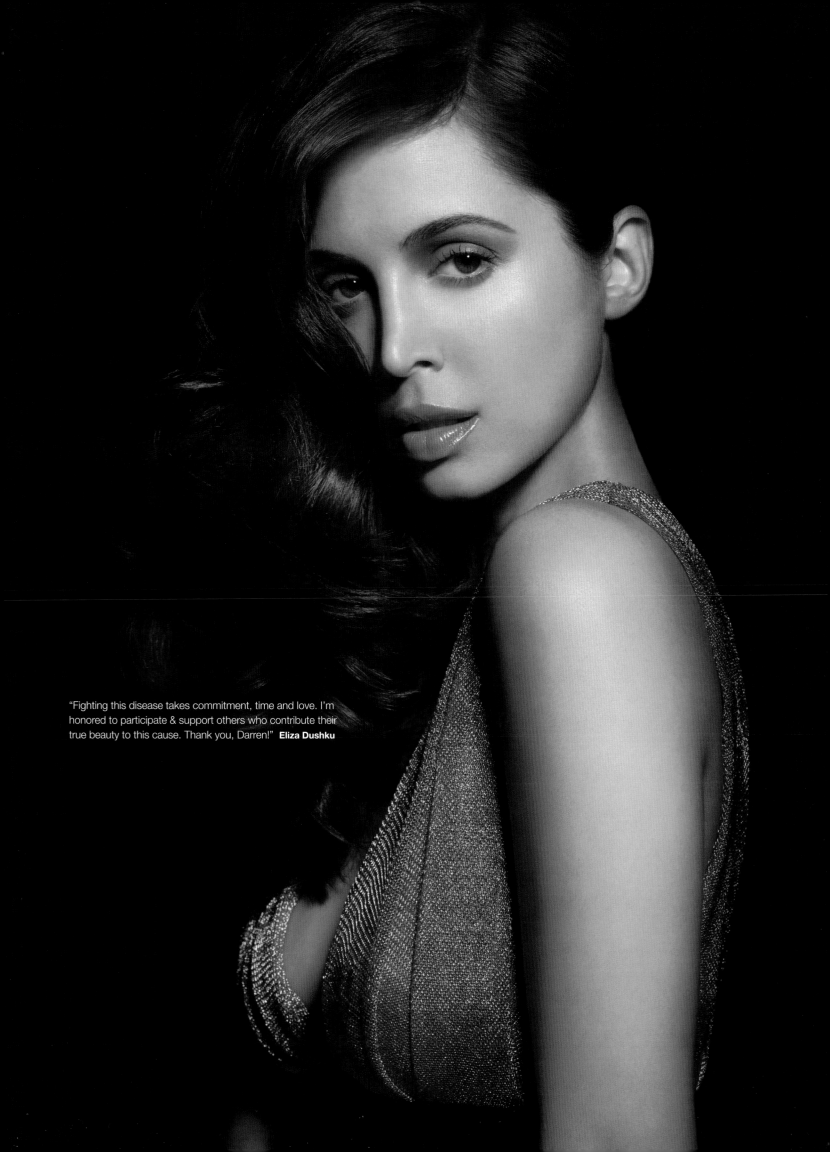

"Fighting this disease takes commitment, time and love. I'm honored to participate & support others who contribute their true beauty to this cause. Thank you, Darren!" **Eliza Dushku**

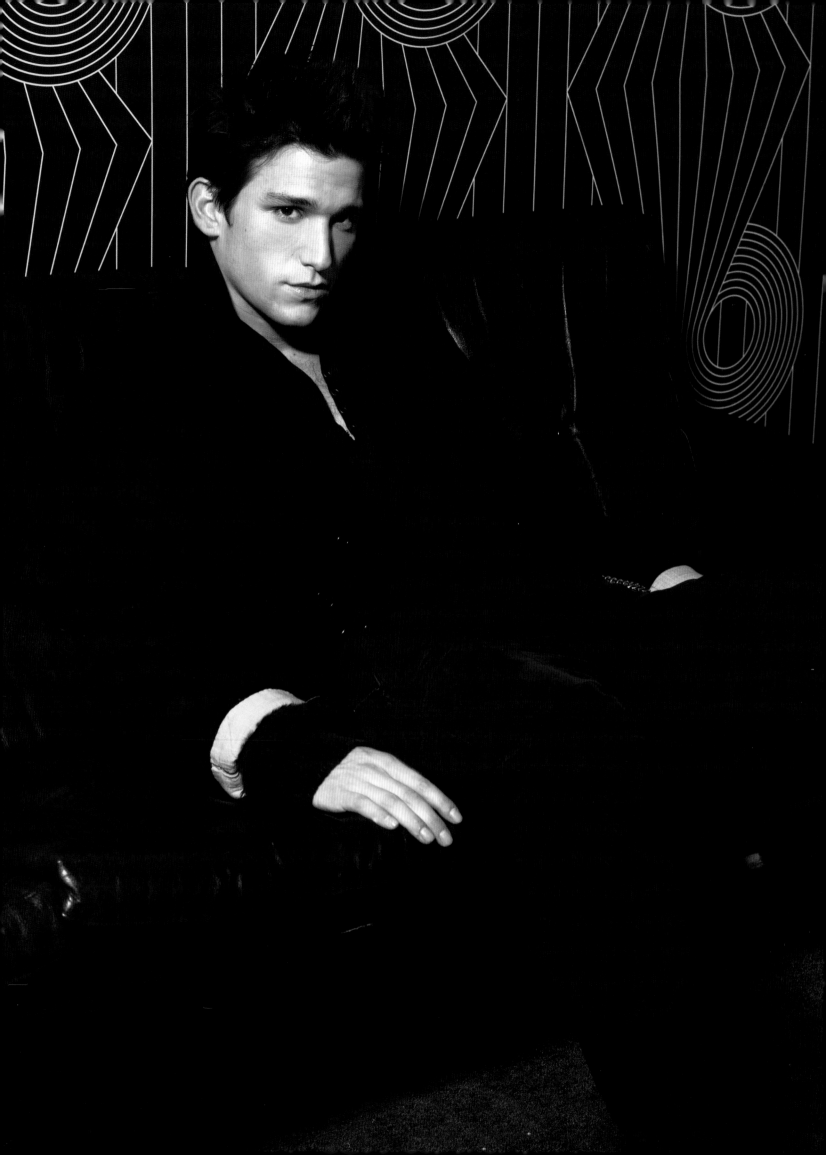

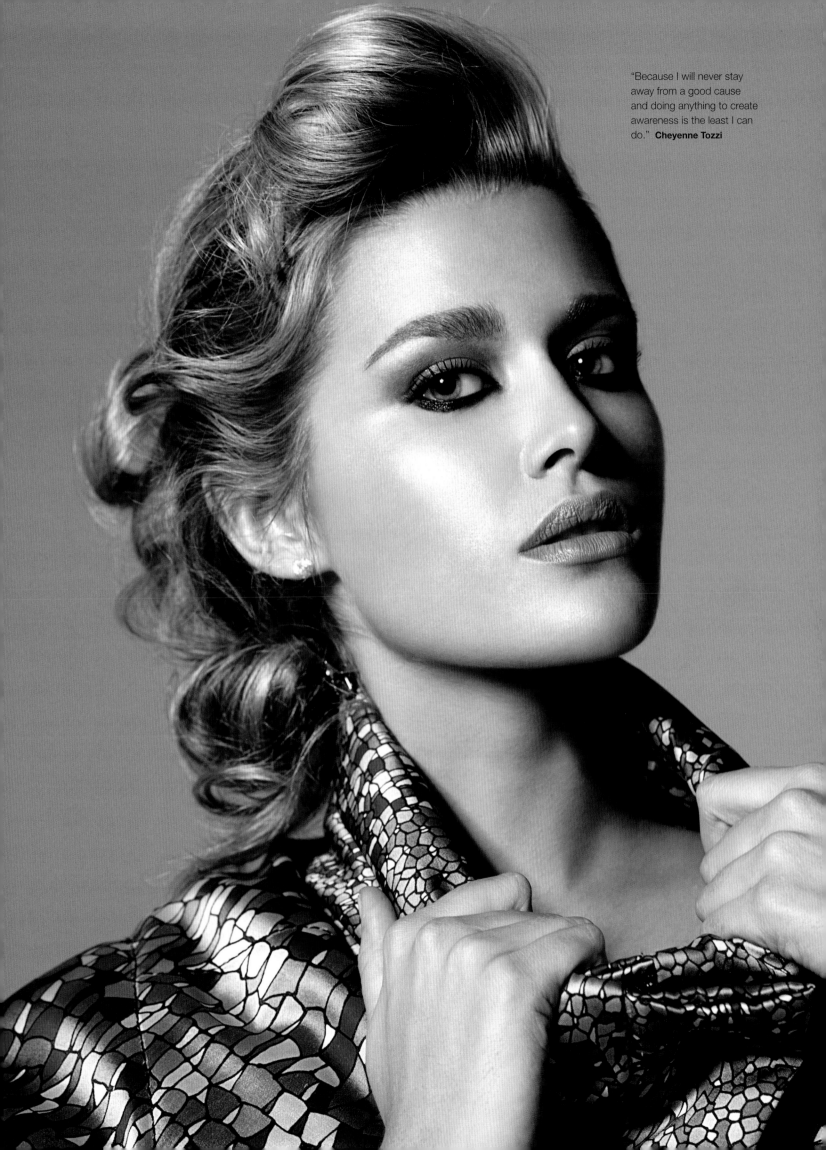

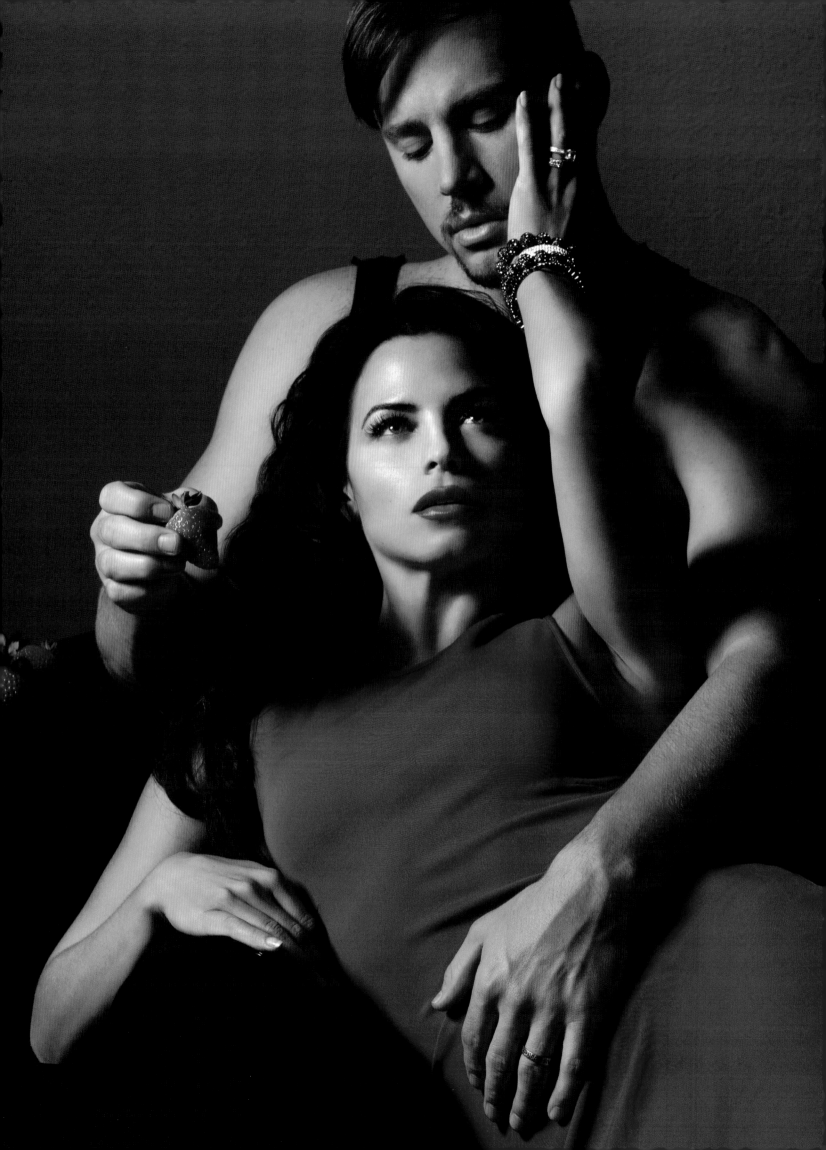

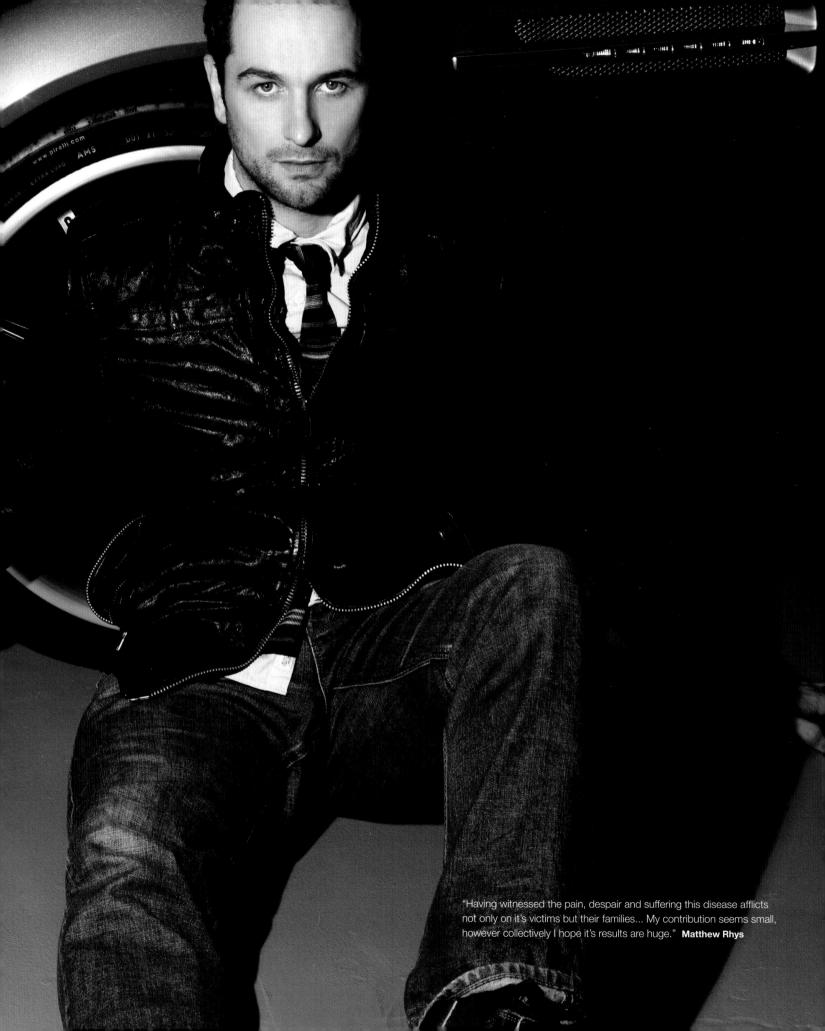

"Having witnessed the pain, despair and suffering this disease afflicts not only on it's victims but their families... My contribution seems small, however collectively I hope it's results are huge." **Matthew Rhys**

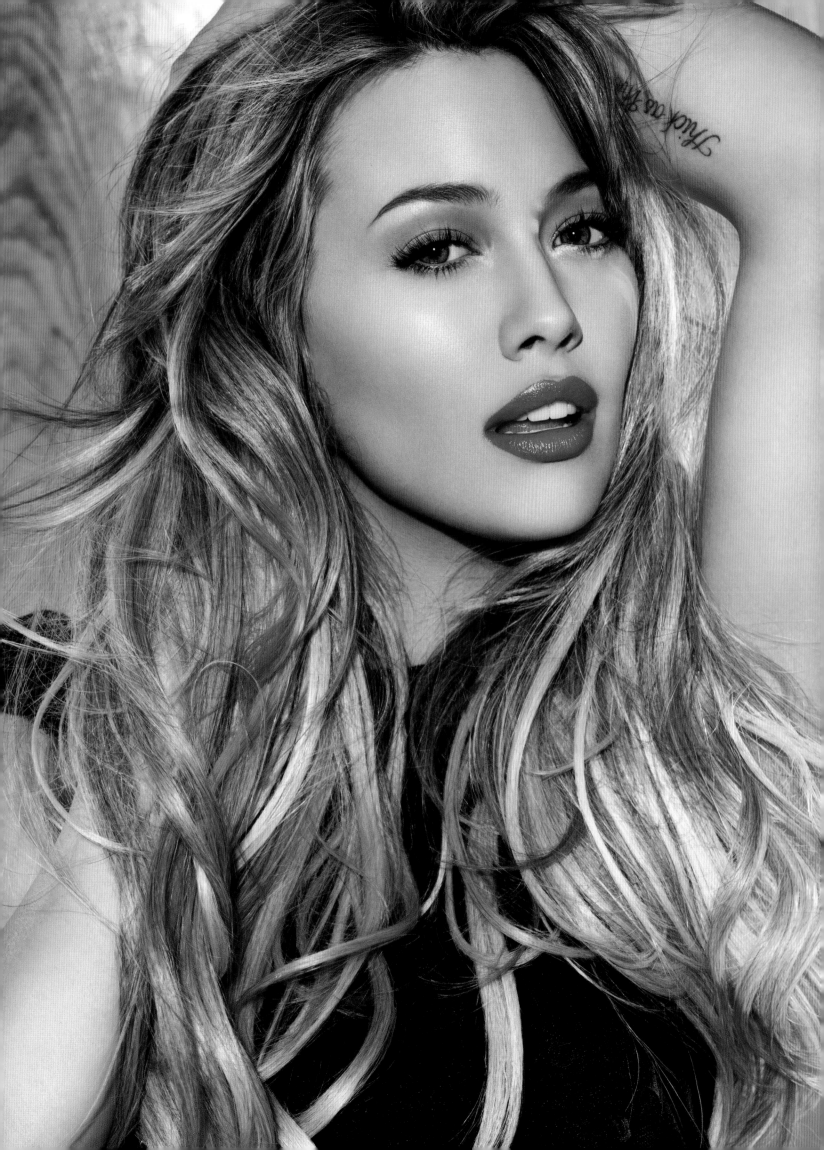

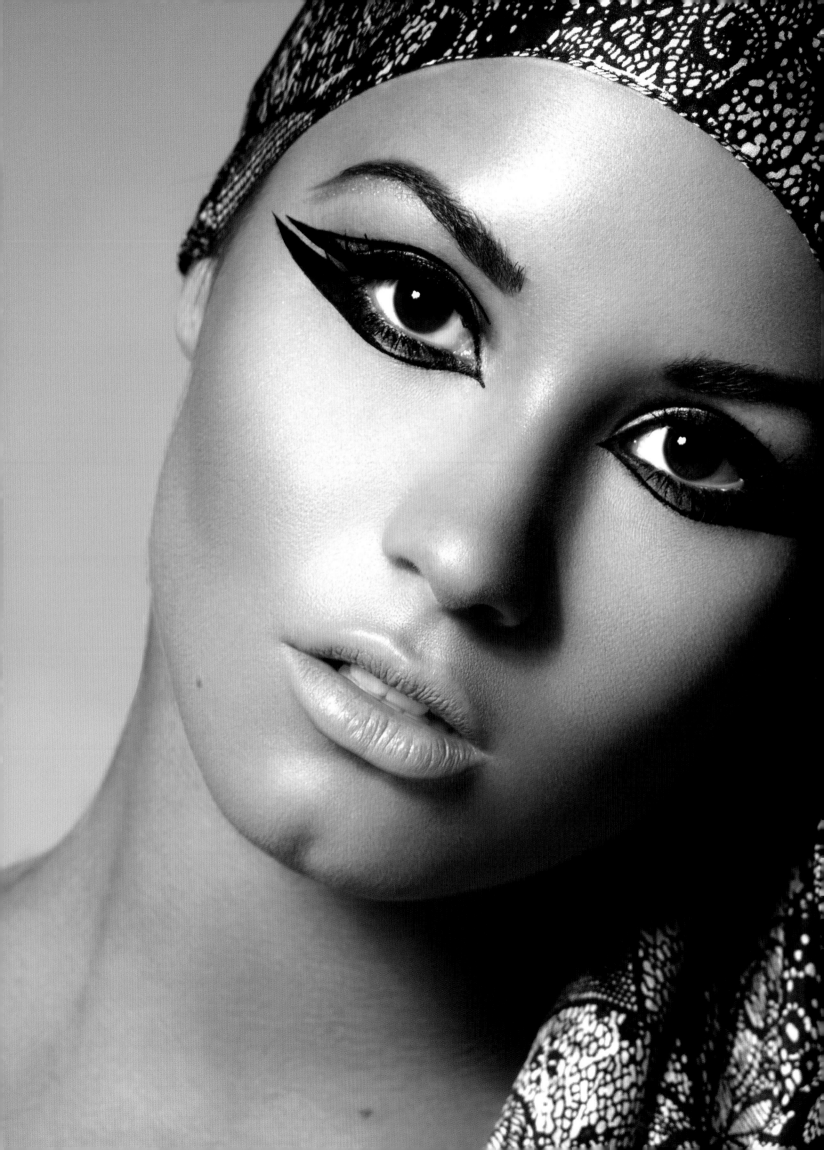

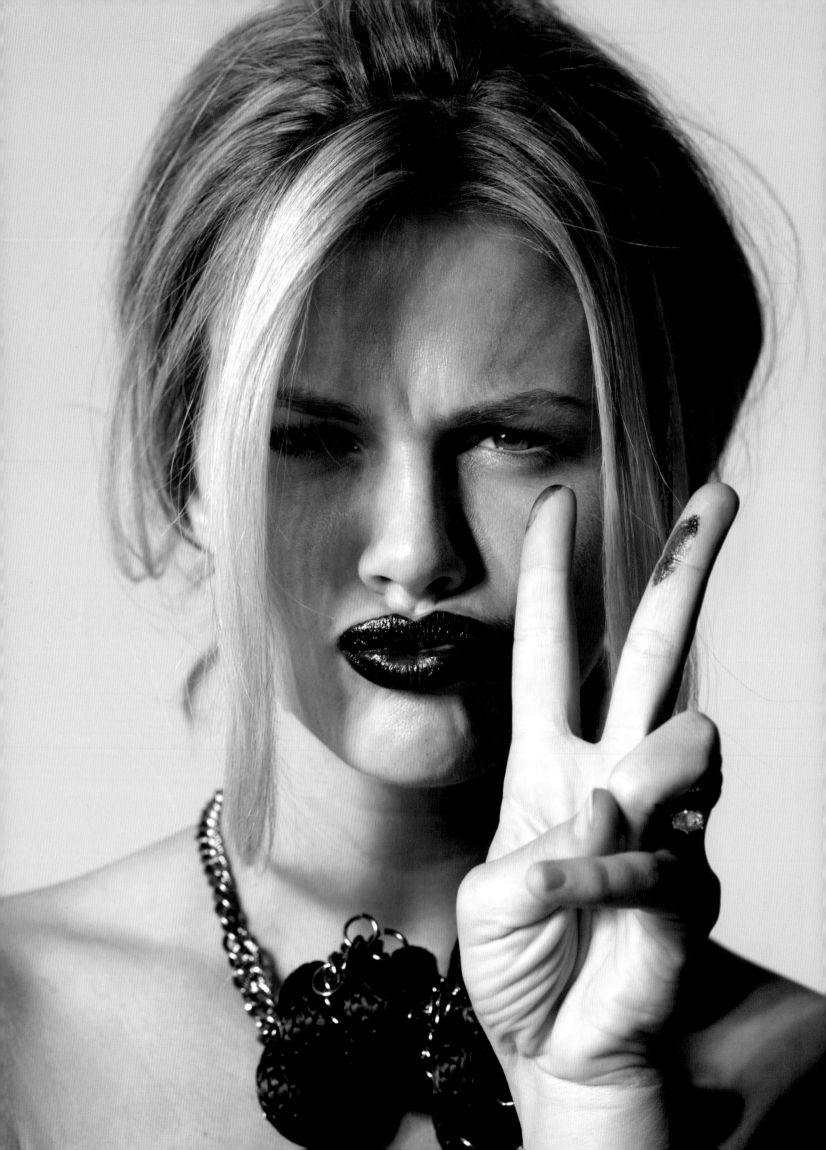

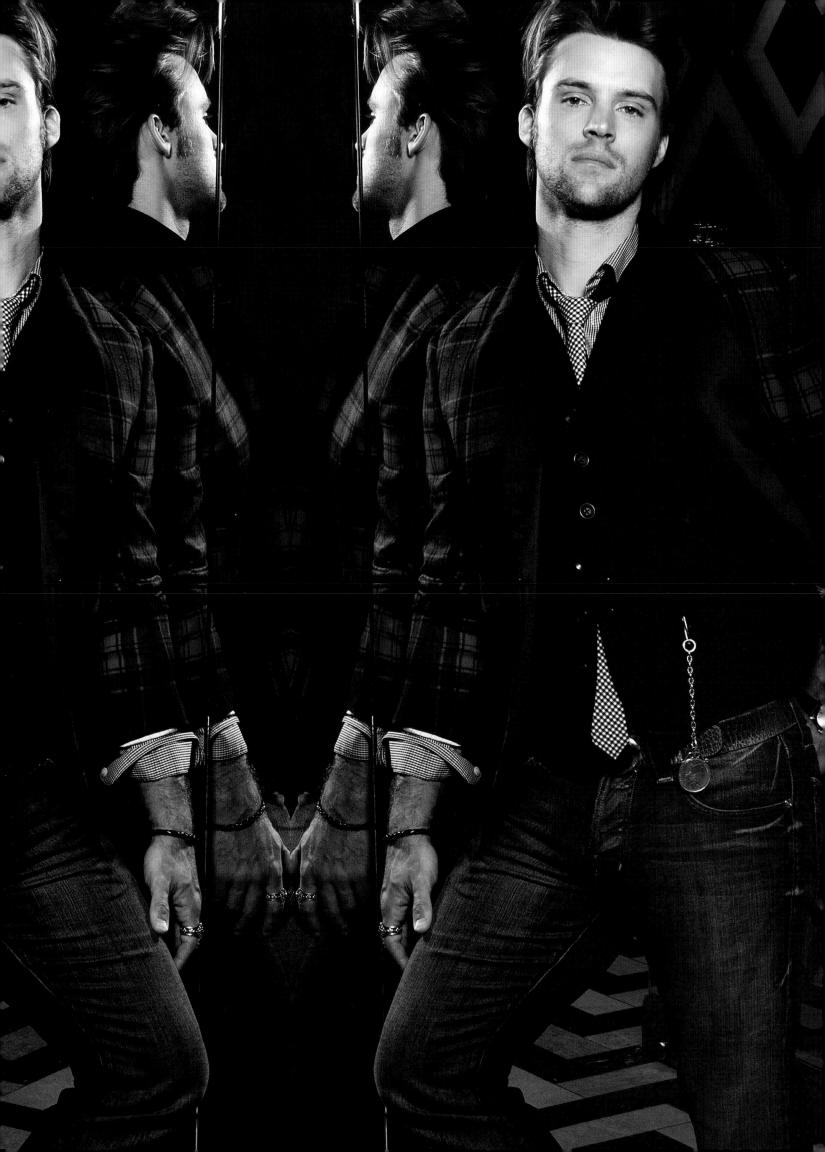

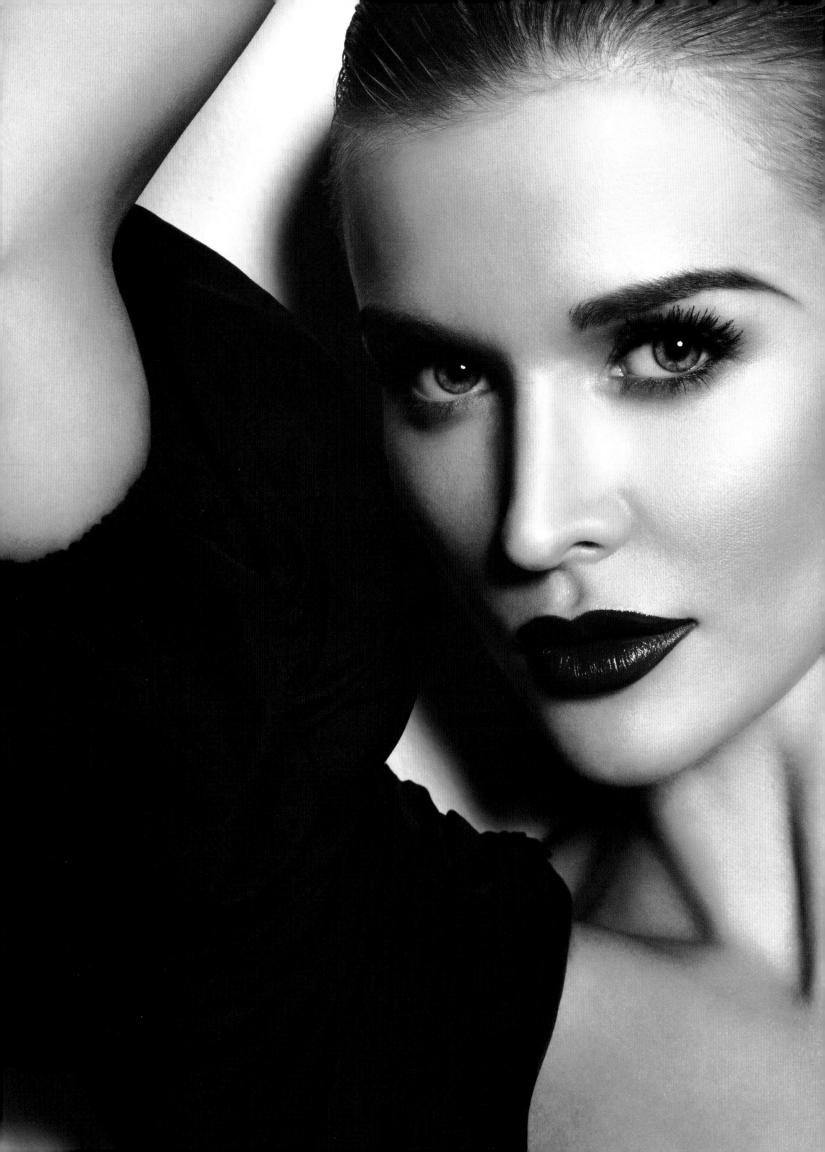

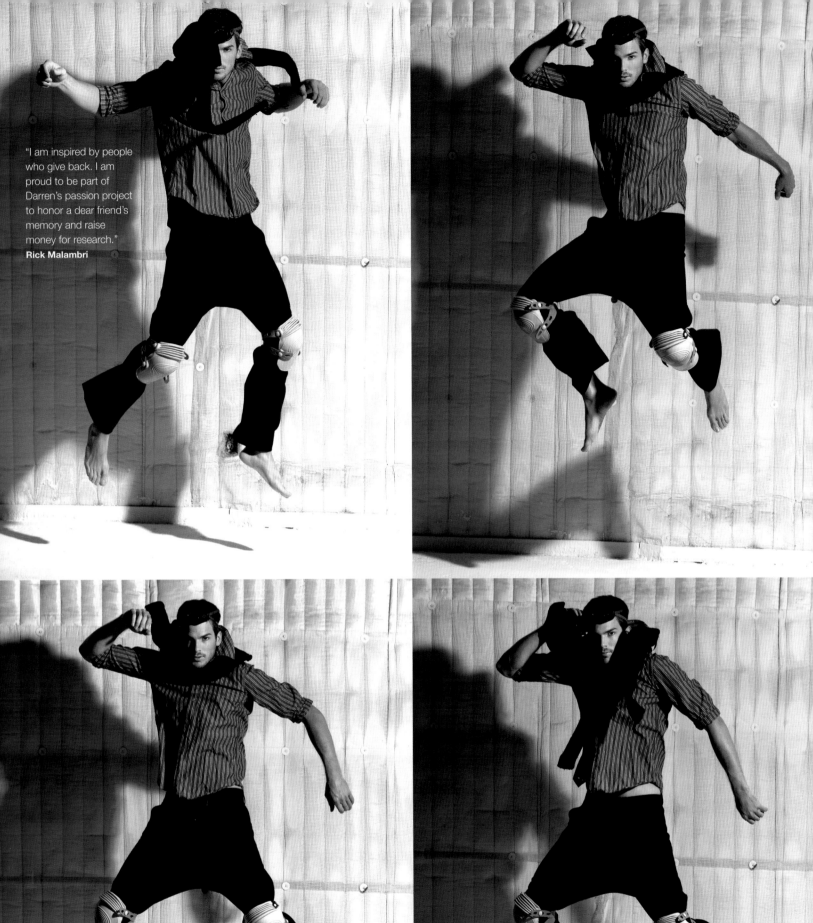

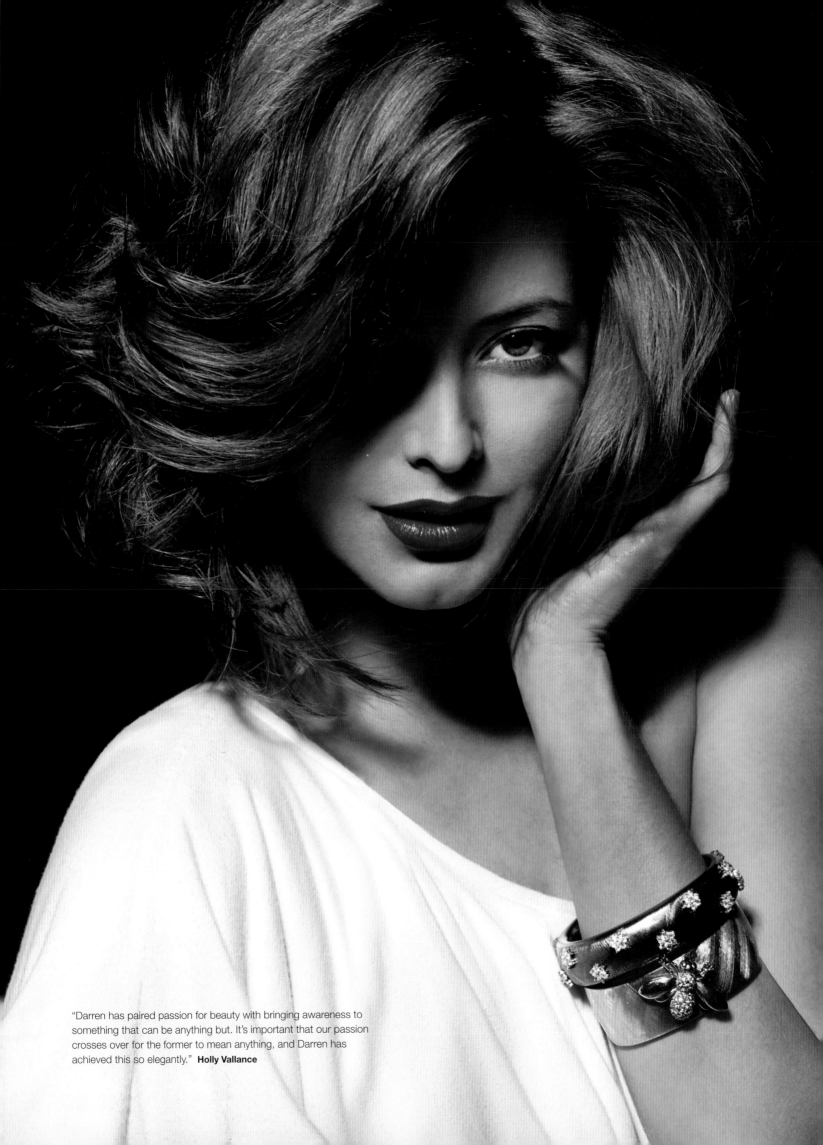

"Darren has paired passion for beauty with bringing awareness to something that can be anything but. It's important that our passion crosses over for the former to mean anything, and Darren has achieved this so elegantly." **Holly Vallance**

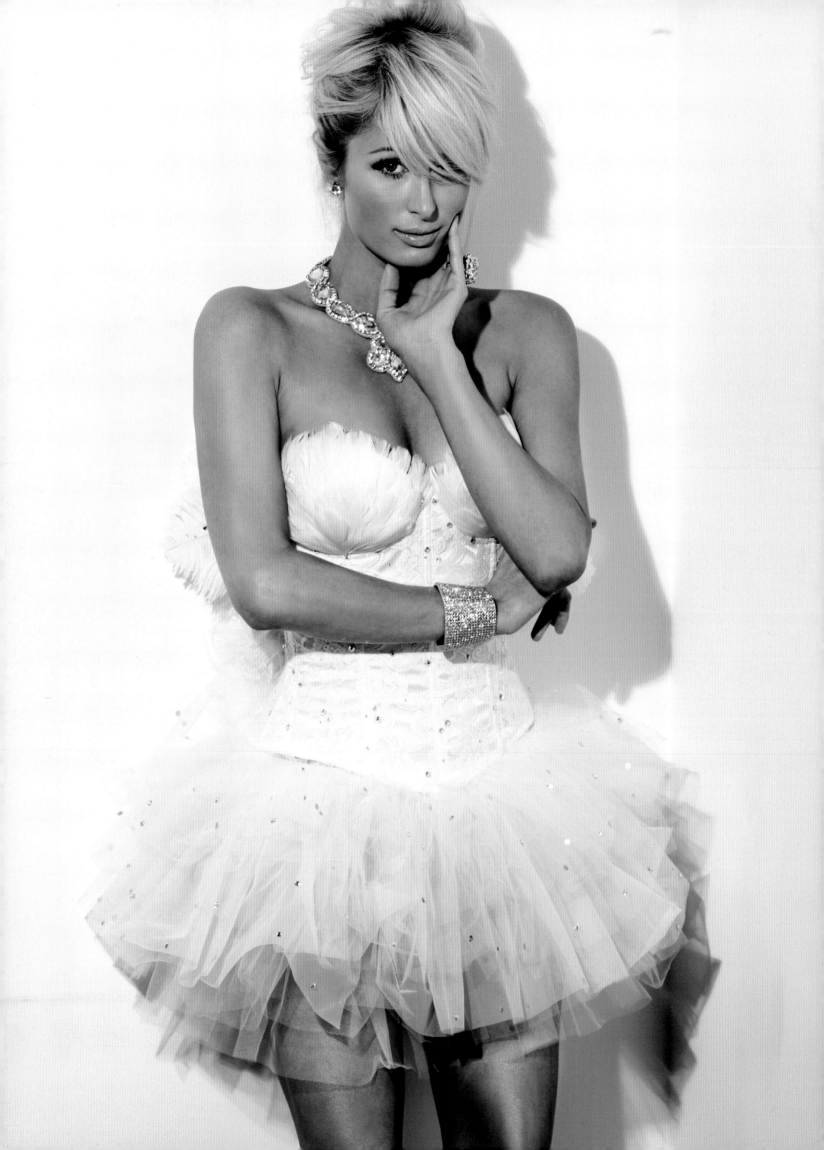

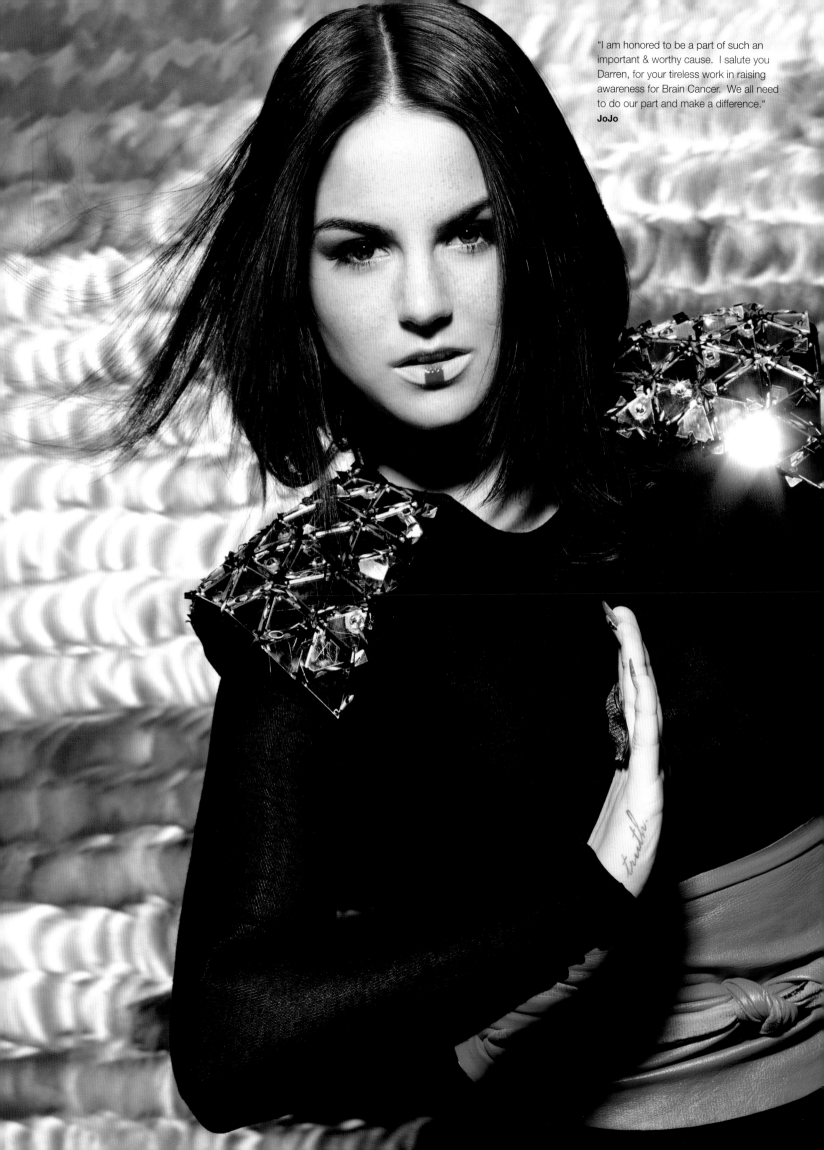

"I am honored to be a part of such an important & worthy cause. I salute you Darren, for your tireless work in raising awareness for Brain Cancer. We all need to do our part and make a difference."
JoJo

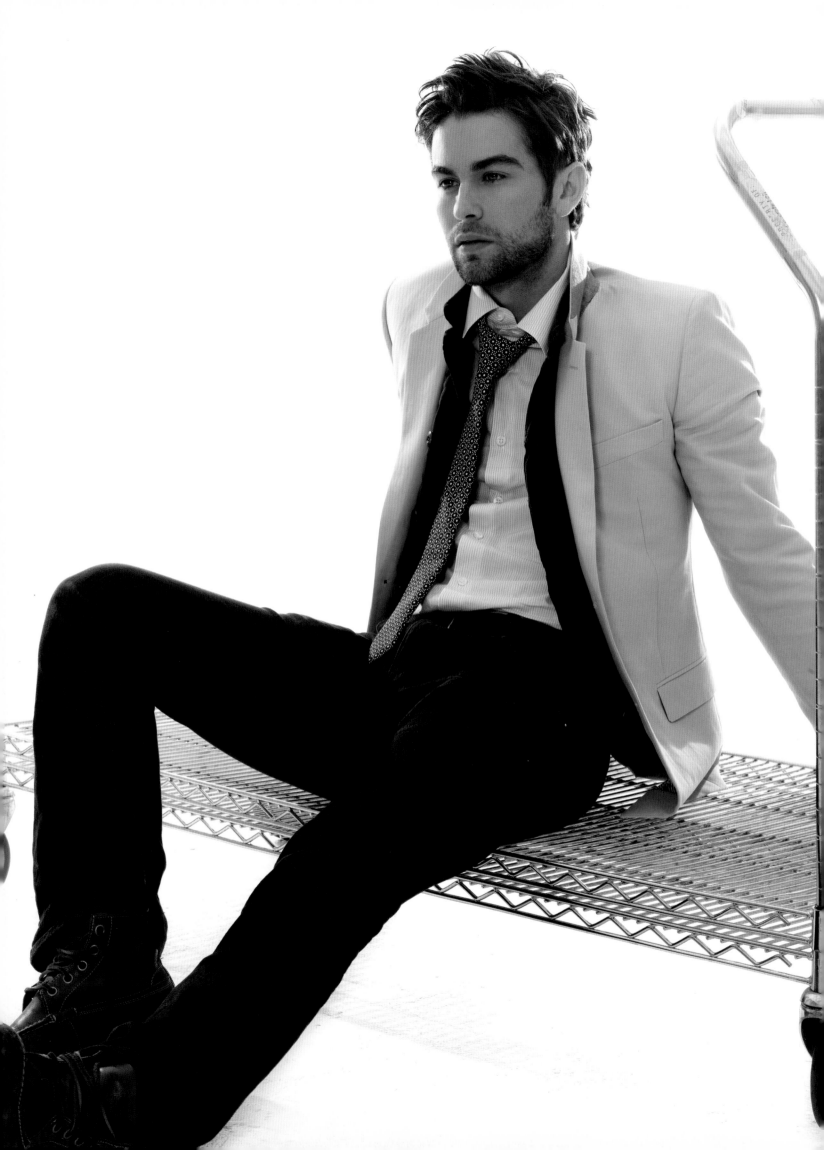

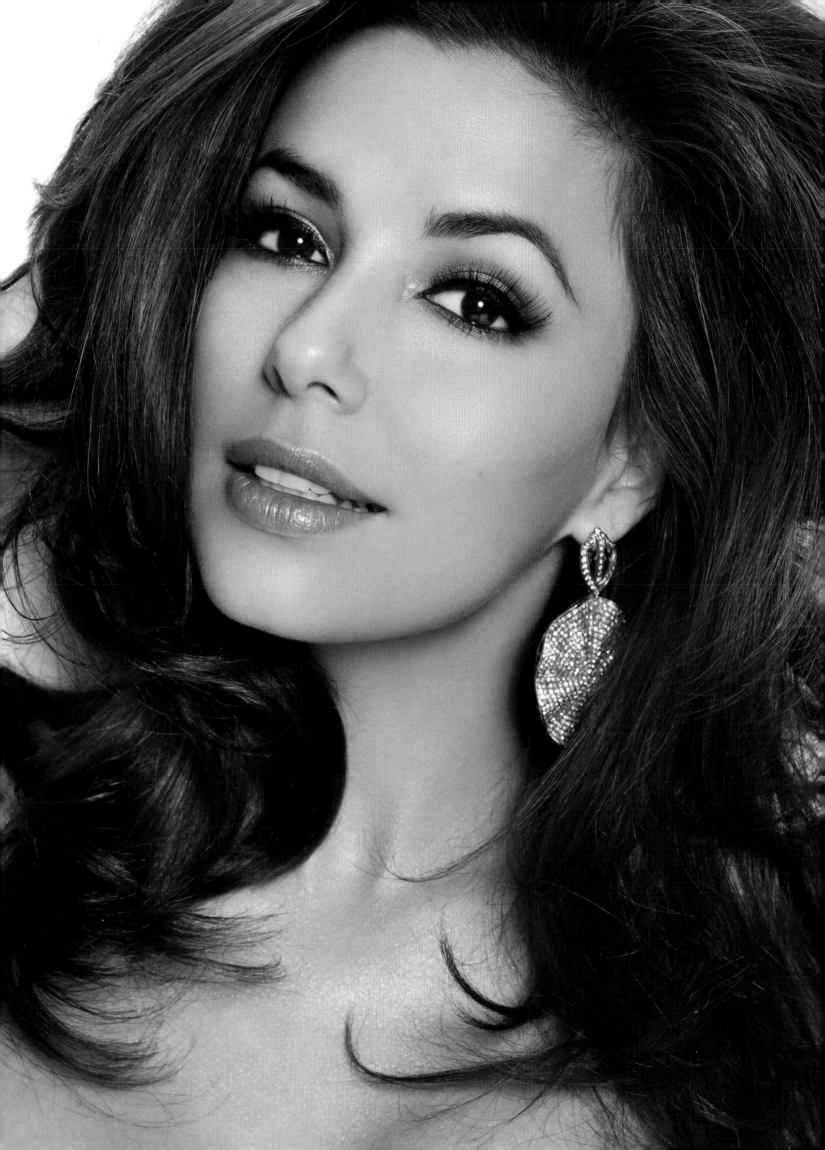

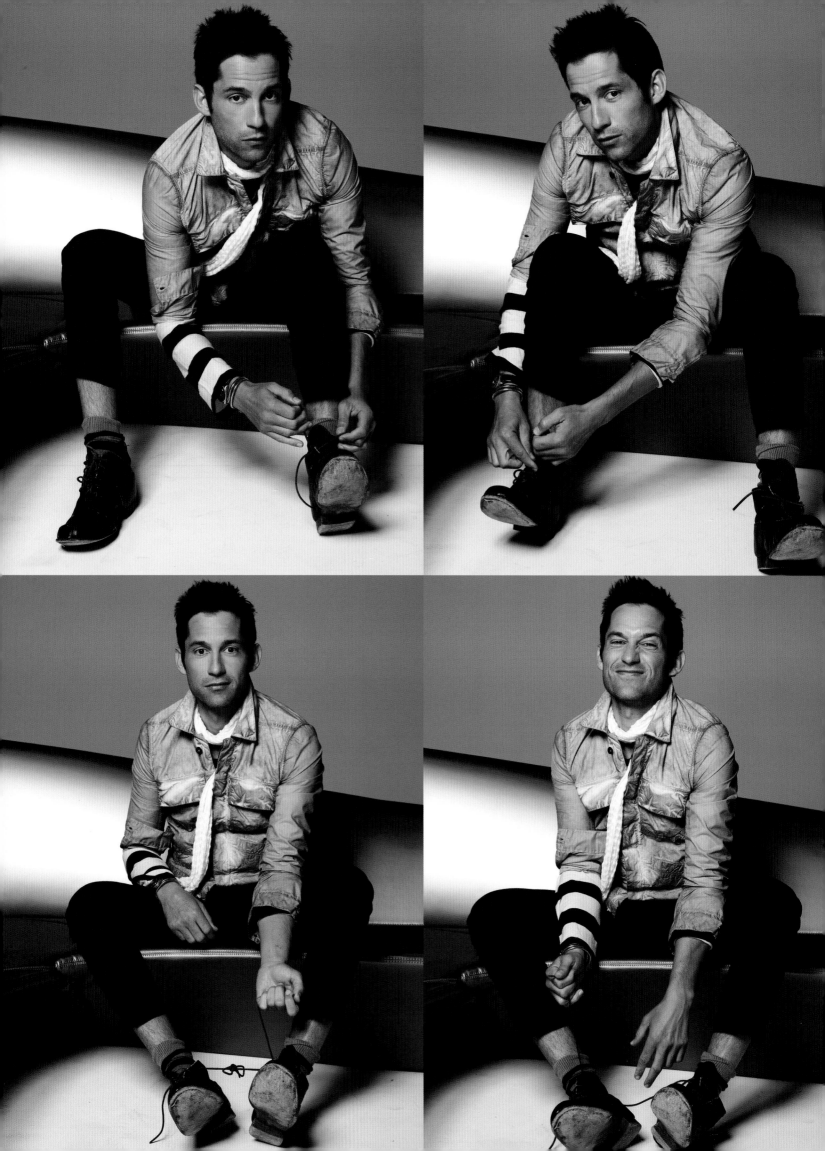

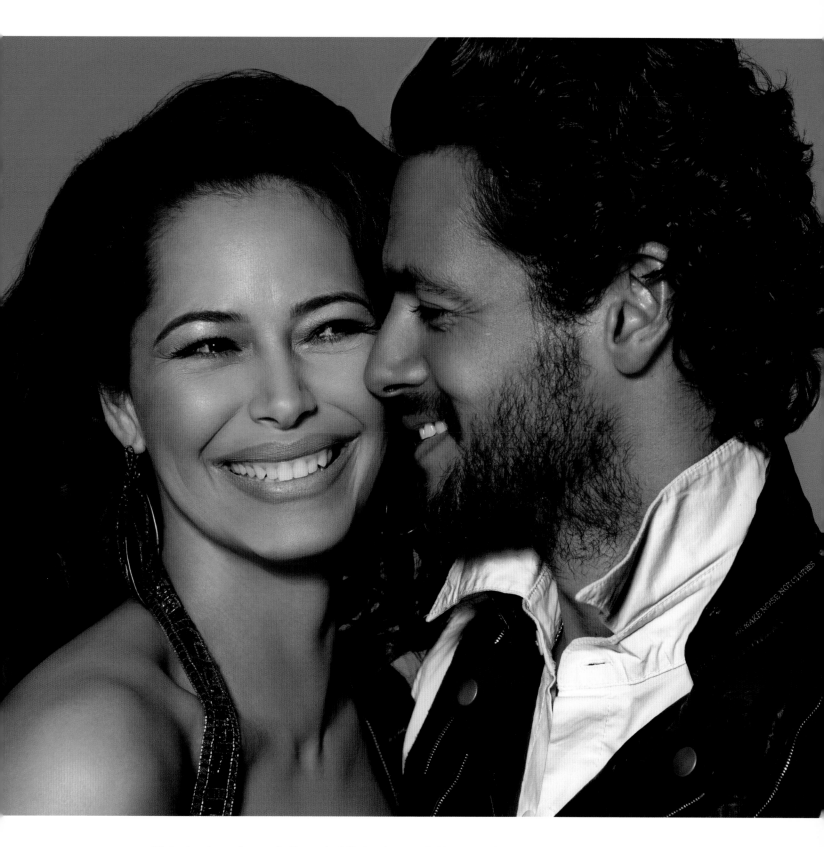

"My husband was diagnosed with non-hodgkin lymphoma early 2011 and we've learned through this how important nutrition is for healing. Awareness is paramount. We believe in an attitude of gratitude." **Angela & Draco Rosa**

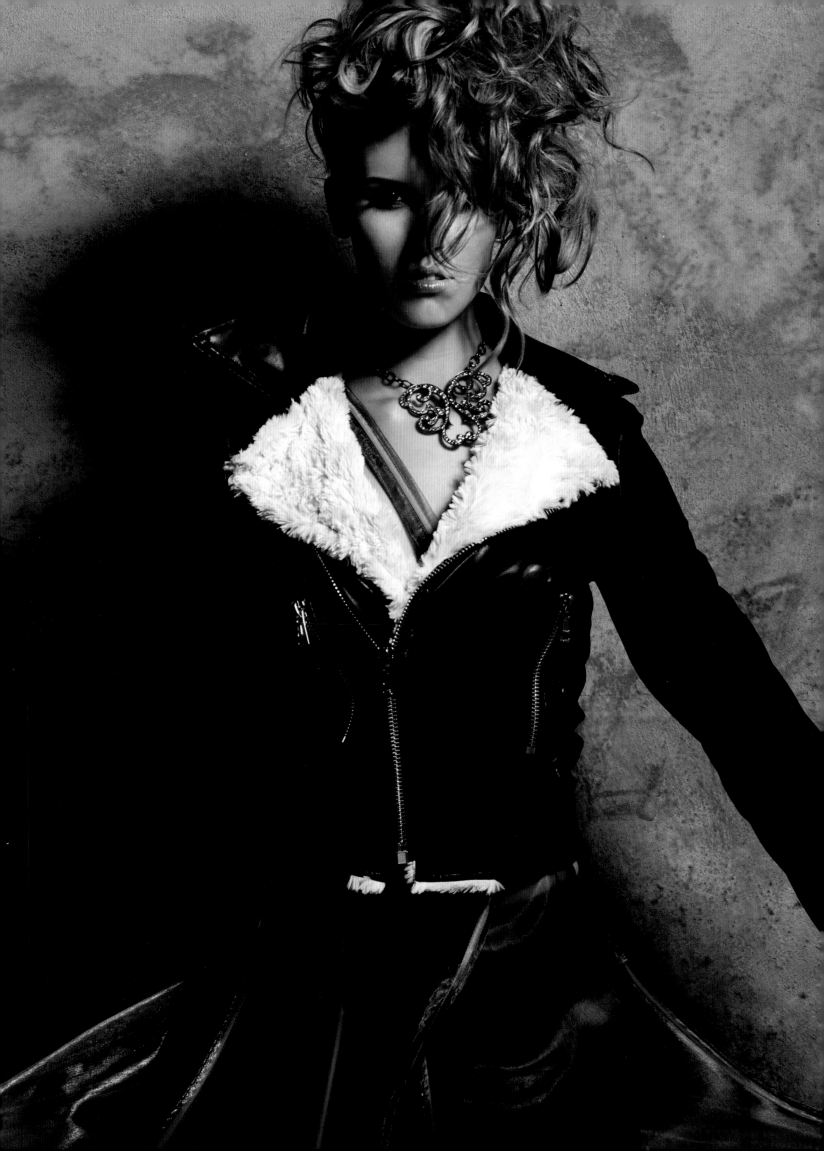

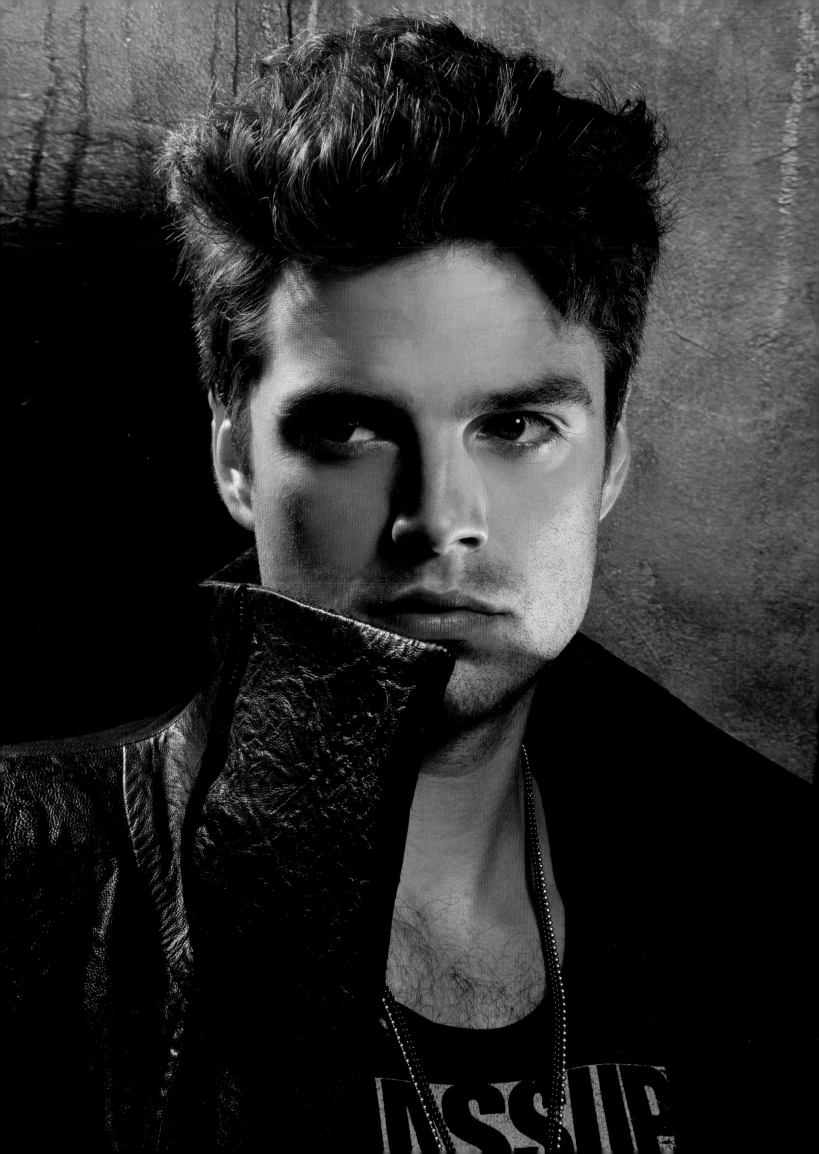

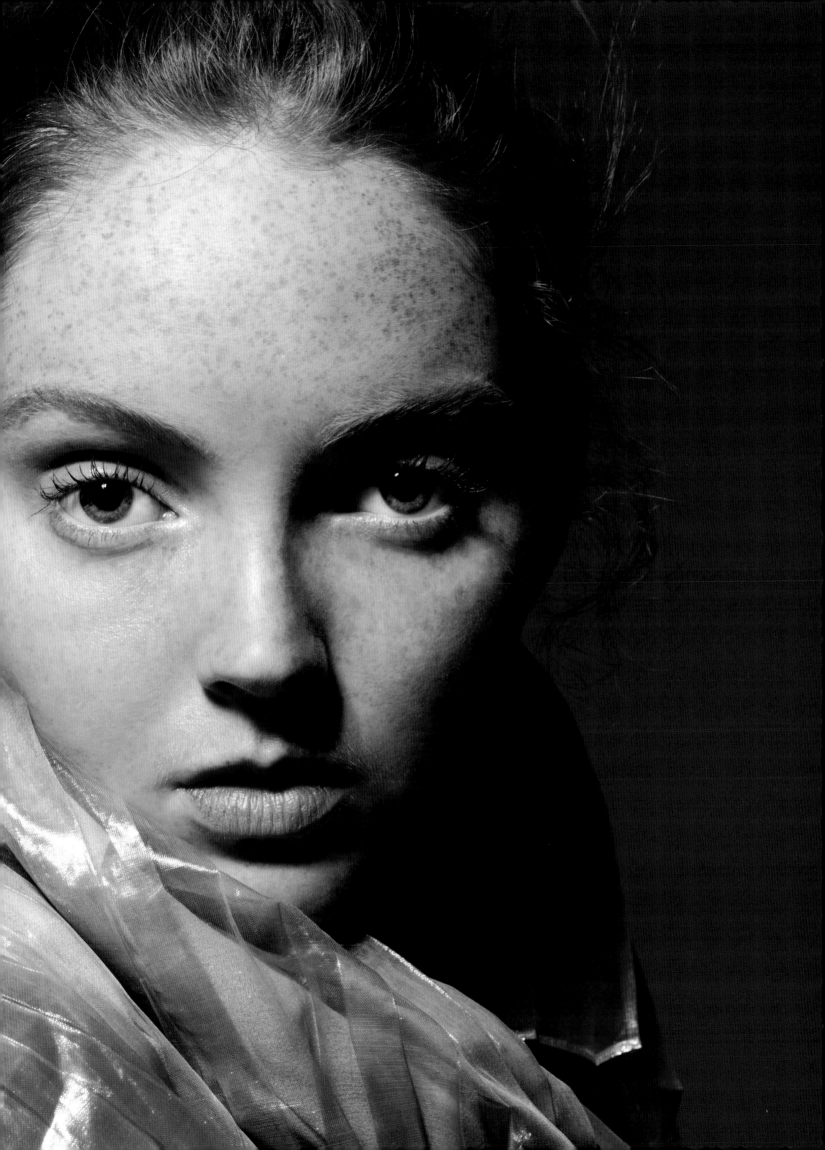

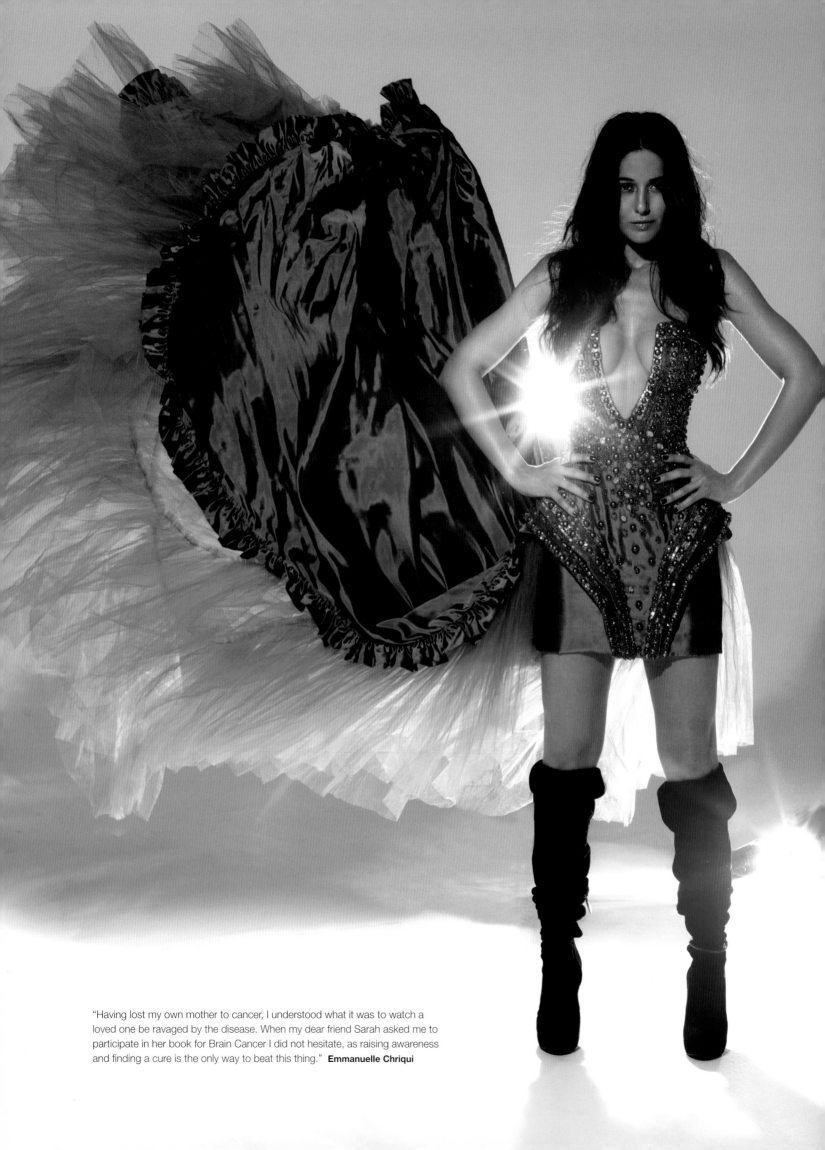

"Having lost my own mother to cancer, I understood what it was to watch a loved one be ravaged by the disease. When my dear friend Sarah asked me to participate in her book for Brain Cancer I did not hesitate, as raising awareness and finding a cure is the only way to beat this thing." **Emmanuelle Chriqui**

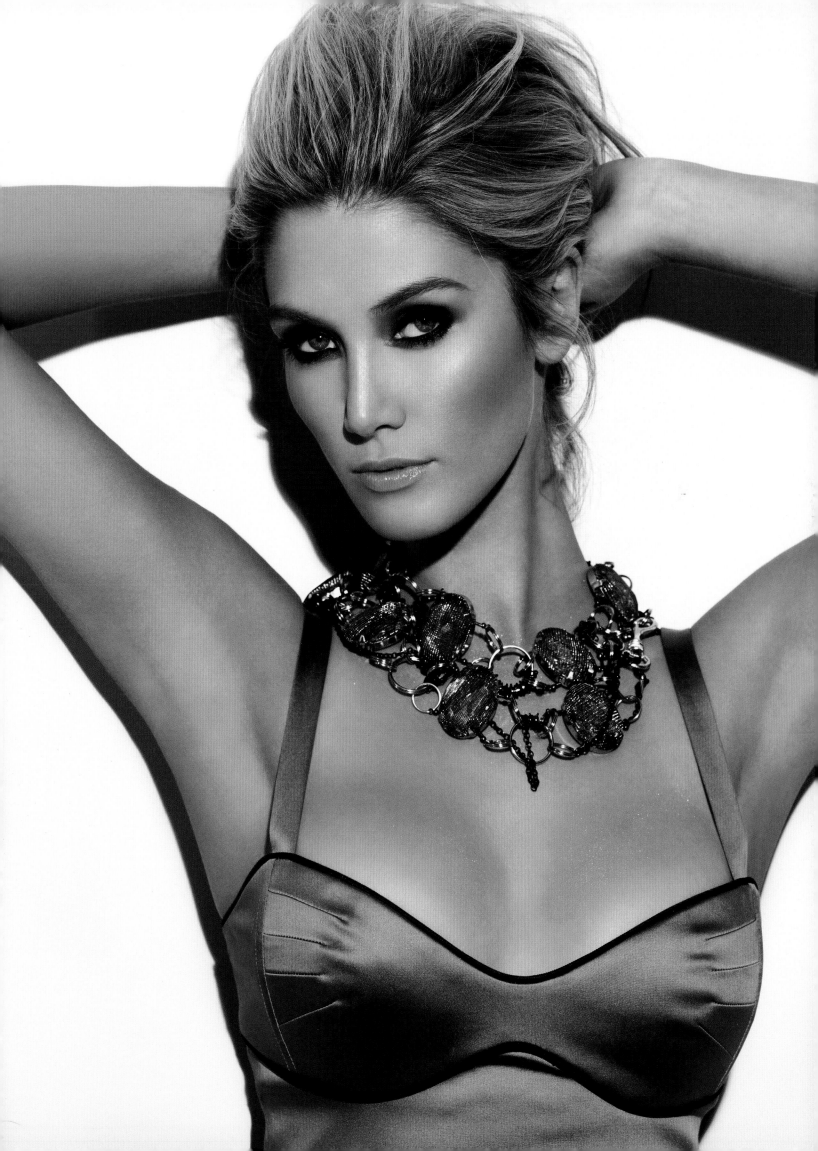

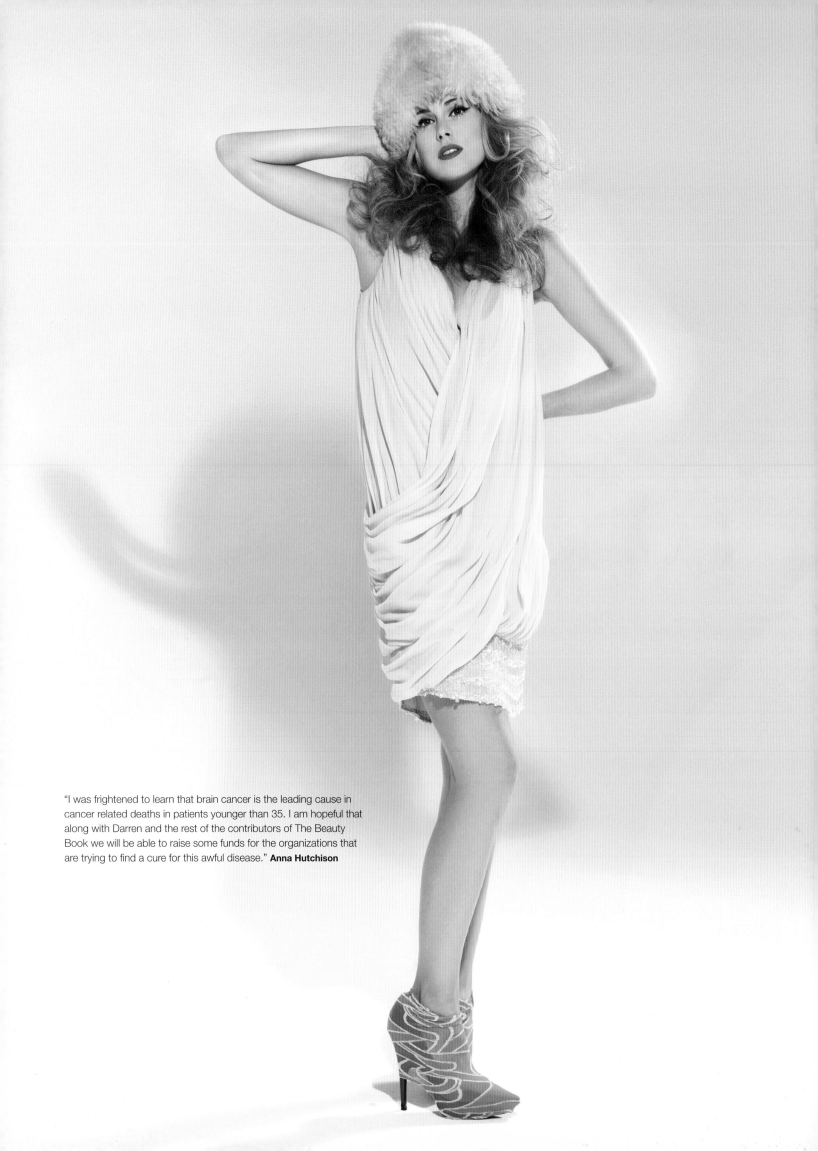

"I was frightened to learn that brain cancer is the leading cause in cancer related deaths in patients younger than 35. I am hopeful that along with Darren and the rest of the contributors of The Beauty Book we will be able to raise some funds for the organizations that are trying to find a cure for this awful disease." **Anna Hutchison**

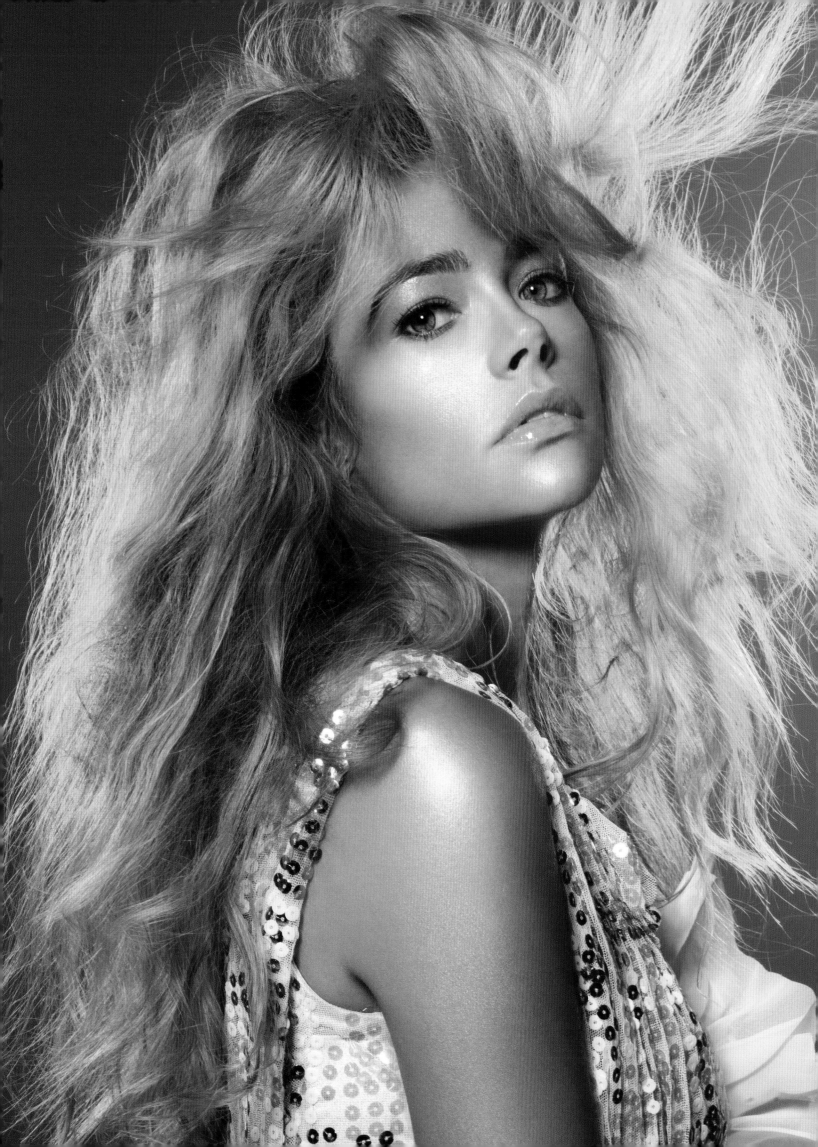

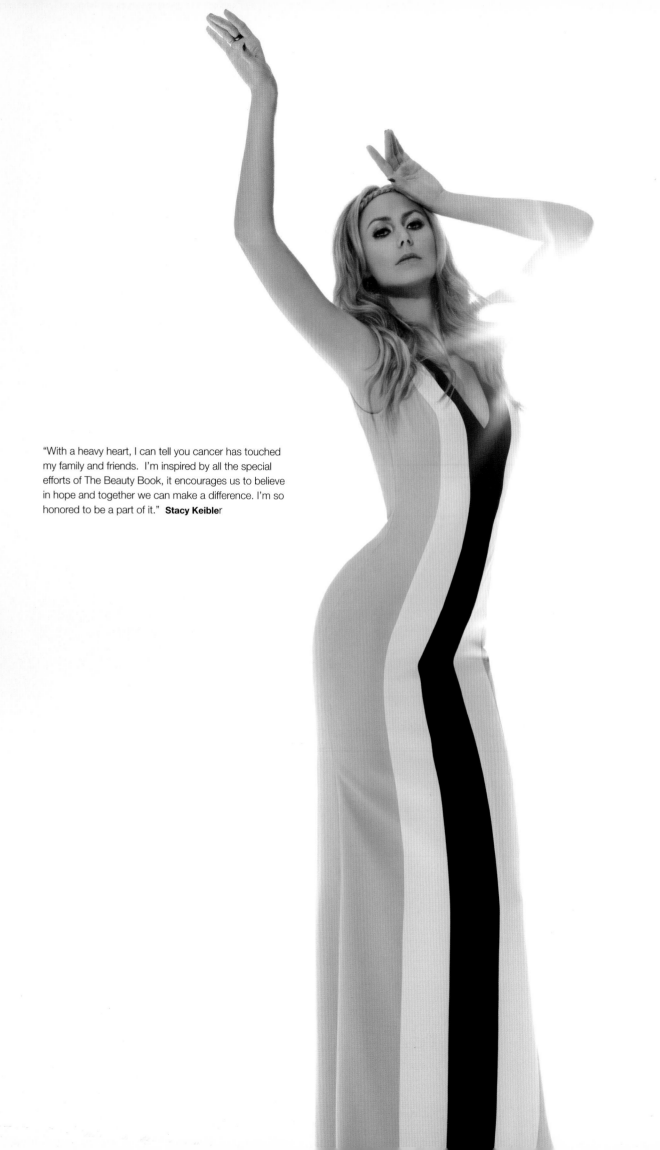

"With a heavy heart, I can tell you cancer has touched my family and friends. I'm inspired by all the special efforts of The Beauty Book, it encourages us to believe in hope and together we can make a difference. I'm so honored to be a part of it." **Stacy Keible**r

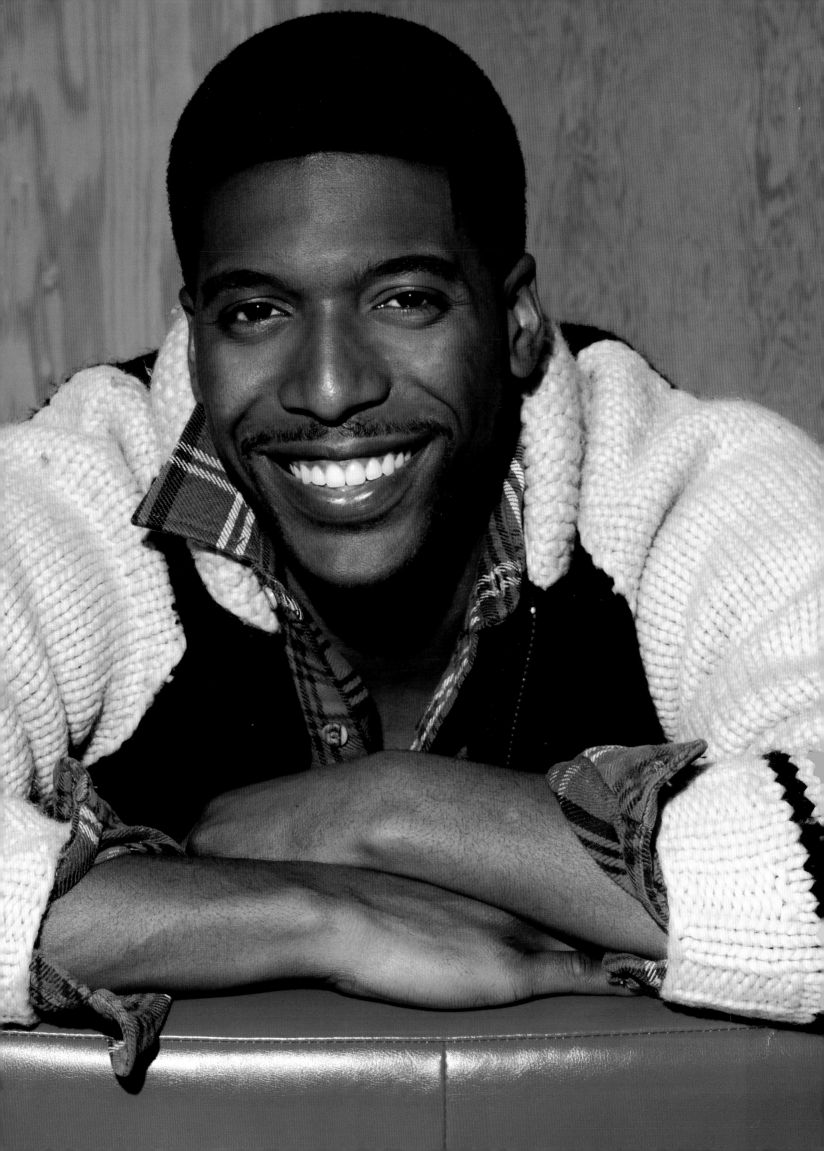

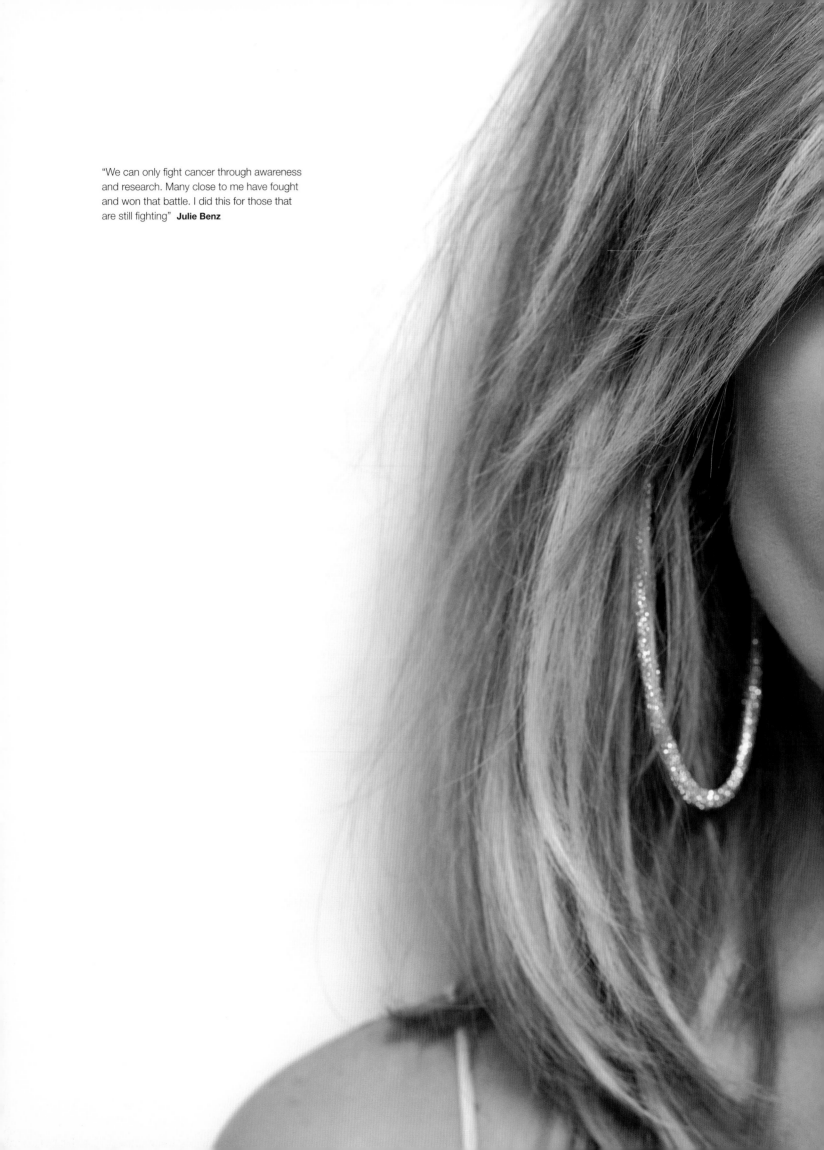

"We can only fight cancer through awareness and research. Many close to me have fought and won that battle. I did this for those that are still fighting" **Julie Benz**

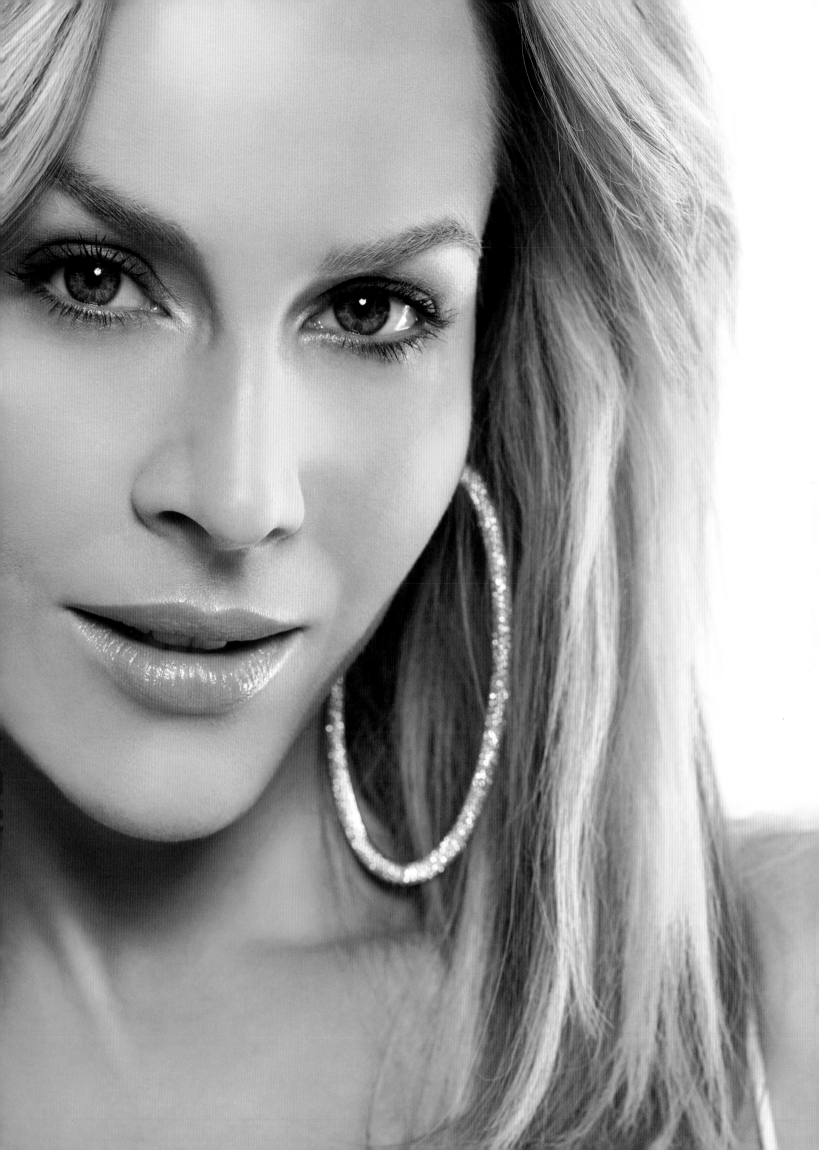

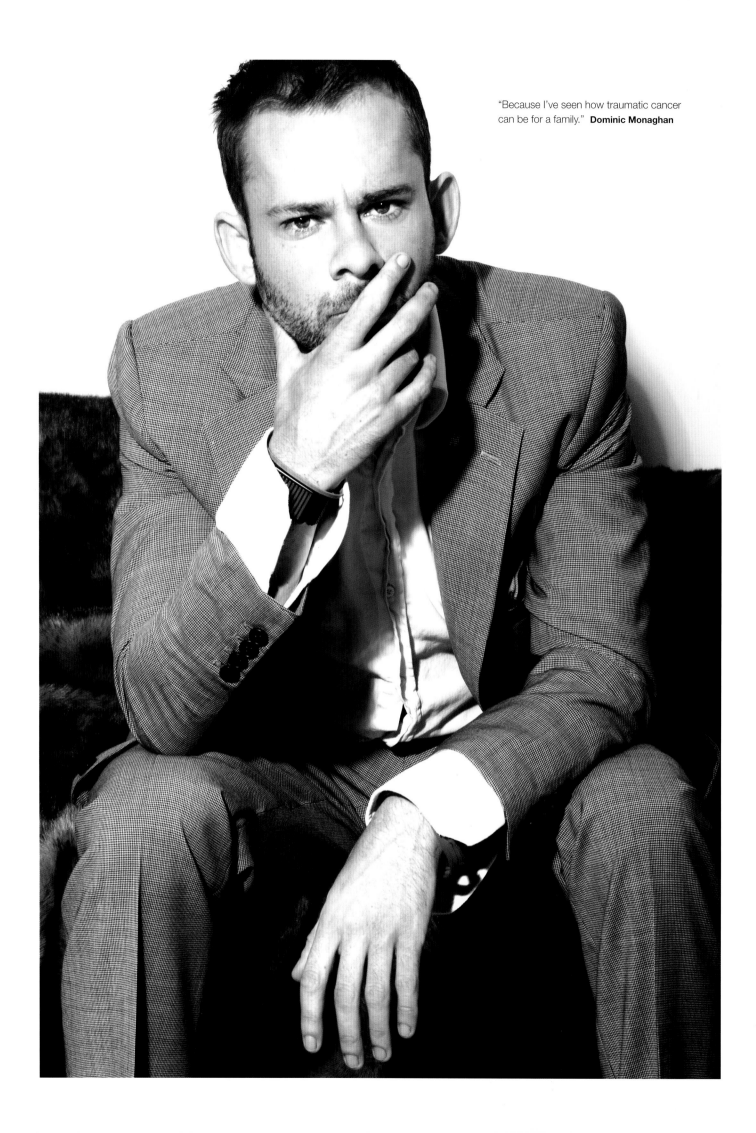

"Because I've seen how traumatic cancer can be for a family." **Dominic Monaghan**

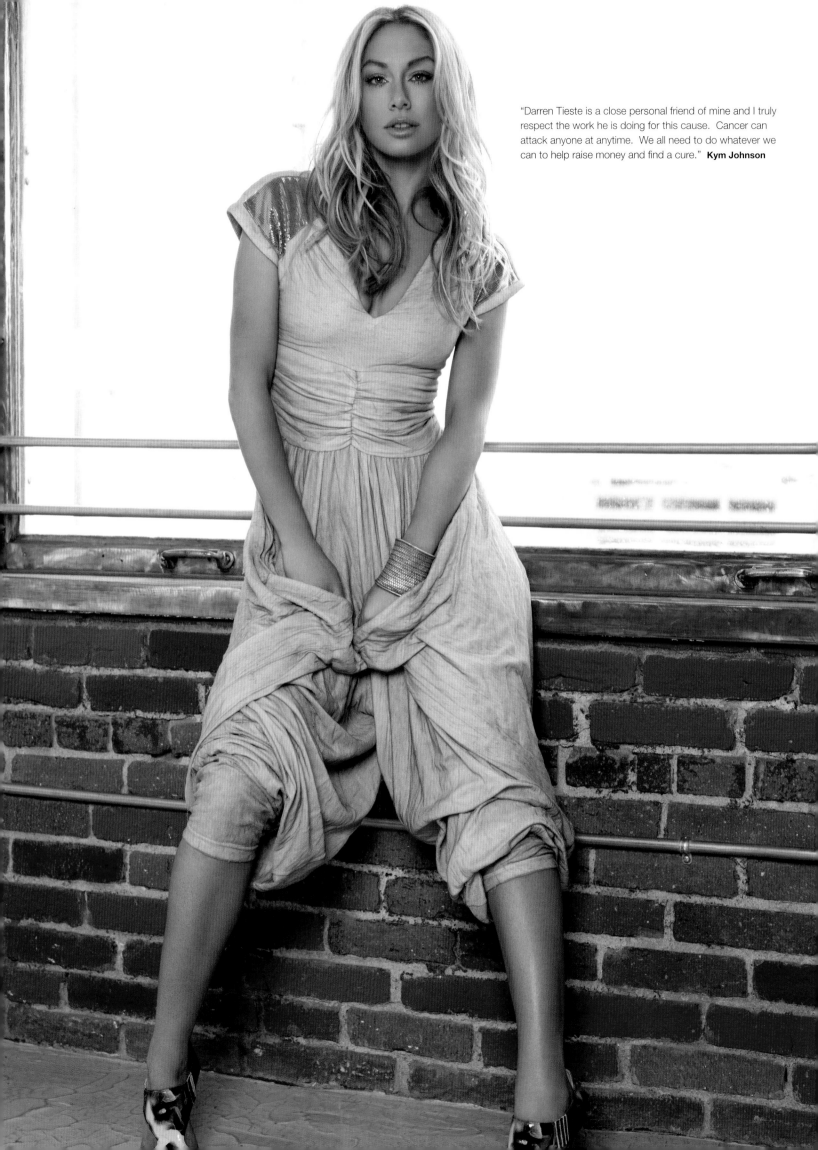

"Darren Tieste is a close personal friend of mine and I truly respect the work he is doing for this cause. Cancer can attack anyone at anytime. We all need to do whatever we can to help raise money and find a cure." **Kym Johnson**

"Darren Tieste is uniquely talented and also very caring, this book gives us all an opportunity to use our contact to the world to help others in need, my cousin died of this at the age of 8 which was so devastating, this book is unbelievable visually and it comes from a place of love not money." **Sophie Monk**

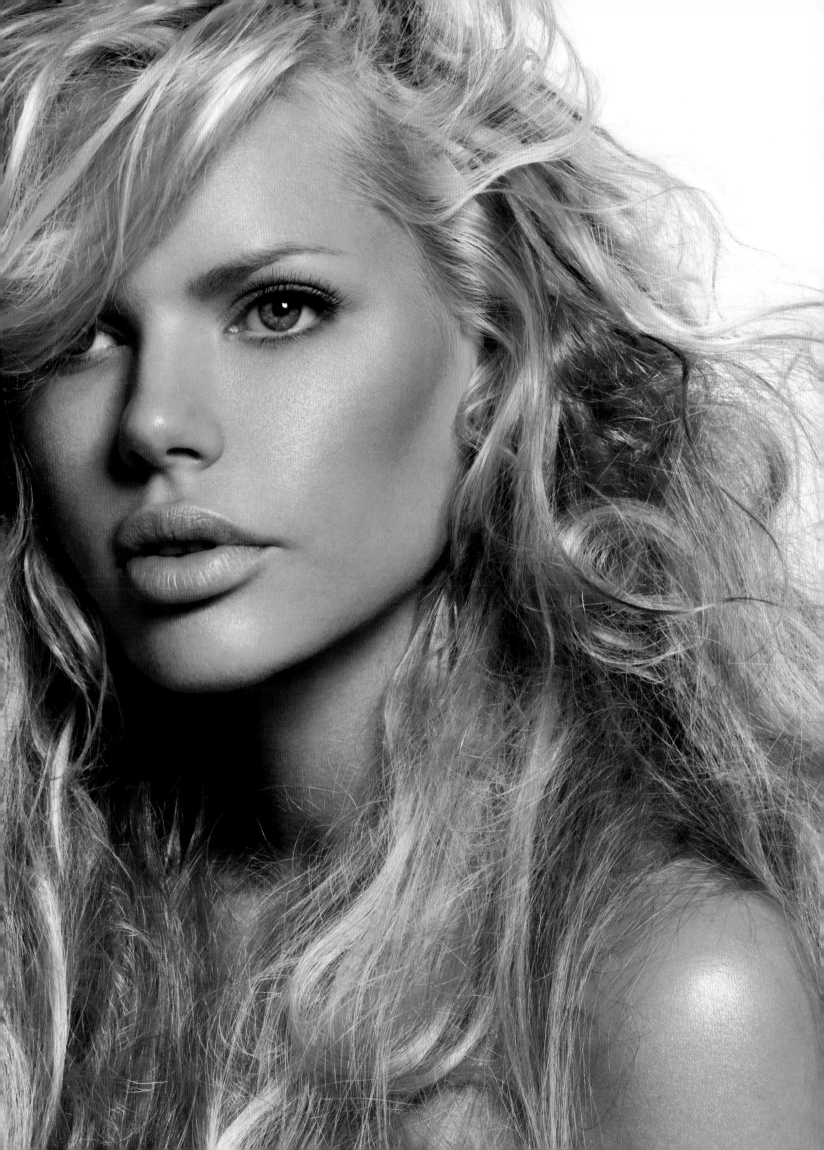

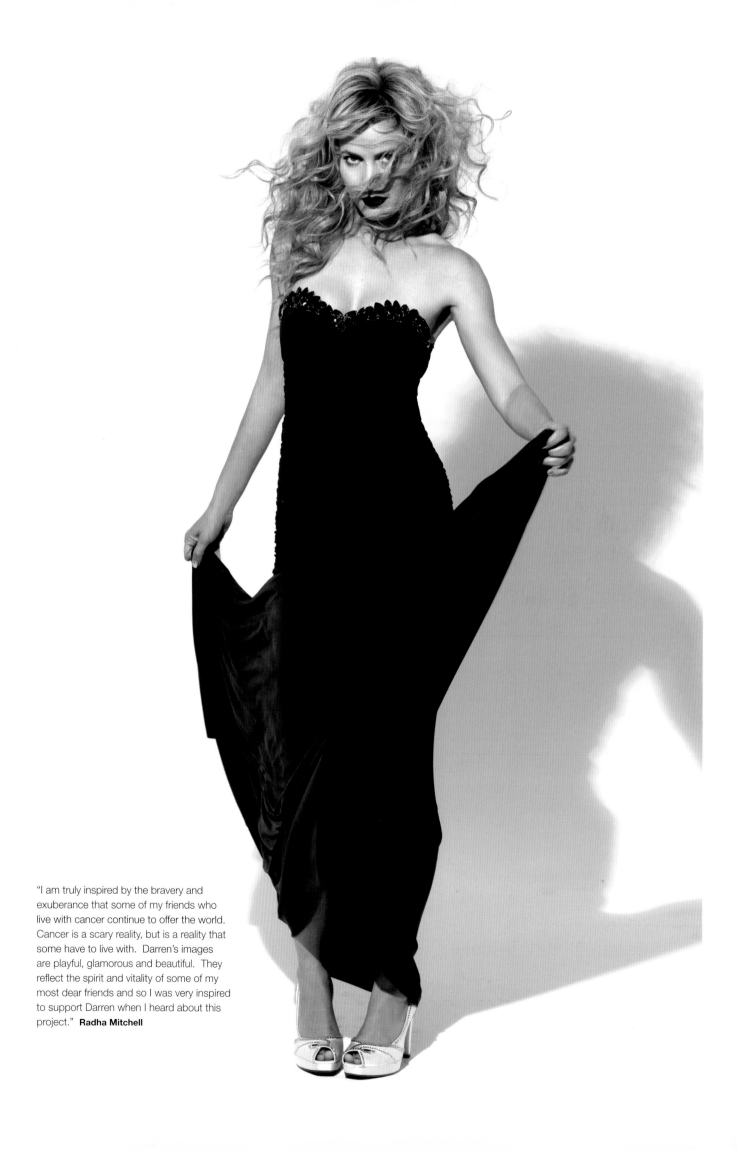

"I am truly inspired by the bravery and exuberance that some of my friends who live with cancer continue to offer the world. Cancer is a scary reality, but is a reality that some have to live with. Darren's images are playful, glamorous and beautiful. They reflect the spirit and vitality of some of my most dear friends and so I was very inspired to support Darren when I heard about this project." **Radha Mitchell**

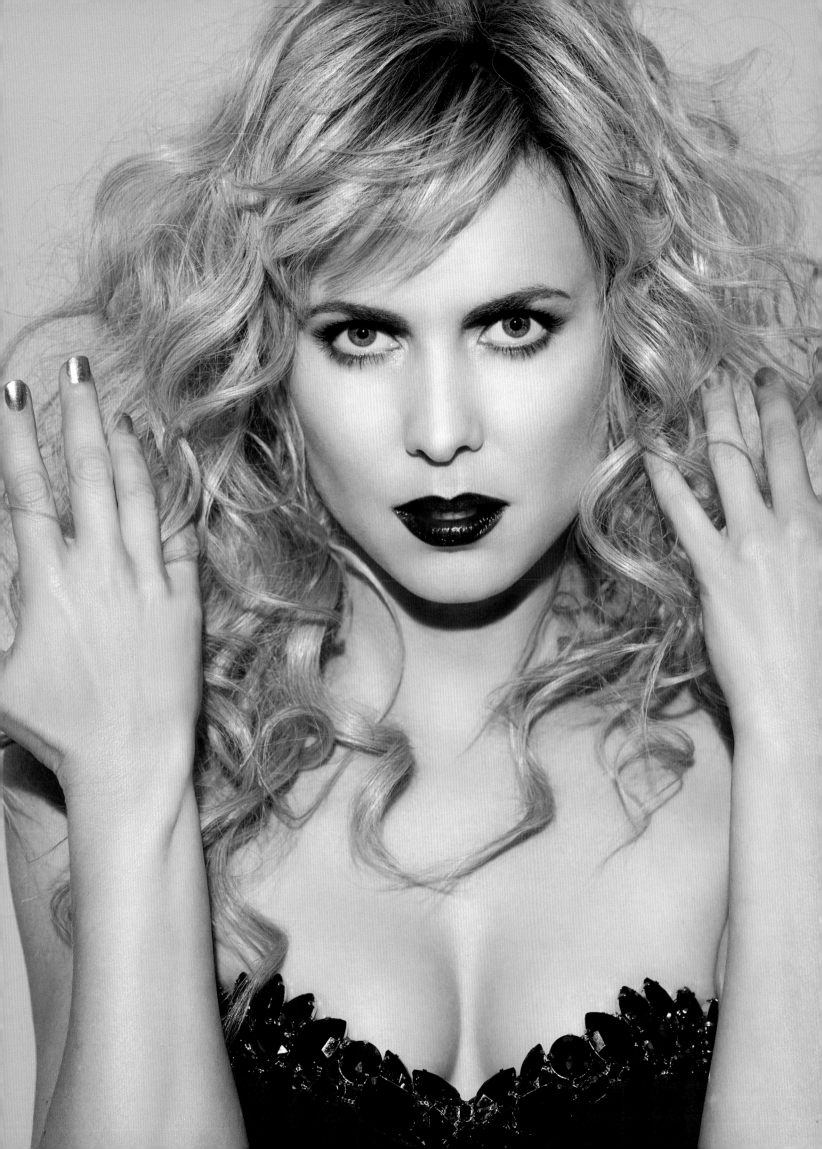

"I participated in supporting this book and in essence "this movement" because I know cancer is a treatable disease, there's no reason why we all shouldn't be joining the fight to save the lives of our loved one's. I've lost beloved family members to this disease, I also watched other loved ones beat this disease, I think some things happen because its time, others I believe happen by chance and I think we forget God made us miracle workers in the earth. Let's do our part and invest our money, efforts and love in helping to create more opportunities to see the miracle of life being preserved." **Meagan Good**

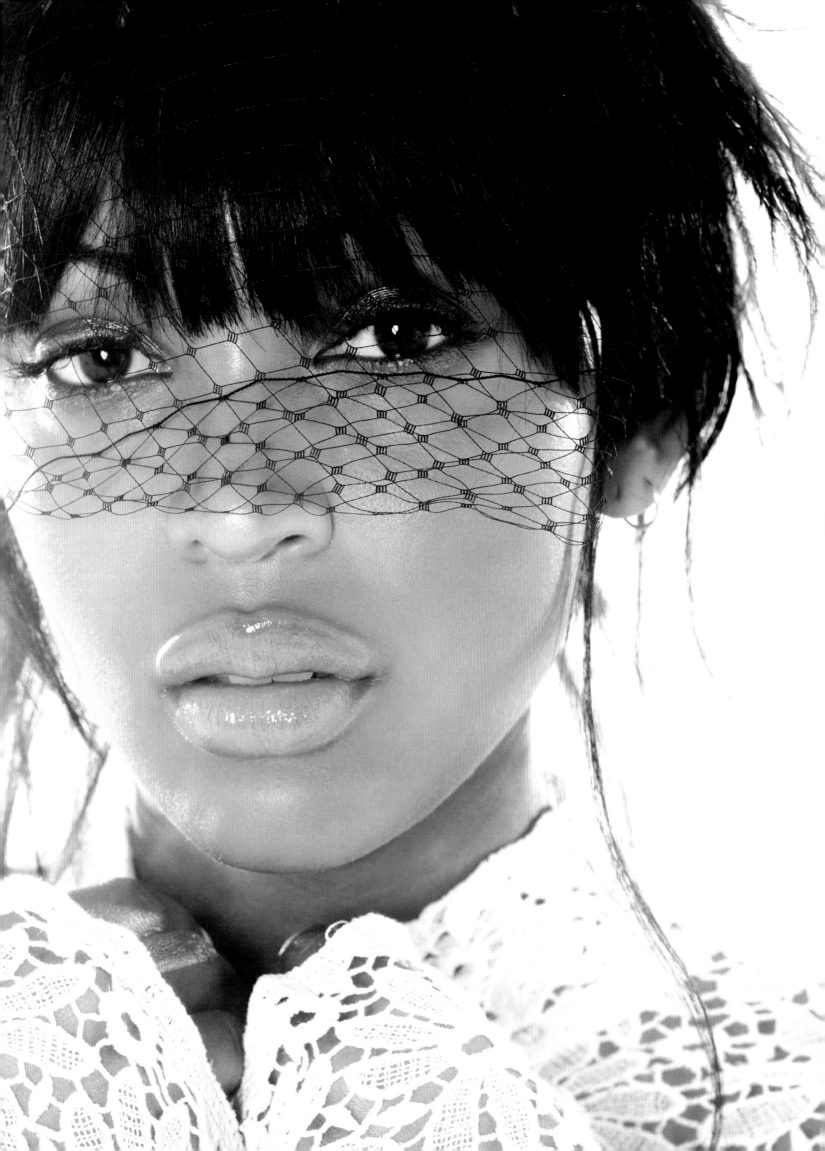

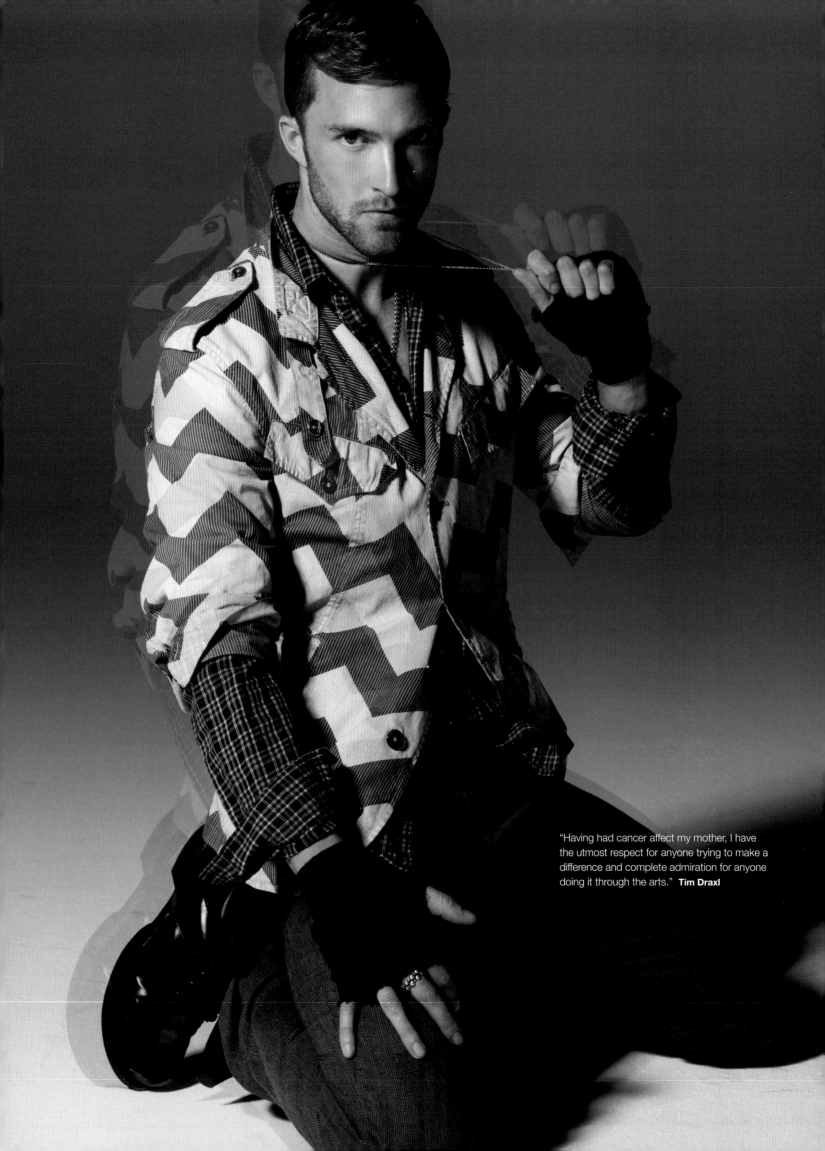

"Having had cancer affect my mother, I have the utmost respect for anyone trying to make a difference and complete admiration for anyone doing it through the arts." **Tim Draxl**

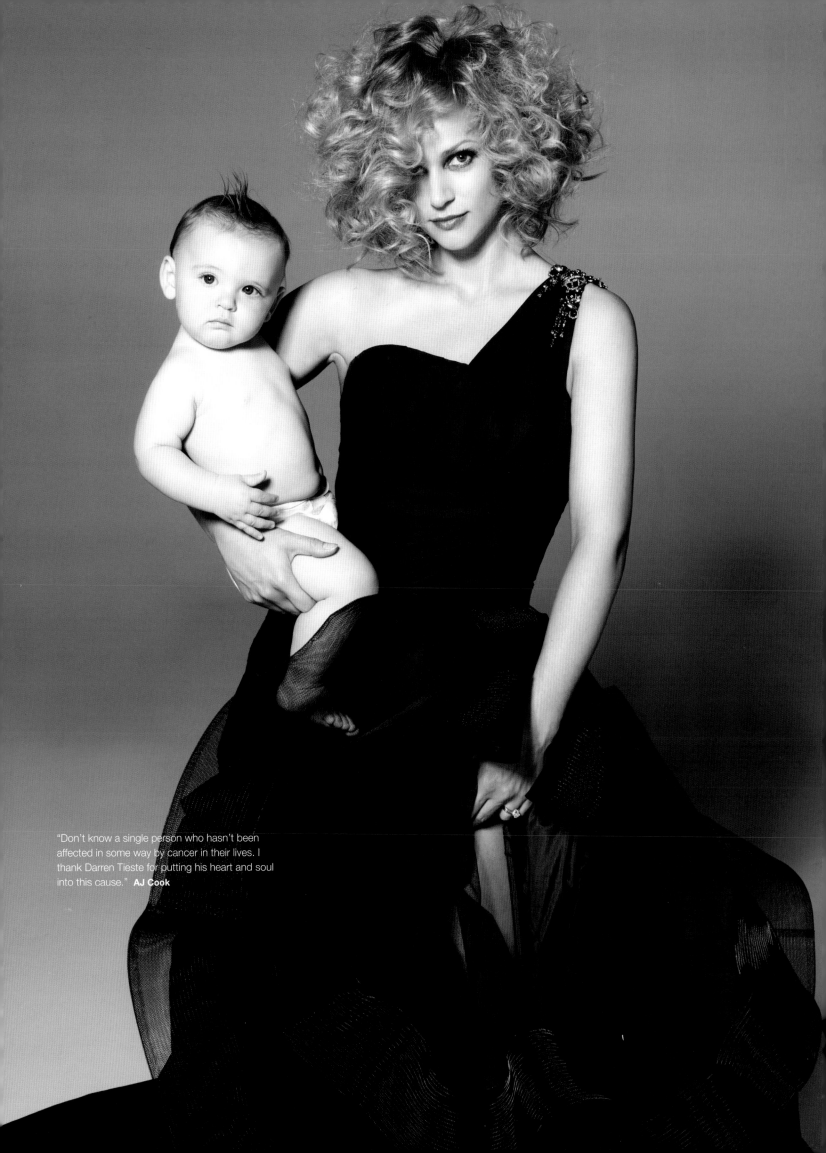

"Don't know a single person who hasn't been affected in some way by cancer in their lives. I thank Darren Tieste for putting his heart and soul into this cause." **AJ Cook**

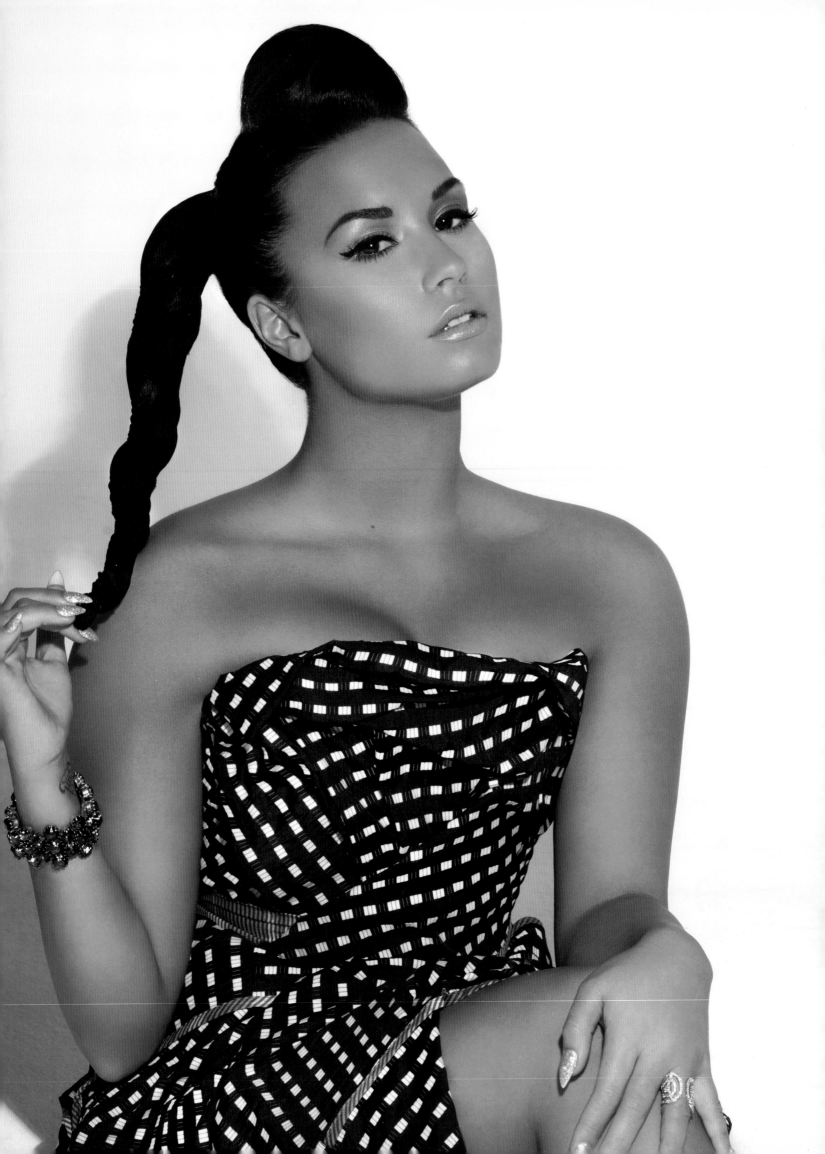

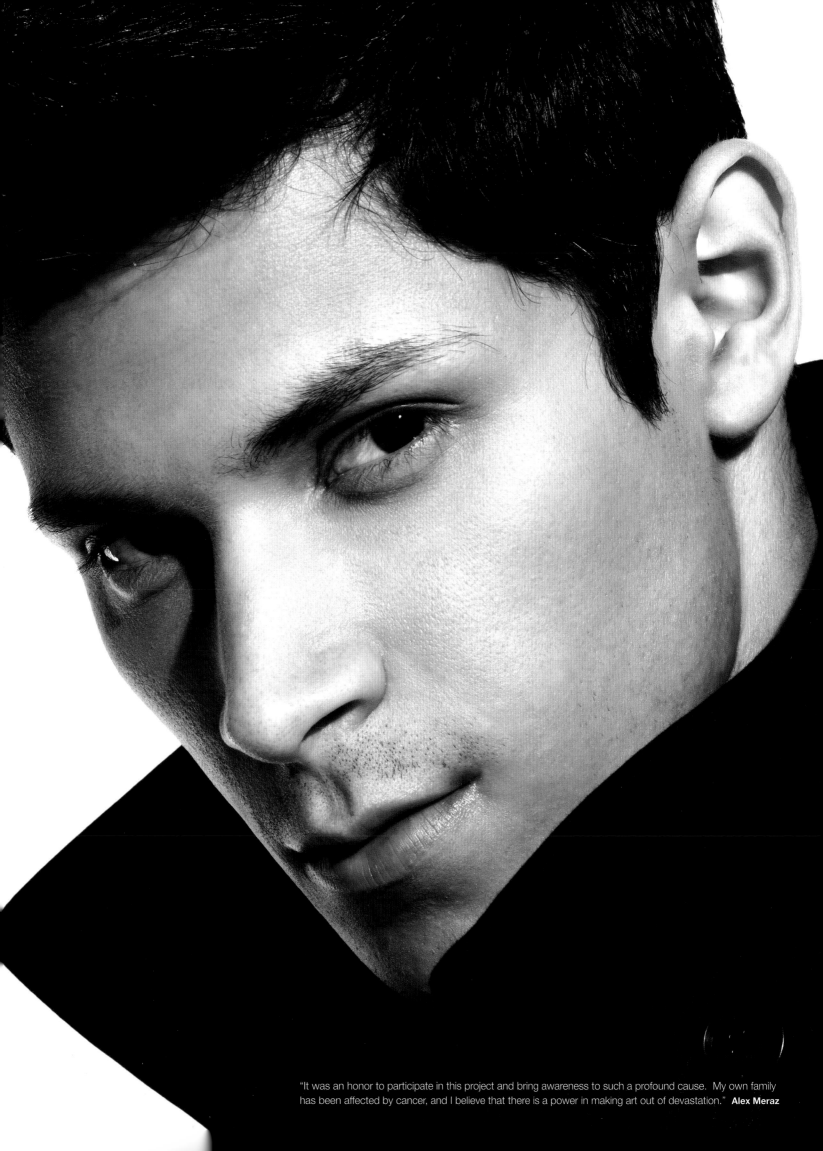

"It was an honor to participate in this project and bring awareness to such a profound cause. My own family has been affected by cancer, and I believe that there is a power in making art out of devastation." **Alex Meraz**

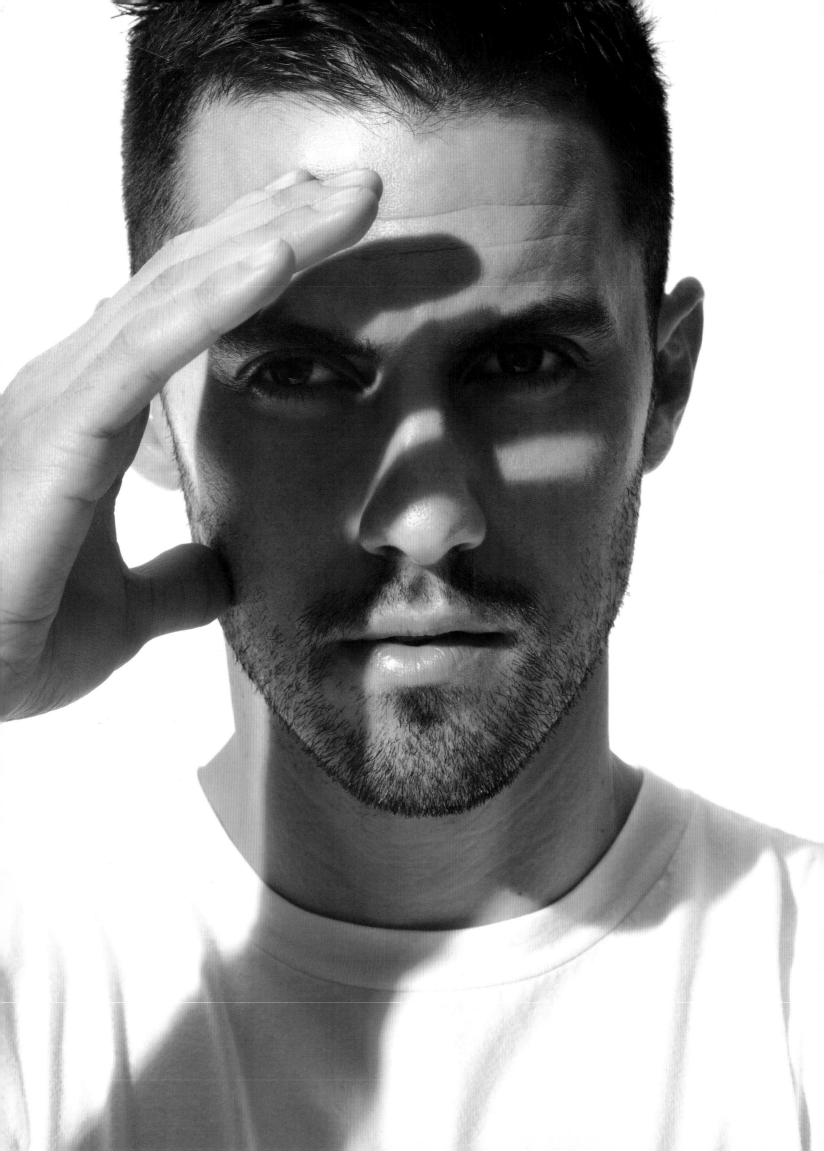

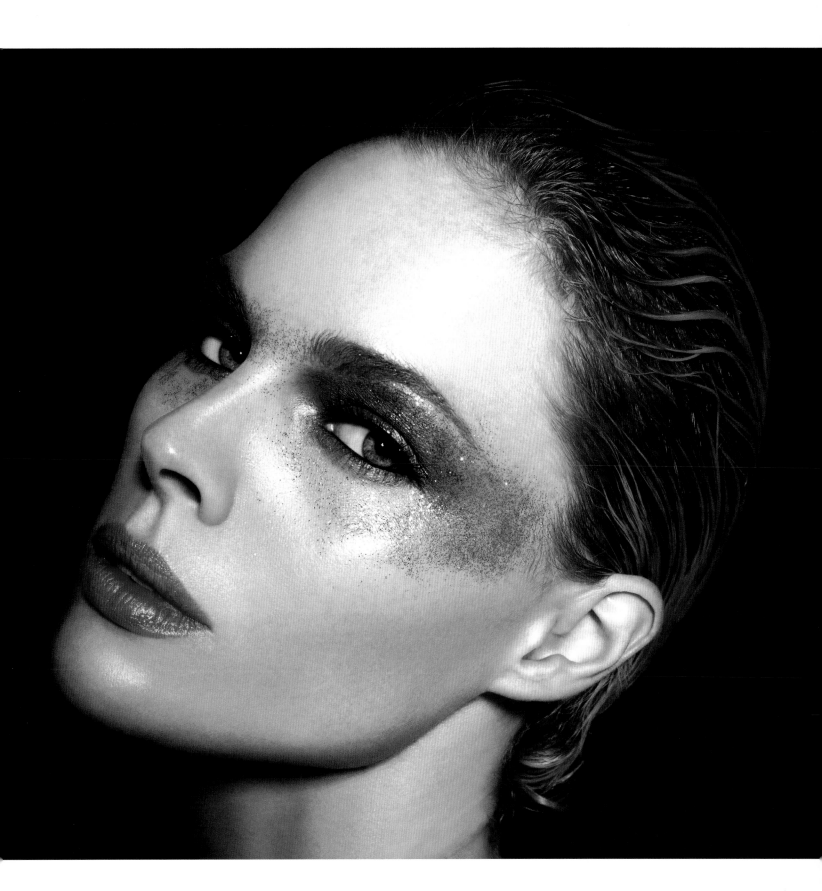

"I see the heart behind this cause & feel so honored to be apart of something that is going to impact many, many lives." **Kate Nauta**

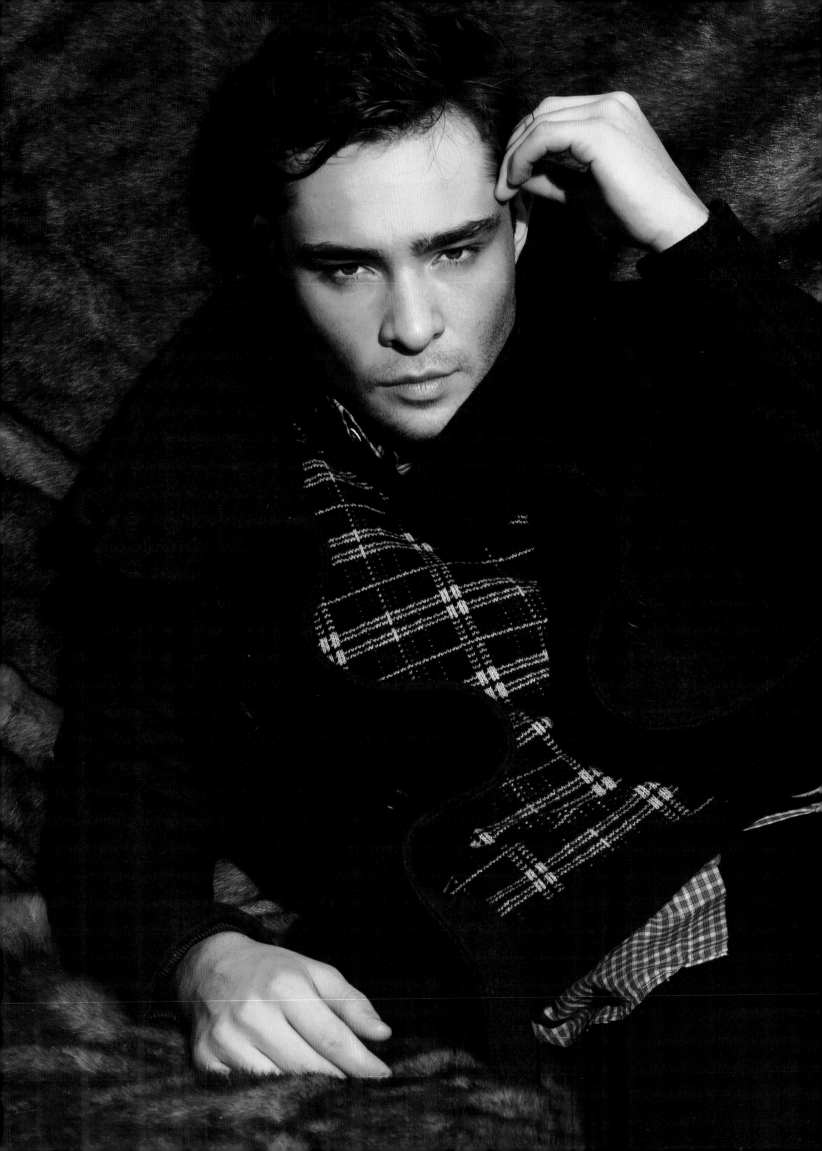

"I wanted to show my support and express the importance of raising awareness and increasing the fight against this condition." **Ed Westwick**

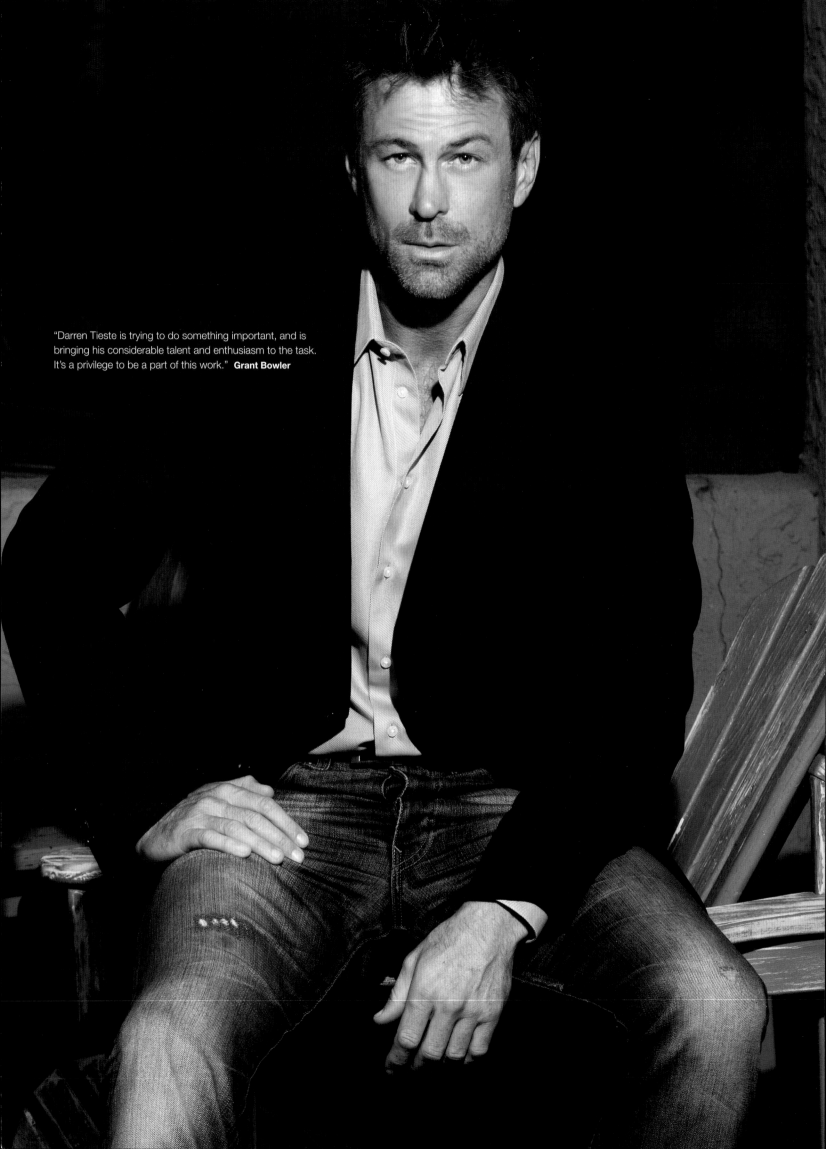

"Darren Tieste is trying to do something important, and is bringing his considerable talent and enthusiasm to the task. It's a privilege to be a part of this work." **Grant Bowler**

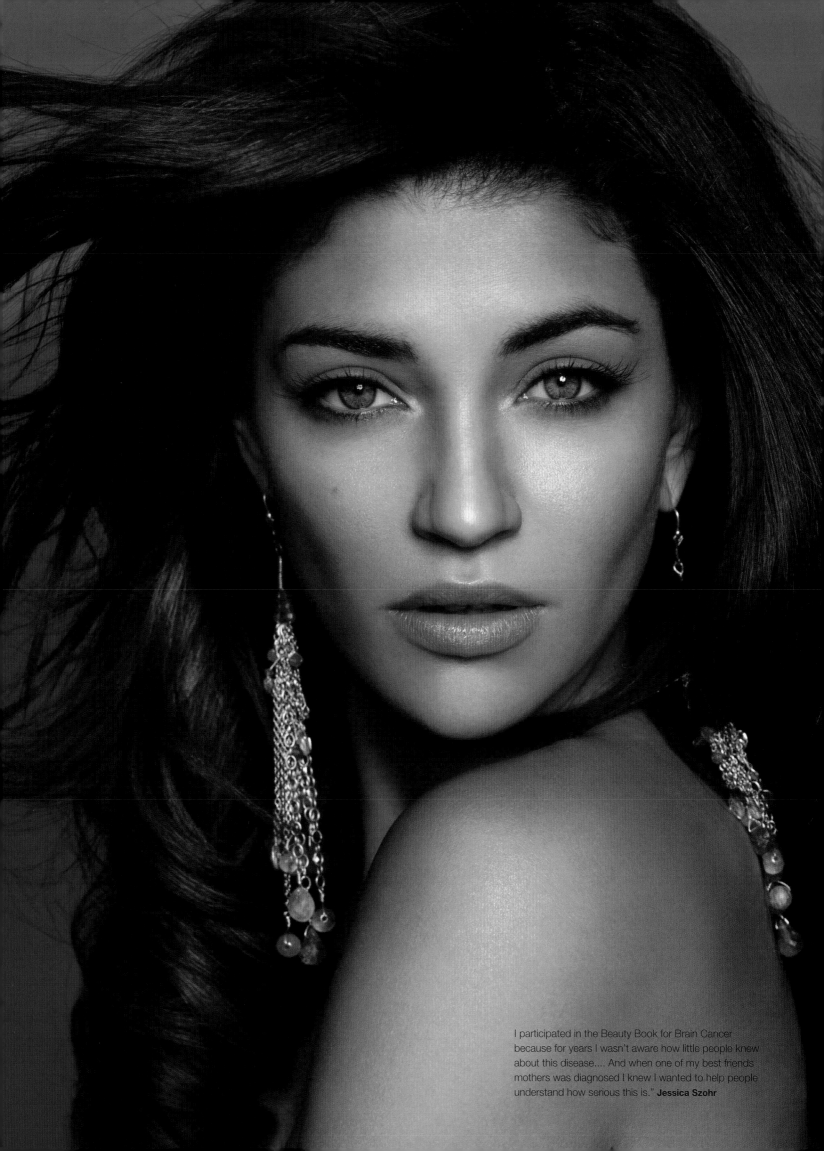

"I participated in the Beauty Book for Brain Cancer because for years I wasn't aware how little people knew about this disease.... And when one of my best friends mothers was diagnosed I knew I wanted to help people understand how serious this is." **Jessica Szohr**

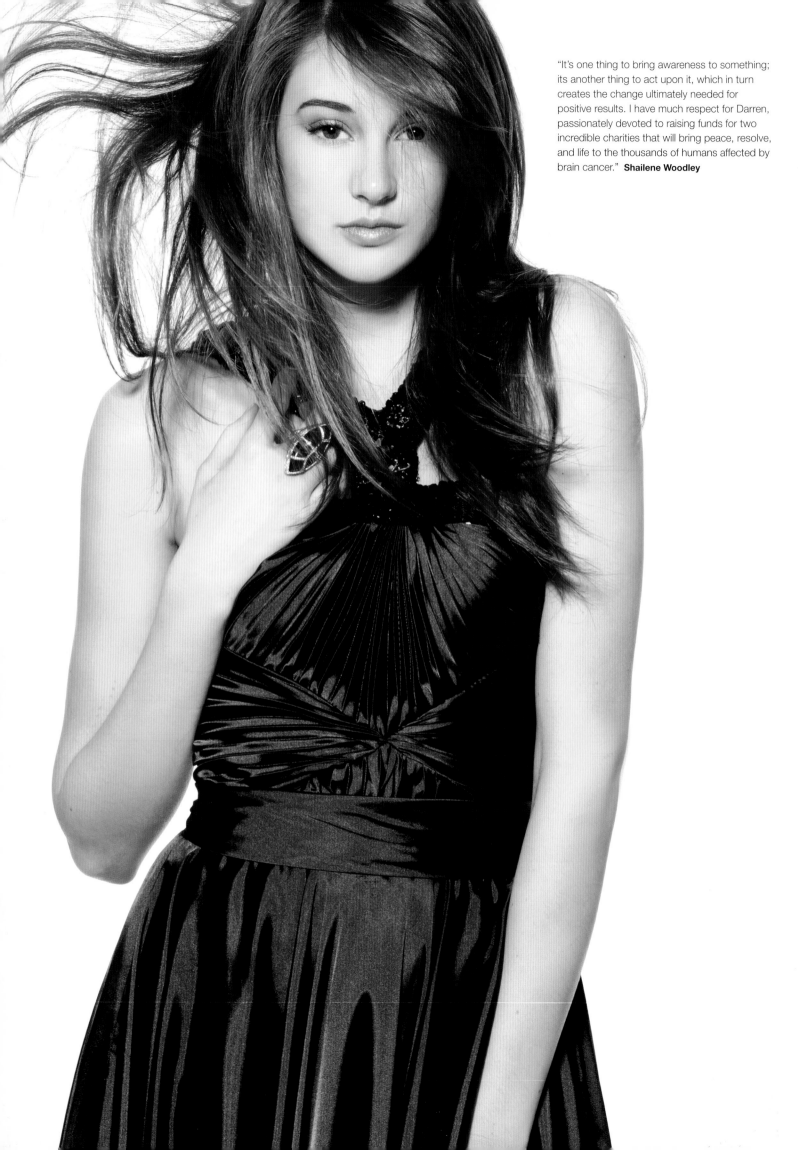

"It's one thing to bring awareness to something; its another thing to act upon it, which in turn creates the change ultimately needed for positive results. I have much respect for Darren, passionately devoted to raising funds for two incredible charities that will bring peace, resolve, and life to the thousands of humans affected by brain cancer." **Shailene Woodley**

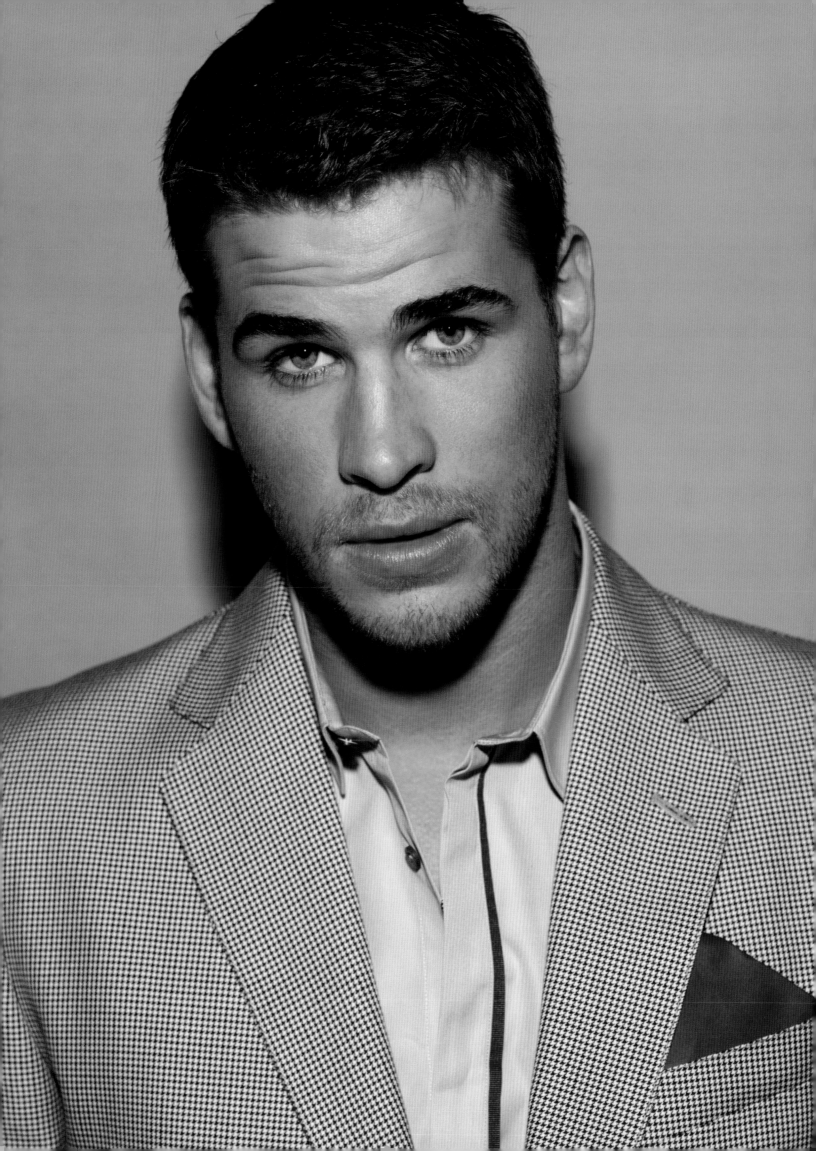

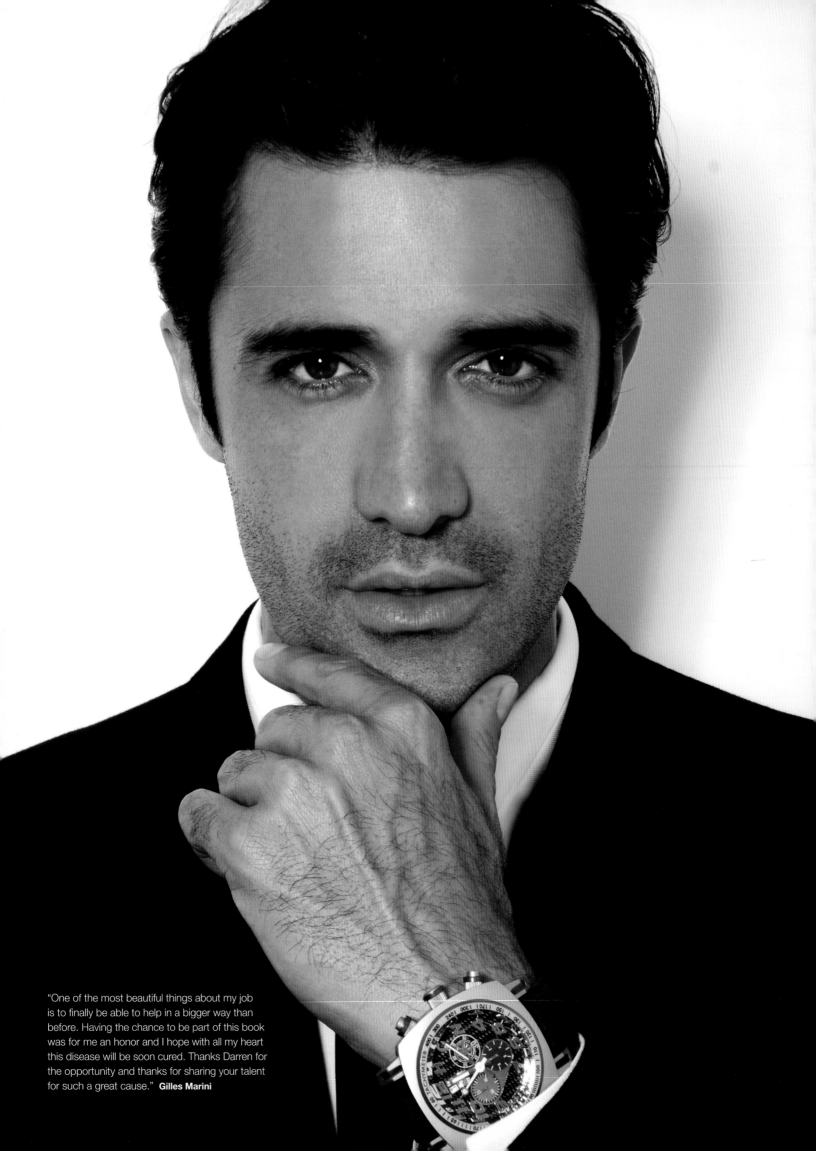

"One of the most beautiful things about my job is to finally be able to help in a bigger way than before. Having the chance to be part of this book was for me an honor and I hope with all my heart this disease will be soon cured. Thanks Darren for the opportunity and thanks for sharing your talent for such a great cause." **Gilles Marini**

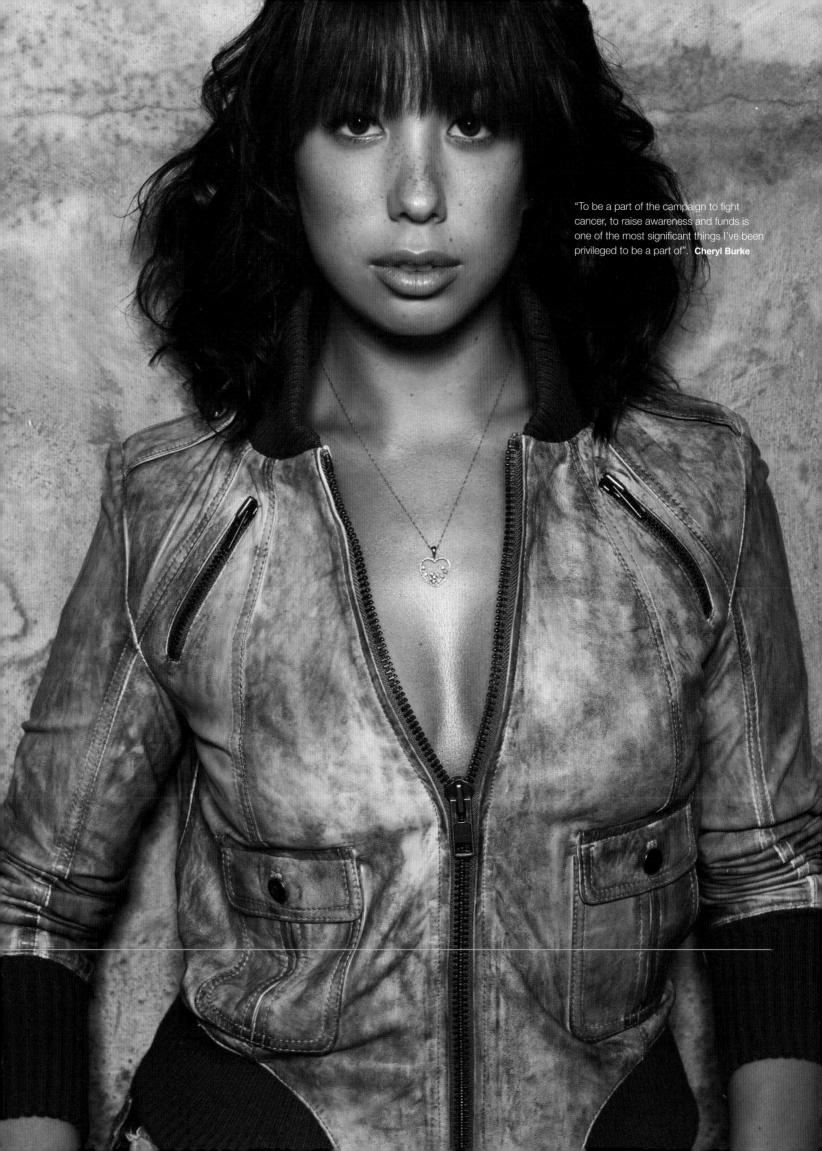

"To be a part of the campaign to fight cancer, to raise awareness and funds is one of the most significant things I've been privileged to be a part of". **Cheryl Burke**

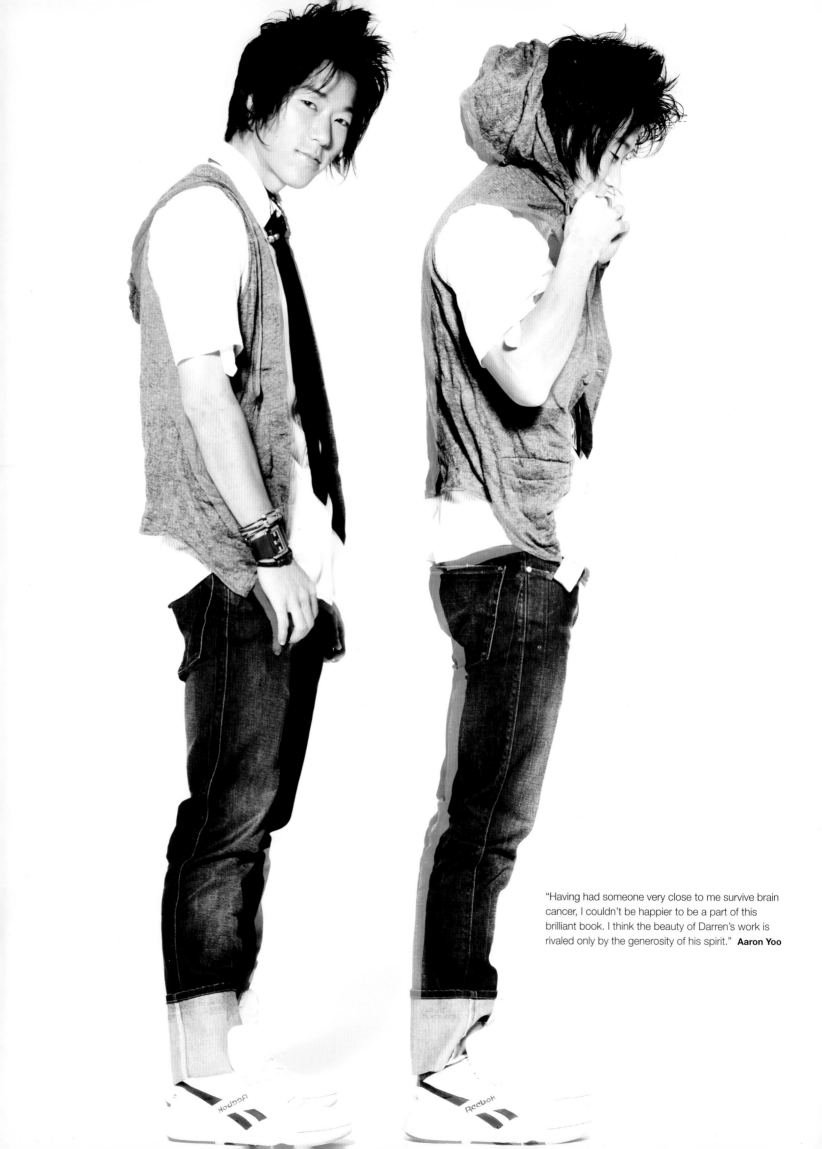

"Having had someone very close to me survive brain cancer, I couldn't be happier to be a part of this brilliant book. I think the beauty of Darren's work is rivaled only by the generosity of his spirit." **Aaron Yoo**

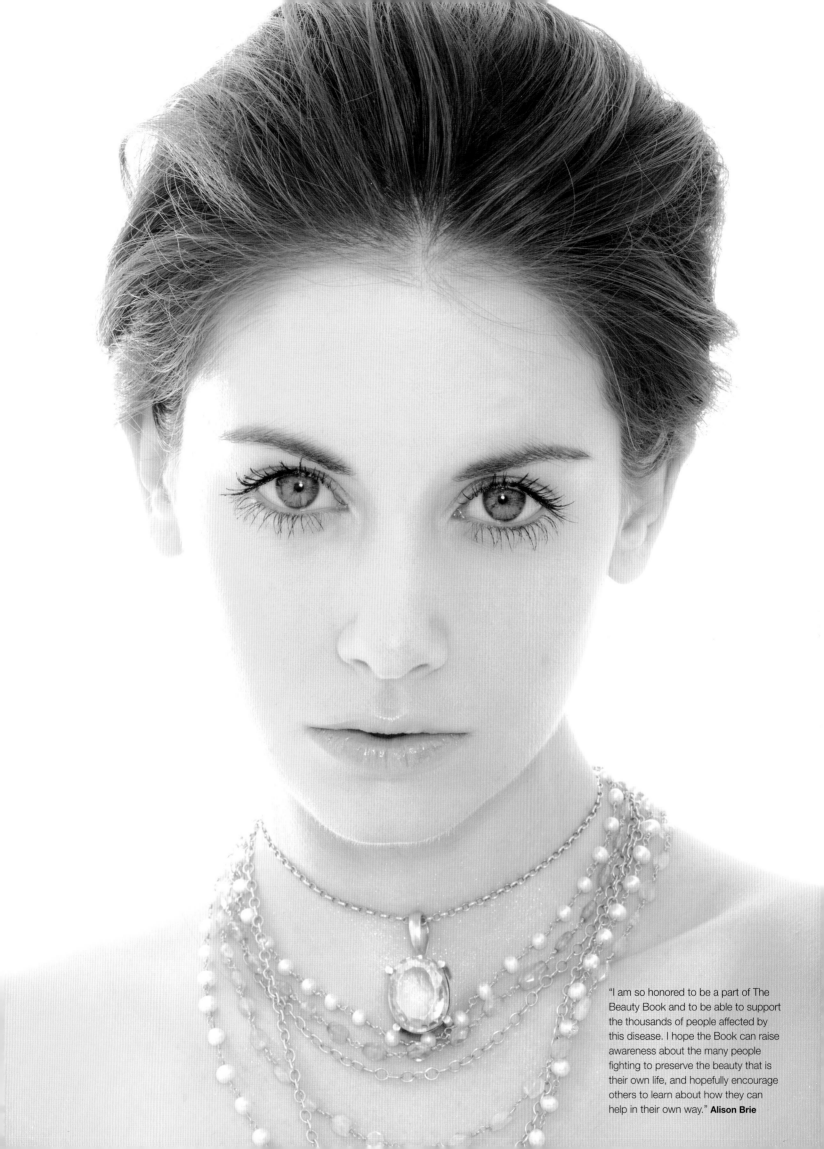

"I am so honored to be a part of The Beauty Book and to be able to support the thousands of people affected by this disease. I hope the Book can raise awareness about the many people fighting to preserve the beauty that is their own life, and hopefully encourage others to learn about how they can help in their own way." **Alison Brie**

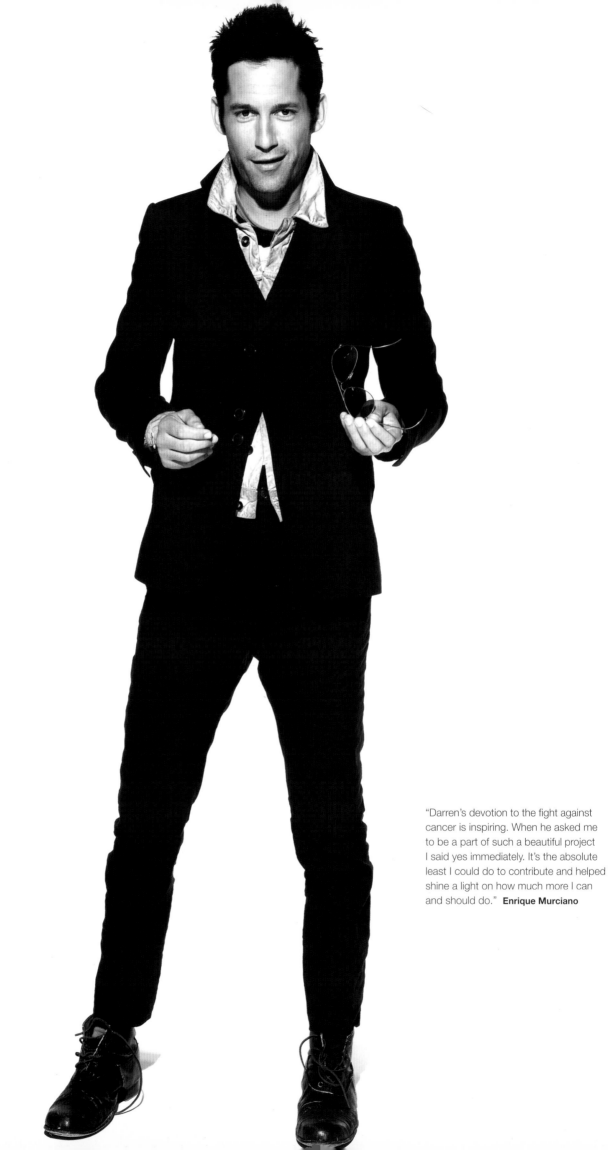

"Darren's devotion to the fight against cancer is inspiring. When he asked me to be a part of such a beautiful project I said yes immediately. It's the absolute least I could do to contribute and helped shine a light on how much more I can and should do." **Enrique Murciano**

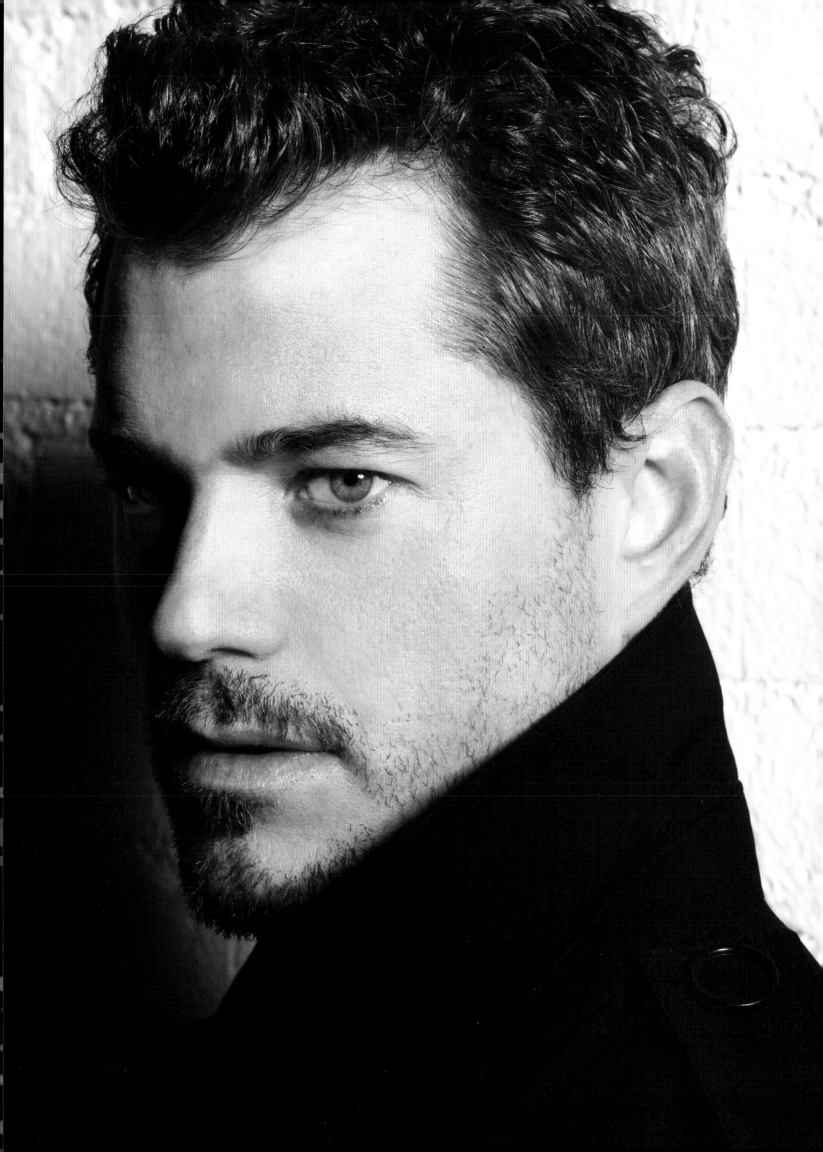

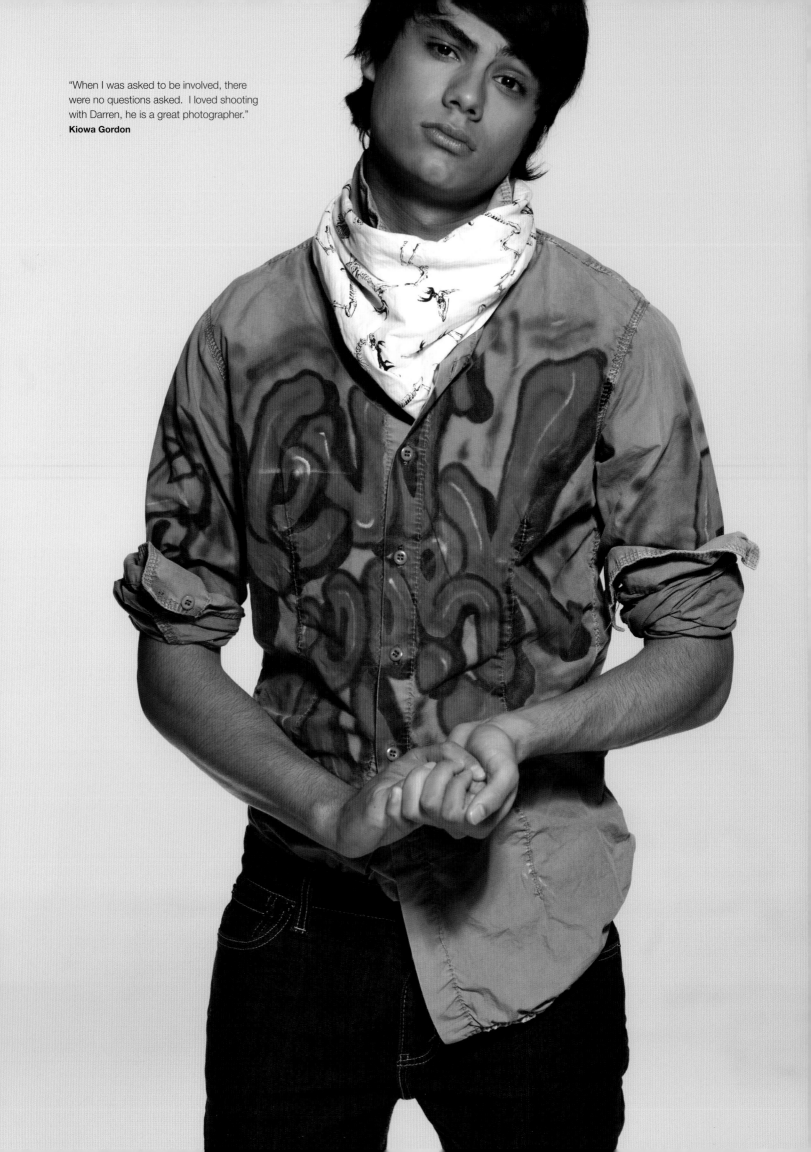

"When I was asked to be involved, there were no questions asked. I loved shooting with Darren, he is a great photographer."
Kiowa Gordon

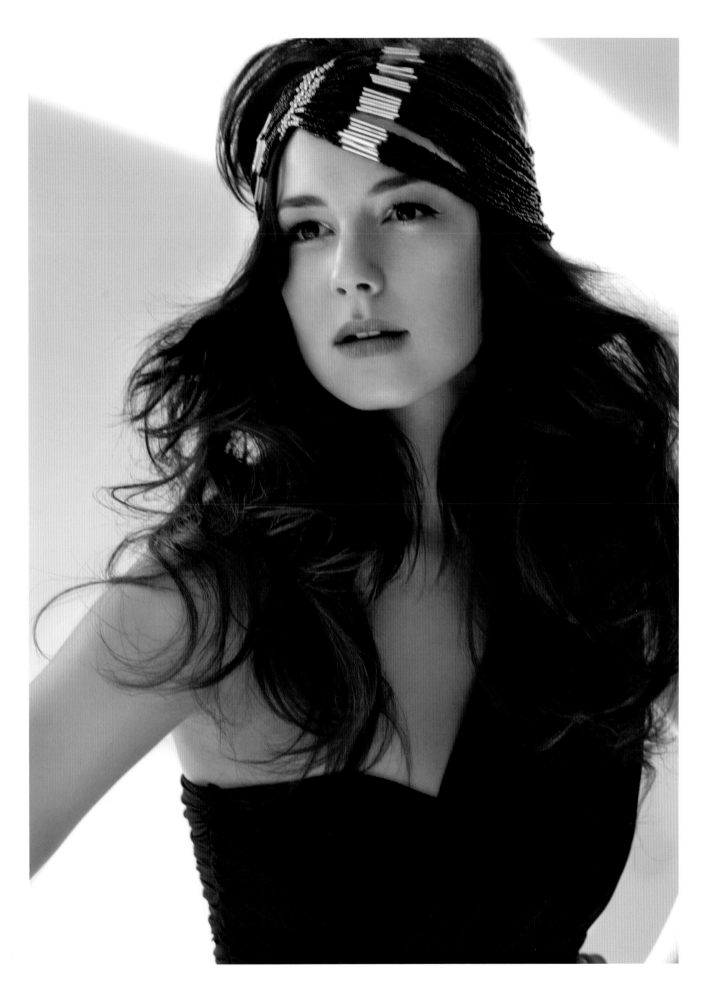

"I am honored to be a part of such a beautiful book that will encourage people to invest in the fight against Cancer. We have all been affected by Cancer either directly or indirectly but together, we can change that course of history by creating awareness." **Emily VanCamp**

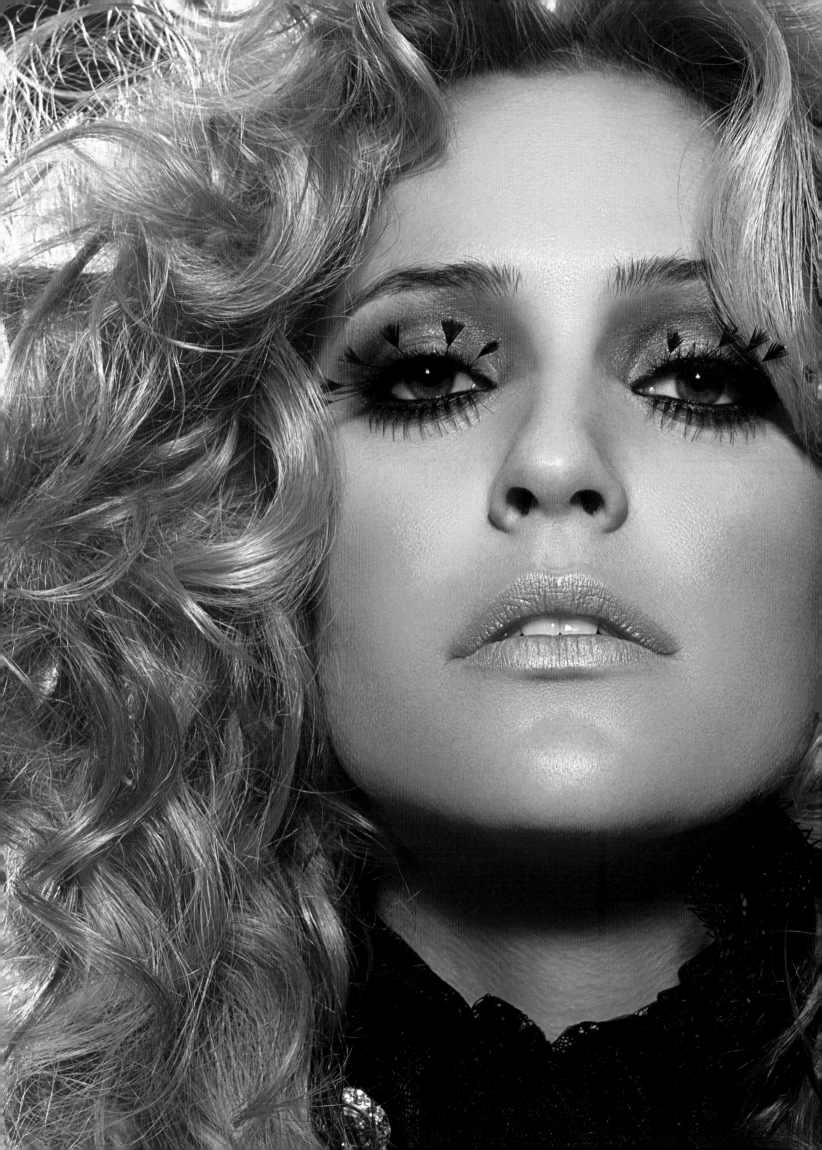

Brain cancer is a killer that effect's people of all ages, genders and backgrounds. Educating your self and helping to spread awareness is the only way to beat a global killer like brain cancer and together, we can do it. **Kristin Cavallari**

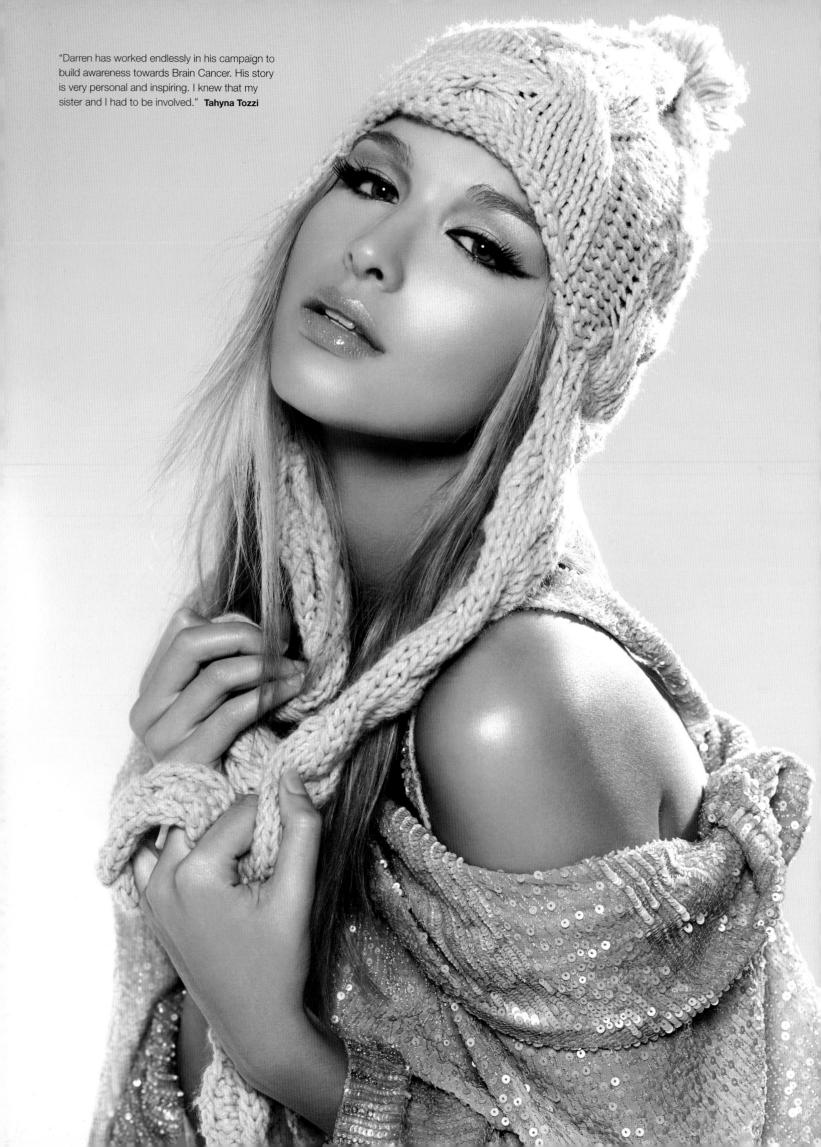

"Darren has worked endlessly in his campaign to build awareness towards Brain Cancer. His story is very personal and inspiring. I knew that my sister and I had to be involved." **Tahyna Tozzi**

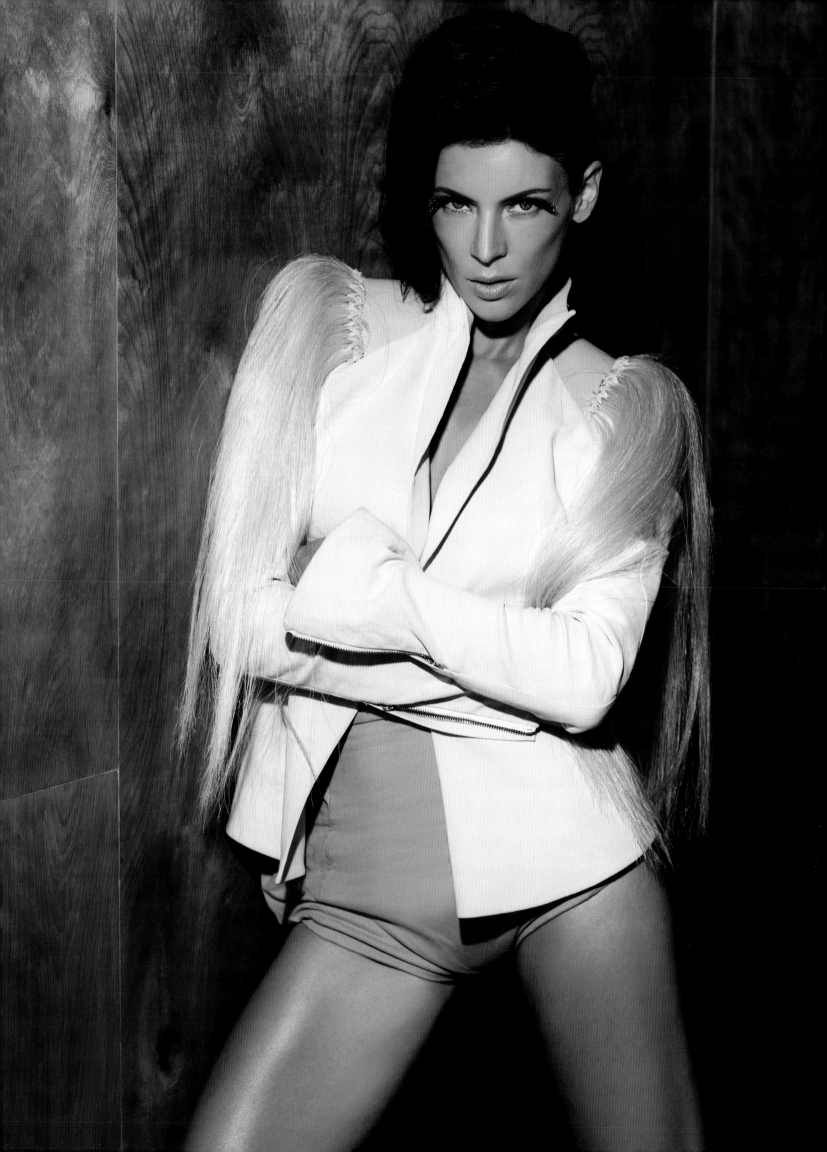

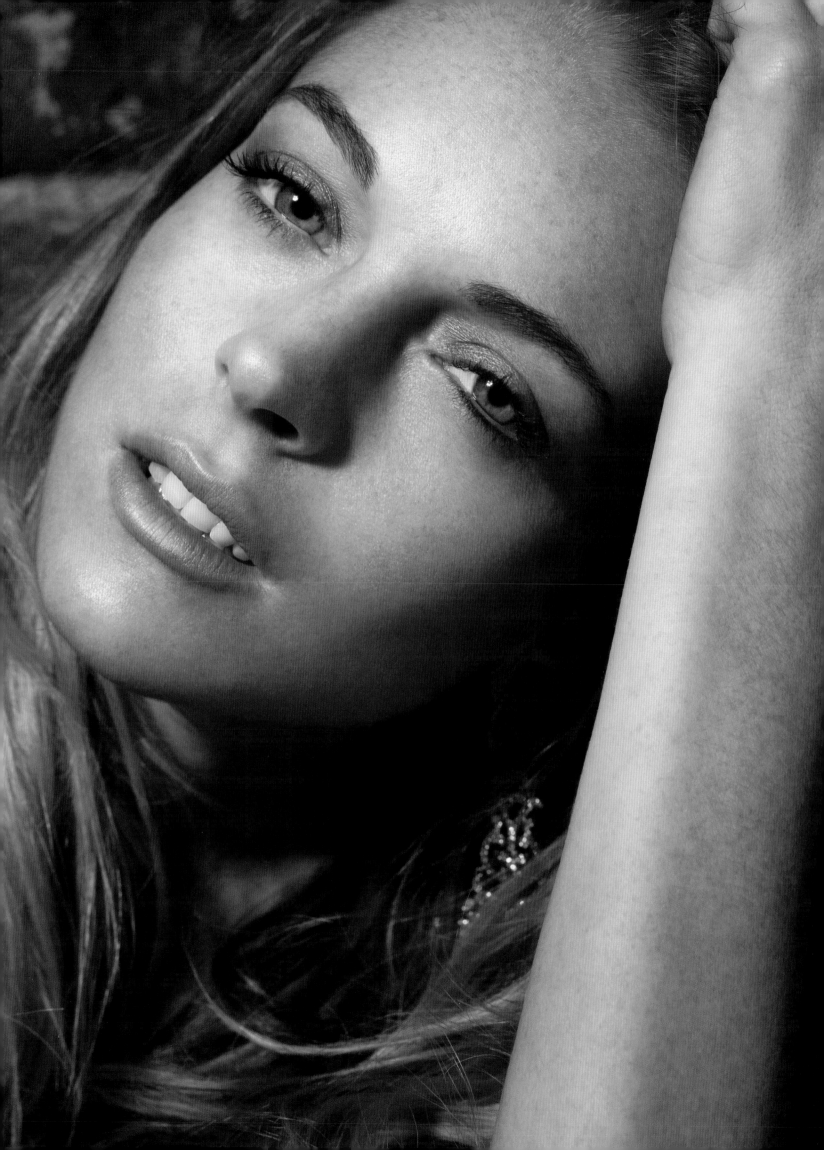

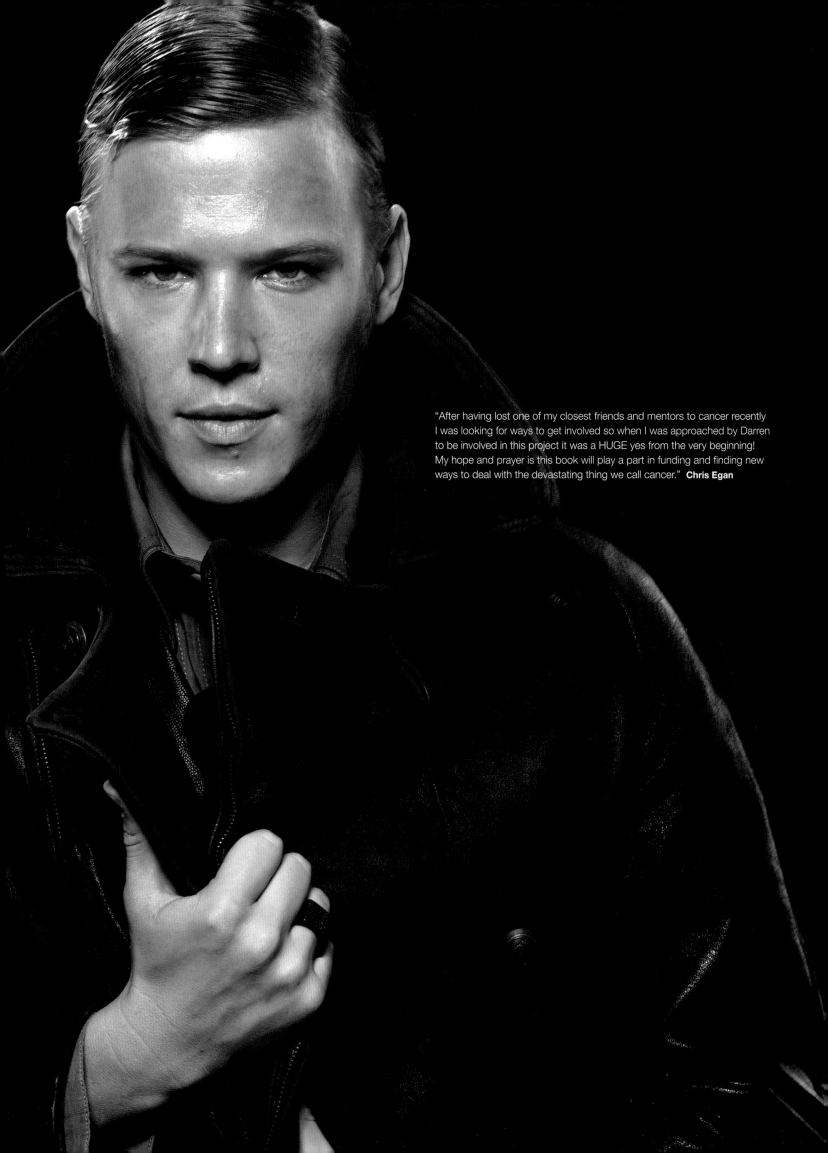

"After having lost one of my closest friends and mentors to cancer recently I was looking for ways to get involved so when I was approached by Darren to be involved in this project it was a HUGE yes from the very beginning! My hope and prayer is this book will play a part in funding and finding new ways to deal with the devastating thing we call cancer." **Chris Egan**

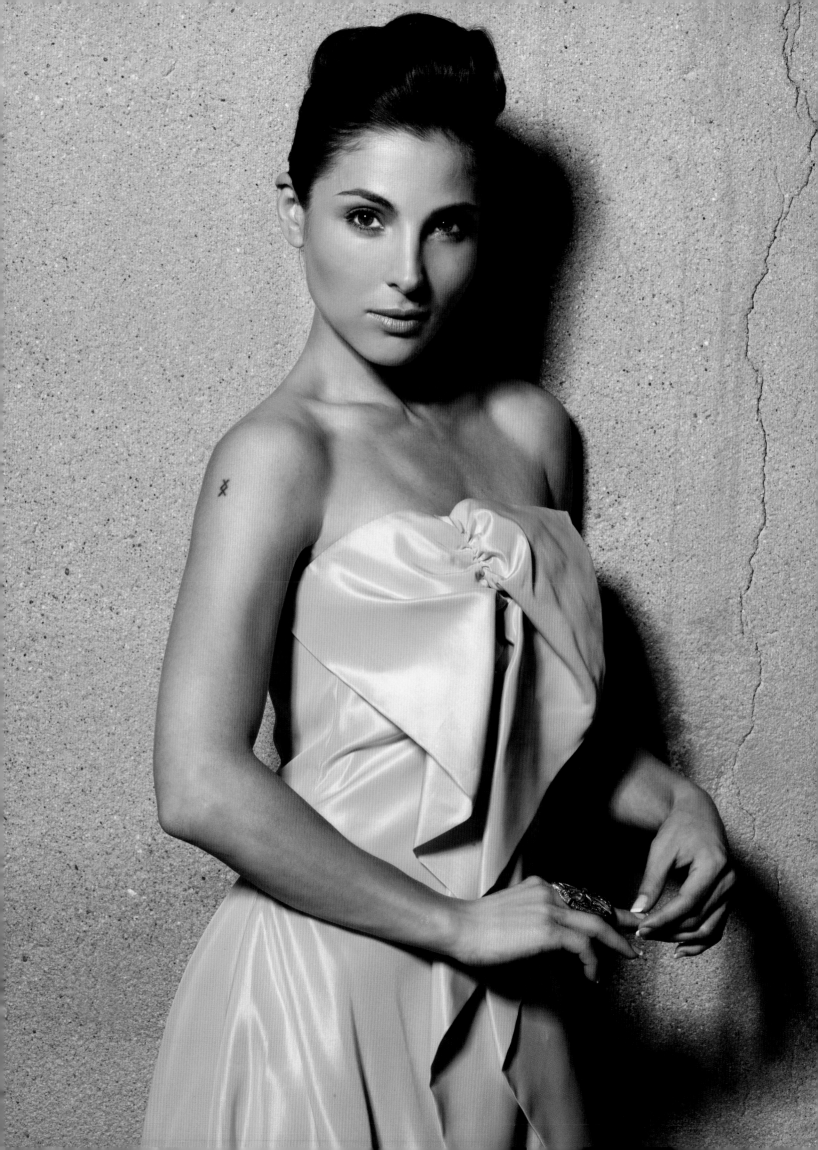

"Cancer, in all its forms needs to be eliminated from our lives. It causes way too much pain. I recently had a family member go through the emotional and difficult journey to beat it, and all the more happy that I signed up to support Darren's worthy cause." **Yvonne Strahovski**

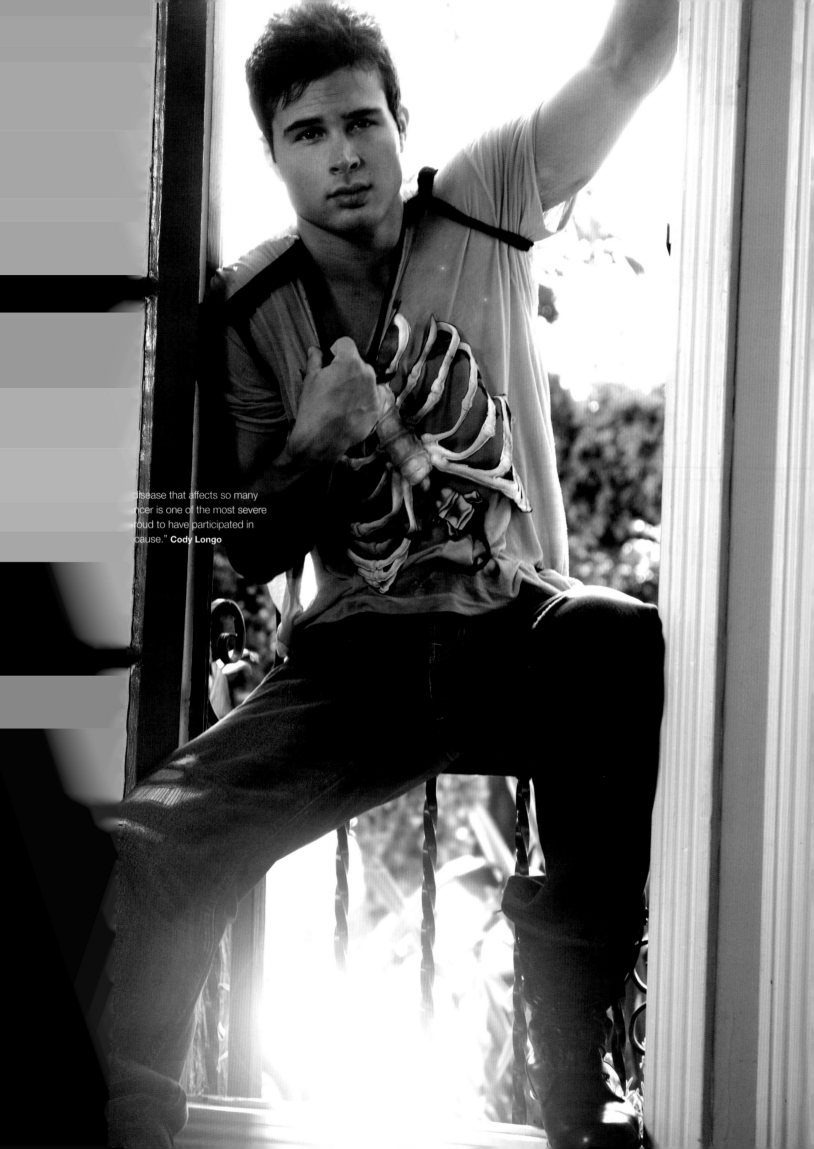

"...disease that affects so many ...ncer is one of the most severe ...roud to have participated in ...cause." **Cody Longo**

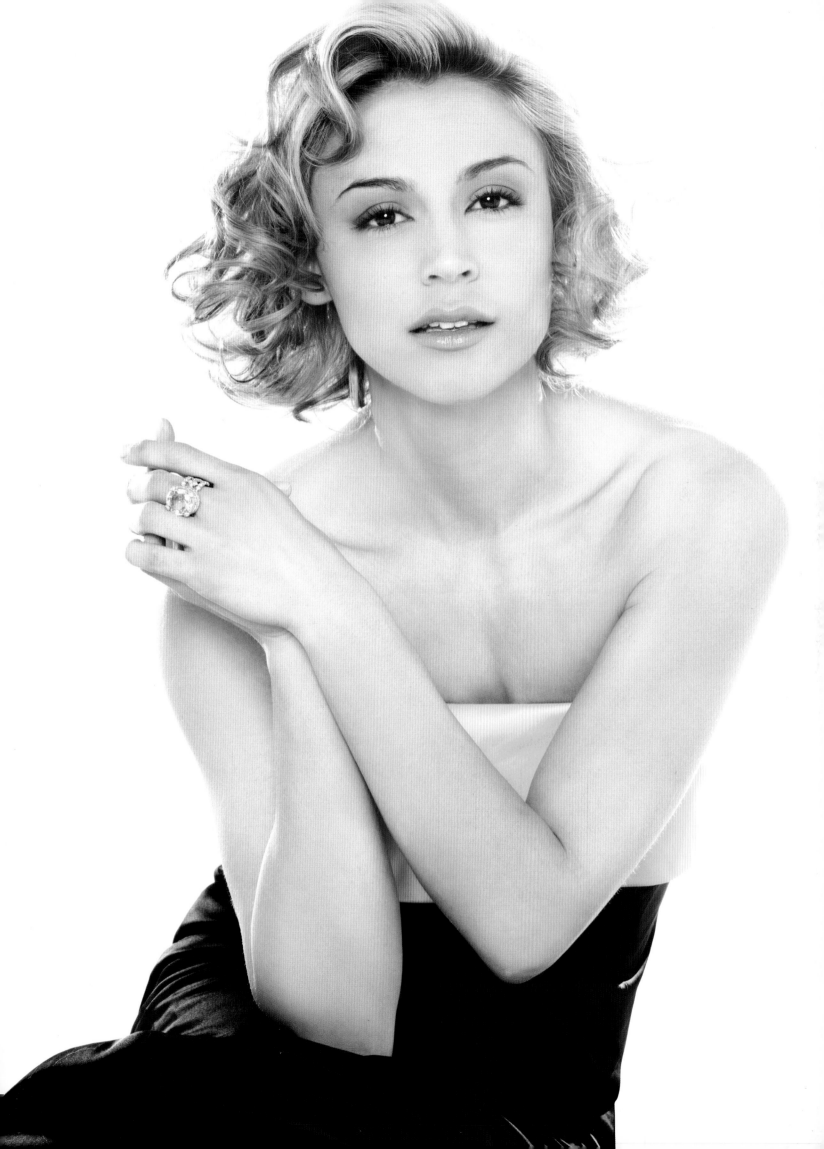

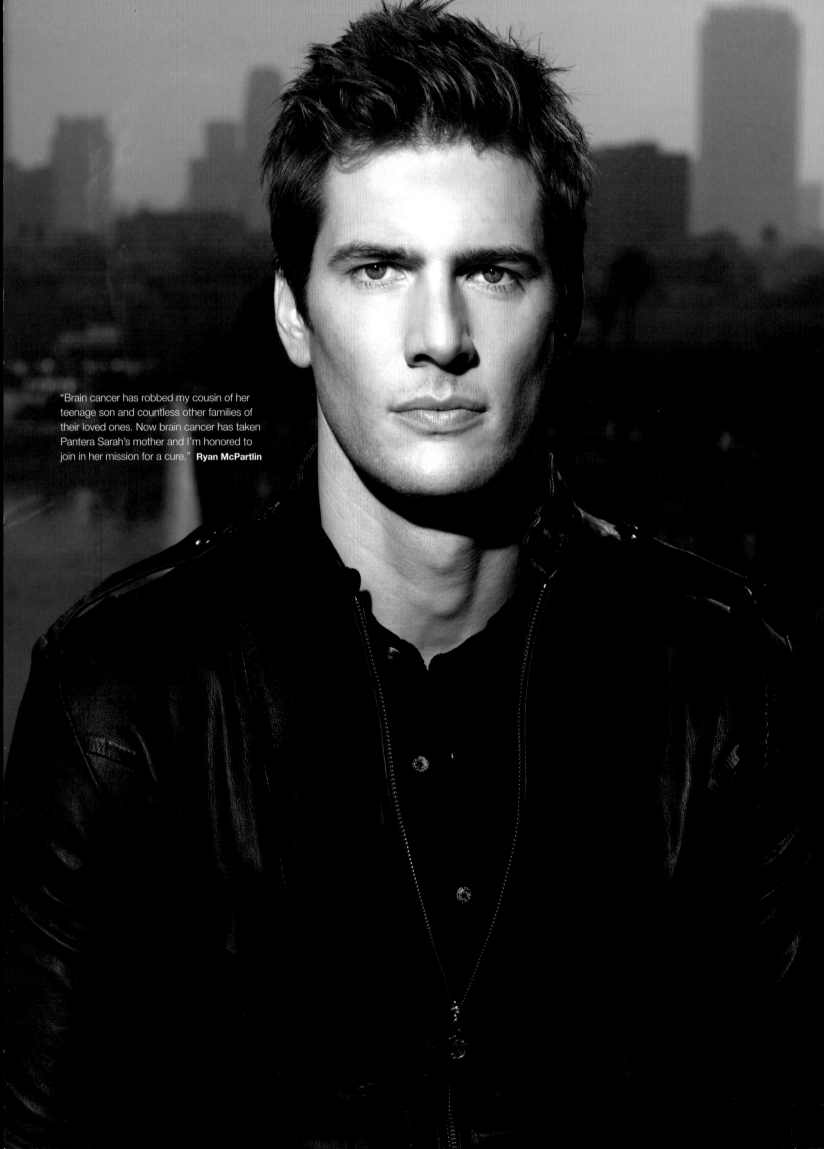

"Brain cancer has robbed my cousin of her teenage son and countless other families of their loved ones. Now brain cancer has taken Pantera Sarah's mother and I'm honored to join in her mission for a cure." **Ryan McPartlin**

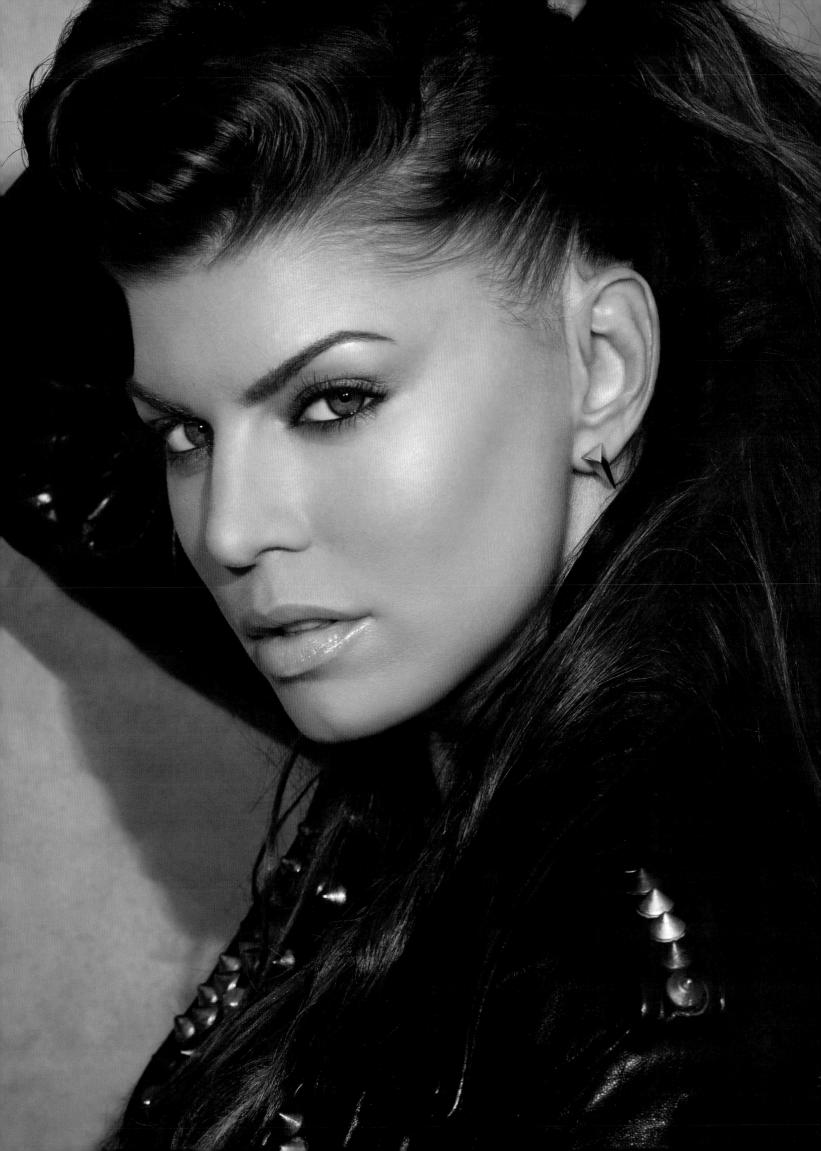

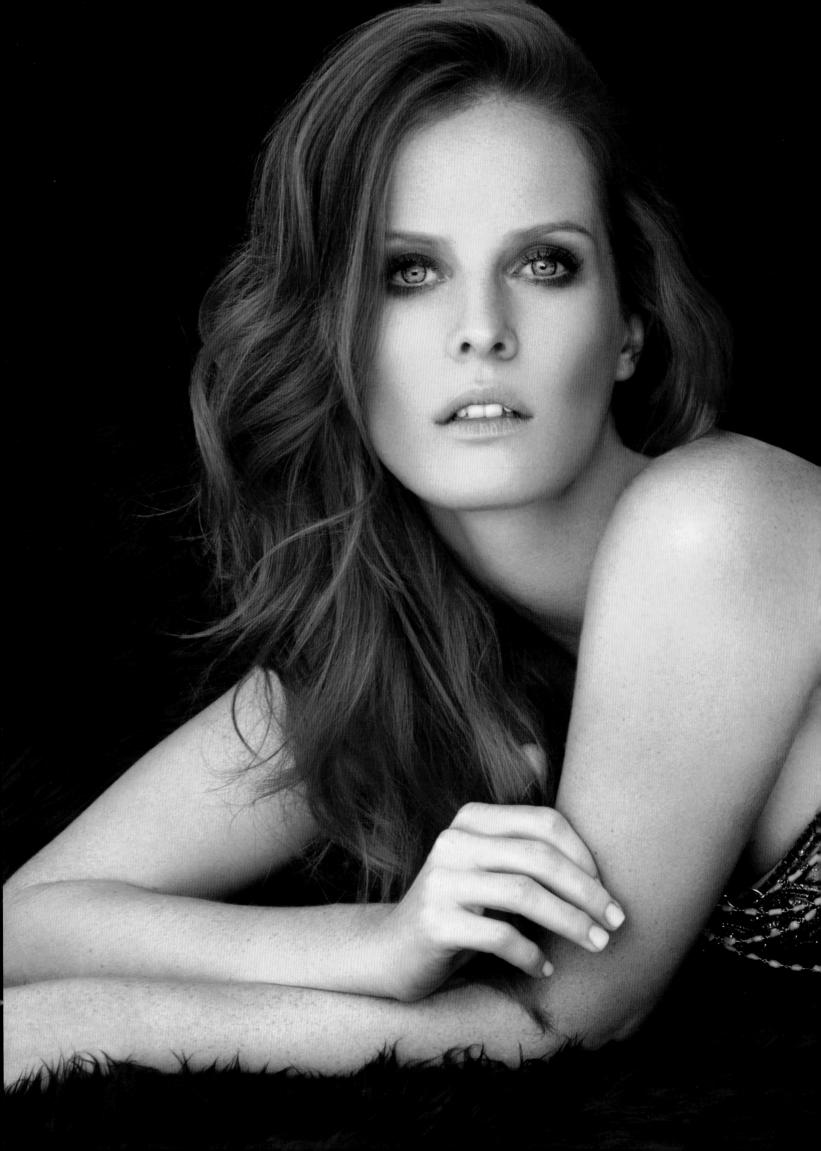

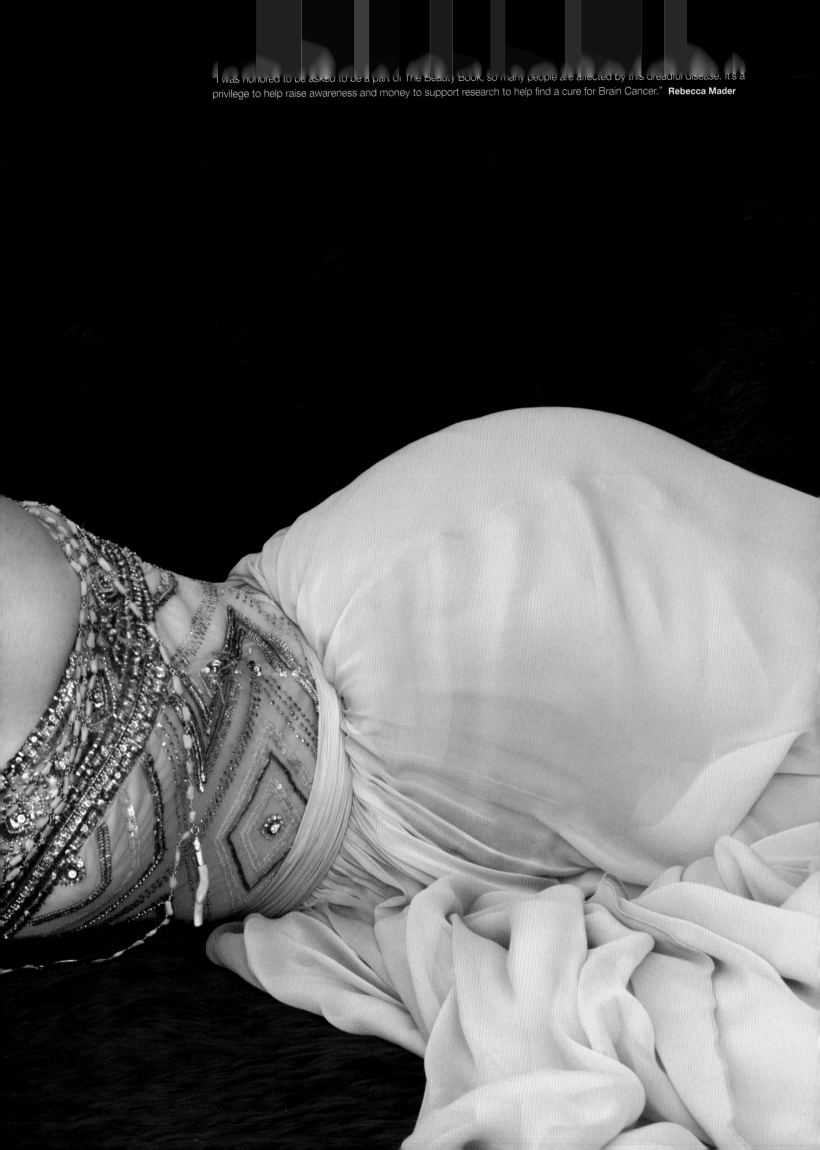

"I was honored to be asked to be a part of The Beauty Book, so many people are affected by this dreadful disease. It's a privilege to help raise awareness and money to support research to help find a cure for Brain Cancer." **Rebecca Mader**

"Darren's passion and enthusiasm to bring awareness to the fight against brain cancer is truly unbelievable. I am so honored to be of support and a part of his vision!" **Jenna Dewan**

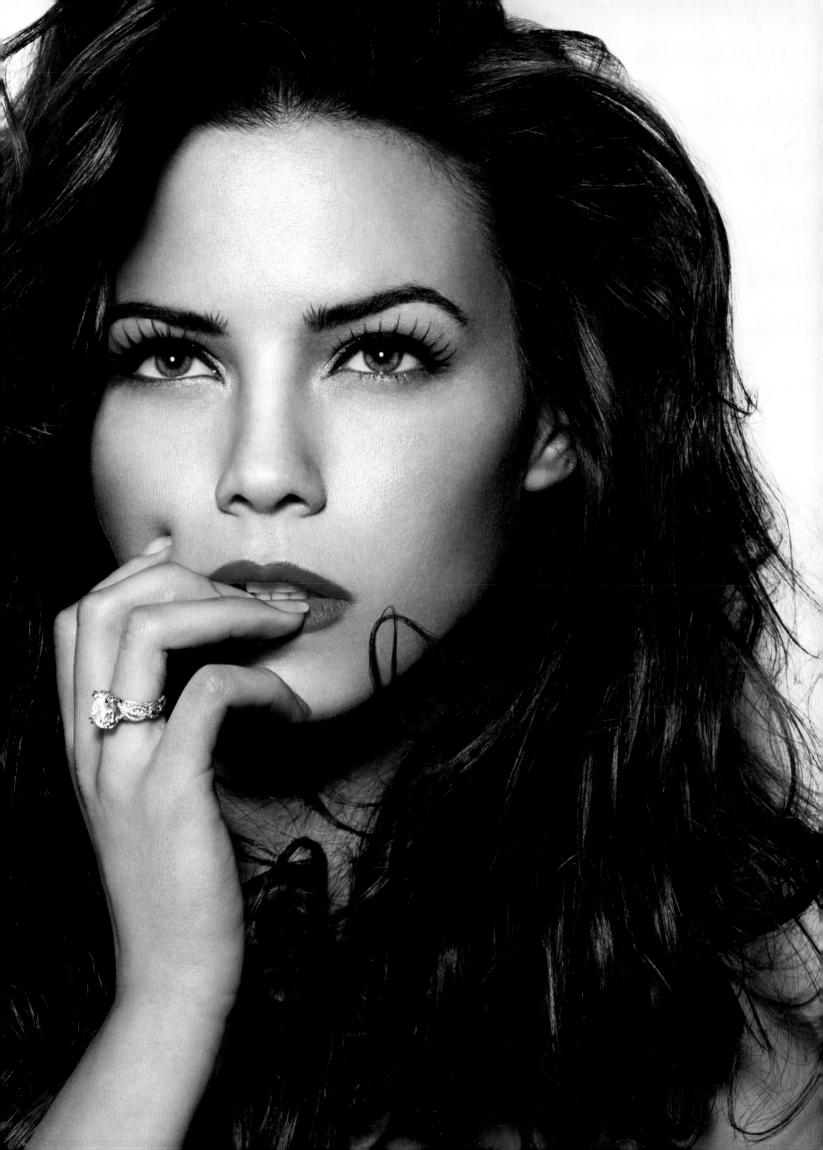

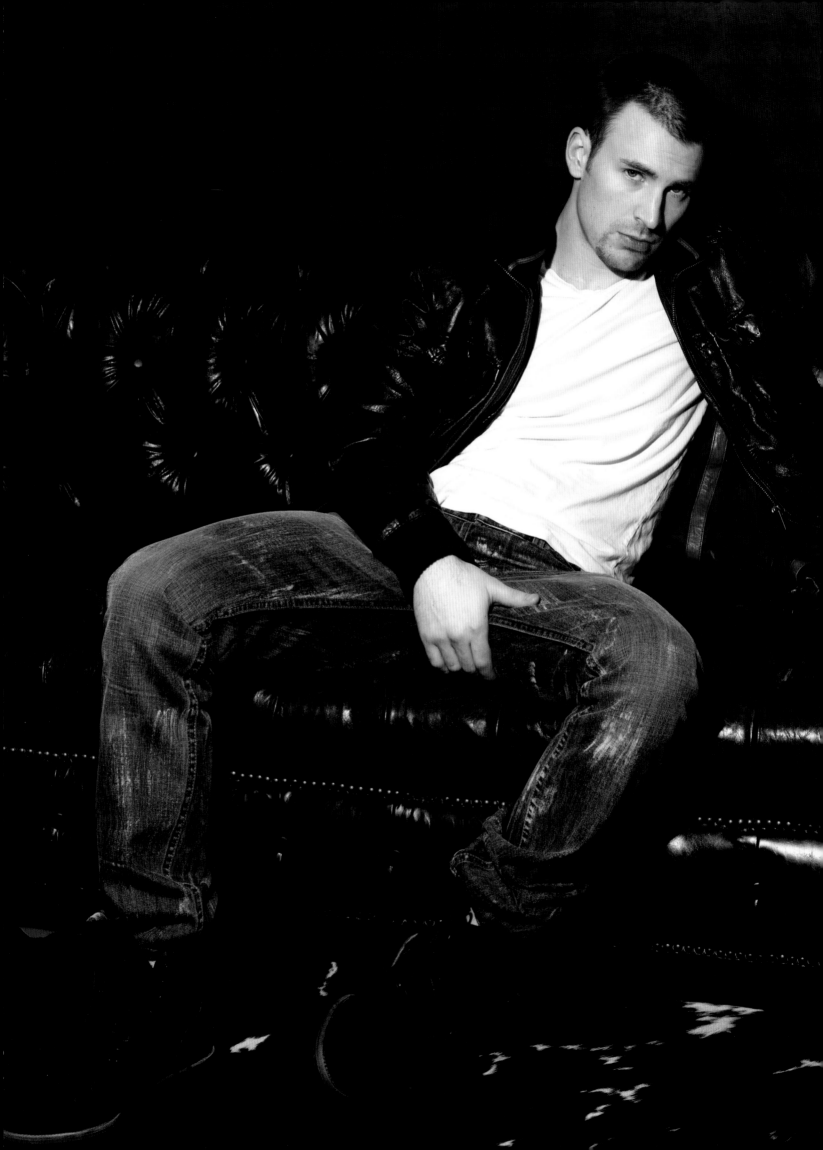

"There are few people in the world with a bigger heart than Sarah. Helping her in any way, especially for a cause that is so personal to her, is a reward on every level." **Chris Evans**

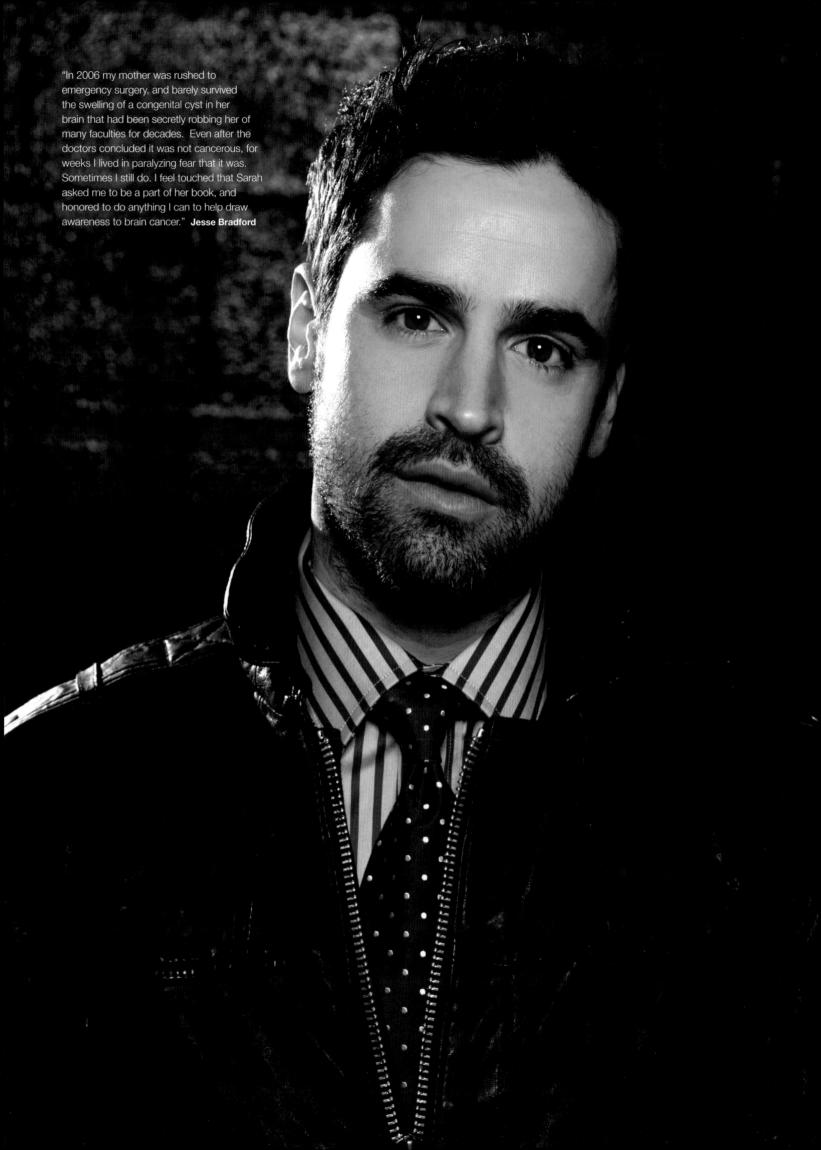

"In 2006 my mother was rushed to emergency surgery, and barely survived the swelling of a congenital cyst in her brain that had been secretly robbing her of many faculties for decades. Even after the doctors concluded it was not cancerous, for weeks I lived in paralyzing fear that it was. Sometimes I still do. I feel touched that Sarah asked me to be a part of her book, and honored to do anything I can to help draw awareness to brain cancer." **Jesse Bradford**

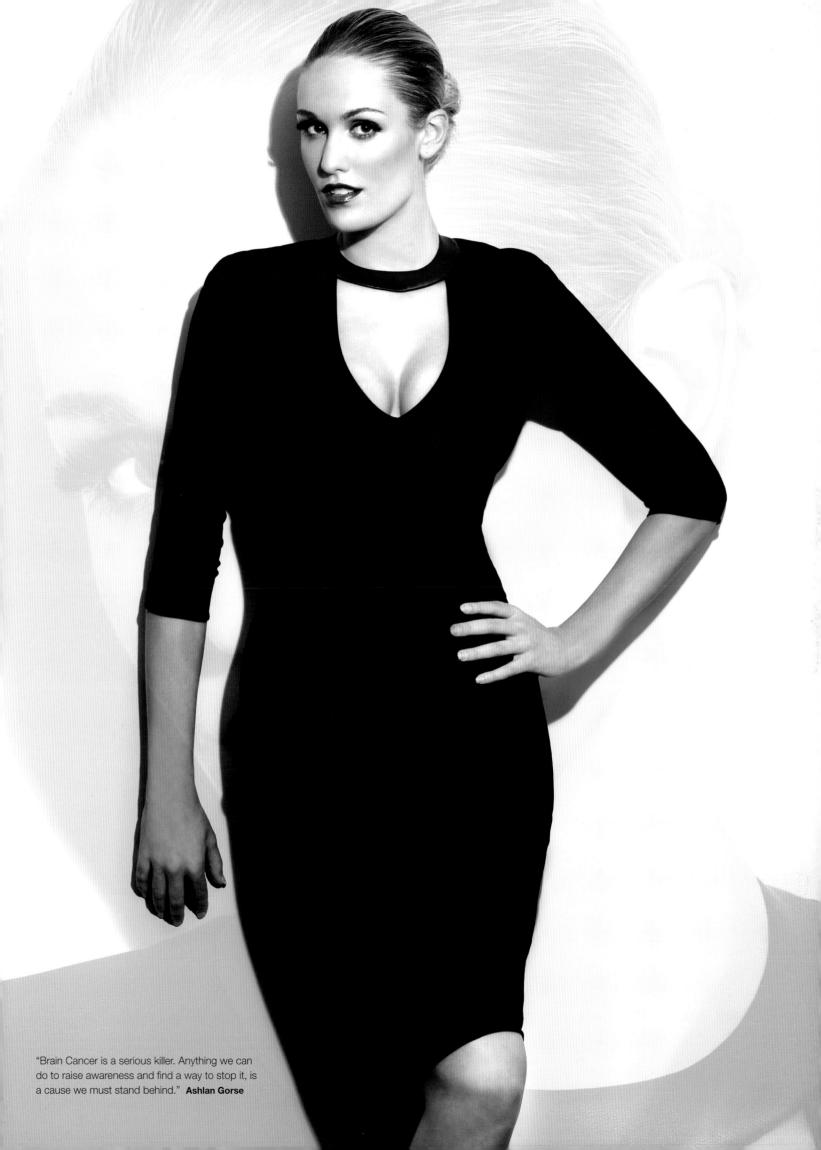

"Brain Cancer is a serious killer. Anything we can do to raise awareness and find a way to stop it, is a cause we must stand behind." **Ashlan Gorse**

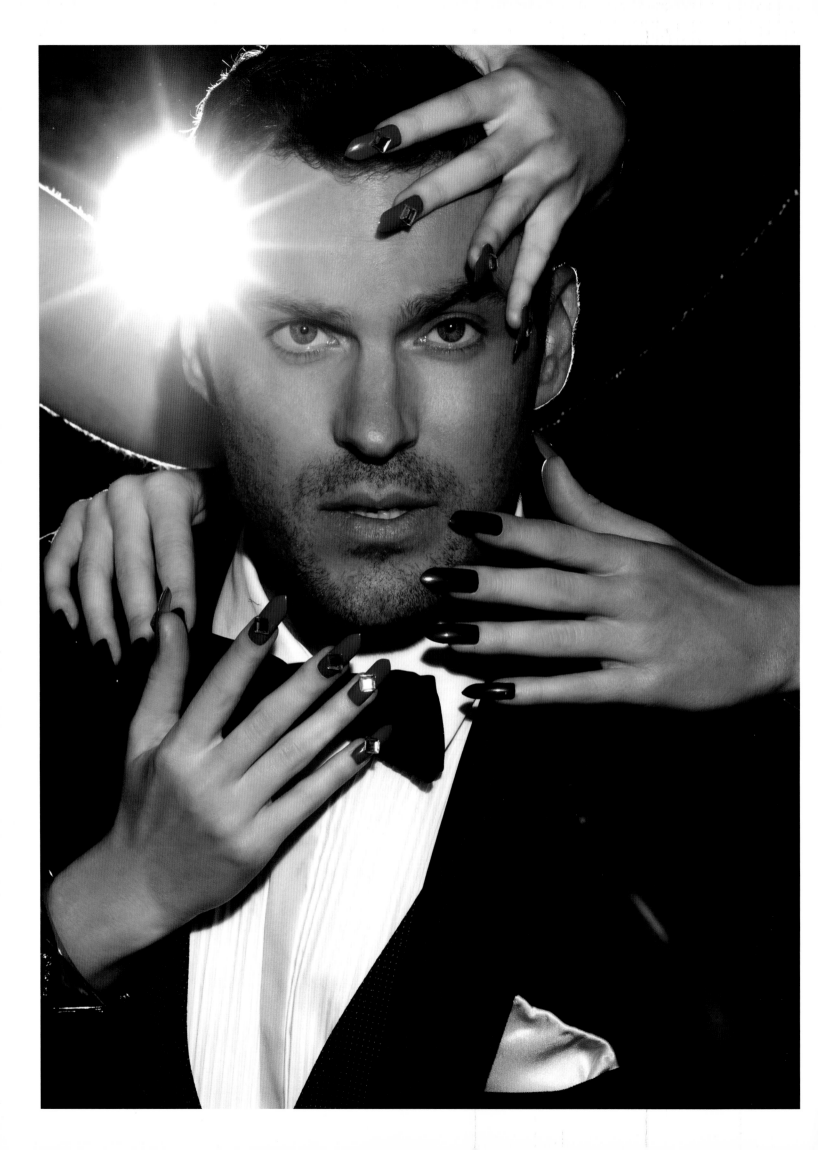

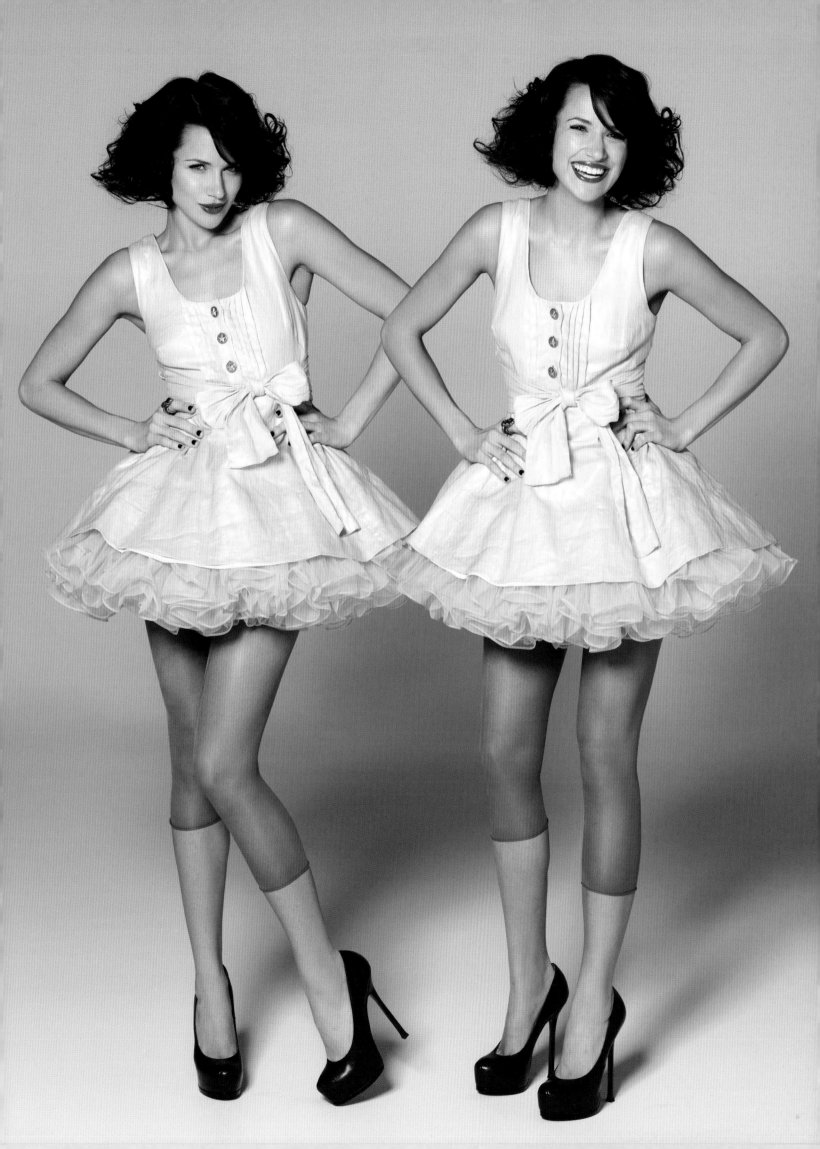

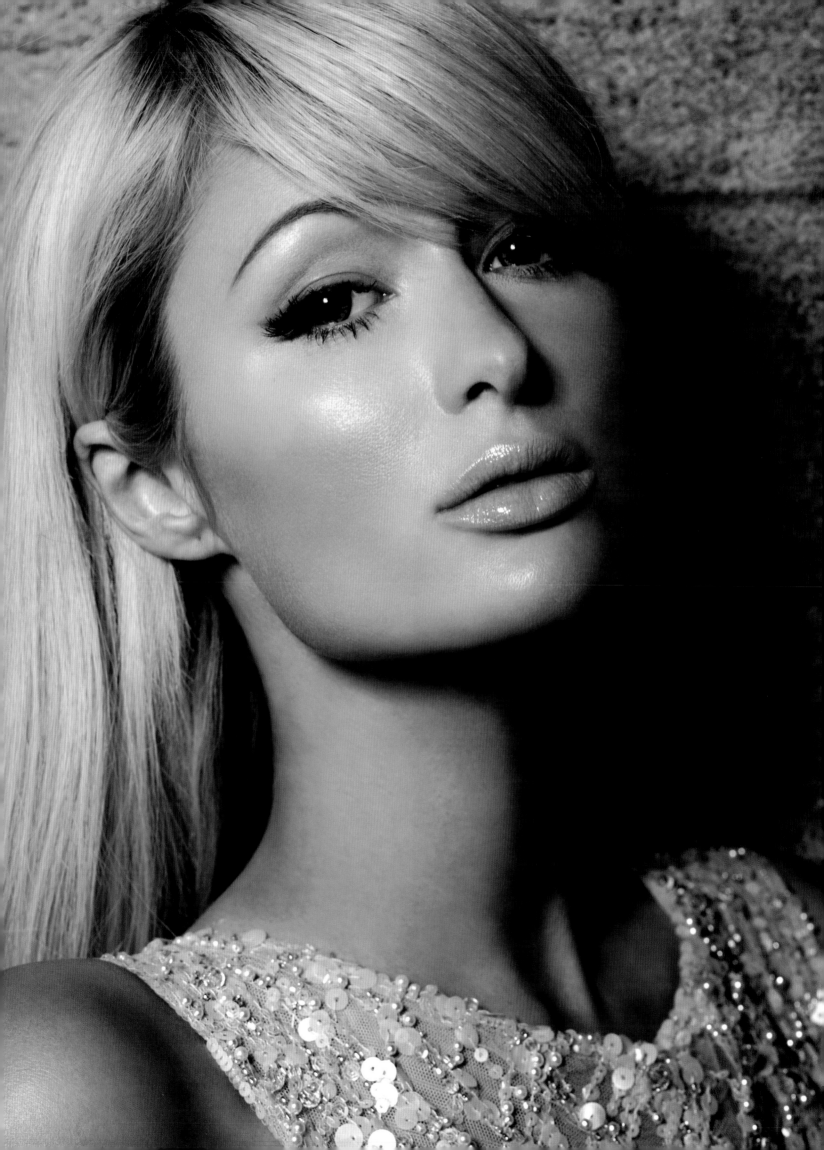

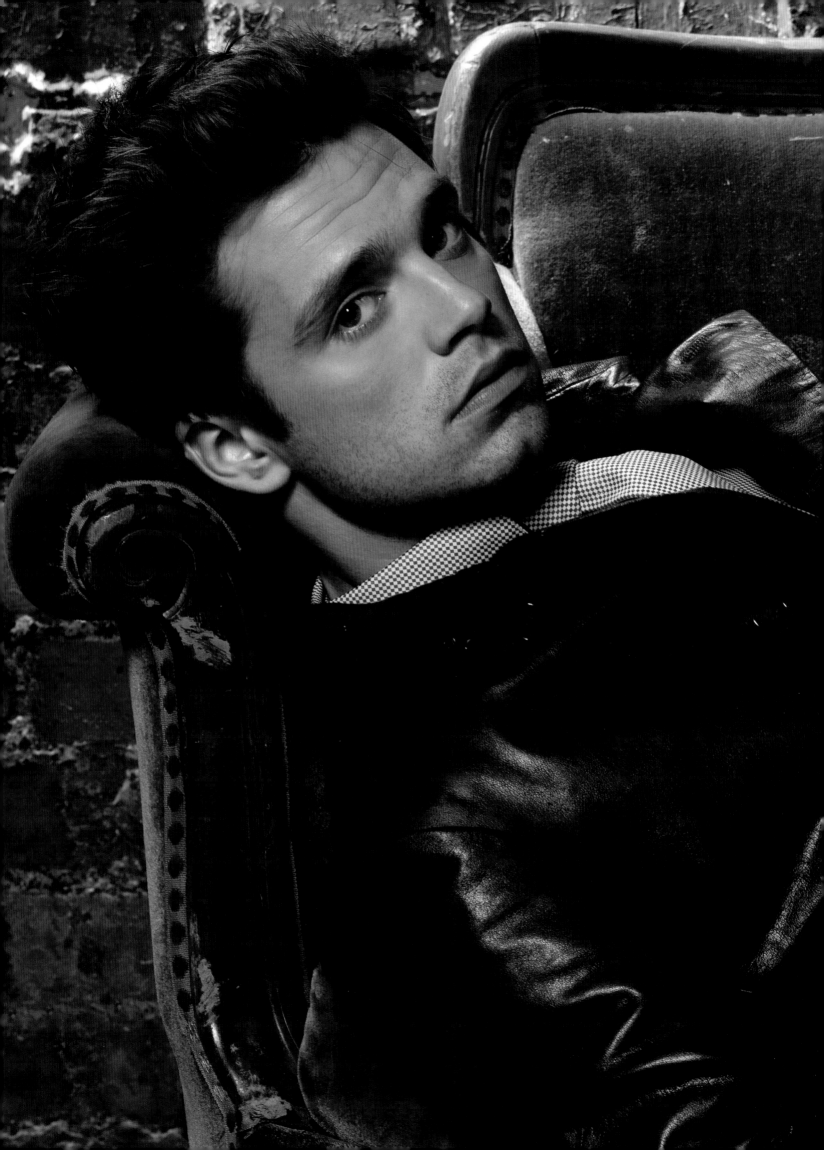

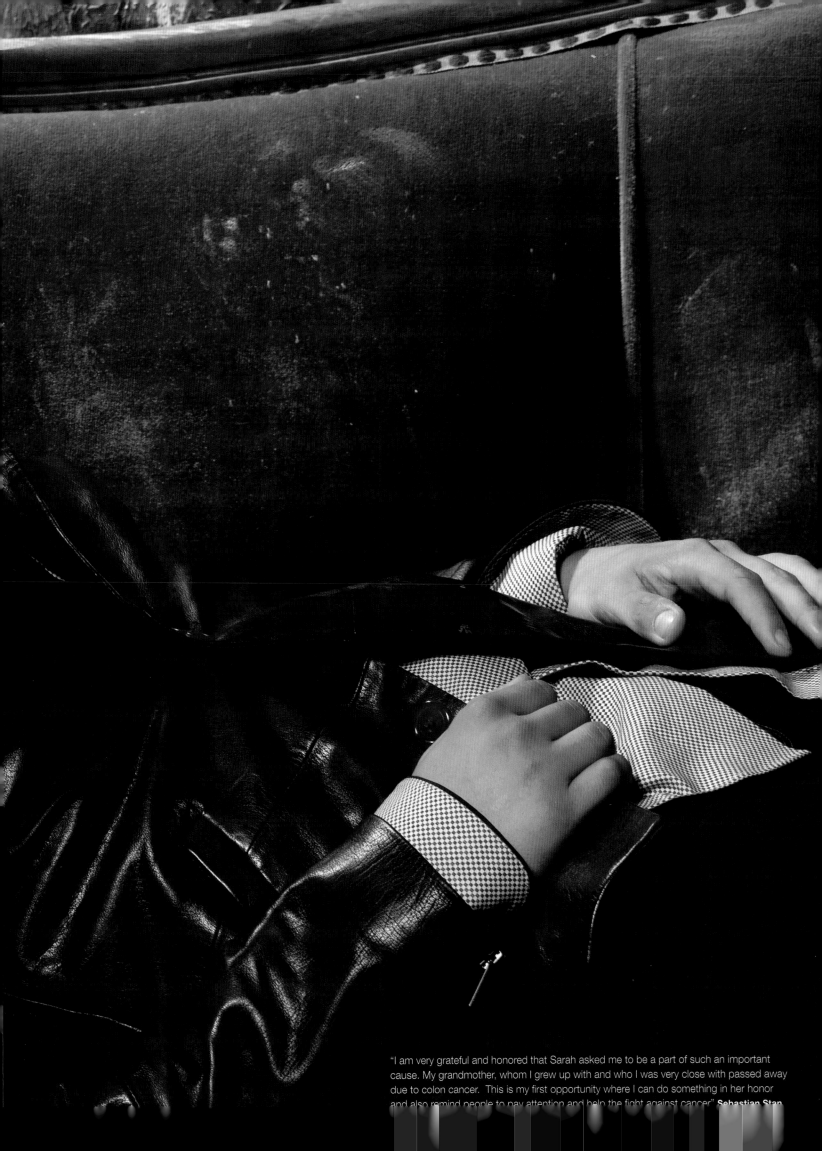

"I am very grateful and honored that Sarah asked me to be a part of such an important cause. My grandmother, whom I grew up with and who I was very close with passed away due to colon cancer. This is my first opportunity where I can do something in her honor and also remind people to pay attention and help the fight against cancer." Sebastian Stan

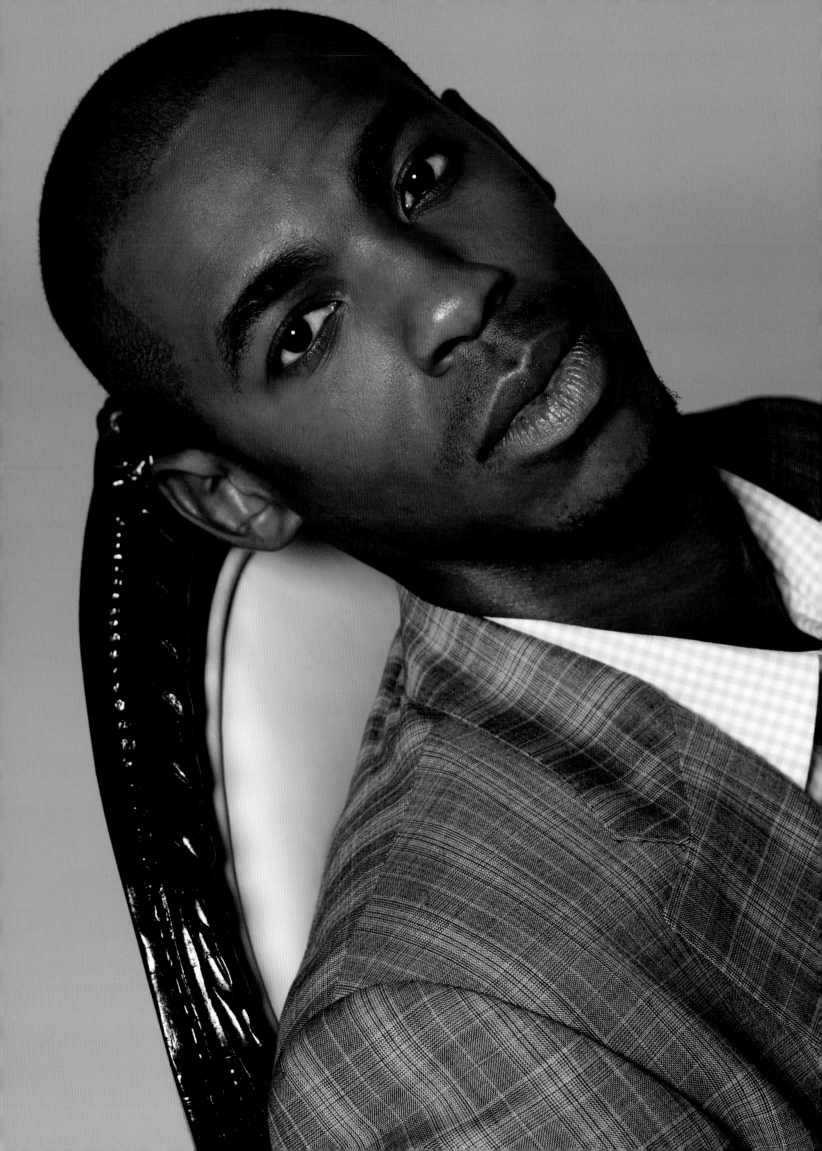

"I am so honored to be a part of this amazing project by Darren Tieste. As a photographer, he has always had a talent for bringing out the beauty in people and the purpose of this book, people helping people, is the definition of beauty!" **Nancy O'Dell**

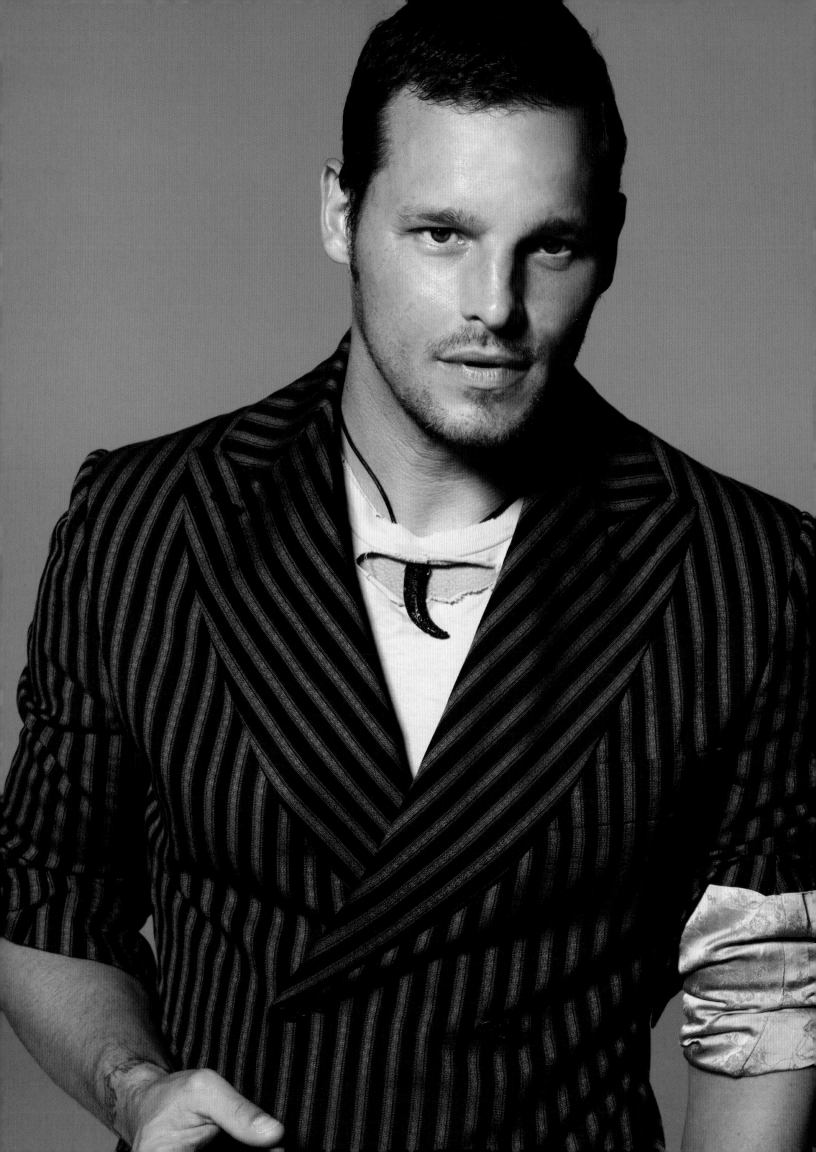

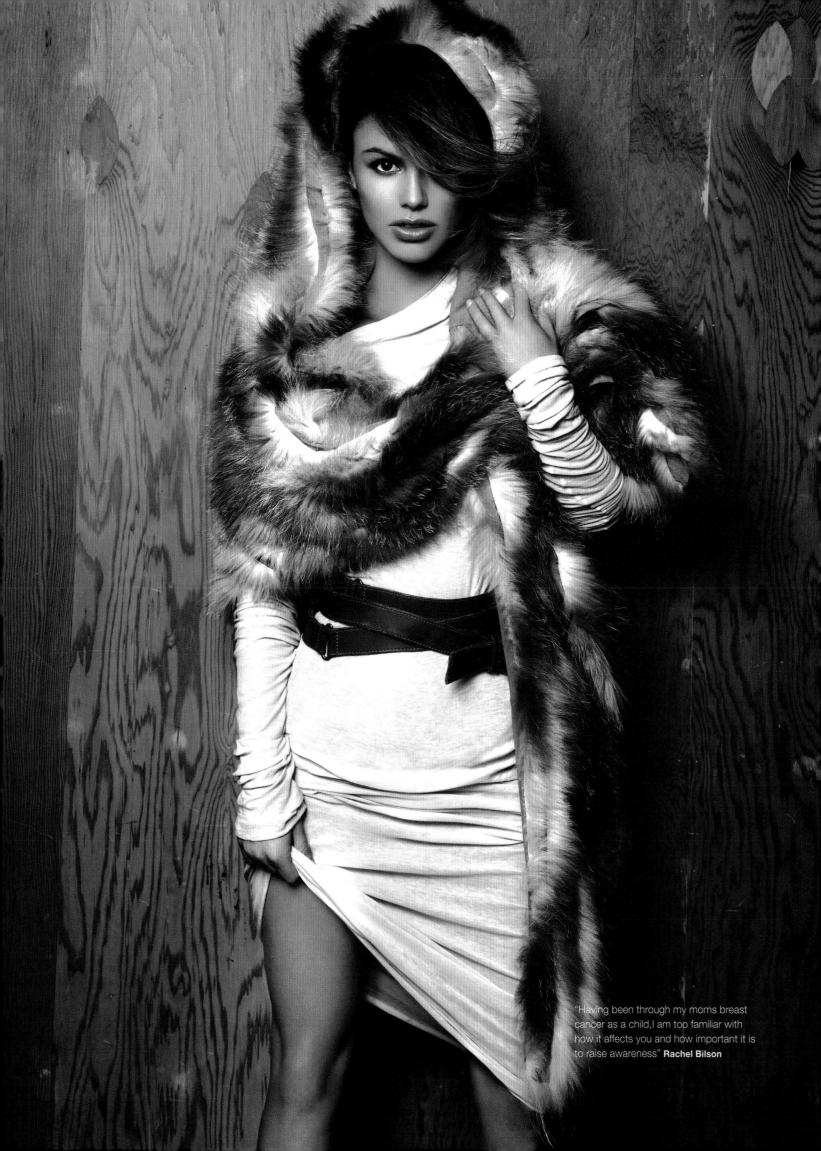

"Having been through my moms breast cancer as a child, I am too familiar with how it affects you and how important it is to raise awareness" **Rachel Bilson**

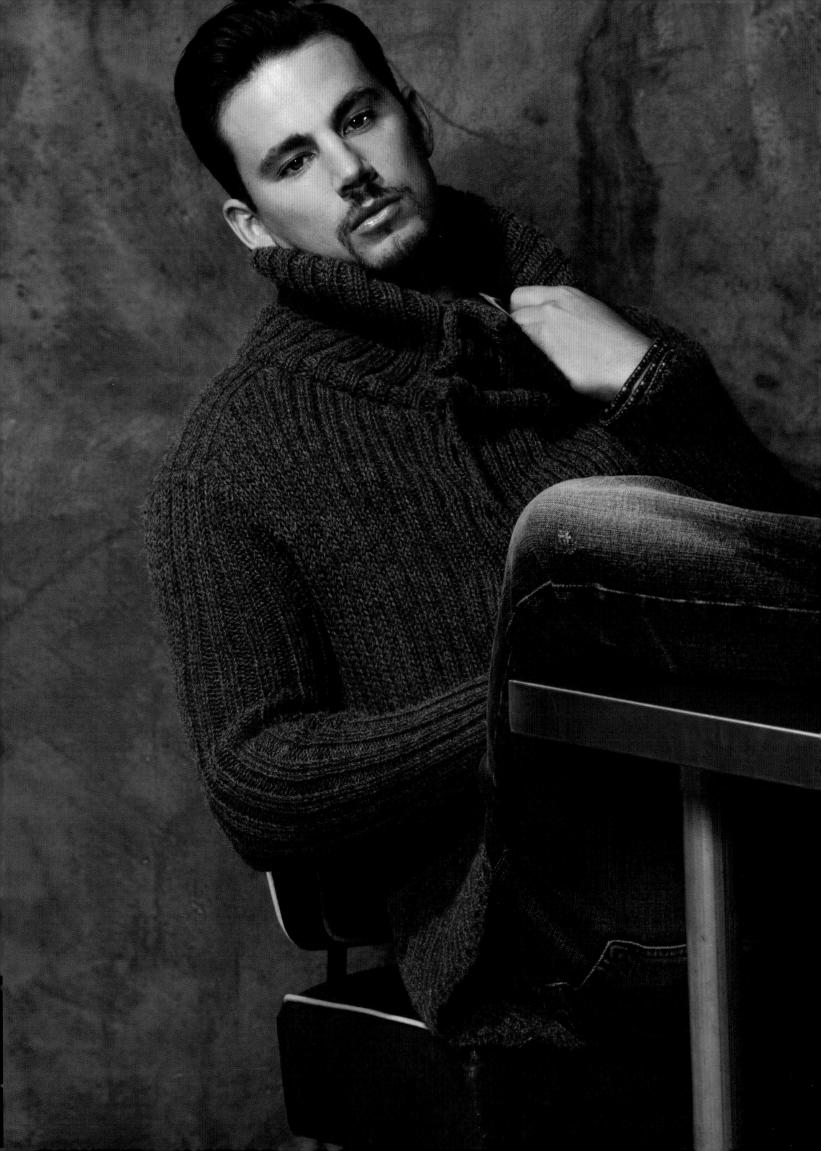

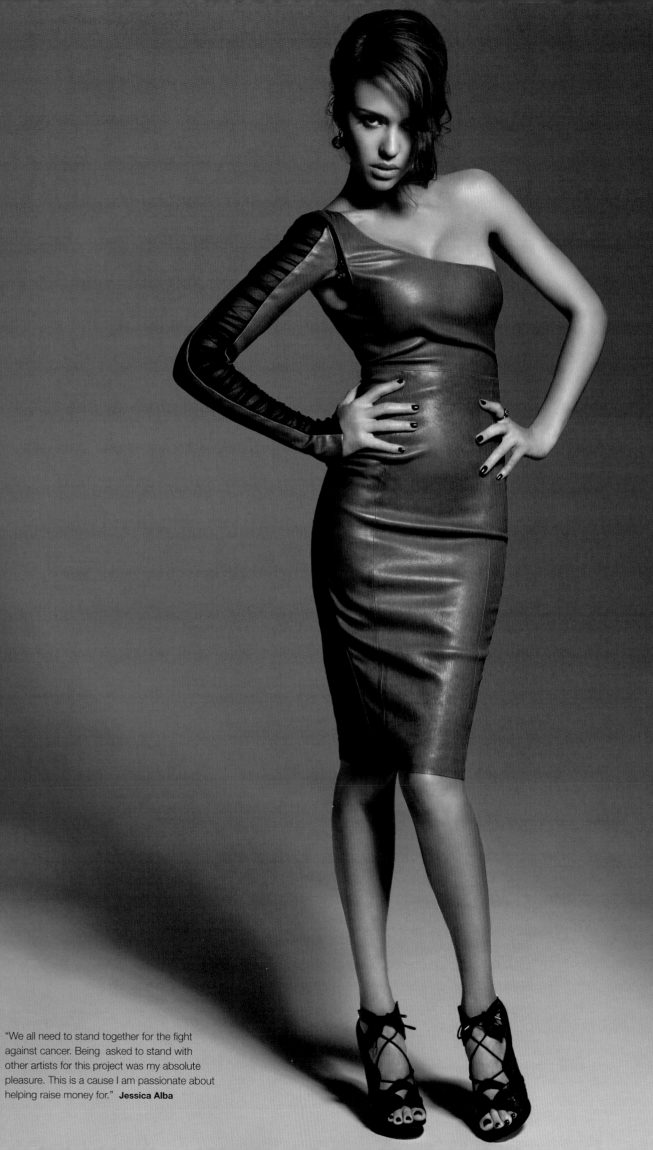

"We all need to stand together for the fight against cancer. Being asked to stand with other artists for this project was my absolute pleasure. This is a cause I am passionate about helping raise money for." **Jessica Alba**

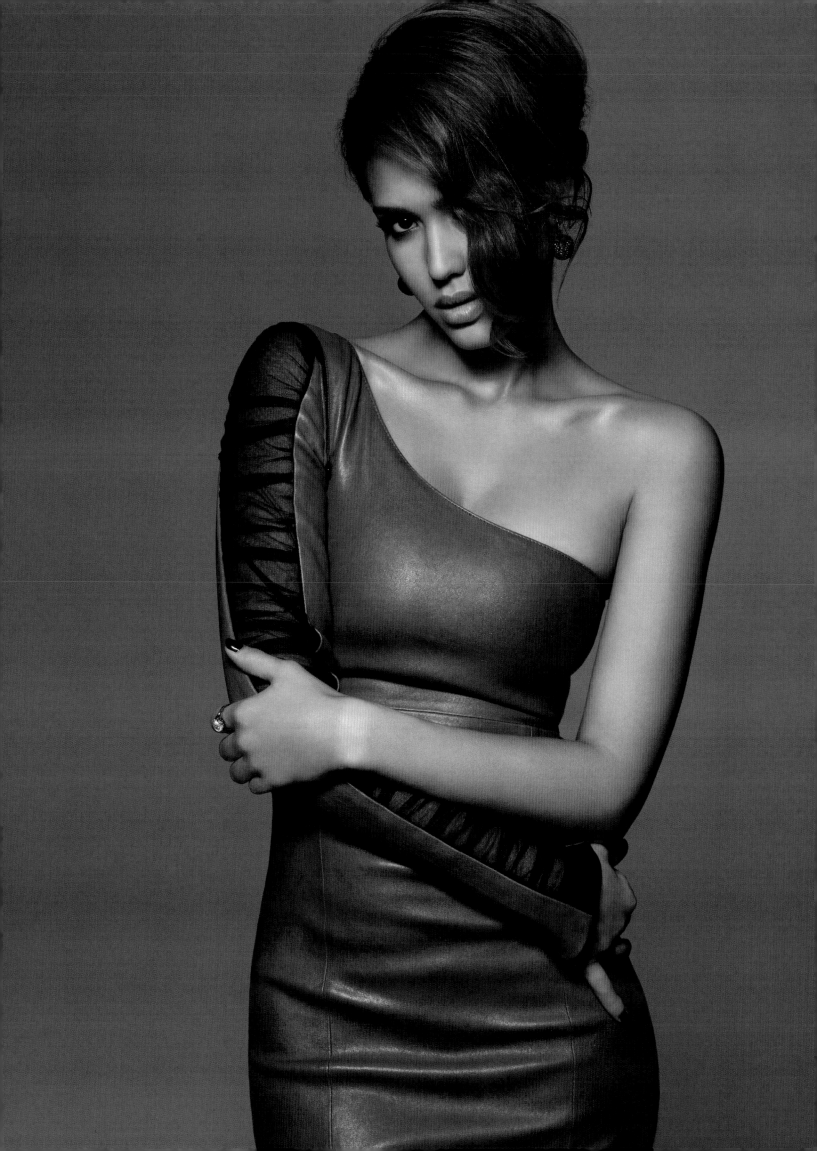

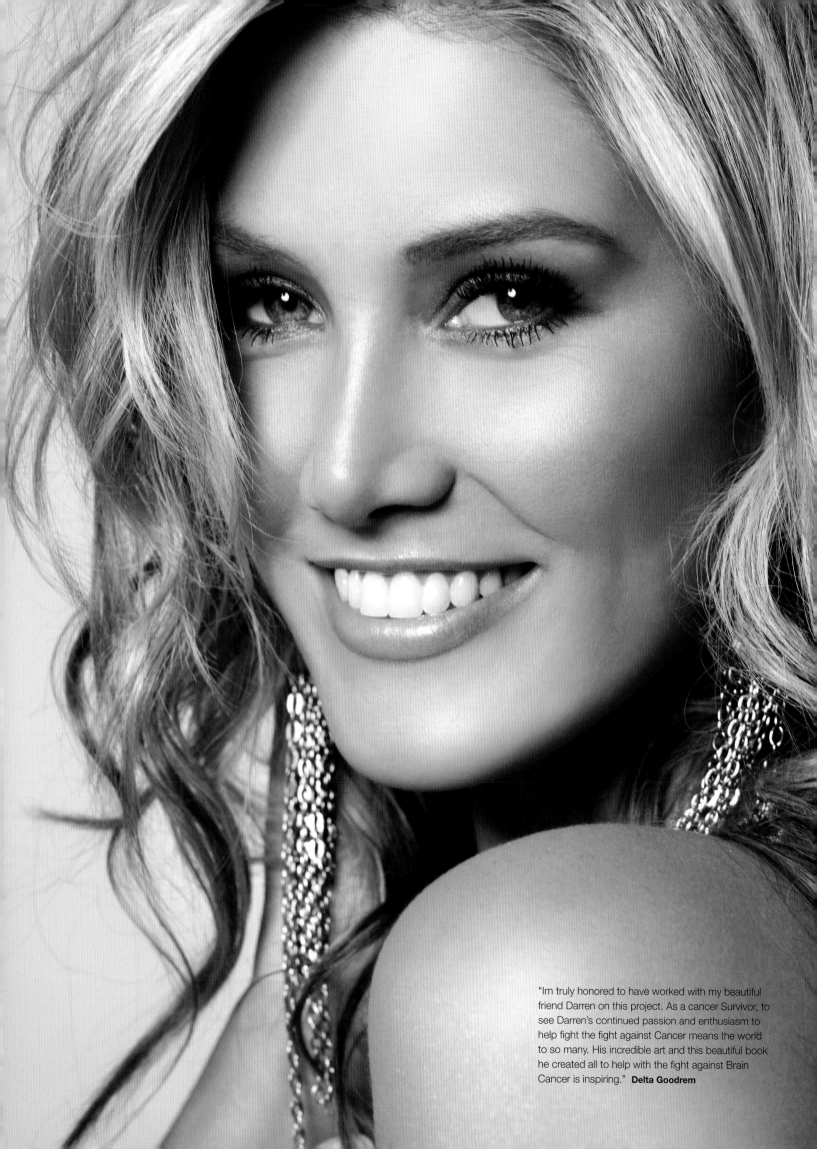

"Im truly honored to have worked with my beautiful friend Darren on this project. As a cancer Survivor, to see Darren's continued passion and enthusiasm to help fight the fight against Cancer means the world to so many. His incredible art and this beautiful book he created all to help with the fight against Brain Cancer is inspiring." **Delta Goodrem**

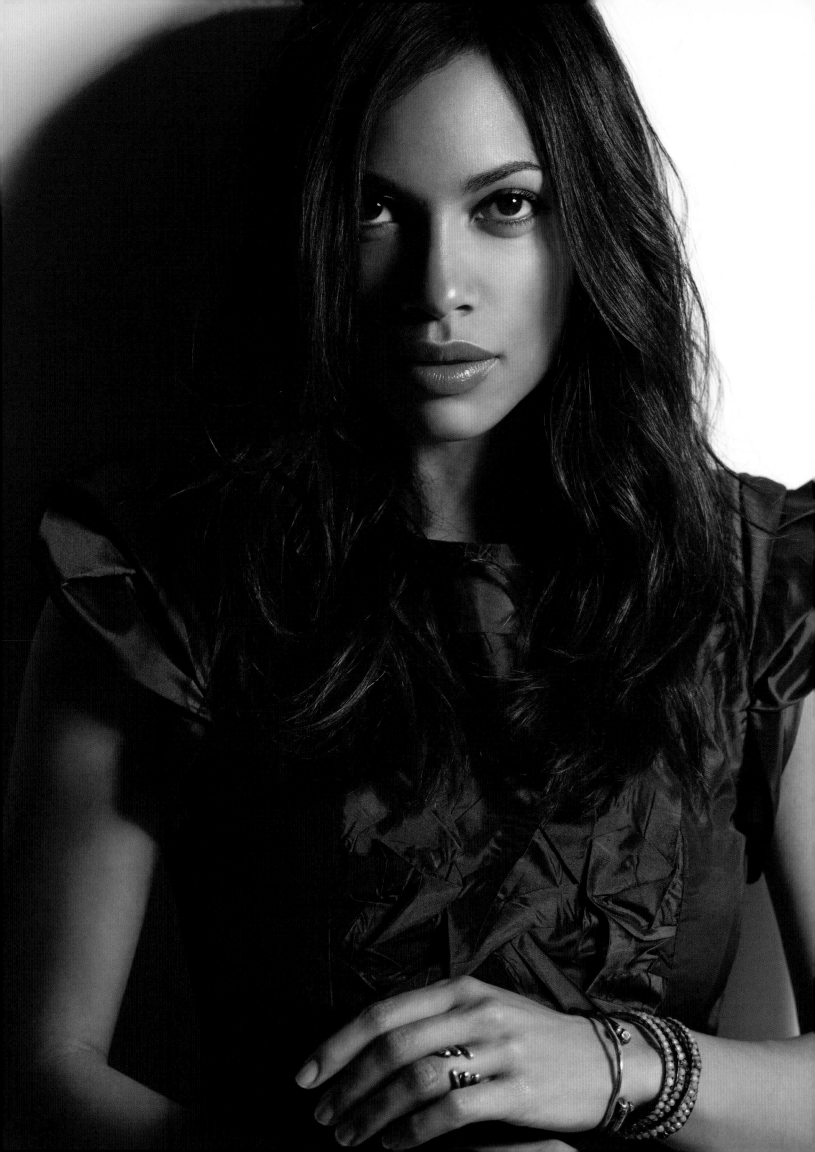

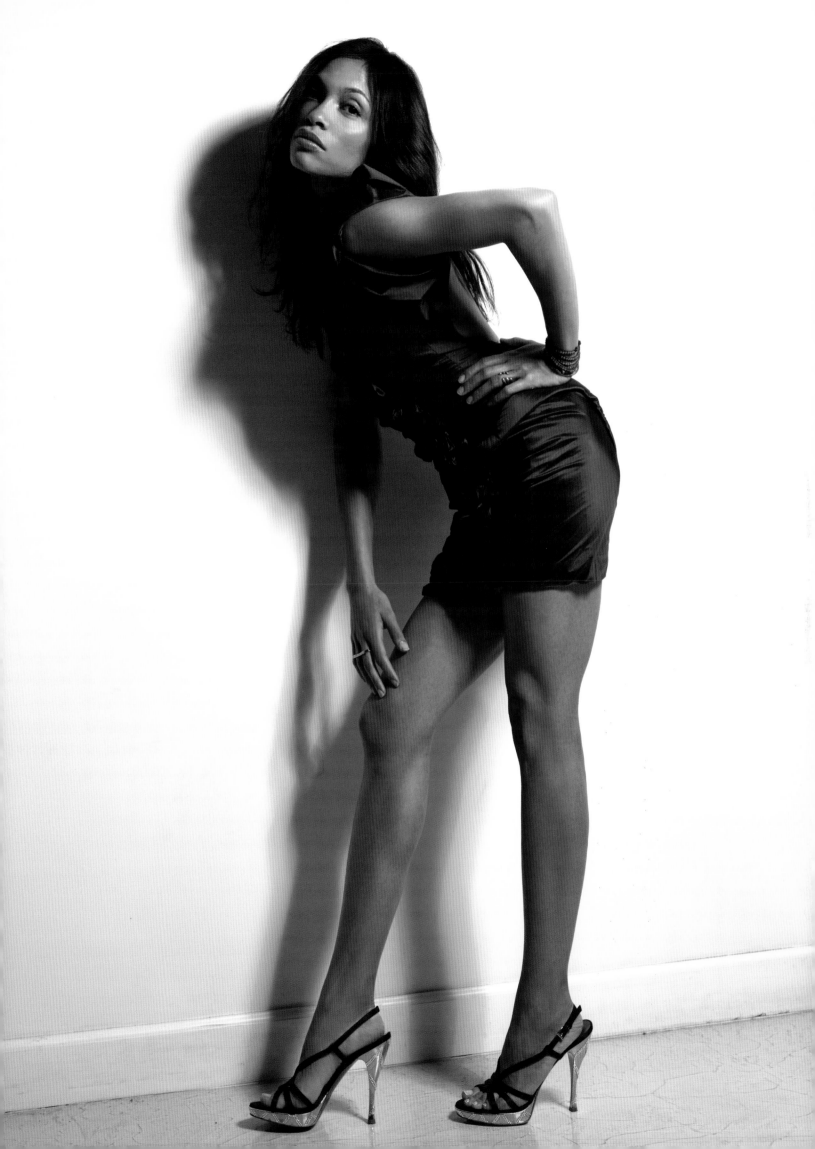

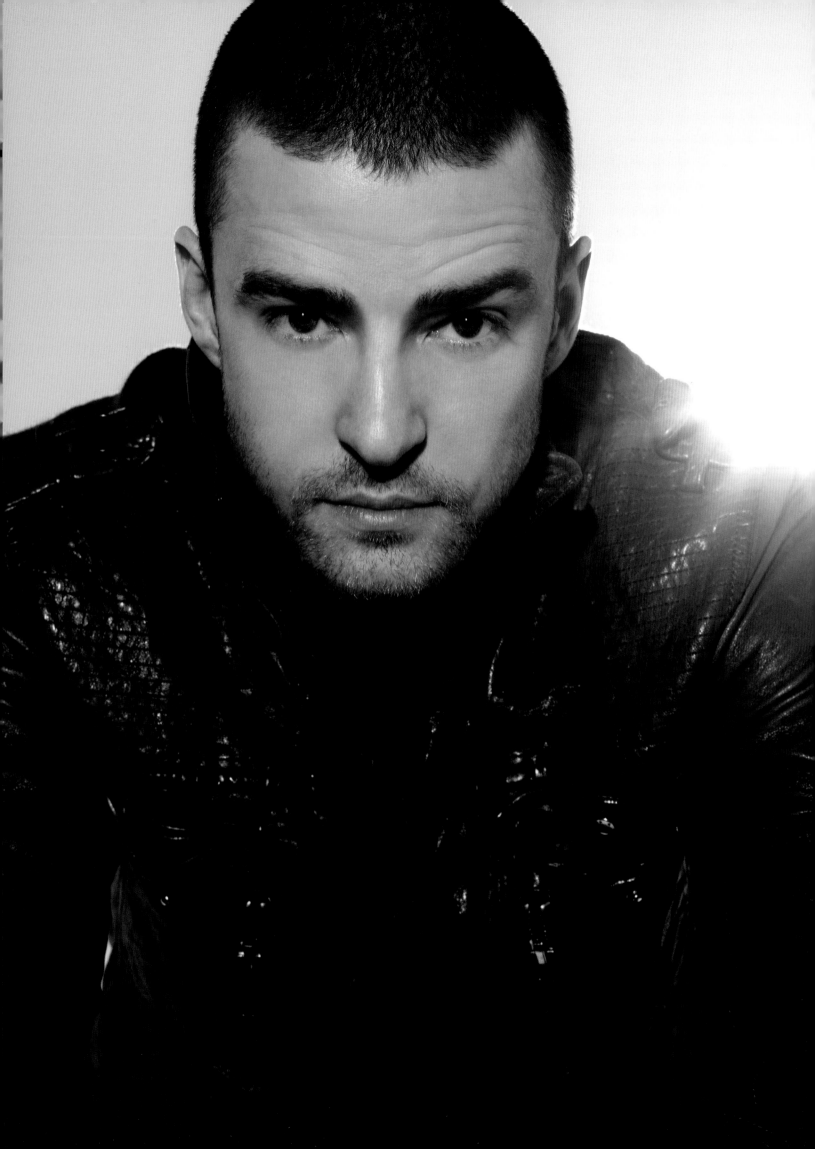

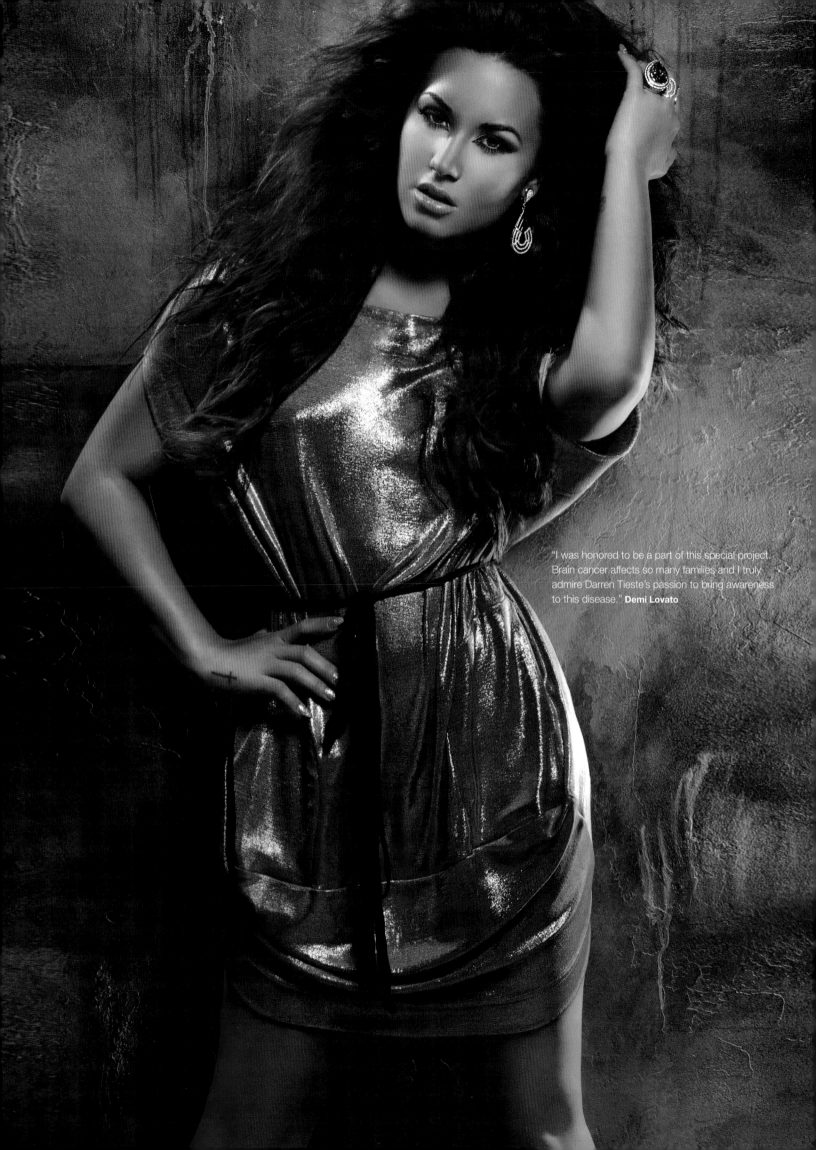

"I was honored to be a part of this special project. Brain cancer affects so many families and I truly admire Darren Tieste's passion to bring awareness to this disease." **Demi Lovato**

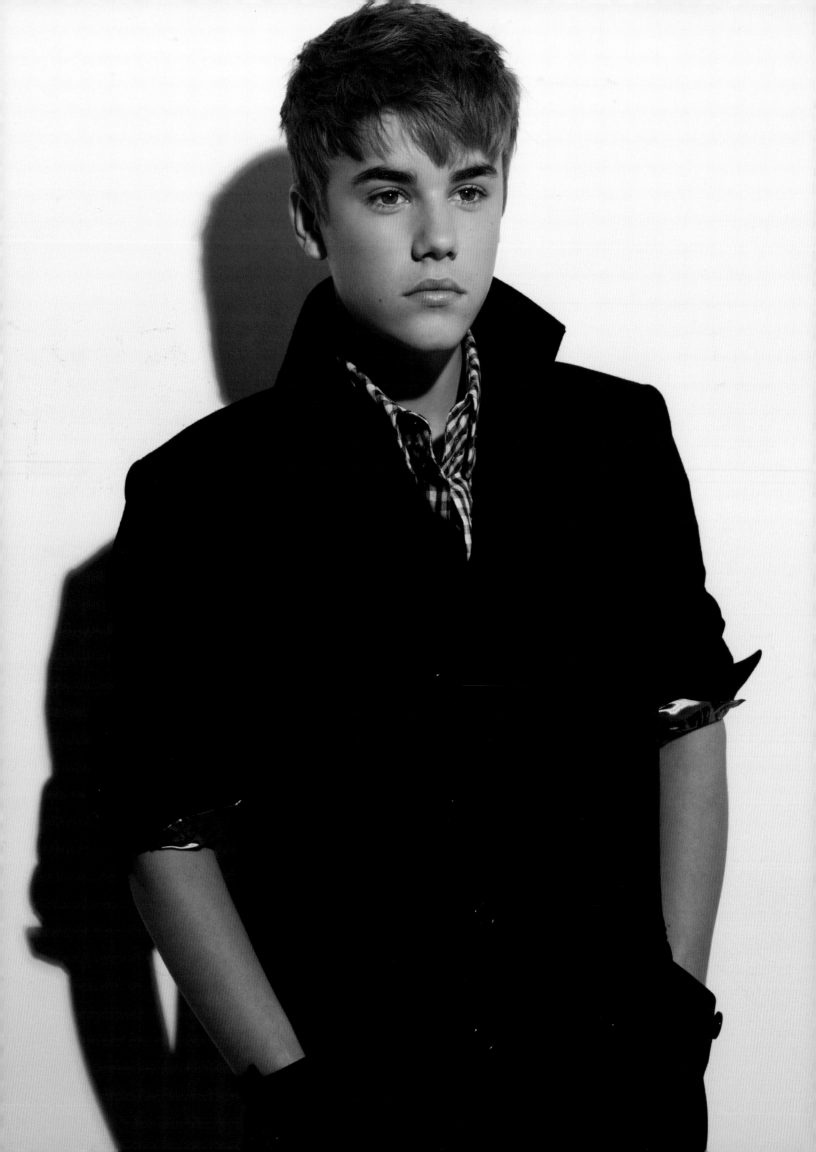

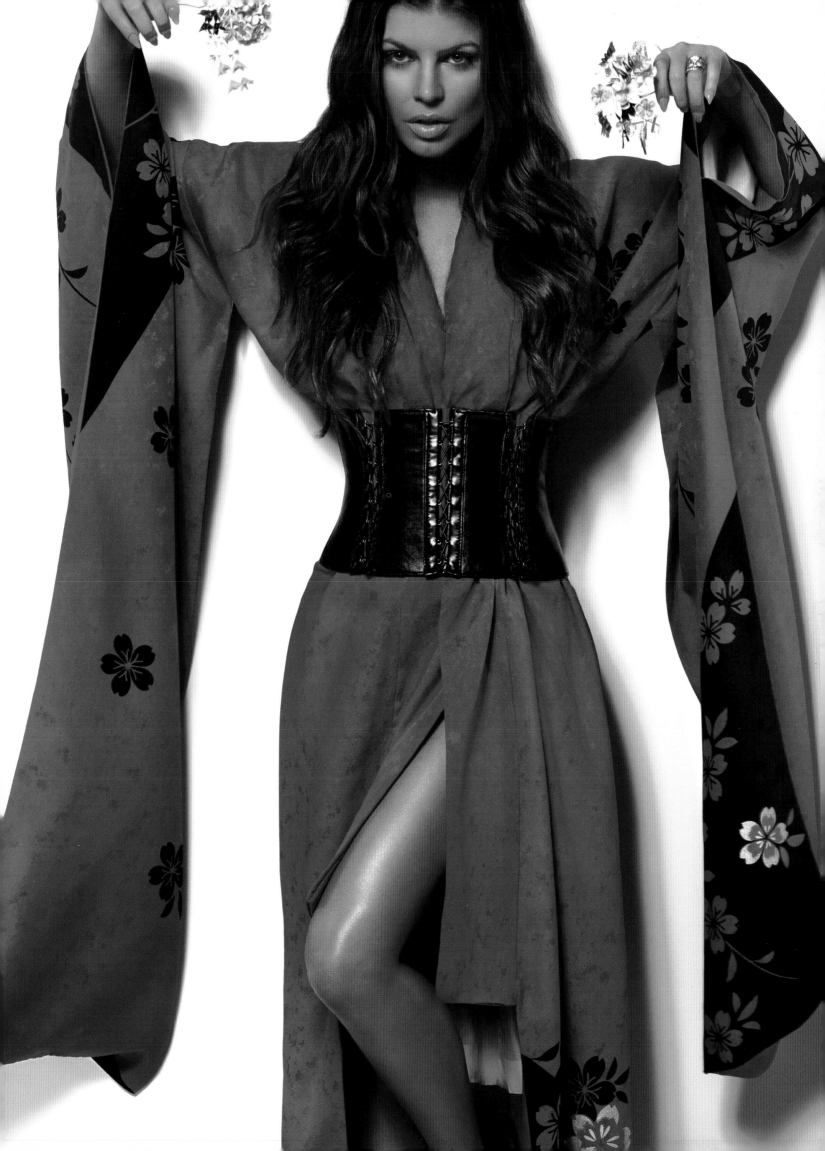

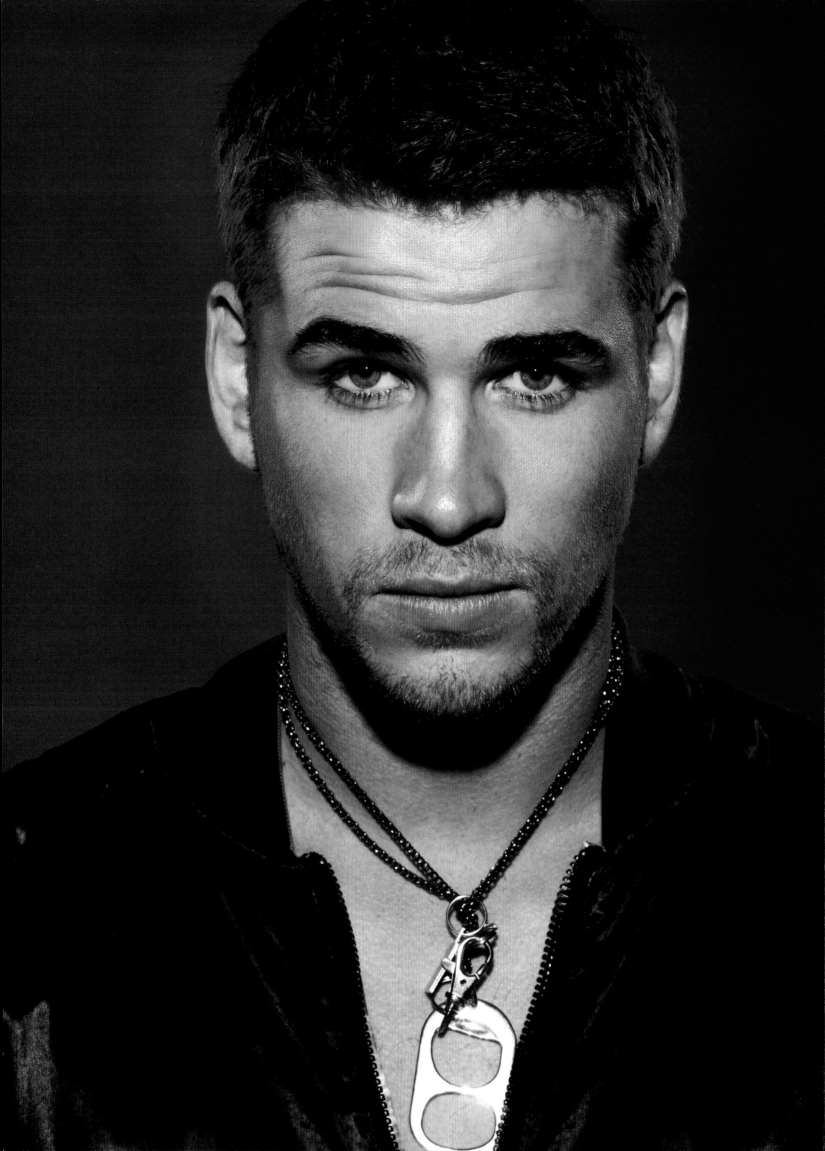

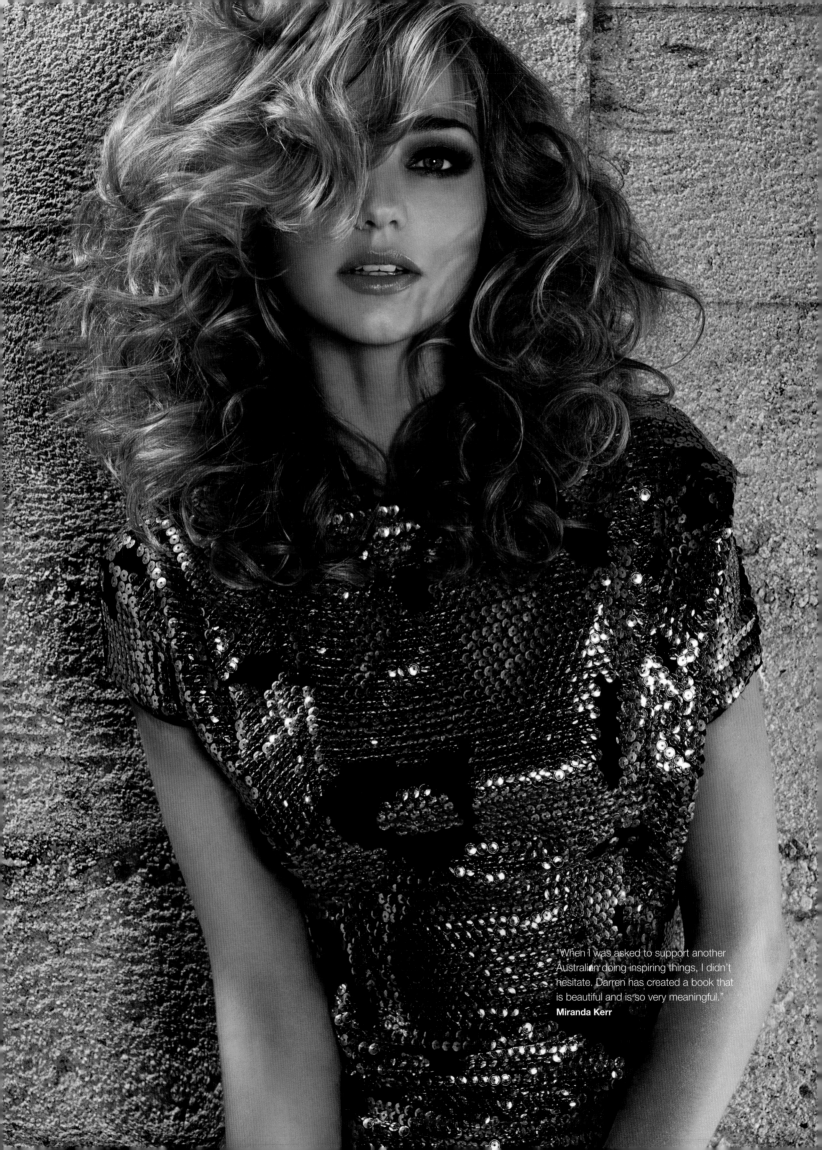

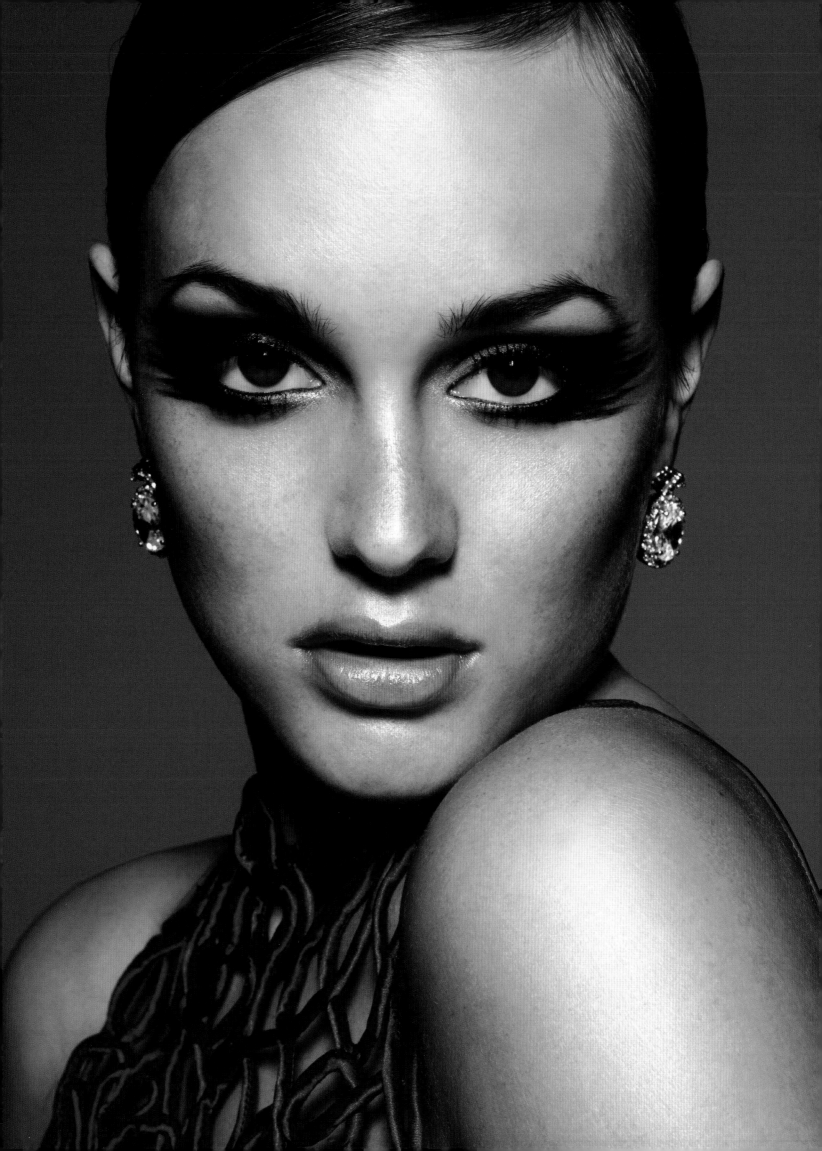

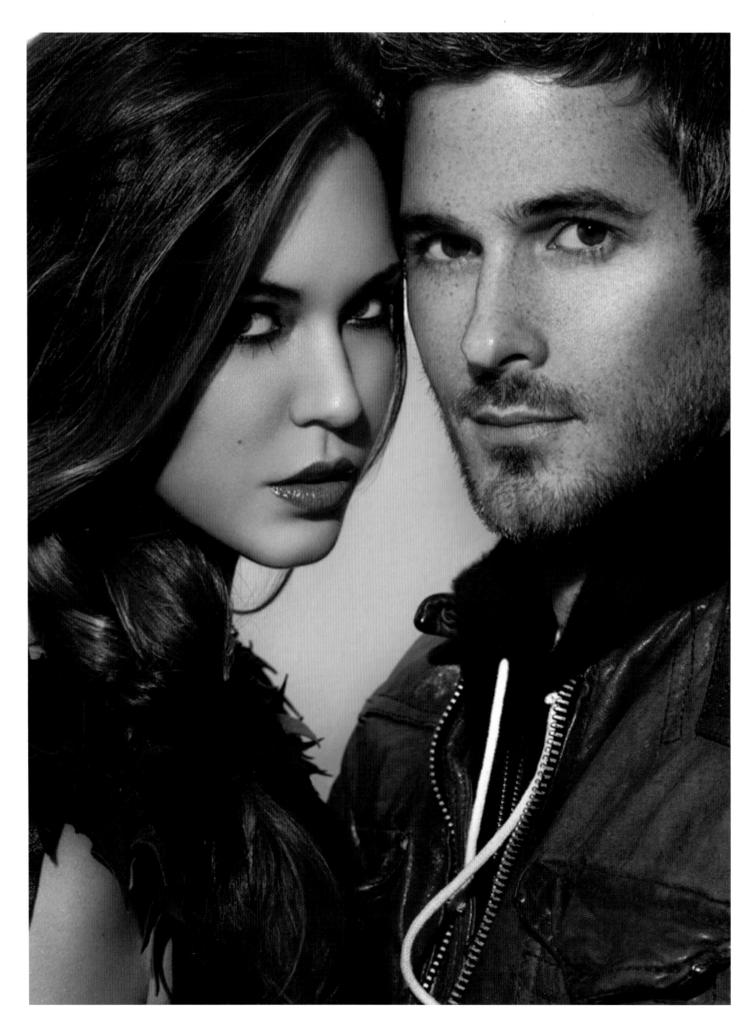

"Not only do we have a personal tie to help fight for our dear friend Pantera Sarah's mother, we are also so humbled to be able to make a stand to help fight brain cancer altogether." **Dave** and **Odette Annable**

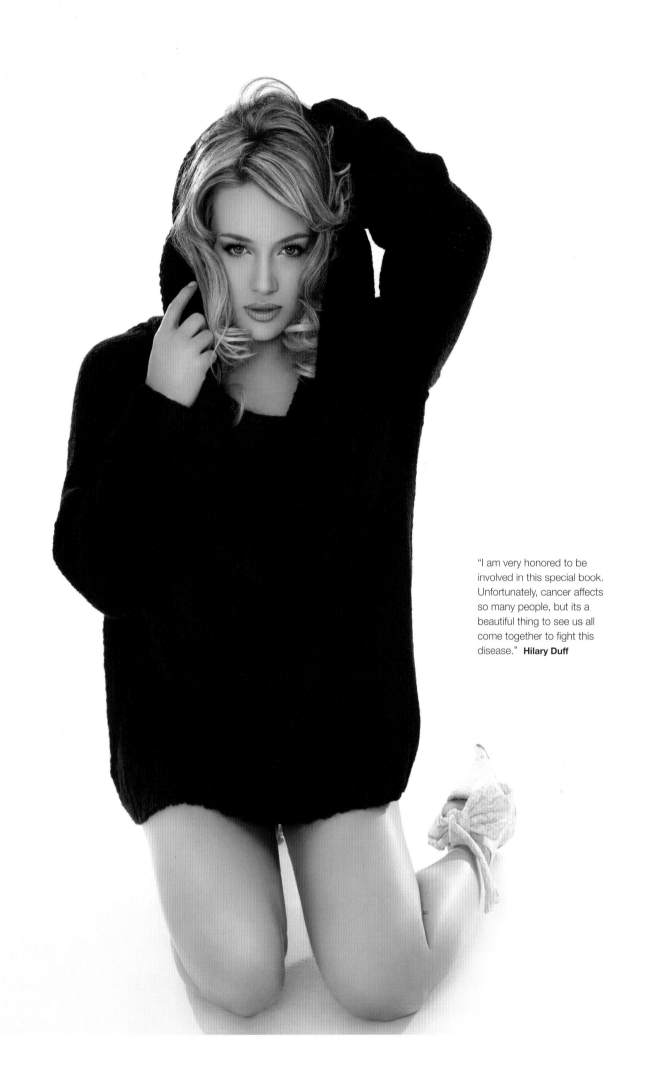

"I am very honored to be involved in this special book. Unfortunately, cancer affects so many people, but its a beautiful thing to see us all come together to fight this disease." **Hilary Duff**

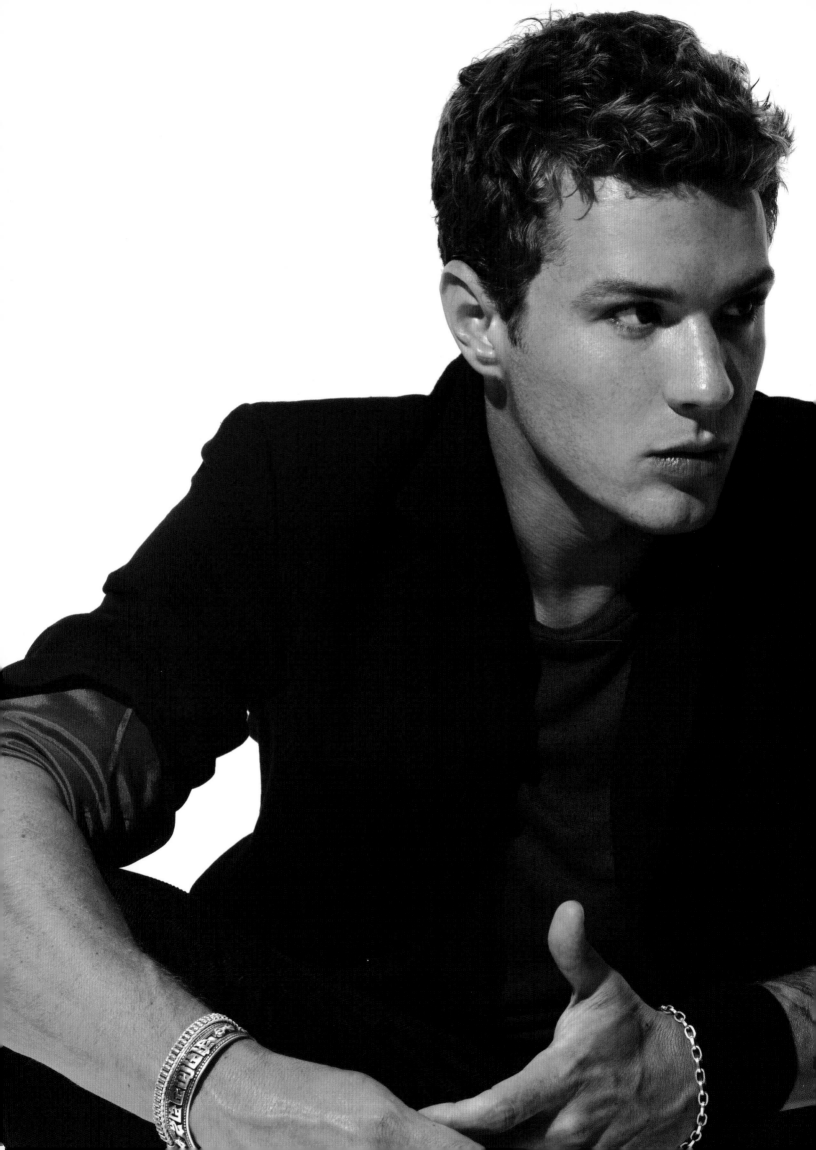

"I was honored to be a part of a project born out of the purest intentions and the most profound pain. The families and friends of those afflicted live in the hope that comes with the steadfast pursuit of a cure." **Ryan Philippe**

"Being asked to be involved in this brain cancer project was not only humbling but also enlightening. I support the quest for a cure and hope this project raises money and more importantly, awareness." **Carey Mulligan**

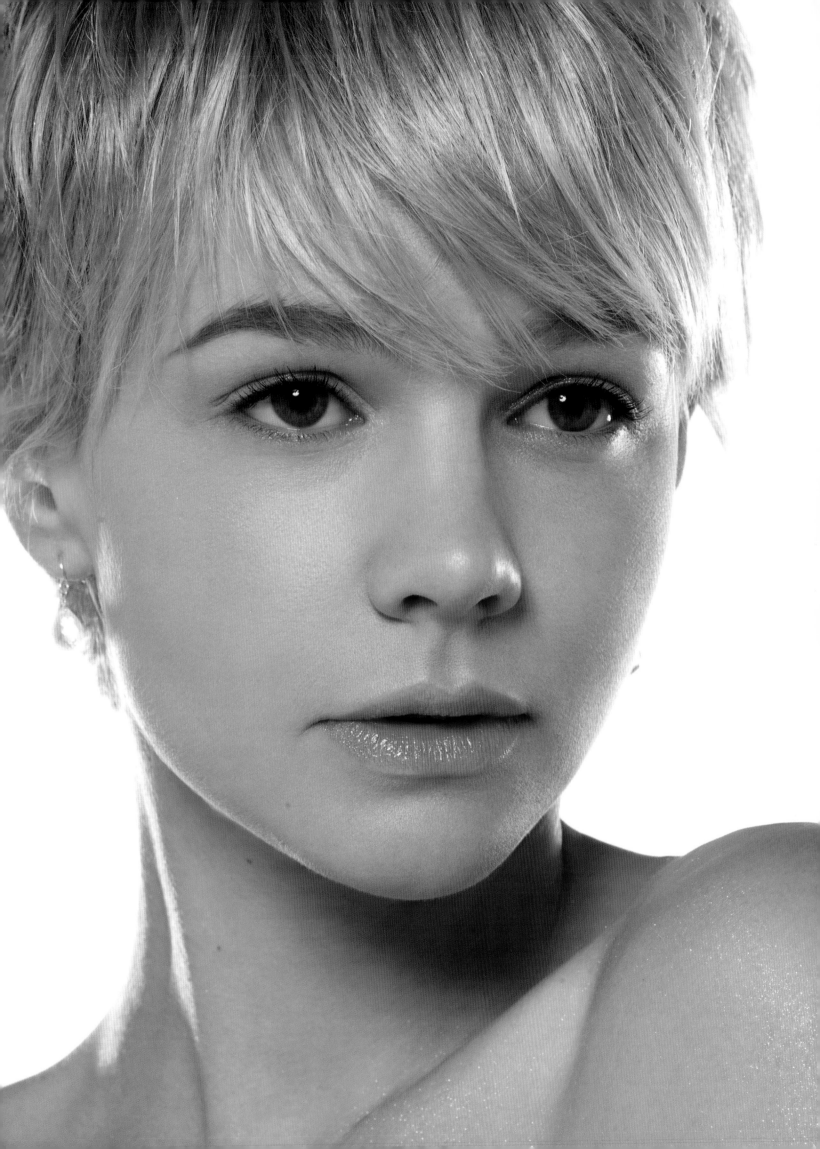

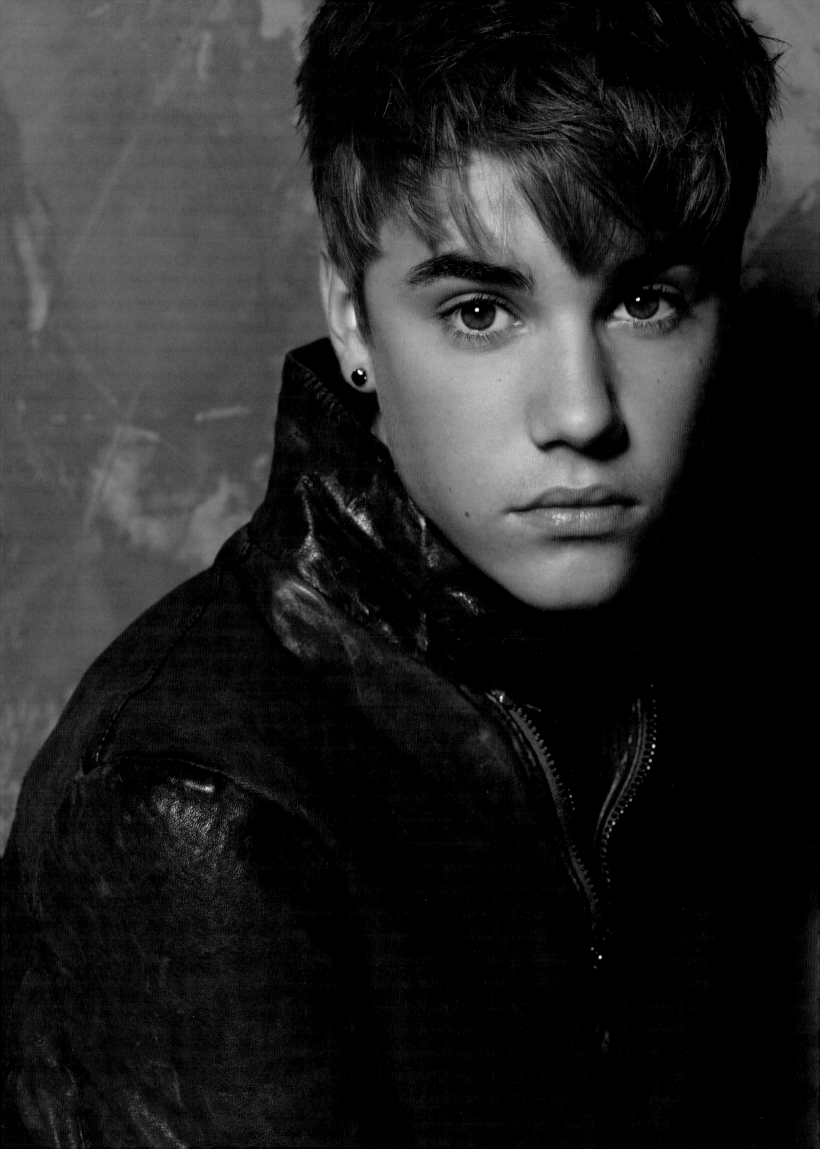

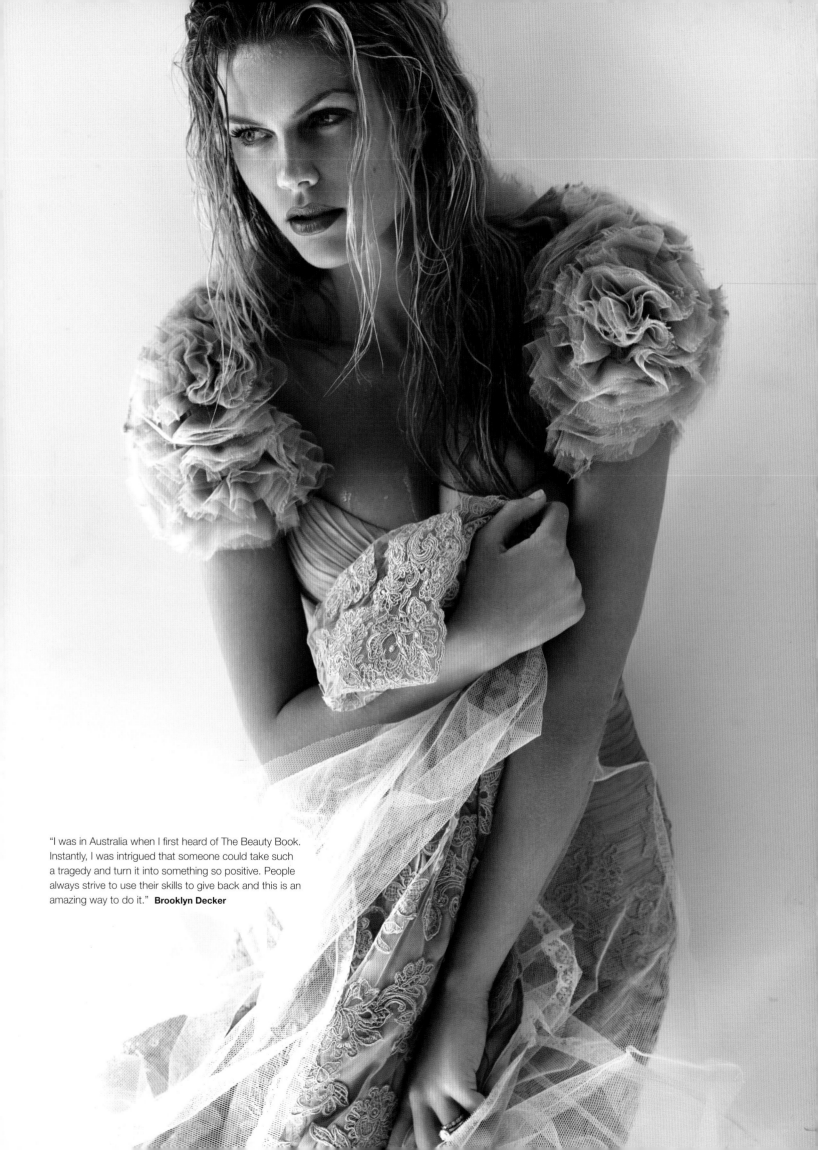

"I was in Australia when I first heard of The Beauty Book. Instantly, I was intrigued that someone could take such a tragedy and turn it into something so positive. People always strive to use their skills to give back and this is an amazing way to do it." **Brooklyn Decker**

"It is imperative that we continue to raise awareness on the battle against brain cancer. I am honored to have gotten to work with such an incredible photographer and to be part of this project that will ultimately help save lives." **Hayden Panettiere**

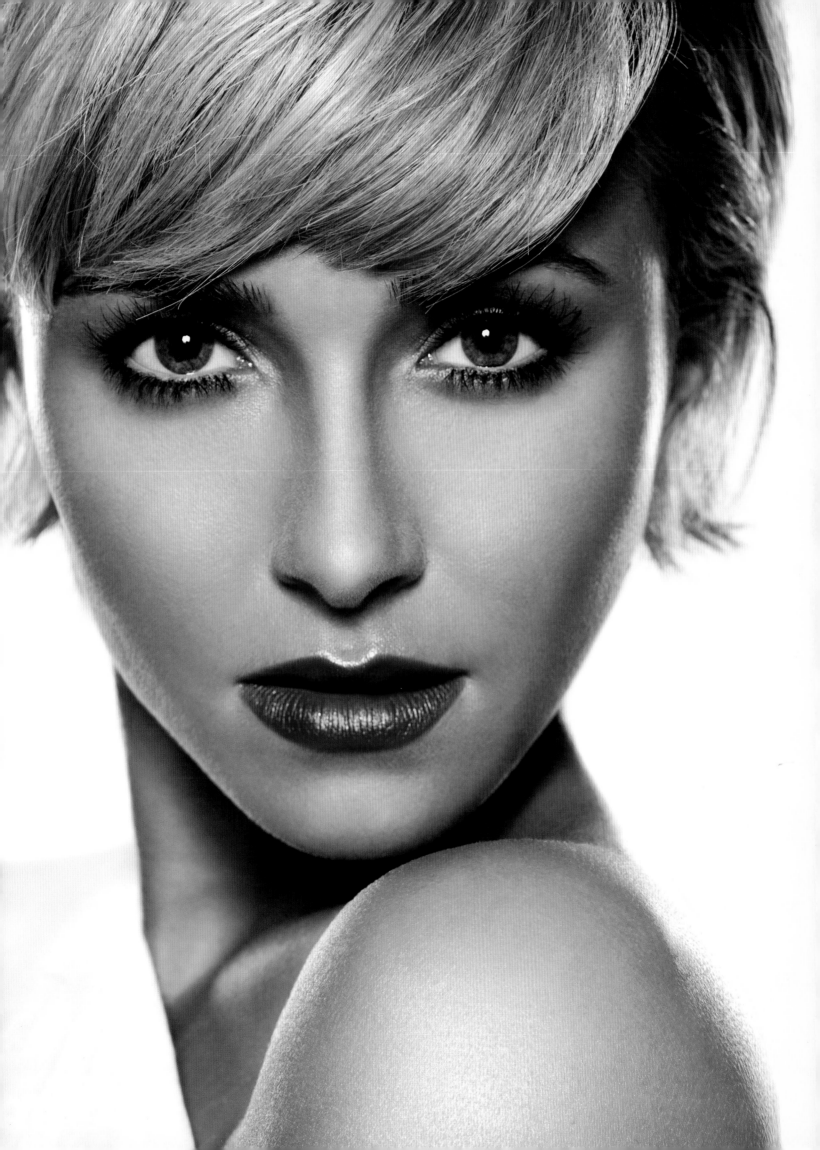

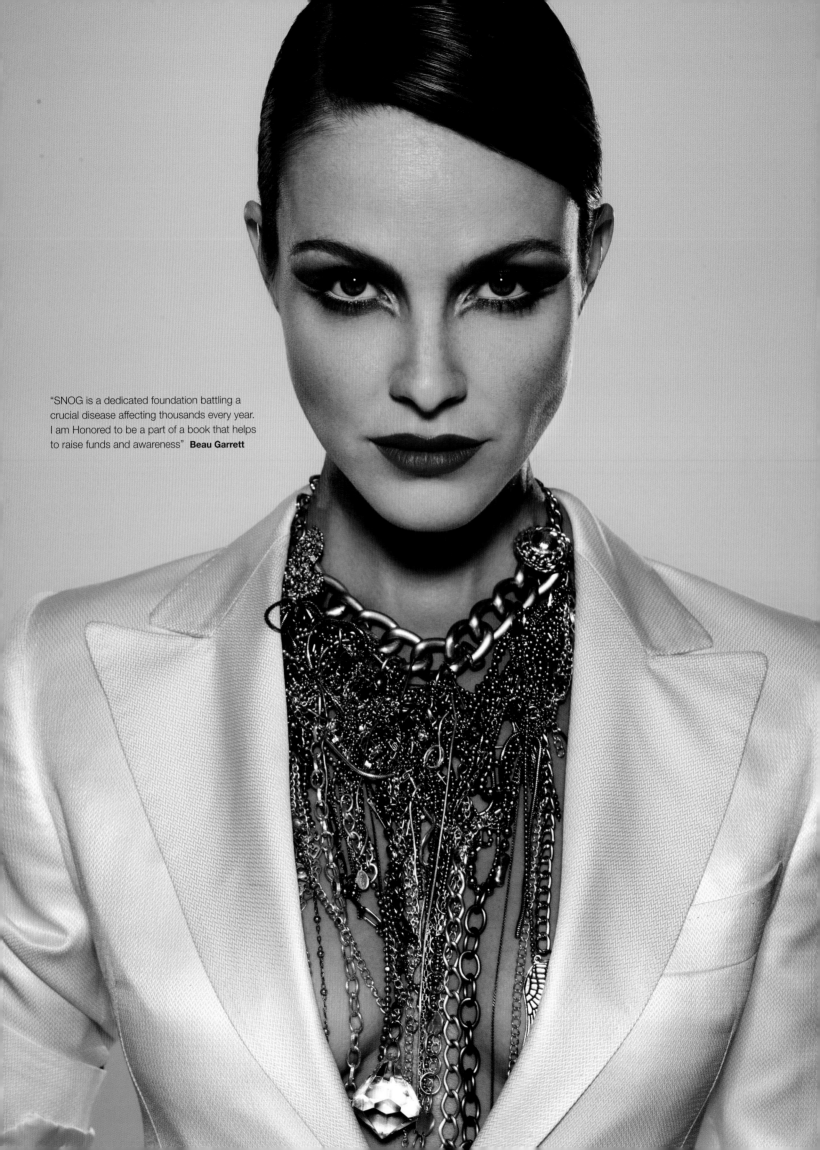

"SNOG is a dedicated foundation battling a crucial disease affecting thousands every year. I am Honored to be a part of a book that helps to raise funds and awareness" **Beau Garrett**

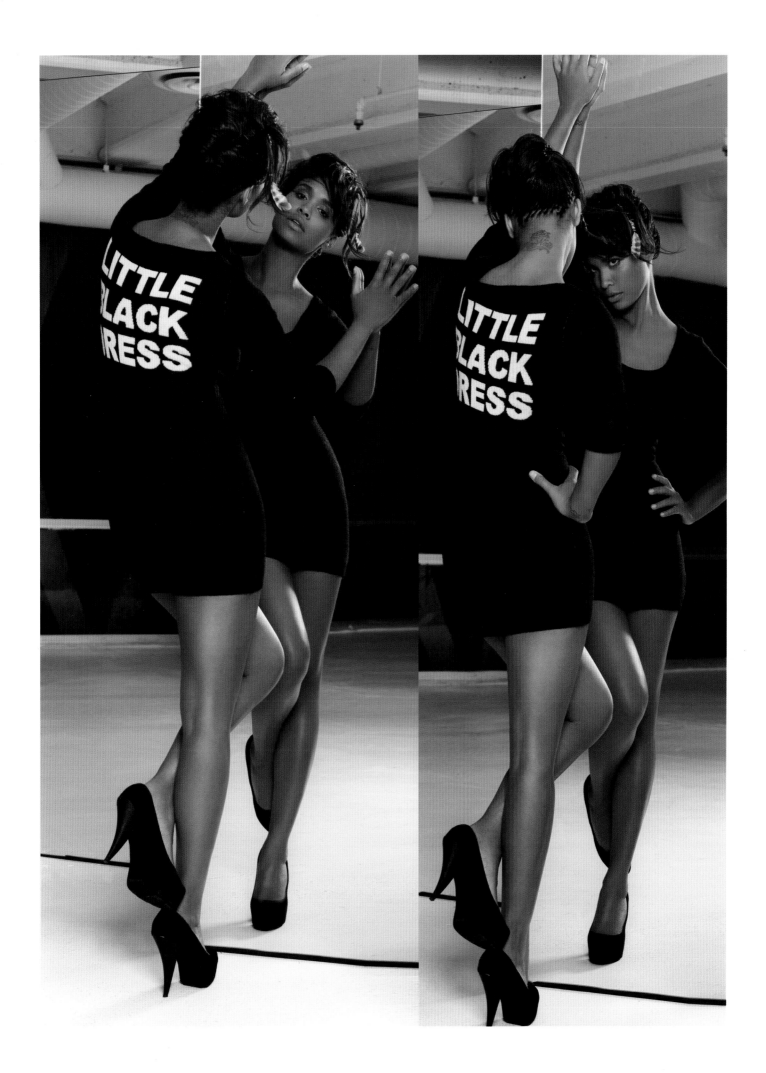

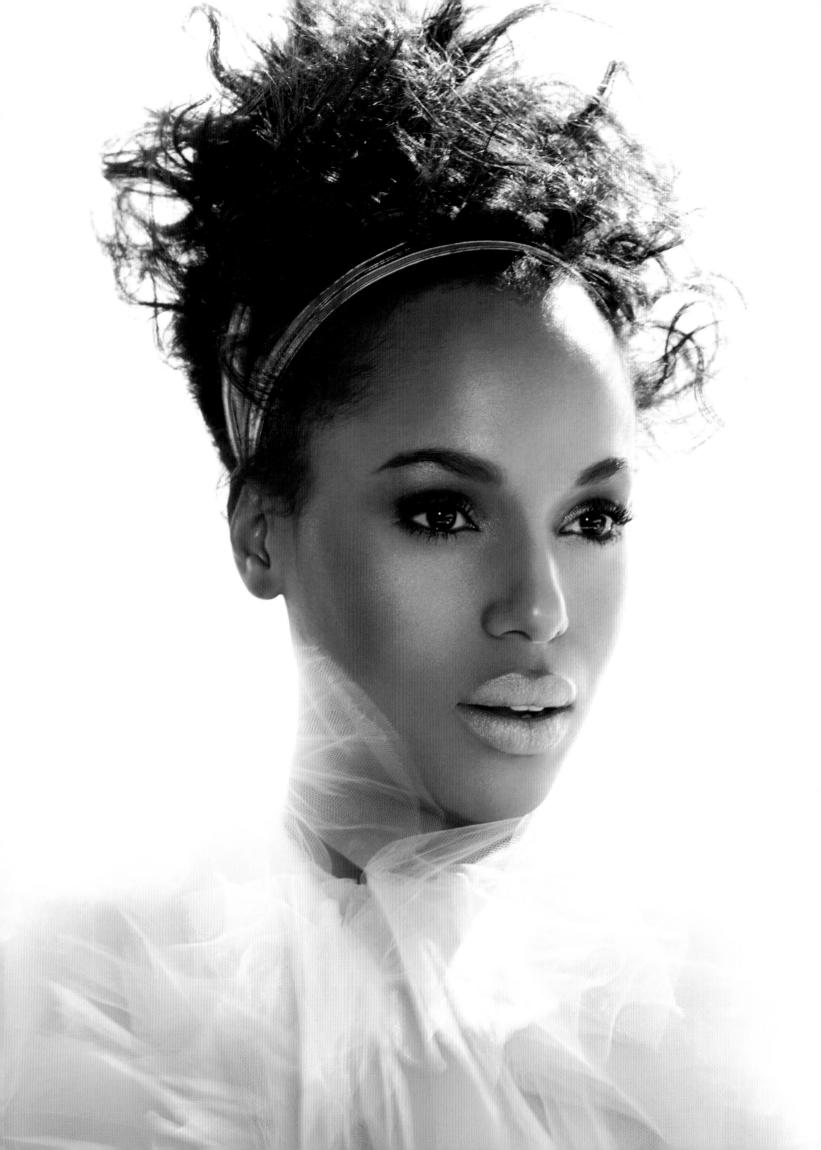

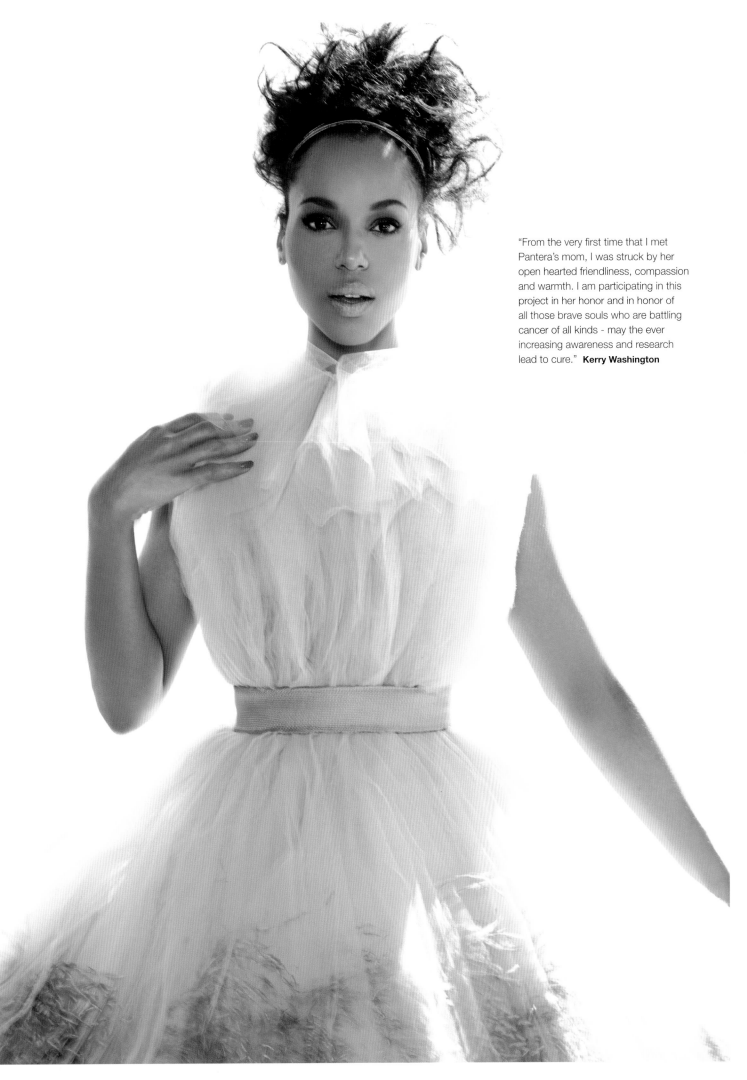

"From the very first time that I met Pantera's mom, I was struck by her open hearted friendliness, compassion and warmth. I am participating in this project in her honor and in honor of all those brave souls who are battling cancer of all kinds - may the ever increasing awareness and research lead to cure." **Kerry Washington**

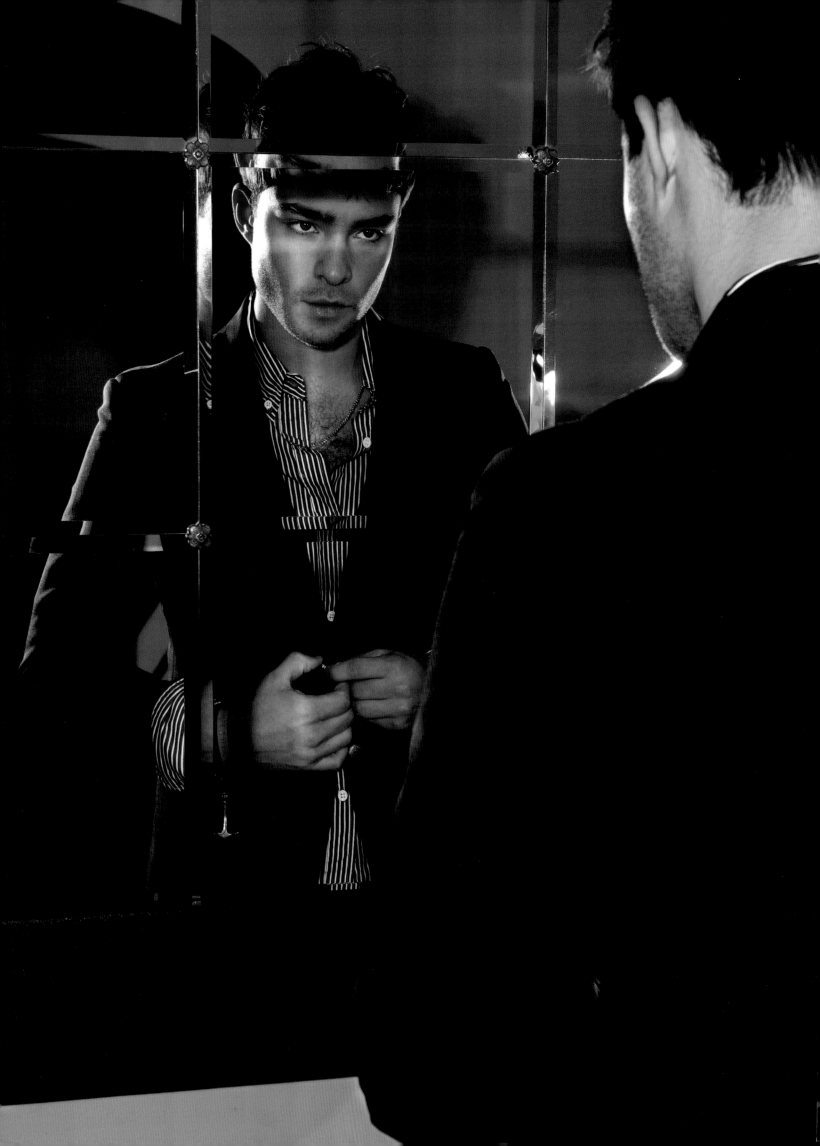

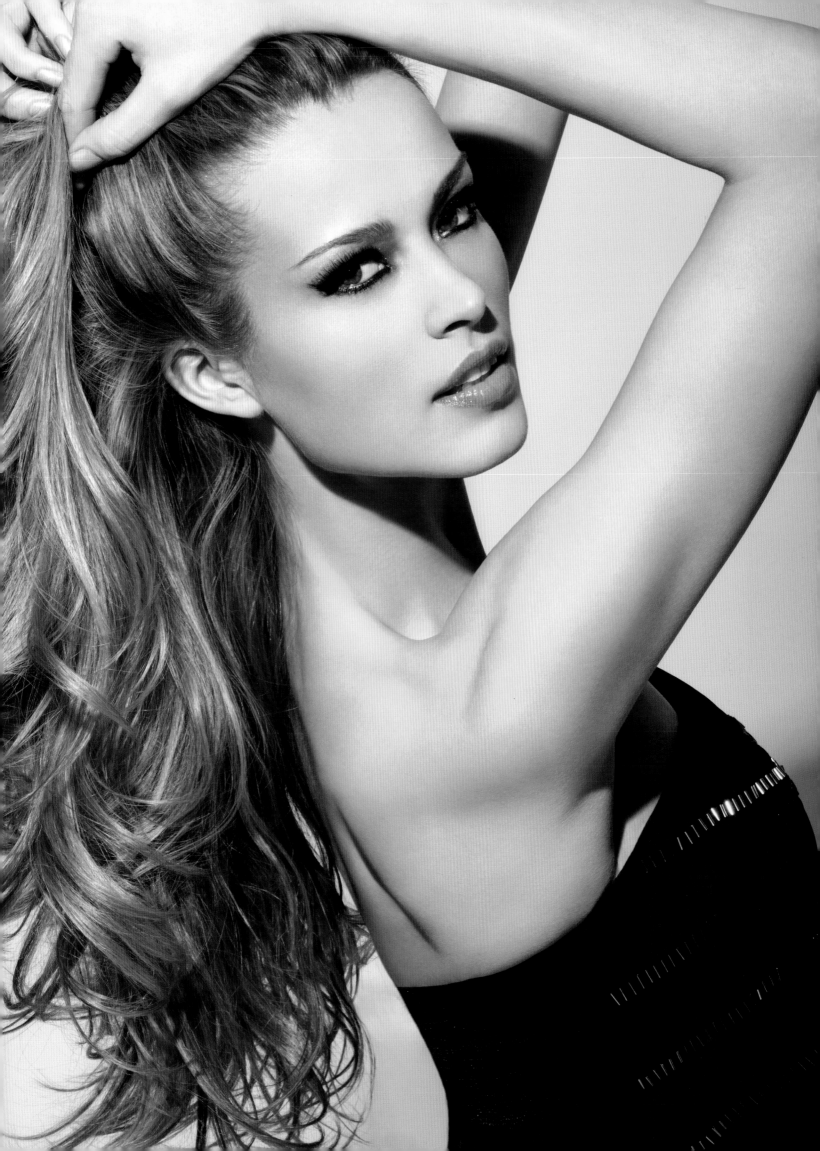

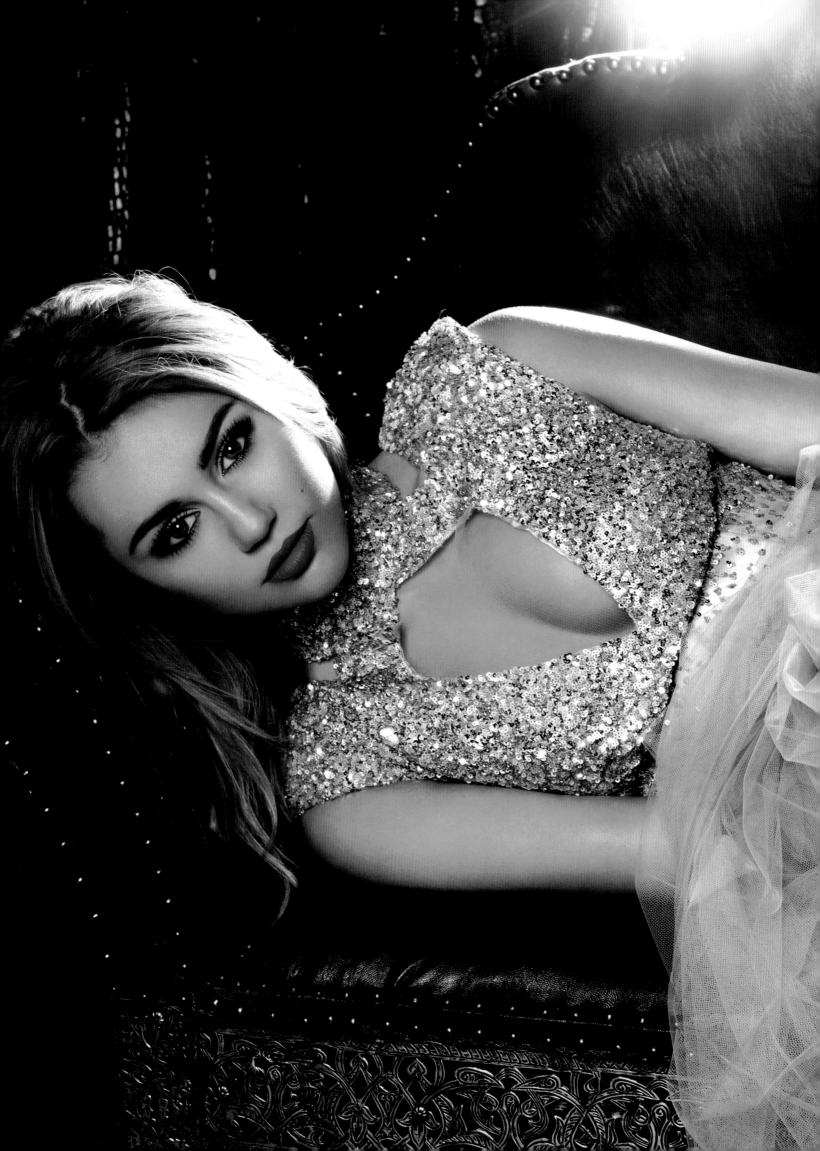

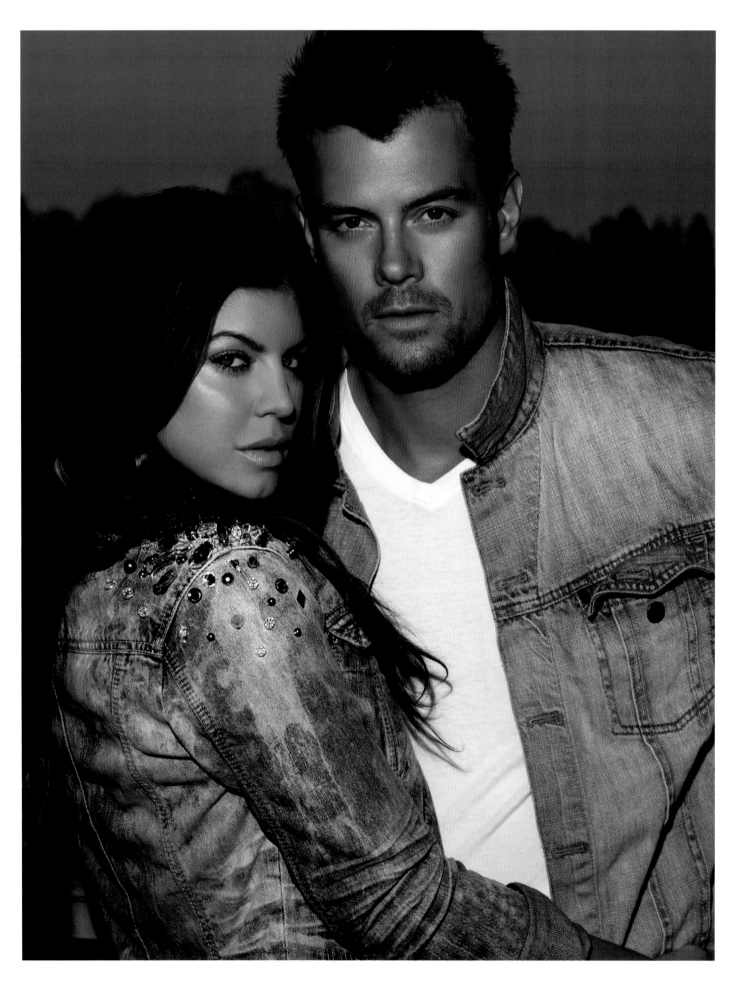

"My life long friend, Pantera Sarah's mom, who've I've known for many years, was diagnosed with brain cancer in 2010. When I was asked to be part of this book, I didn't think twice. Josh and I wanted to be a part of it to raise awareness and money for the fight against cancer." **Fergie**

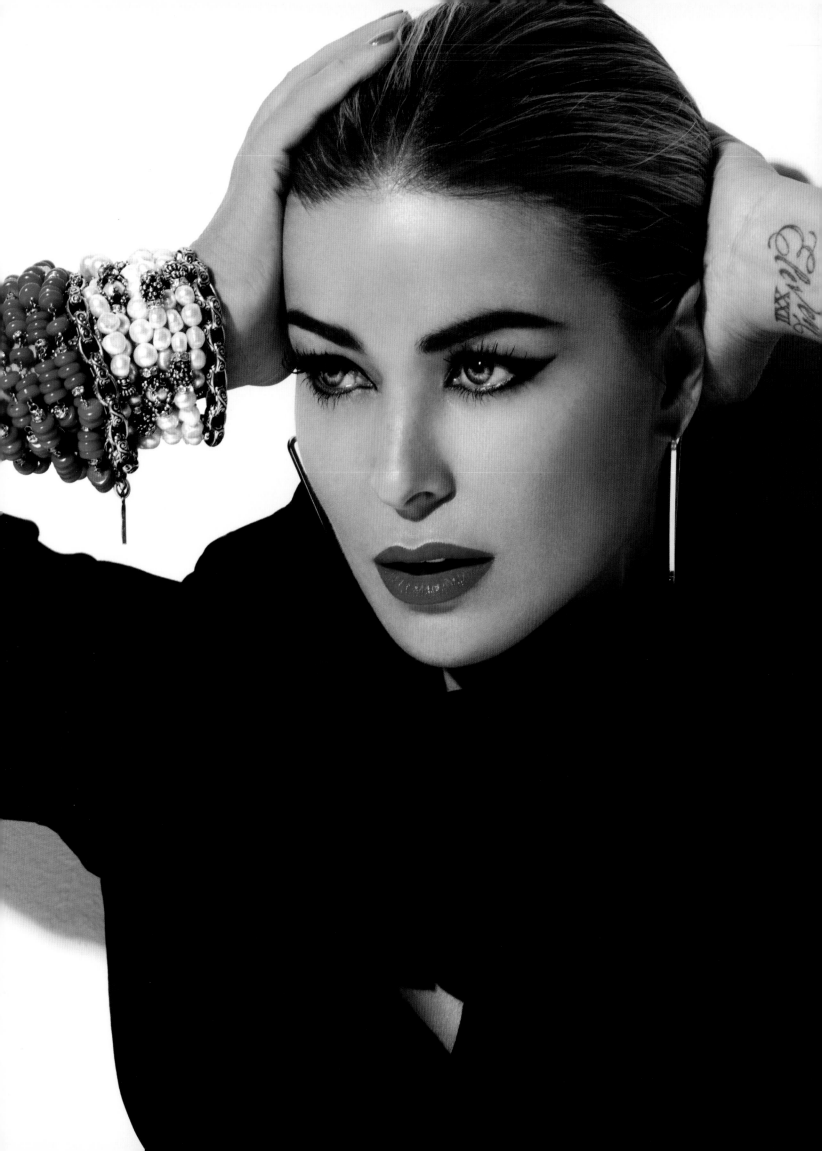

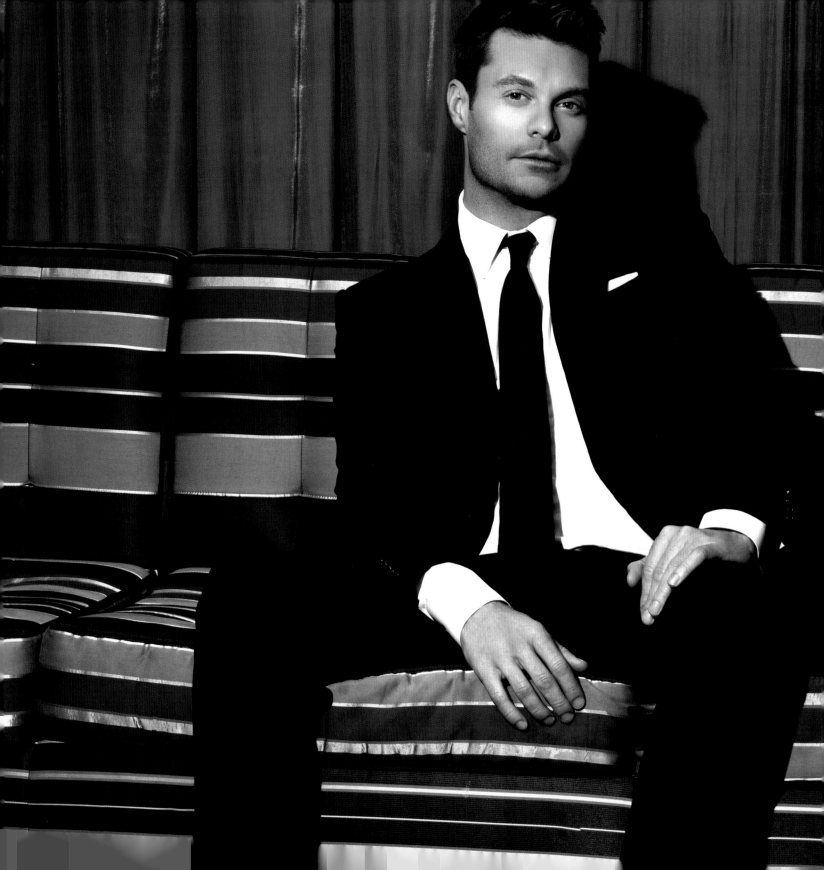

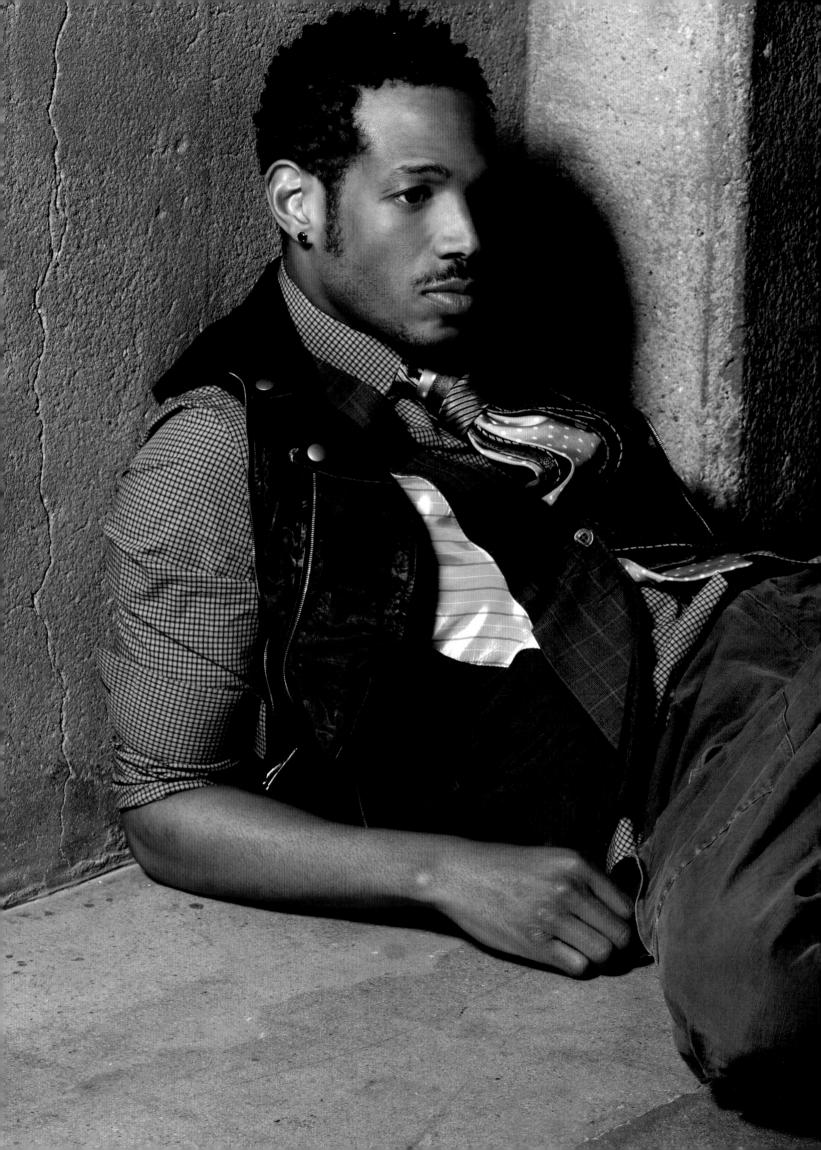

"Brain cancer doesn't just affect the person; it affects their entire family, circle of friends and loved ones. I know many have passed because of this disease. I want to do any and everything I can to raise awareness and help these families." **Marlon Wayans**

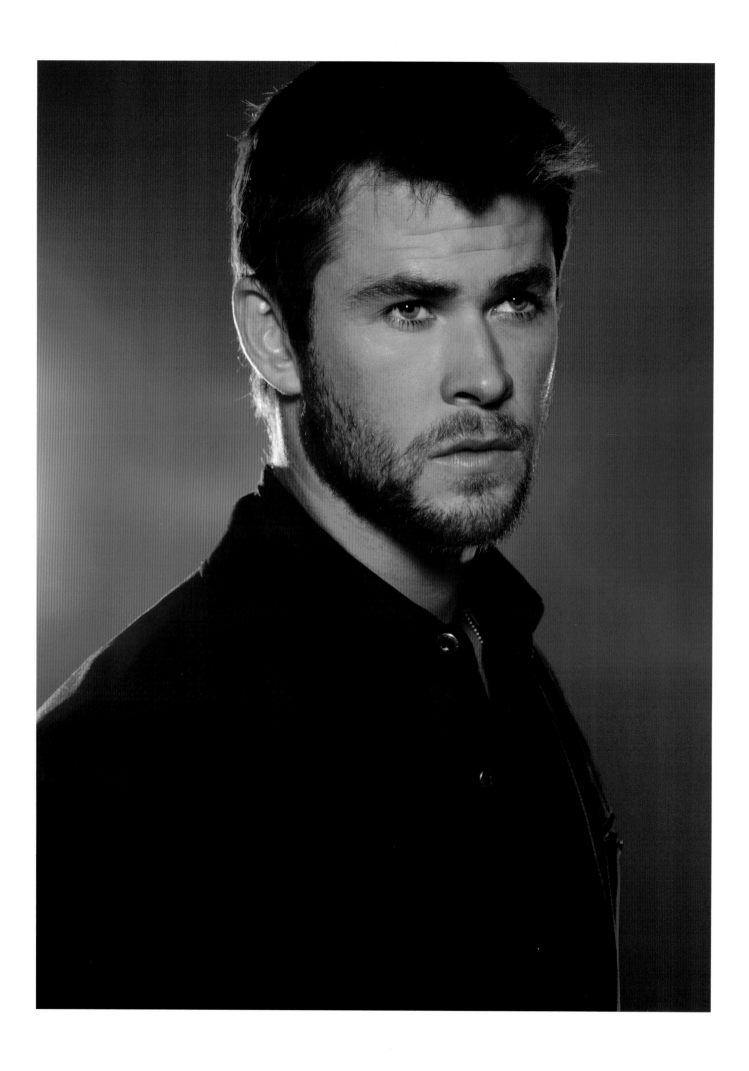

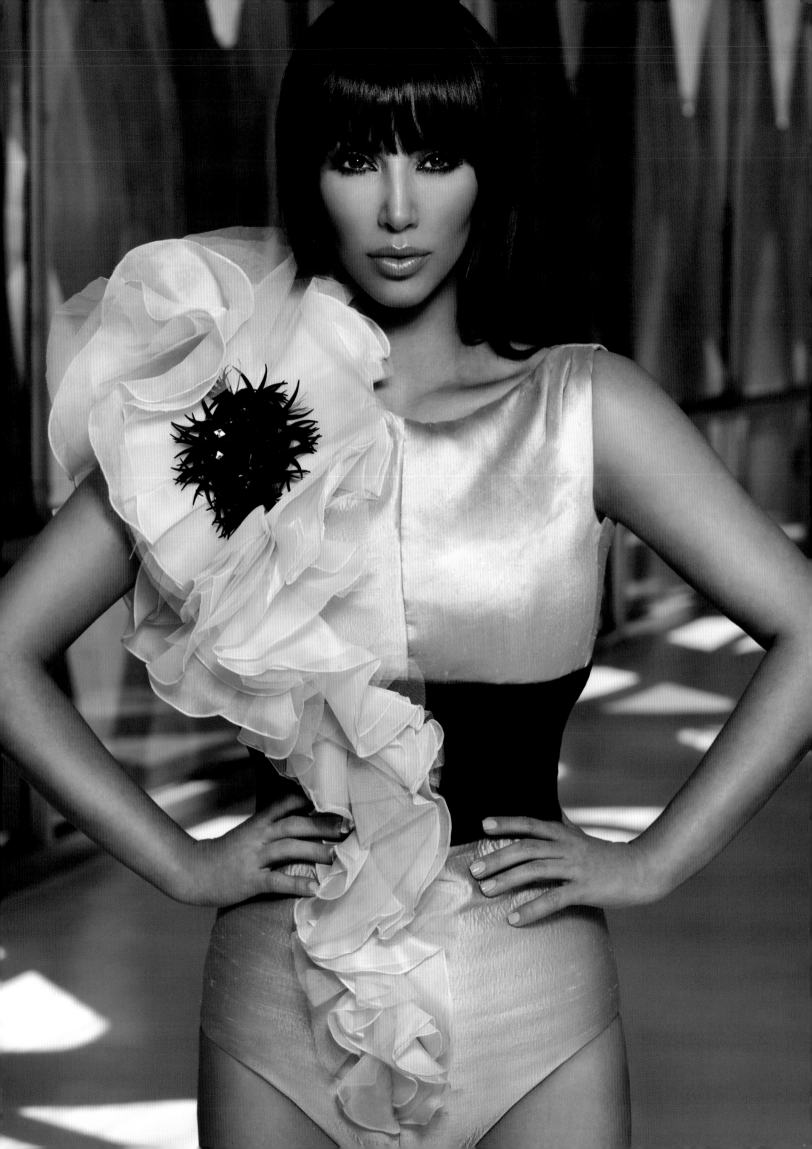

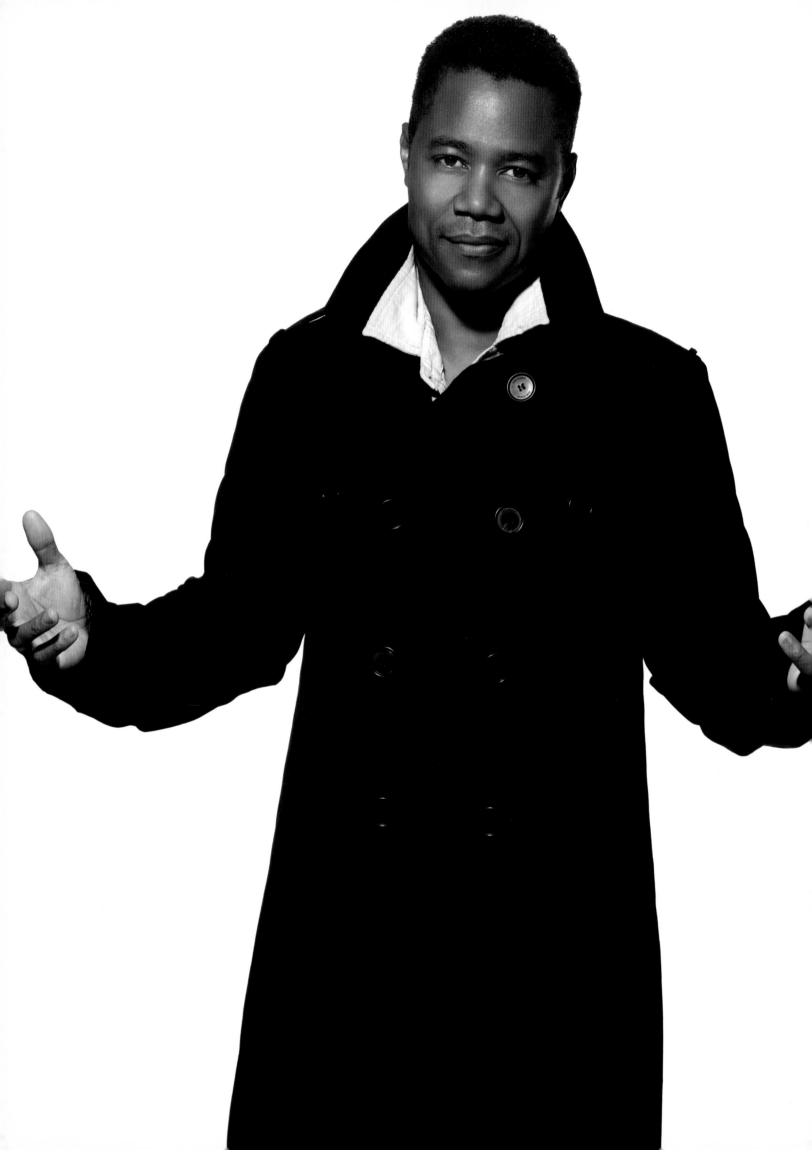

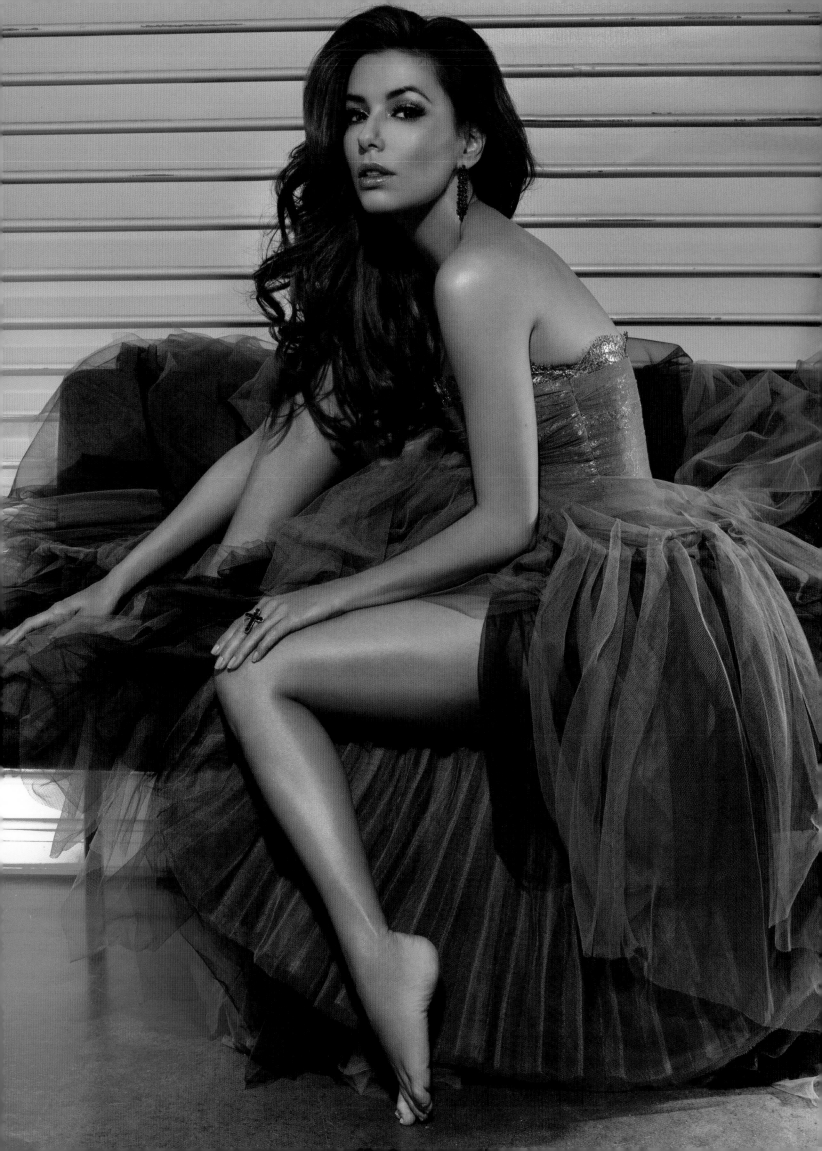

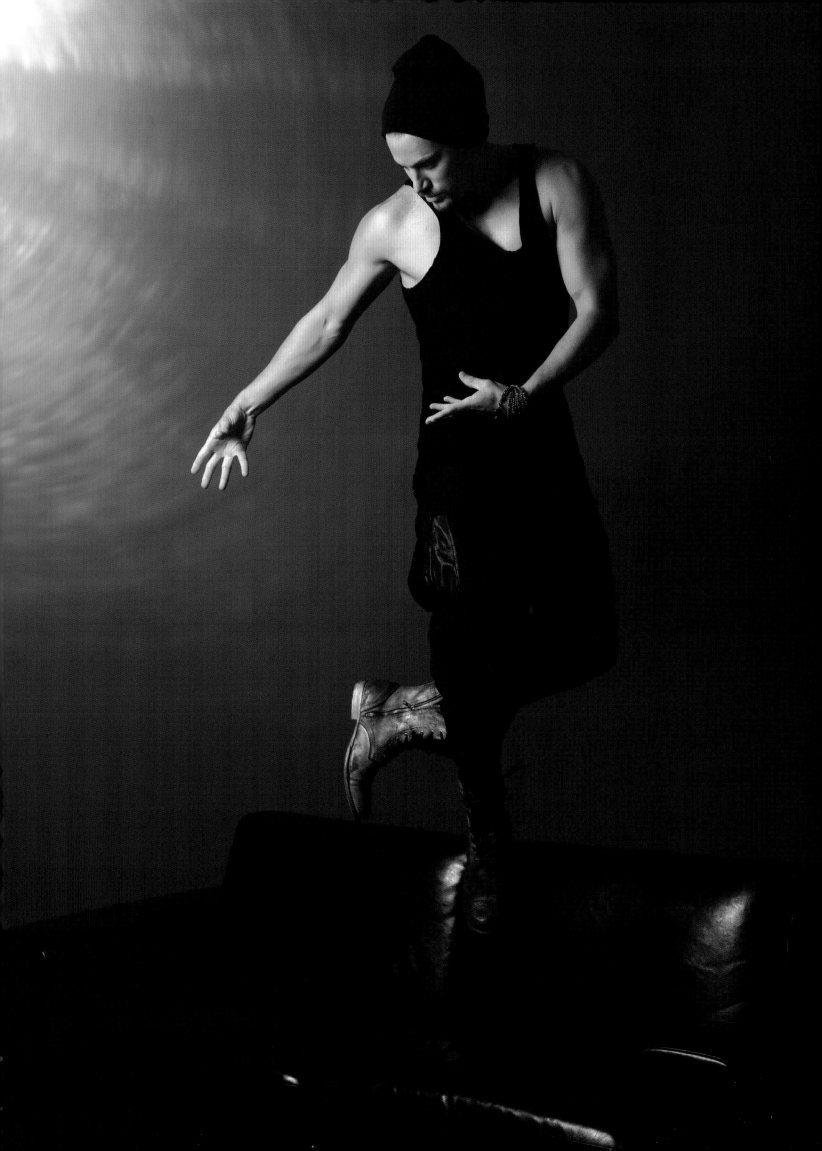

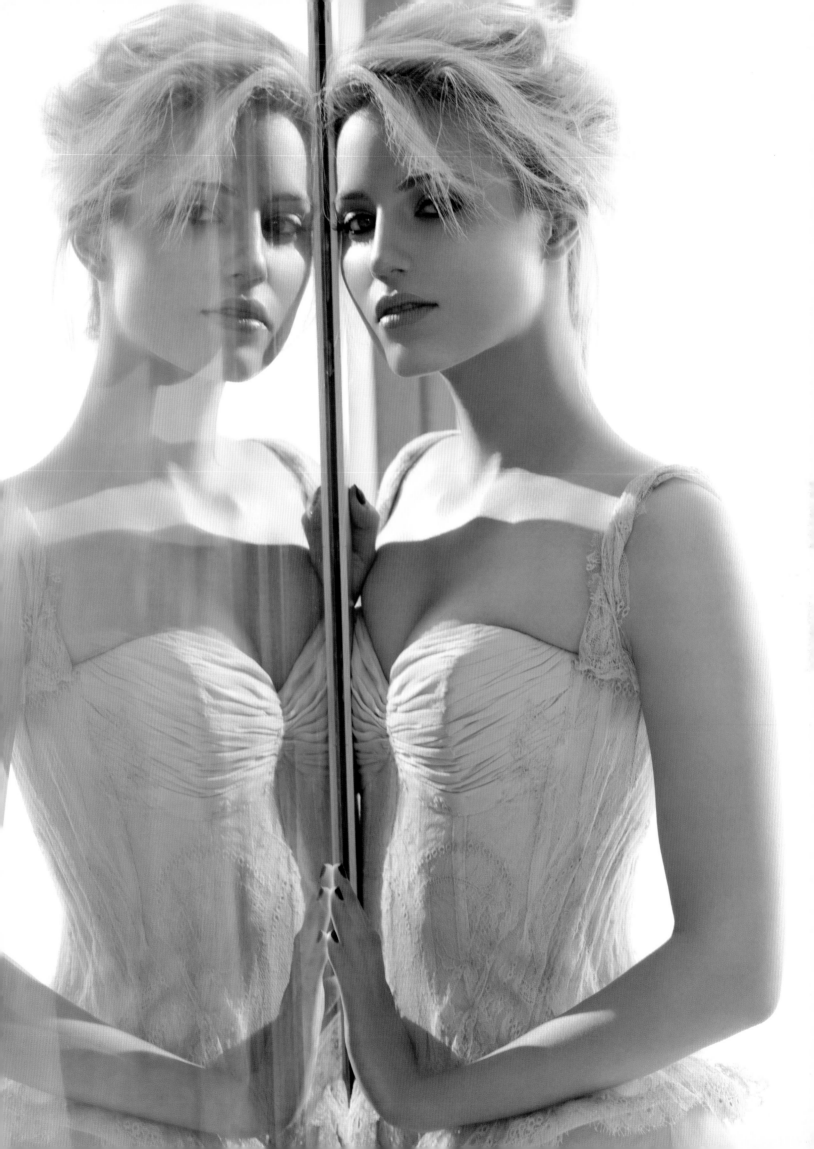

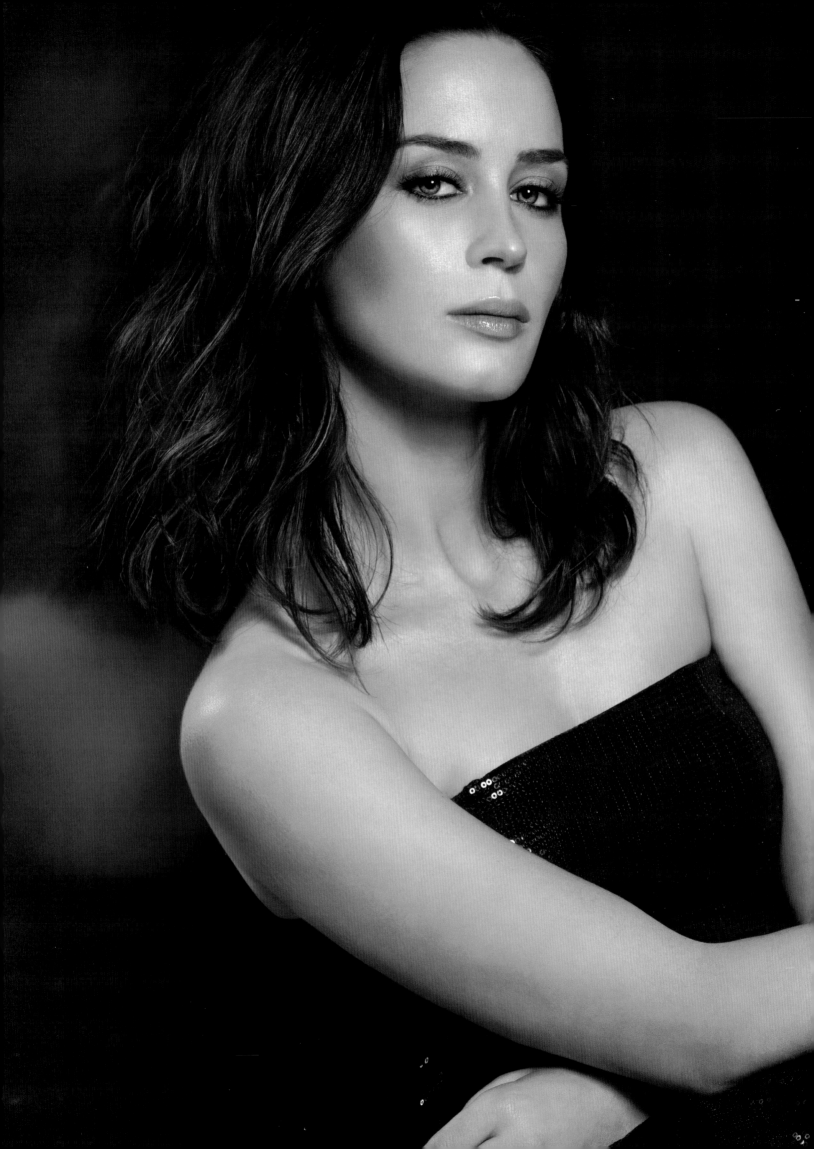

"It was a genuine honor to be asked by Darren to be shot for this inspiring book. I was very happy to be able to support SNOG and the invaluable work that they are doing to combat brain cancer and it has been a privilege to learn more about the organization through working with Darren on this beautifully shot project." **Emily Blunt**

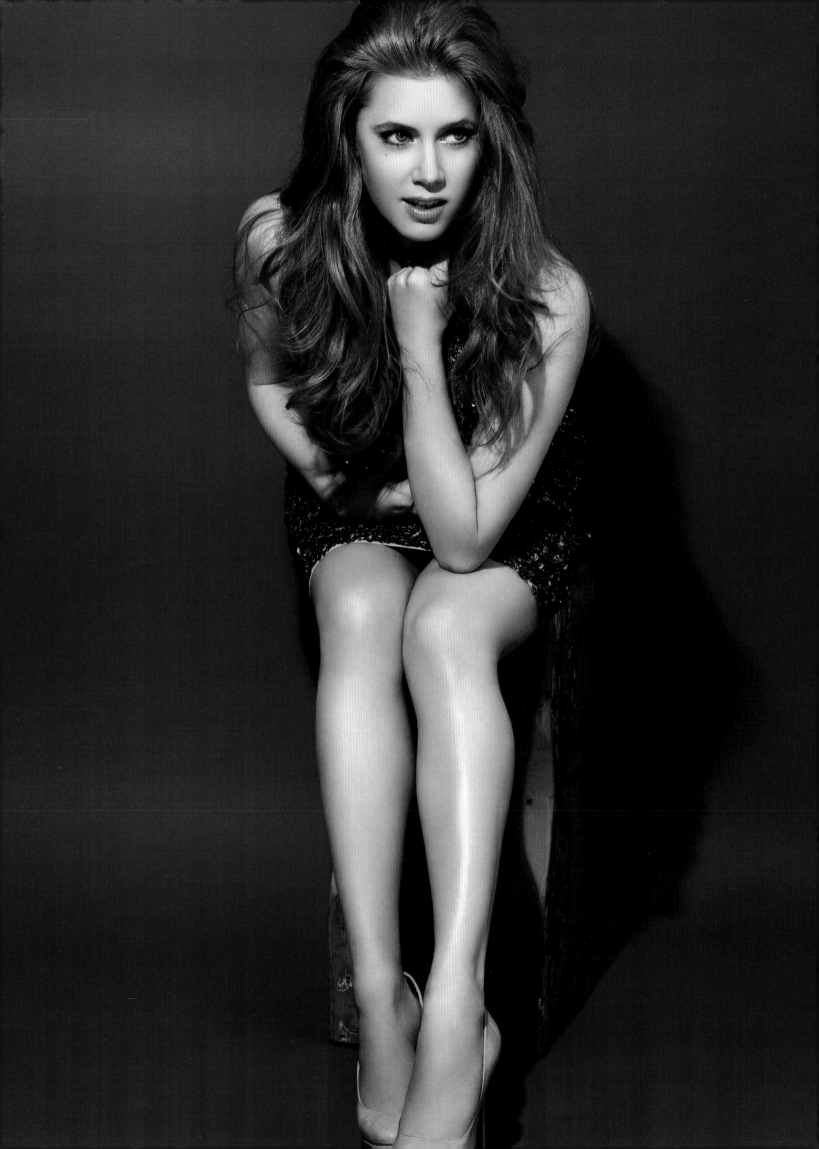

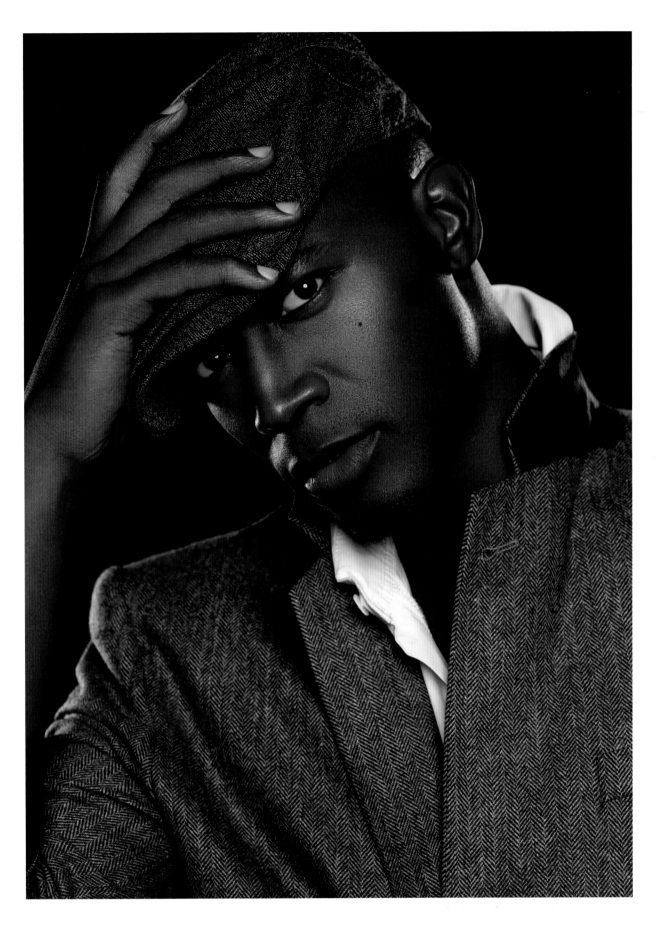

"Pantera Sarah has been responsible for my social life in Los Angeles. Despite my allegiance to NYC, she made LA seem welcoming and full of energy. She has always been down to earth and honest. Upon hearing of her mother's diagnosis, I immediately wanted to do whatever I could to help. Hopefully this book will effect people in a positive way and assist in the battle against brain cancer." **Taye Diggs**

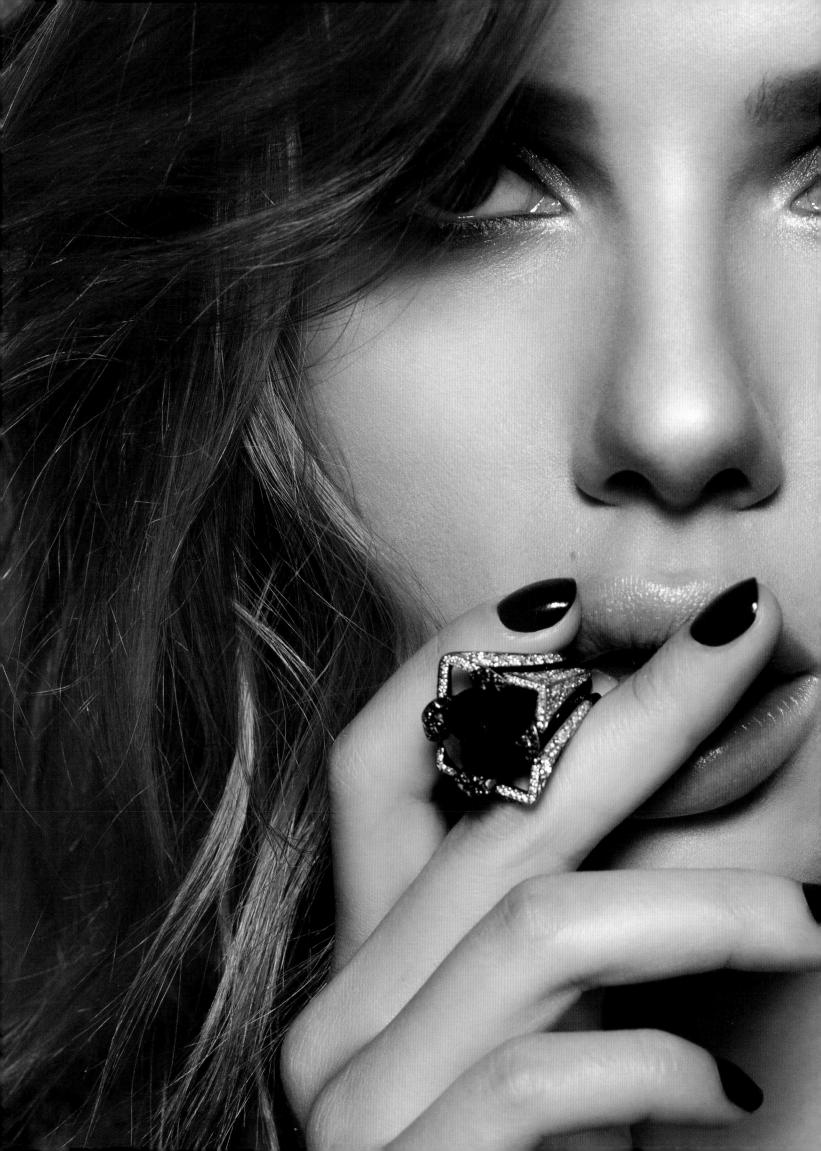

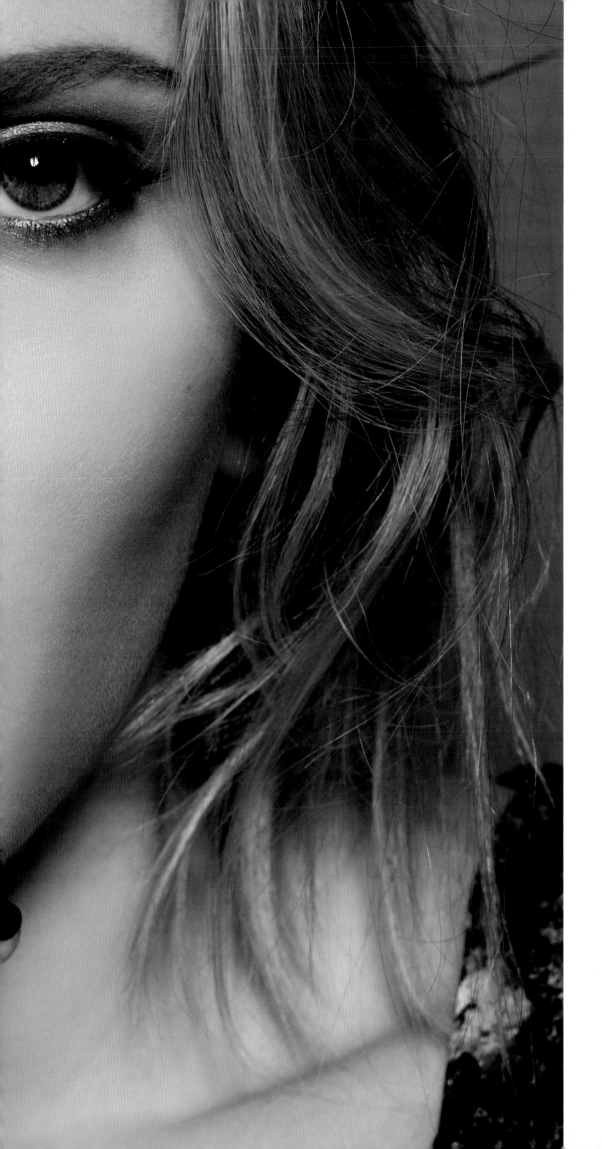

CPi SYNDICATION

SMASHBOX DIGITAL

Samy's Camera

high profile
productions

SMASHBOX

5th and Sunset | Studios

SMUDGEPHOTOSTUDIO.COM

miauhaus

1201 south la brea avenue, los angeles, ca 90019 t 323.933.6180 f 323.933.6279
mail@miauhaus.com www.miauhaus.com

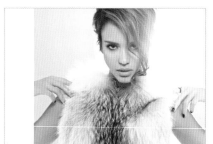

Jessica Alba wears leather & fox fur vest by Thomas Wilde
MAKEUP Lauren Anderson
HAIR Robert Ramos
MANICURE Jenna Hipp
PHOTO ASSISTANT Andrew Ryan
RETOUCHING Kristen Lauber
SHOT AT Smudge Studio

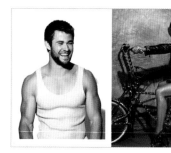

Chris Hemsworth in oatmeal ribbed tank top by LeonardoAguirre
GROOMING Chechel Joson
HAIR David Stanwell
PHOTO ASSISTANT Andrew Ryan
SHOT AT Miahaus Studios
Fergie in Amercian Apparrell leotard, Robins Jeans studded jacket & Fergie footwear
MAKEUP Ronit Shapow
PHOTO ASSISTANT Chris Noonan
RETOUCHING Kristen Lauber

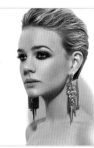

Justin Timberlake wears leather bomber & wool peacoat both by All Saints
GROOMING Kelsey Deenihan
PHOTO ASSISTANT Andrew Ryan
SHOT AT Miahaus studios
Carey Mulligan wears Gasoline couture
MAKEUP Georgie Eisdell
HAIR Jenny Cho
PHOTO ASSISTANT Andrew Ryan
RETOUCHING Kristen Lauber
SHOT AT 5th & Sunset Studio

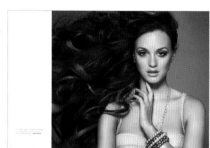

Leighton Meester wears vintage fishnet dress by Givenchy Vintage Gold & Diamond Earrings & Bracelet by Chanel, Diamond Ring by Neil Lane
MAKEUP Stephen Sollitto
HAIR Rick Gradone
FASHION STYLIST Logan Horne
MANICURE Jenna Hipp
PHOTO ASSISTANT Leonardo Esposito
RETOUCHING Grace Testa
SHOT AT Smashbox Studio

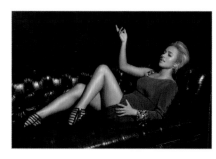

Hayden Panettiere wears Chagoury Couture dress & shoes by Victor & Rolfe
MAKEUP Amy Oresman
MANICURE Jenna Hipp
PHOTO ASSISTANT Alice Chabtini
RETOUCHING Kristen Lauber
SHOT AT Smudge Studios

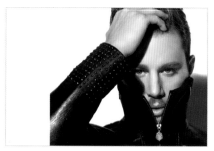

Channing Tatum wears studded zip leather bomber by Skin Graft
GROOMING Glenn Nutley
PHOTO ASSISTANT Andrew Ryan
RETOUCHING Kristen Lauber
SHOT AT Miahaus studios

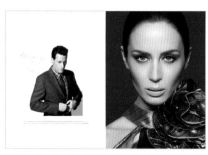

Ioan Gruffudd wears suit, shirt & tie by Paul Smith
GROOMING Chechel Joson
HAIR Sally Henley
PHOTO ASSISTANT Andrew Ryan
SHOT AT Smudge Studios
Emily Blunt wears sheer silk organza halter top with rose by Ella Zallan.
MAKEUP Matthew VanLeeuwen
HAIR Laini Reeves
MANICURE Jenna Hipp
PHOTO ASSISTANT Andrew Ryan
RETOUCHING Judith Caingat
SHOT AT Miauhaus Studios

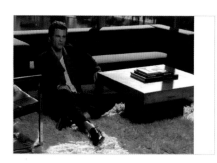

James Marsden wears white V neck Tshirt by James Perse, grey knit by All Saints, black wool blazer by All Saints, navy trouser by Armani Xchange, black leather brogue by Prada
GROOMING Amy Oresman
HAIR David Stanwell
PHOTO ASSISTANT Andrew Ryan
SHOT AT www.concreteloft.com

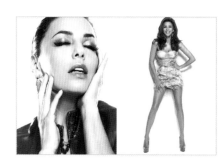

Eva Longoria wears leather jacket by Chagoury Couture, gold wing earrings with rubies & black + yellow diamond necklaces by Theodore (right) Pink corset dress with feather by Chagoury Couture & nude pumps by Christian Louboutin, Diamond earrings & diamond ring by Loree Rodkin
MAKEUP Iris Moreau
HAIR Glenn Nutley
MANICURE Jenna Hipp
PHOTO ASSISTANT Andrew Ryan
RETOUCHING Kristen Lauber
SHOT AT Smashobx Studios

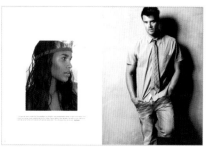

Joy Bryant wears feathered head dress by Gara Gamboucci
MAKEUP Garret Gervais
HAIR Glenn Nutley
PHOTO ASSISTANT Andrew Ryan
RETOUCHING Kristen Lauber
SHOT AT www.concreteloft.com
Josh Duhamel wears Levis jeans, his own shirt
PHOTO ASSISTANT Chris Noonan

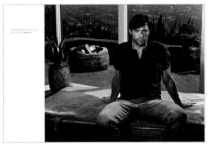

Hugh Jackman wears T-Shirt by
John Varvatos for Converse, Jeans
by Michael Kors
GROOMING Amy Nadine
FASHION STYLIST Albert Mendonca
PHOTO ASSISTANT Leonardo Esposito
RETOUCHING Judith Caingat

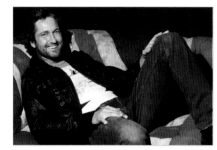

Gerard Butler wears his own clothes
GROOMING Chechel Joson
HAIR Sally Henley
PHOTO ASSISTANT Andrew Ryan
SHOT AT Smudge Studios

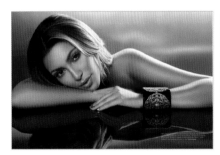

Kim Kardashian wears Cuff by Bo Chic
MAKEUP Mario Dedivanovic
HAIR Frankie Payne
FASHION STYLIST Albert Mendonca
MANICURE Chris
PHOTO ASSISTANT Leonardo Esposito
RETOUCHING Judith Caingat
SHOT AT Miauhaus Studios

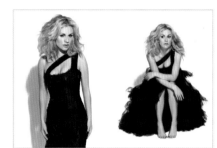

Anna Paquin wears Tony Ward dress
MAKEUP Sabrina Bedrani
HAIR Jenny Cho
FASHION STYLIST Albert Mendonca
MANICURE Jenna Hipp
PHOTO ASSISTANT Leonardo Esposito
RETOUCHING Kristen Lauber
SHOT AT Miauhaus Studios

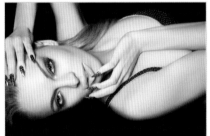

Lindsay Lohan wears Elle Macpherson
bra
MAKEUP & HAIR Glenn Nutley
MANICURE Jenna Hipp
PHOTO ASSISTANT Leonardo Esposito
RETOUCHING Judith Caingat
SHOT AT High Profile Productions

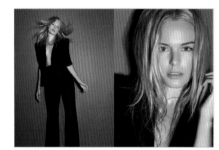

Kate Bosworth wears black tuxedo with
tails and cummerbund all by Nicole Miller
MAKEUP Amy Oresman
HAIR Clyde Haygood
MANICURE Jenna Hipp
PHOTO ASSISTANT Andrew Ryan
RETOUCHING Kristen Lauber
SHOT AT Smashbox Studios

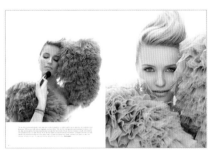

Dianna Agron wears lime green ruffled
shrug by Shane and Falguni Peacock
MAKEUP Amy Oresman
HAIR Clyde Haygood
PHOTO ASSISTANT Andrew Ryan
RETOUCHING Kristen Lauber
SHOT AT www.concreteloft.com

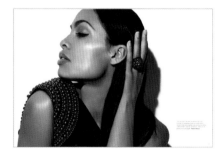

Rosario Dawson wears A-symmetrical
gown with beaded shoulder by Diva
Couture www.divacouture.com Vintage
cocktail ring
MAKEUP Agostina
HAIR Stephanie Hobgood
PHOTO ASSISTANT Andrew Ryan
RETOUCHING Judith Caingat

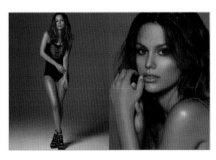

Rachel Bilson wears bodysuit with
chains by Todd Lynn, shoes by Mui Mui
MAKEUP Amy Oresman
HAIR Clyde Haygood
MANICURE Jenna Hlpp
PHOTO ASSISTANT Andrew Ryan
RETOUCHING Kristen Lauber
SHOT AT Miauhaus Studios

Scarlett Johansson wears black, green
trimmed gown by Pierreancy www.
pierreancy.it Scarab necklace by Loree
Rodkin, peep toe boots by Alejandro
Ingelmo Diavolina Los Angeles
MAKEUP Mai Quynh
HAIR David Babaii
MANICURE Jenna Hipp
PHOTO ASSISTANT Andrew Ryan
RETOUCHING Kristen Lauber
SHOT AT www.concreteloft.com

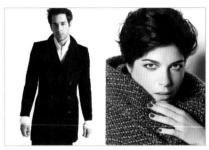

Zachary Levi wears black double breasted cashmere Pea Coat, white cotton & cashmere long sleeve knit by Giorgio Armani, black tapered pant by Balenciaga Paris
GROOMING & HAIR Glenn Nutley
Selma Blair wears brown wool hooded jacket by Ports 1961
MAKEUP Rachel Goodwin
HAIR David Gardner
MANICURE Kimmie Kyees
PHOTO ASSISTANT Leonardo Esposito
SHOT AT High Profile Productions

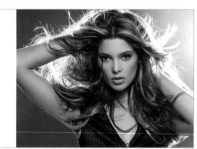

Ashley Green wears silk navy blue dress by Espaco Fashion
www.espacofashion.com.br
MAKEUP Vanessa Scali
HAIR Clyde Haygood
MANICURE Jenna Hipp
PHOTO ASSISTANT Andrew Ryan
SHOT AT Miauhaus Studios

Alex O'loughlin wears navy striped shirt by Paul Smith, navy tie by Givenchy, white silk blazer by Gucci, white cotton draw string trousers LeonardoAguirre
GROOMING Georgie Eisdell
PHOTO ASSISTANT Andrew Ryan
SHOT AT MHA

Kate Nauta wears all jewelry by Azature
MAKEUP Garret Gervais
HAIR Aaron Light
MANICURE Jenna Hipp
PHOTO ASSISTANT Andrew Ryan
Mehcad Brooks wears all jewelry by Azature
GROOMING Garret Gervais
PHOTO ASSISTANT Andrew Ryan

Brooklyn Decker wears sage green bolero and dress by Elie Saab
MAKEUP & HAIR Glenn Nutley
PHOTO ASSISTANT Andrew Ryan

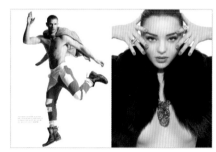

Lucus Kerr wears red white blue striped shirt by Gucci, red + white racing pant by LeonardoAguirre, boots by All Saints
GROOMING Georgie Eisdell
Miranda Kerr wears black fur jacket by Todd Lynn, chain necklace is vintage, rings by Azature.
MAKEUP Glenn Nutley
HAIR David Keough
FASHION STYLIST Taylor Bass
MANICURE Jenna Hipp
PHOTO ASSISTANT Leonardo Esposito
SHOT AT MHA

Eric Dane wears pink plaid shirt and mixed tweed blazer all by Paul Smith
GROOMING Jenna Hipp
PHOTO ASSISTANT Leonardo Esposito
SHOT AT High Profile Productions

Denise Richards
MAKEUP Joanna Schillup
HAIR Richard Marin
MANICURE Kimmie Kyees
PHOTO ASSISTANT Leonardo Esposito
SHOT AT High Profile Productions
Chelsea Handler wears black chain-mesh trimmed dress by Sheri Bodel, gold + black pump by Fendi
MAKEUP Gina Monaci
HAIR Clyde Haygood
PHOTO ASSISTANT Andrew Ryan
Retoucher Kristen Lauber

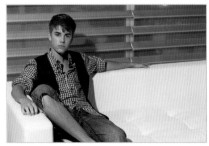

Justin Bieber wears Navy & white gingham shirt & charcoal waist coat all by Vivienne Westwood, denim shots by DC
GROOMING Vanessa Price
SHOT AT www.concreteloft.com

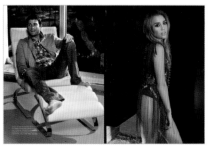

Bryan Greenberg wears plaid work shirt, cotton blazer both by All Saints, washed denim jeans by William Rast
GROOMING Amy Oresman
HAIR David Stanwell
PHOTO ASSISTANT Andrew Ryan
SHOT AT www.concreteloft.com
Miley Cyrus wears red roses & chains leotard by Pelguni & Shane Peacock
MAKEUP + HAIR Denika Bedrossian
RETOUCHING Kristen Lauber

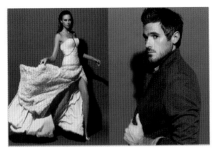

Odette Annable wears baby pink ruffled Gown by Chagoury Couture, body jewelry by Loree Rodkin, ruby + diamond ring by Theodore
MAKEUP Iris Moreau
HAIR Glenn Nutley
MANICURE Jenna Hipp
Dave Annable wears denim work shirt & grey wool blazer by H&M
GROOMING Iris Moreau
HAIR Glenn Nutley
PHOTO ASSISTANT Andrew Ryan
SHOT AT Smashbox Studios

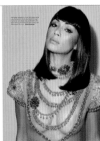

Nicole Scherzinger wears nude jeweled gown by Georges Hobeika, nude lizard pump by Nicholas Kirkwood
MAKEUP Carlene K
HAIR Clyde Haygood
PHOTO ASSISTANT Andrew Ryan
SHOT AT www.concreteloft.com

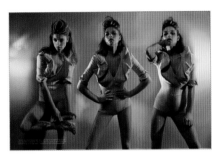

Ashley Green wears pink bodysuit by Espaco Fashion www.espacofashion.com.br
MAKEUP Vanessa Scali
HAIR Clyde Haygood
MANICURE Jenna Hipp
PHOTO ASSISTANT Andrew Ryan
SHOT AT Miauhaus Studios

Chris Evans wears white tshirt by Calvin Klein, black tuxedo blazer by Paul Smith
GROOMING Chechel Joson
HAIR Sally Henley
PHOTO ASSISTANT Andrew Ryan
SHOT AT Smudge Studios

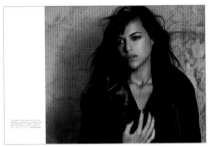

Michelle Rodriguez wears black leather jacket by Rick Owens
MAKEUP + HAIR Glenn Nutley
MANICURE Kimmie Kyees
PHOTO ASSISTANT Andrew Ryan
SHOT AT Miauhaus Studios

will.i.am wears his own clothes
GROOMING Debbie Denson
PHOTO ASSISTANT Andrew Ryan

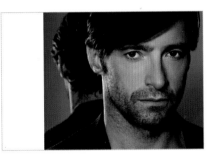

Hugh Jackman wears suit by Etro
GROOMING Amy Nadine
FASHION STYLIST Albert Mendonca
PHOTO ASSISTANT Leonardo Esposito

Zoe Saldana wears white cotton & kimono belt by Yves Saint Laurent, white leotard by Woolford, black patent peep toe pump by Givenchy, diamond braclets by Loree Rodkin
MAKEUP Vera Steimberg
HAIR Mara Rozsak
MANICURE Jenna Hipp
PHOTO ASSISTANT Andrew Ryan
SHOT AT Smashbox Studios

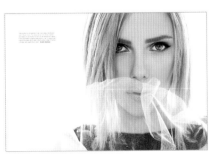

Scarlett Johansson wears black beaded & tule cocktail dress by Georges Hobeika
MAKEUP Mai Quynh
HAIR David Babaii
MANICURE Jenna Hipp
PHOTO ASSISTANT Andrew Ryan
SHOT AT www.concreteloft.com

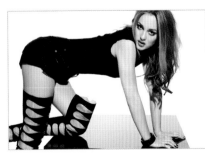

Leighton Meester wears Proenza Schouler top, Levis shorts, Christian Louboutin boots, House of Lavande bracelet.
MAKEUP Stephen Sollito
HAIR Frank Galasso
FASHION STYLIST Logan Horne
MANICURE Jenna Hipp
PHOTO ASSISTANT Leonardo Esposito
SHOT AT Smashbox Studios

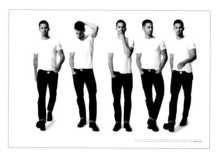

Milo Ventimiglia wears Dior Homme
T-shirt, Levis jeans, US Military boots
GROOMING Georgie Eisdell
FASHION STYLIST Paris Libby
PHOTO ASSISTANT Andrew Ryan
SHOT AT Milk Studios

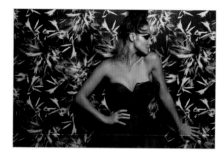

Beau Garrett wears grey a-symmetrical
arc dress, Lee Klabin www.leeklabin.com
MAKEUP Garret Gervais
HAIR Clyde Haygood
PHOTO ASSISTANT Andrew Ryan
RETOUCHING Kristen Lauber
SHOT AT Smashbox Studios

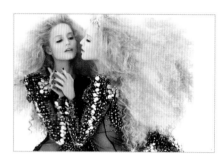

Dianna Agron wears mirrored bodysuit
by Pelguni & Shane Peacock
MAKEUP Amy Oresman
HAIR Clyde Haygood
PHOTO ASSISTANT Andrew Ryan
RETOUCHING Kristen Lauber
SHOT AT www.conreteloft.com

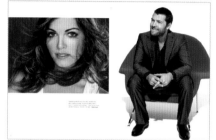

Kate French wears tank by Guess
MAKEUP Georgie Eisdell
HAIR Glenn Nutley
RETOUCHING Judith Caingat
SHOT AT 5th & Sunset
Sam Worthington wears Salvatore
Ferragamo suit and shoes, Dior Homme
shirt.
GROOMING Georgie Eisdell
FASHION STYLIST Paris Libby
PHOTO ASSISTANT Andrew Ryan
RETOUCHING Kristen Lauber
SHOT AT Milk Studios

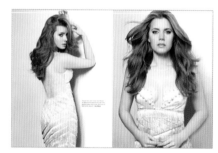

Amy Adams wears cream lace and
fringed dress by Felja www.felja.it
MAKEUP Stephen Sollitto
HAIR Adir Abergel
PHOTO ASSISTANT Andrew Ryan
RETOUCHING Kristen Lauber

James Marsden wears light blue plaid
collared shirt by All Saints
GROOMING Amy Orseman
HAIR David Stanwell
PHOTO ASSISTANT Andrew Ryan
SHOT AT www.conreteloft.com

Christina Hendricks wears white ruffled
organza wrap
MAKEUP Georgie Eisdell
HAIR Jonathan Joseph Hanousek
PHOTO ASSISTANT Grace Testa
SHOT AT Smashbox Studios

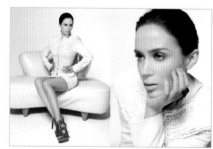

Emily Blunt wears cream blazer with
beaded details by Todd Lynn
MAKEUP Matthew VanLeeuwen
HAIR Laini Reeves
MANICURE Jenna Hipp
PHOTO ASSISTANT Andrew Ryan
RETOUCHING Grace Testa
SHOT AT Miauhaus Studios

Nicole Richie wears sequin beaded
dress by Chloe
MAKEUP Troy Jensen
HAIR Scott Cunha
FASHION STYLIST Simone Harouche
PHOTO ASSISTANT Andrew Ryan
RETOUCHING Judith Caingat
SHOT AT Milk Studios

Daren Kagasoff wears pinstripe blazer
Vintage, sweater Vest by Paul Smith,
Striped shirt by M. Casshirt, tie by J.
Lindberg, black Jeans by Dior Homme
watch by Hermes, shoes by P.F Flier
GROOMING Georgie Eisdell
PHOTO ASSISTANT Leonardo Esposito
Kate Bosworth wears ox blood leather
dress by DSquared
MAKEUP Amy Orseman
HAIR Clyde Haygood
MANICURE Jenna Hipp
SHOT AT Smashbox Studios

Miley Cyrus wears cognac belted
Fur vest by Thomas Wylde, diamond
snake ring by Loree Rodkin
MAKEUP + HAIR Denika Bedrossian
RETOUCHING Judith Caingat

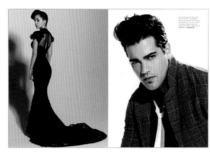

Eliza Dusku wears black lace gown
byEnzoani www.enzoani.com
MAKEUP Garret Gervais
HAIR Glenn Nutley
PHOTO ASSISTANT Andrew Ryan
SHOT AT 5th & Sunset Studios
Jesse Metcalfe wears shirt, tie & plaid
blazer by Emporio Armarni
GROOMING Glenn Nutley
PHOTO ASSISTANT Leonardo Esposito
SHOT AT Smashbox Studios

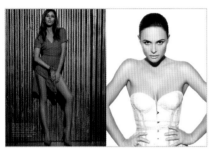

Kayla Ewell wears hot pink belted dress
by Leonardo Aguirre, Red satin pumps
by Pour Le Vitorre
MAKEUP Agostina
HAIR Jessica
SHOT AT Miauhaus Studios
Josie Moran wears cream lace corset by
Agent Provocateur
MAKEUP Jessica
HAIR Glenn Nutley
PHOTO ASSISTANT Andrew Ryan
RETOUCHING Judith Caingat
SHOT AT Miauhaus Studio

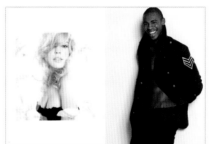

Melissa George wears black bustier
MAKEUP Leiane Taylor
HAIR Laini Reeves
RETOUCHING Grace Testa
Mehcad Brooks wears wool Pea coat
with Stingray collar by Royal
Underground, Jeans by Crate
GROOMING Al Ingram
PHOTO ASSISTANT Leonardo Espostio
SHOT AT High Profile Productions

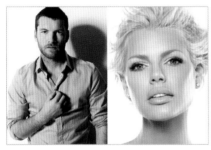

Sam Worthington wears shirt, pant
& belt by Dolce & Gabbana
GROOMING Georgie Eisdell
FASHION STYLIST Paris Libby
PHOTO ASSISTANT Andrew Ryan
SHOT AT Milk Studios
Sophie Monk wears own earrings
MAKEUP Amy Orseman
HAIR Clyde Haygood
PHOTO ASSISTANT Andrew Ryan
RETOUCHING Kristen Lauber

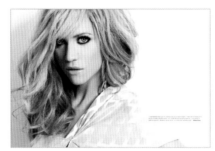

Brittany Snow wears lace A-Line
strapless dress by Ports 1961
MAKEUP Tasha Reiko-Brown
HAIR Campbell McAuley
PHOTO ASSISTANT Leonardo Esposito
RETOUCHING Judith Caingat

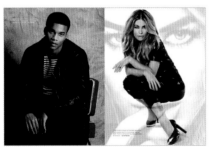

Cory Hardrict wears denim Jeans
by PRPS, striped thermal by Army Navy
Surplus, leather bomber jacket by Rick
Owens
GROOMING Georgie Eisdell
SHOT AT Miauhaus Studios
Carmen Electra wears metallic jumpsuit
by TEAMO, Cobalt Pumps by Sergio
Rossi
MAKEUP Georgie Eisdell
HAIR George Papanikolos
MANICURE Kimmie Kyees
PHOTO ASSISTANT Leonardo Espostio
SHOT AT High Profile Productions

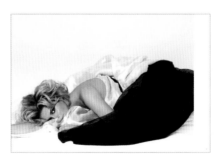

Rachel Hunter wears black and white
organza strapless dress by Fabio Gritti
MAKEUP & HAIR Glenn Nutley
PHOTO ASSISTANT Leonardo Esposito
SHOT AT Smashbox Studios

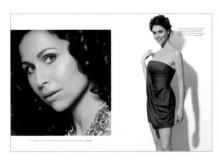

Minnie Driver wears Azature necklace
MAKEUP Gregory Arlt
HAIR Giovanni Giuliano
RETOUCHING Judith Caingat
Samantha Harris wears green strapless
cocktail dress by Max Azria
MAKEUP Rebecca Epifano
HAIR David Stanwell
FASHION STYLIST Taylor Bass
PHOTO ASSISTANT Leonardo Esposito
RETOUCHING Kristen Lauber

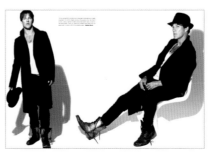

Stephen Moyer wears black macintosh
by Gucci, white vneck tshirt by
American Apparel, wool trousers with
long johns by Daniel Patrick
GROOMING Chechel Joson
HAIR David Stanwell
PHOTO ASSISTANT Andrew Ryan
SHOT AT Miauhaus Studios

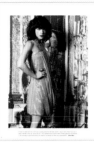
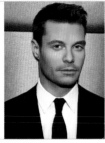

Selma Blair wears wears silver strapless Dress by Ports 1961, Tourmaline ring by Loree Rodkin
MAKEUP Rachel Goodwin
HAIR David Gardner
MANICURE Jenna Hipp
PHOTO ASSISTANT Leonardo Esposito
SHOT AT High Profile Productions
Ryan Seacrest wears Dior suit & tie, Gucci White shirt

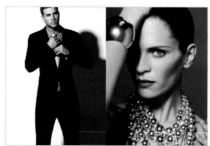

Liam Hemsworth wears suit, shirt, tie by Gucci
GROOMING Georgie Eisdell
PHOTO ASSISTANT Andrew Ryan
SHOT AT Smashbox Studios
Frankie Rayder wears bracelet & necklaces by Tom Binns Available at Maxfield Los Angeles
MAKEUP + HAIR Glenn Nutley
RETOUCHING Judith Caingat
SHOT AT High Profile Productions

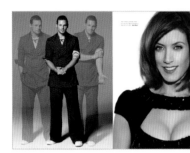

Justin Chambers wears pin stripe suit Vivienne Westood, champagne long sleeve top by Michel Bourendi White leather hi-top sneaker by Lanvin Shark tooth lava necklace by Ana Reign
GROOMING Georgie Eisdell
HAIR George Papanikolas
PHOTO ASSISTANT Leonardo Esposito
SHOT AT High Profile Productions
Kate Walsh wears Elle Saab cocktail dress
MAKEUP + HAIR Glenn Nutley
RETOUCHING Judith Caingat
SHOT AT MHA

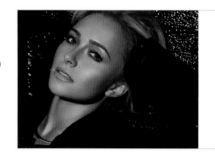

Hayden Panettiere wears black leather bomber by All Saints, necklace by Azature
MAKEUP Amy Oresman
MANICURE Jenna Hipp
PHOTO ASSISTANT Alice Chabtini
RETOUCHING Kristen Lauber
SHOT AT Smudge Studios

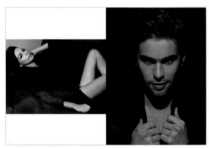

Moran Atias wears coat by Salvatore Farragmo, denim shorts by Levis
MAKEUP Georgie Eisdell
HAIR David Keough
PHOTO ASSISTANT Leonardo Esposito
Chace Crawford wears black washed leather jacket by Skin Graft
GROOMING Chechel Joson
HAIR David Stanwell
SHOT AT www.concreteloft.com

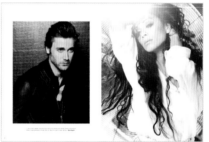

Ryan Eggold wears black Bolero Tuxedo blazer by Dior Homme Black collared shirt by Prada
GROOMING Georgie Eisdell
HAIR Larry Sims
PHOTO ASSISTANT Leonardo Esposito
SHOT AT 5th & Sunset Studios
Nicole Scherzinger wears white chifon top by Thomas Wylde
MAKEUP Carlene K
HAIR Clyde Haygood
PHOTO ASSISTANT Andrew Ryan
SHOT AT www.concreteloft.com

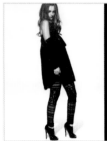

Leighton Meester wears Bally leggings Vivienne Westwood dress, Christian Louboutin shoes
MAKEUP Stephen Sollitto
HAIR Frank Galasso
FASHION STYLIST Logan Horne
Eliza Dushku wears gold dress by Bodymar
MAKEUP Garret Gervais
HAIR Glenn Nutley
PHOTO ASSISTANT Andrew Ryan
RETOUCHING Grace Testa
SHOT AT 5th & Sunset Studios

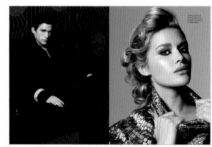

Daren Kagasoff wears black tee by Hanes, cable-knit cardigan by Rogues Gallery, double-breasted peak lapel by Costume Homme, pants and suspenders Vintage, boots by Sergio Rossi
GROOMING Georgie Eisdell
PHOTO ASSISTANT Leonardo Esposito
Cheyenne Tozzi wears geometric multi color stuffed jacket by Todd Lynn
MAKEUP Elan Bongiorno
HAIR David Keough
Photo Assistant Andrew Ryan
RETOUCHING Judith Caingat

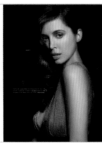
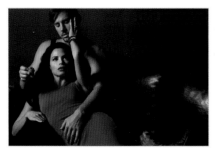

Jenna Dewan + Channing Tatum
Jenna wears red jersey dress by Single Channing wears black tank by 2xist, jersey & leather cargo pant by Skin Graft, distressed combat boot by All Saints
MAKEUP + HAIR Glenn Nutley
PHOTO ASSISTANT Andrew Ryan
RETOUCHING Kristen Lauber
SHOT AT Miauhaus Studios

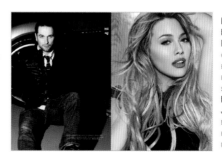

Matthew Rhys wears shirt, tie & leather bomber by All Saints, Jeans by William Rast
GROOMING Chechel Joson
HAIR Sally Henley
PHOTO ASSISTANT Andrew Ryan
SHOT AT Smudge Studio
Hilary Duff wears black lace top by Jonano - www.jonano.com
MAKEUP Chechel Joson
HAIR David Stanwell
RETOUCHING Kristen Lauber

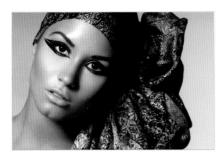

Demi Lovato
MAKEUP Joyce Bonelli
HAIR Clyde Haygood
ASSISTANT Andrew Ryan
RETOUCHING Kristen Lauber
SHOT AT Space 905

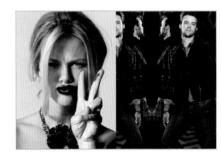

Brooklyn Decker wears Azature necklace
MAKEUP + HAIR Glenn Nutley
PHOTO ASSISTANT Andrew Ryan
Jesse Spencer wears tartan shawl collar
tuxedo Jacket by Moschino
Window paign check shirt by Prada
gingham tie by J. Lindeberg
Navy waistcoat by Rag & Bone
GROOMING + HAIR Glenn Nutley
PHOTO ASSISTANT Leonardo Espostio
SHOT AT the Chamberlain Hotel

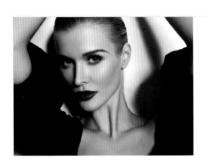

Joanna Krupa wears black
ruffled dress by Thomas Wylde
MAKEUP Georgie Eisdell
HAIR David Stanwell
PHOTO ASSISTANT Leonardo Esposito
RETOUCHING Judith Caingat
SHOT AT Miahaus Studios

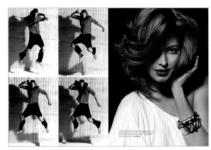

Rick Malambri wears black knit Costume
National, red striped shirt by Vivienne
Westwood, wide leg drop crotch trouser
by Alexander McQueen
GROOMING Georgie Eisdell
PHOTO ASSISTANT Andrew Ryan
Holly Vallance wears white one shoulder
dress by The Batallion Rosegold Pewter
cuffs by Misis
MAKEUP + HAIR Glenn Nutley
PHOTO ASSISTANT Leonardo Espostio
RETOUCHING Judith Caingat
SHOT AT Smashbox Studios

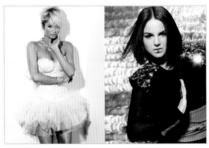

Paris Hilton wears her own dress
+ jewels
MAKEUP Georgie Eisdell
HAIR David Keough
SHOT AT MHA
Jojo wears mirror shouldered knit by
Espaco Fashion, red leather obie belt by
EM & Co
MAKEUP Carlene K
HAIR Glenn Nutley
PHOTO ASSISTANT Andrew Ryan
SHOT AT 5th & Sunset Studios

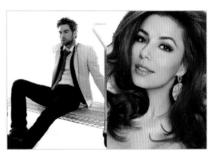

Chace Crawford wears light beige blazer,
striped shirt & tie by Marc Jacobs
GROOMING Chechel Joson
HAIR David Stanwell
SHOT AT www.concreteloft.com
Eva Longoria wears diamond earrings by
Loree Rodkin
MAKEUP Iris Moreau
HAIR Glenn Nutley
PHOTO ASSISTANT Andrew Ryan
RETOUCHING Kristen Lauber
SHOT AT Smashobx Studios

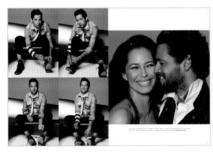

Enrique Murciano wears nylon jacket
by Rick Owens, block striped shirt by
Number Nine both available at Maxfield
Trouser & suspenders by Vivienne
Westwood, Ox blood boots by Prada
GROOMING Jenna Hipp
SHOT AT High Profile Productions
Angela Alvarado-Rosa wears gown by
Elie Saab, earrings by Loree Rodkin
Draco Rosa wears leather bomber vest
by Commes des Garcon, shirt by Skin
Graft
MAKEUP Garret Gervais
HAIR Rick Gradone

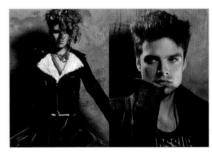

Maggie Grace wears leather shearling
bomber-Vintage stylists own
Sheer blue structured skirt, S.WIND.A
www.swinda.com
MAKEUP Georgie Eisdell
HAIR Larry Sims
PHOTO ASSISTANT Leonardo Esposito
Sebastian Stan wears leather jacket-Skin
Graft, T-shirt-actors own
GROOMING Chechel Joson
ASSISTANT Andrew Ryan
SHOT AT Space 905

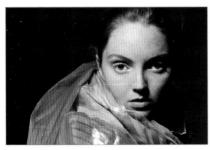

Lily Cole wears baby blue & coral
pleated dresses by Ports1961
MAKEUP Garret Gervais
HAIR Rick Gradone
PHOTO ASSISTANT Leonardo Esposito
SHOT AT Miauhaus Studios

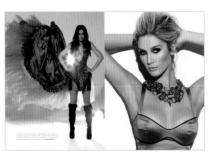

Emmanuelle Chriqui wears olive gown
by Ella Zahlan, suede over knee boot
by Loriblu
MAKEUP Iris Moreau
HAIR Angelo Tsimourtos
PHOTO ASSISTANT Andrew Ryan
SHOT AT Miauhaus Studios
Delta Goodrem wears lime green silk
haulter dress by Nicole Miller, jewels by
Azature
MAKEUP + HAIR Dale Dorning
PHOTO ASSISTANT Andrew Ryan
RETOUCHING Judith Caingat

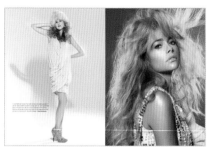

Anna Hutchison wears buttercup chiffon dress by Ellie Saab, shoes with cover by Pour la Victore, vintage fur hat
MAKEUP Georgie Eisdell
HAIR David Keough
SHOT AT Miauhaus Studios
Denise Richards wears vintage dress
MAKEUP Joanna Schillup
HAIR Richard Marin
MANICURE Kimmie Kyees
PHOTO ASSISTANT Leonardo Esposito
RETOUCHING Judith Caingat
SHOT AT High Profile Productions

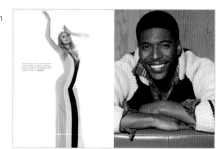

Stacy Keibler wears graypinkblack Graphic dress by Bodyamr
MAKEUP Iris Moreau
HAIR Glenn Nutley
MANICURE Jenna Hipp
PHOTO ASSISTANT Andrew Ryan
RETOUCHING Kristen Lauber
Jocko Sims wears chunky knit cardigan by Bathing Ape, vintage work shirt
GROOMING Georgie Eisdell
SHOT AT Miauhaus Studios

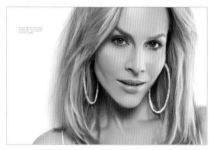

Julie Benz wears 2 tone oval hoops
MAKEUP Garret Gervais
HAIR Aaron Light
PHOTO ASSISTANT Andrew Ryan
RETOUCHING Judith Caingat

Dominic Monaghan wears Paul Smith suit and shirt
GROOMING Georgie Eisdell
Kym Johnson wears Creme harem jumper, Sado Fashion www.sadofashion.com
Floral sandals, Loriblu www.loriblu.com
Copper weaved cuff by Miles McNeel www.milesmcneel.com
MAKEUP Garret Gervais
HAIR David Stanwell
PHOTO ASSISTANT Andrew Ryan

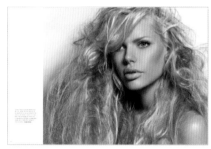

Sophie Monk
MAKEUP Amy Oresman
HAIR Clyde Haygood
PHOTO ASSISTANT Andrew Ryan
RETOUCHING Kristen Lauber

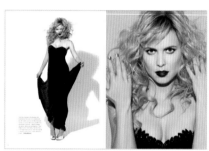

Radha Mitchell wears midnight blue strapless jeweled gown by Reem Acra, white satin peep toe pumy by Loriblu
MAKEUP Deborah Platino
HAIR Jonathan Joseph Hanousek
MANICURE Jenna Hipp
PHOTO ASSISTANT Andrew Ryan
RETOUCHING Judith Caingat
SHOT AT Miauhaus Studios

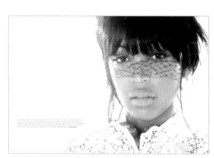

Meagan Good wears lace vintage dress
MAKEUP Georgie Eisdell
HAIR Larry Sims
PHOTO ASSISTANT Leonardo Esposito
SHOT AT Smashbox Studios

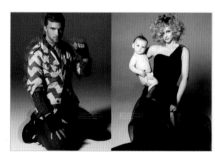

Tim Draxl wears two-tone safari Jacket by Vivienne Westwood, plaid collared Shirt by J. Lindberg, Prorsum Burbury Pants, Boots Army Surplus, necklace and ring by Chrome Hearts
GROOMING Glenn Nutley
PHOTO ASSISTANT Leonardo Esposito
SHOT AT 5th & Sunset Studios
AJ Cook wears one shouldered silk +toile gown by Enzoani
MAKEUP + HAIR Glenn Nutley
PHOTO ASSISTANT Leonardo Esposito
SHOT AT High Profile Productions

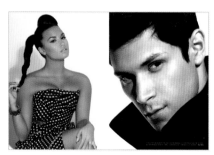

Demi Lovato wears navy geometric dress by Vivienne Westwood, blue sapphire bangle by The Passionate Collector www.thepassionatecollector
MAKEUP Joyce Bonelli
HAIR Clyde Haygood
ASSISTANT Andrew Ryan
RETOUCHER Kristen Lauber
SHOT AT Space 905
Alex Meraz wears cashmere peat coat by YSL
GROOMING Chechel Joson
HAIR Keiko Hamaguchi
PHOTO ASSISTANT Leonardo Esposito
SHOT AT Smashbox Studios

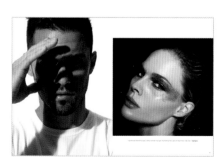

Milo Ventimiglia wears Dior Homme T-shirt
GROOMING Georgie Eisdell
FASHION STYLIST Paris Libby
PHOTO ASSISTANT Andrew Ryan
SHOT AT Milk Studios
Kate Nauta
MAKEUP + HAIR Glenn Nutley
PHOTO ASSISTANT Leonardo Esposito
RETOUCHING Judith Caingat
SHOT AT Smashbox Studios

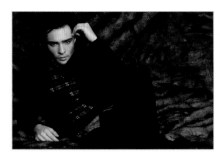

Ed Westwick in checked collared shirt & plaid sweater vest by Band Of Brothers, charcoal peacoat by All Saints.
GROOMING Chechel Joson
PHOTO ASSISTANT Andrew Ryan

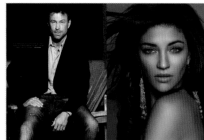

Grant Bowler wears his own clothes
GROOMING Georgie Eisdell
Jessica Szohr
MAKEUP Amy Orseman
HAIR Glenn Nutley
PHOTO ASSISTANT Andrew Ryan
RETOUCHING Kristen Lauber
SHOT AT www.concreteloft.com

Shailene Woodley wears purple silk cocktail dress by Elie Saab
MAKEUP Glenn Nutley
HAIR Glenn Nutley
PHOTO ASSISTANT Leonardo Esposito
SHOT AT Smashbox Studios
Liam Hemsworth wears baby blue shirt + hounds tooth blazer by Gucci
GROOMING Georgie Eisdell
PHOTO ASSISTANT Andrew Ryan
SHOT AT Smashbox Studios

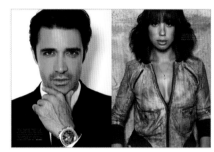

Gilles Marini wears white concealed shirt by Givenchy, black 2 button blazer by Givenchy, tie by Dior Homme
GROOMING Georgie Eisdell
Cheryl Burke wears Rock & Republic jacket
MAKEUP Carlene K
FASHION STYLIST Albert Mendonca
PHOTO ASSISTANT Leonardo Esposito
SHOT AT Miauhaus Studios

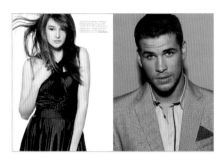

Aaron Yoo wears white shirt + Tie by Dior Homme, jeans + shoes his own
GROOMING Glenn Nutley
PHOTO ASSISTANT Leonardo Esposito
SHOT AT Smashbox Studios
Alison Brie wears all necklaces by Loree Rodkin
MAKEUP Georgie Eisdell
HAIR David Stanwell
PHOTO ASSISTANT Leonardo Esposito

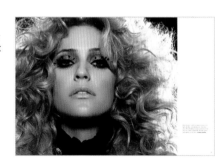

Enrique Murciano wears navy cotton suit by Vivienne Westwood, grey nylon jacket by Rick Owens, ox blood lace boots by Prada
GROOMING Jenna Hipp
PHOTO ASSISTANT Leonardo Esposito
SHOT AT High Profile Productions
Eric Dane wears black trench coat by Dior Homme
GROOMING Jenna hipp
PHOTO ASSISTANT Leonardo Esposito
SHOT AT High Profile Productions

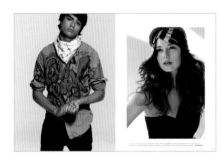

Kiowa Gordon wears grey graffiti shirt by Voyage London, dark denim jeans by Dior Homme, skeleton scarf by Skingraft
GROOMING Glenn Nutley
PHOTO ASSISTANT Andrew Ryan
SHOT AT Miahaus Studios
Emily VanCamp wears black one shoulder dress by Nicole Miller
MAKEUP Amy Orseman
HAIR Glenn Nutley
PHOTO ASSISTANT Andrew Ryan
RETOUCHING Kristen Lauber
SHOT AT www.concreteloft.com

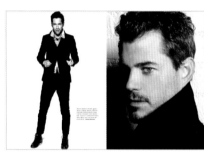

Kristin Cavallari wears black vintage stretch lace dress
MAKEUP + HAIR Glenn Nutley
PHOTO ASSISTANT Leonardo Esposito
SHOT AT Smashbox studios

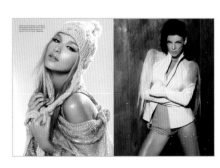

Tahyna Tozzi wears lavender and cream sequins cowl neck by Ellie SaabVintage tan knit beanie stylists own
MAKEUP Elan Bongiorno
PHOTO ASSISTANT Leonardo Esposito
RETOUCHING Kristen Lauber
Liberty Ross wears tan jacket with horse HAIR shoulders by Todd Lynne, high waisted hot shorts by Espaco Fashion
MAKEUP Amy Oresman
HAIR David Stanwell
PHOTO ASSISTANT Andrew Ryan
SHOT AT www.concreteloft.com

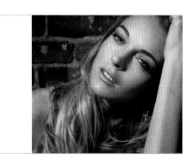

Lindsay Lohan wears gold & diamond drop earrings by Loree Rodkin
MAKEUP & HAIR Glenn Nutley
MANICURE Jenna Hipp
PHOTO ASSISTANT Leonardo Esposito
RETOUCHING Grace Testa
SHOT AT Soul Studios

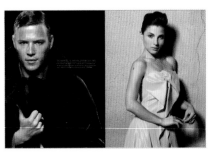

Chris Egan wears dark gray double collared shirt by Skin Graft, Silk Tie by Gucci Leather double breasted jacket by Morphine Generation
GROOMING Glenn Nutley
Elsa Pataky wears yellow dress by Shosanan, Iron cross yellow gold with diamonds ring by Loree Rodkin
MAKEUP Chechel Joson
HAIR Rick Gradone
PHOTO ASSISTANT Leonardo Esposito
SHOT AT 5th & Sunset Studios

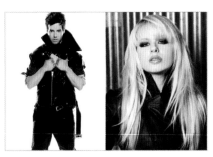

Travis Garland wears black leather sleeveless bomber by Junya Watanabe Navy and white striped shirt by Leroy @ Church Boutique Los Angeles Navy cotton trousers - stylists own
GROOMING Carlene K
PHOTO ASSISTANT Andrew Ryan
SHOT AT 5th & Sunset Studios
Orianthi wears leather armor shoulder jacket by Skin Graft
MAKEUP + HAIR Glenn Nutley
PHOTO ASSISTANT Andrew Ryan
SHOT AT Miauhaus Studios

Draco Rosa wears checked shirt by Givenchy, plaid shirt as scarf by JLindeberg charcoal waist coat byJohn Galliano, cropped pants by Endovanera,
GROOMING Carlene K
PHOTO ASSISTANT Andrew Ryan
SHOT AT 5th & Sunset Studios
Yvonne Strahovski wears ruffle top by Skin Graft
MAKEUP Stephen Sollito
HAIR John D
PHOTO ASSISTANT Andrew Ryan

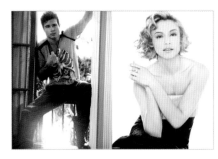

Cody Longo wears Levis one of a kind 501's, hot pink American apparel pink tshirt, stylist own bone Tshirt
GROOMING Georgie Eisdell
PHOTO ASSISTANT Andrew Ryan
Samaire Armstrong wears dress by Ella Zallal, ring by Loree Rodkin
MAKEUP Chechel Joson
HAIR Keiko Hamaguchi
PHOTO ASSISTANT Leonardo Esposito
SHOT AT Smashbox Studios

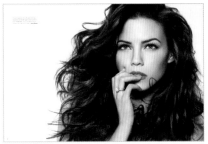

Ryan McPartlin wears hand painted ¾ length cardigan by John Galliano, tshirt & jeans by William Rast
GROOMING Amy Oresman
HAIR Glenn Nutley
PHOTO ASSISTANT Andrew Ryan
SHOT AT www.concreteloft.com
Fergie wears Robins Jeans studded jacket
MAKEUP Ronit Shapow
PHOTO ASSISTANT Chris Noonan
RETOUCHING Judith Caingat

Rebecca Mader wears pink beaded gown by Reem Acra
MAKEUP Georgie Eisdell
HAIR David Stanwell
PHOTO ASSISTANT Leonardo Esposito

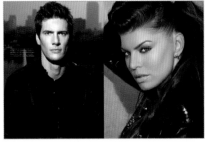

Jenna Dewan wears own ring
MAKEUP + HAIR Glenn Nutley
PHOTO ASSISTANT Leonardo Esposito
RETOUCHING Judith Caingat
SHOT AT 5th & Sunset Studios

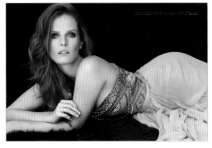

Chris Evans wears own clothes
GROOMING Chechel Joson
HAIR Sally Henley
PHOTO ASSISTANT Andrew Ryan
SHOT AT Smudge Studios

Jesse Bradford wears shirt + tie by Paul Smith, leather bomber by All Saints
GROOMING Chechel Joson
HAIR Sally Henley
PHOTO ASSISTANT Andrew Ryan
SHOT AT Smudge Studios
Ashlan Gorse wears black jersey + leather shift dress by YSL
MAKEUP Georgie Eisdell
HAIR David Keough
PHOTO ASSISTANT Leonardo Esposito

Brian Austin Green wears shirt + suit by Gucci
GROOMING Kim Verbeck
FASHION STYLIST Jenny Ricker
MANICURE Barbara Warner + Kaamilya
PHOTO ASSISTANT Andrew Ryan
Shantel VanSanten wears lemon yellow laminated linen Tu-Tu Dress with Bow by Maggie Barrie, lime green Tights by American Apparel, charcoal tribute Pump by YSL, multi coloured sapphire snake head ring by Loree Rodkin
MAKEUP + HAIR Glenn Nutley
PHOTO ASSISTANT Leonardo Esposito
SHOT AT High Profile Productions

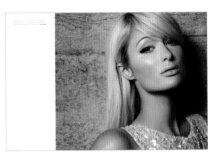

Paris Hilton wears lace dress by
Nicole Miller
MAKEUP Georgie Eisdell
HAIR David Keough
RETOUCHING Judith Caingat
SHOT AT MHA

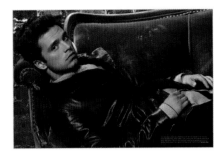

Sebastian Stan wears dark brown
leather jacket by Vivienne Westwood,
blue and white gingham collared shirt
& tie by Vivienne Westwood,
dark denim jeans by Dior Homme
GROOMING Chechel Joson
ASSISTANT Andrew Ryan
SHOT AT Space 905

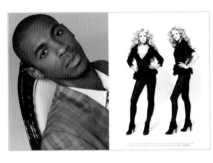

Mehcad Brooks wears suit, shirt & tie
by Paul Smith
GROOMING Al Ingram
PHOTO ASSISTANT Leonardo Espostio
SHOT AT High Profile Productions
Nancy Odell wears ruffled blazer
by Junya Watanabe, leather legging
by Alexander Wang
HAIR Clyde Haygood
Shot Miauhaus Studios

Justin Chambers wears pin stripe suit
Vivienne Westwood, champagne long
sleeve top by Michel Bourendi White
leather hi-top sneaker by Lanvin Shark
tooth lava necklace by Ana Reign
GROOMING Georgie Eisdell
HAIR George Papanikolas
SHOT AT High Profile Productions
Rachel Bilson wears Tshirt dress, belt,
fur by Todd Lynne
MAKEUP Amy Orseman
HAIR Clyde Haygood
Shot Miauhaus Studios

Channing Tatum wears charcoal turtle
cardigan by Skin Graft
GROOMING Glenn Nutley
PHOTO ASSISTANT Andrew Ryan
SHOT AT Miahaus studios

Jessica Alba wears grey leather one
sleeve dress by Thomas Wilde, black
pumps by Nicholas Kirkwood available
at Maxfields, diamond ring by Theodoros
Savopoulos
MAKEUP Lauren Anderson
HAIR Robert Ramos
MANICURE Jenna Hipp
PHOTO ASSISTANT Andrew Ryan
RETOUCHING Kristen Lauber
SHOT AT Smudge Studio

Delta Goodrem wears multi chain
earrings by Azature
MAKEUP + HAIR Dale Dorning
PHOTO ASSISTANT Andrew Ryan
RETOUCHING Judith Caingat

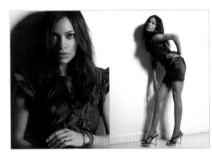

Rosario Dawson wears copper silk
dress by Espaco Fashion, gold strapped
sandle by Loriblu
MAKEUP Agostina
HAIR Stephanie Hobgood
PHOTO ASSISTANT Andrew Ryan
RETOUCHING Judith Caingat

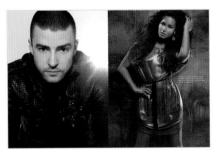

Justin Timberlake wears brown leather
bomber by All Saints
GROOMING Kelsey Deenihan
PHOTO ASSISTANT Andrew Ryan
RETOUCHING Kristen Lauber
SHOT AT Miahaus studios
Demi Lovato wears silver belted dress
by Vivienne Westwood, rings and
earrings by Lauren G Adams
www.laurengadams.com
MAKEUP Joyce Bonelli
HAIR Clyde Haygood
ASSISTANT Andrew Ryan
RETOUCHER Kristen Lauber
SHOT AT Space 905

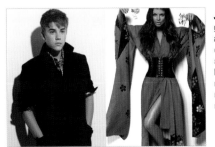

Justin Bieber wear Navy & white
gingham shirt & long black Chesterfield
all by Vivienne Westwood
GROOMING Vanessa Price
SHOT AT www.concreteloft.com
Fergie wears original Kimono from Japan
MAKEUP Ronit Shapow
PHOTO ASSISTANT Chris Noonan
RETOUCHING Kristen Lauber

305

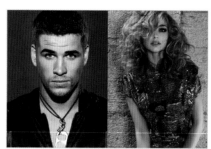

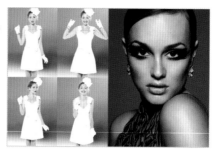

Liam Hemsworth wears black vintage baseball jacket, bottle opener as necklace by Azature
GROOMING Georgie Eisdell
PHOTO ASSISTANT Andrew Ryan
Miranda Kerr wears gold sequined sleeveless top by Nicole miller
MAKEUP Glenn Nutley
HAIR David Keough
FASHION STYLIST Taylor Bass
MANICURE Jenna Hipp
PHOTO ASSISTANT Leonardo Esposito
Retoucher Judith Caingat
SHOT AT MHA

Rebecca Gayheart wears white shift dress collar by Enrico Coveri, flower hair piece by Drew Bird Couture, vintage gloves
MAKEUP Garret Gervais
HAIR Clyde Haygood
PHOTO ASSISTANT Andrew Ryan
Leighton Meester wears vintage Versace dress & House of Lavande earrings
MAKEUP Stephen Sollito
HAIR Frank Galasso
FASHION STYLIST Logan Horne
MANICURE Jenna Hipp
PHOTO ASSISTANT Leonardo Esposito

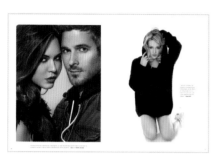

Odette & Dave Annable
MAKEUP Iris Moreau
HAIR Glenn Nutley
MANICURE Jenna hipp
PHOTO ASSISTANT Andrew Ryan
Hilary Duff wears black large knit cow neck sweater by Rachel Pally, cream lace tie back wedges by Loriblu
MAKEUP Chechel Joson
HAIR David Stanwelll
PHOTO ASSISTANT Andrew Ryan
RETOUCHING Kristen Lauber
SHOT AT www.concreteloft.com

Ryan Phillippe wears navy linen blazer by Vivienne Westwood, tshirt & pants by Paul Smith
GROOMING Amy Oresman
PHOTO ASSISTANT Andrew Ryan
SHOT AT Miauhaus Studios

Carey Mulligan
MAKEUP Georgie Eisdell
HAIR Jenny Cho
PHOTO ASSISTANT Andrew Ryan
RETOUCHING Kristen Lauber
SHOT AT 5th & Sunset Studio

Justin Bieber wears brown leather jacket by Giorgio Brato from Traffic Los Angeles
GROOMING Vanessa Price
SHOT AT www.concreteloft.com
Brooklyn Decker wears sage green bolero and dress by Elie Saab
MAKEUP & HAIR Glenn Nutley
PHOTO ASSISTANT Andrew Ryan
RETOUCHING Kristen Lauber

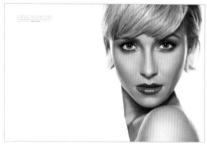

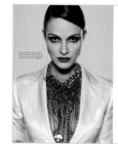
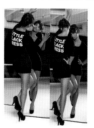

Hayden Panettiere wears white off shoulder t by All Saints
MAKEUP Amy Oresman
MANICURE Jenna Hipp
PHOTO ASSISTANT Alice Chabtini
RETOUCHING Kristen Lauber
SHOT AT Smudge Studios

Beau Garrett wears off white blazer by Prada, multi chain necklace by Azature
MAKEUP Garret Gervais
HAIR Clyde Haygood
PHOTO ASSISTANT Andrew Ryan
RETOUCHING Kristen Lauber
Joy Bryant wears lack knit "little black dress" by Jeremy Scott, pumps by Peoples Revolution
MAKEUP Garret Gervais
HAIR Glenn Nutley
PHOTO ASSISTANT Andrew Ryan
RETOUCHING Kristen Lauber
SHOT AT www.concreteloft.com

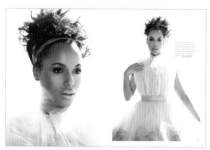

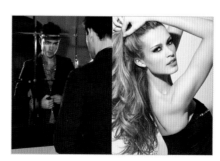

Kerry Washington wears ude tule and feathers cocktail dress by ASHI
MAKEUP Carola Gonzalez
HAIR Clyde Haygood
PHOTO ASSISTANT Andrew Ryan
RETOUCHING Kristen Lauber
SHOT AT www.concreteloft.com

Ed Westwick wears navy + white striped shirt, navy cotton blazer by Band of Outsiders
GROOMING Chechel Joson
Petra Nemcova wears black jumpsuit by Stella & Jamie
MAKEUP Iris Moreau
HAIR David Stanwell
PHOTO ASSISTANT Andrew Ryan
RETOUCHING Kristen Lauber
SHOT AT Smashbox Studios

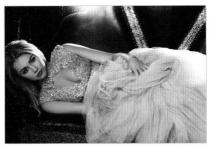

Miley Cyrus wears champaign sequined bodice gown by Jad Ghandour www.jadghandour.com
MAKEUP + HAIR Denika Bedrossian
RETOUCHING Judith Caingat

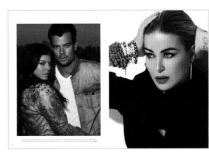

Fergie & **Josh Duhamel** wear their own clothes
MAKEUP Ronit Shapow
PHOTO ASSISTANT Chris Noonan
RETOUCHING Kristen Lauber
Carmen Electra wears Ruffle collar top by Junya Watanabe, Hoop Earrings by New Hi-Mart, bracelets by Ana Reign
MAKEUP Georgie Eisdell
HAIR George Papanikolas
MANICURE Kimmie Kyees
RETOUCHING Judith Caingat
SHOT AT High Profile Productions

Ryan Seacrest wears Dior suit & tie, Gucci White shirt

Marlon Wayans wears blue checked shirt by Prada, dotted tie by Gucci, silver striped tie by Dior Homme, mini skull tie by Alexander McQueen, plaid vest by J. Lindeberg, leather vest by Junya Watanabe, military pants by Miharayasuhiro, zip boot by Guidi
GROOMING Rebecca DeHerrera
HAIR Linda Villalobos
PHOTO ASSISTANT Andrew Ryan
SHOT AT 5th & Sunset Studios

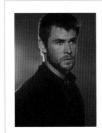

Chris Hemsworth in shirt + jacket by Gucci
GROOMING Chechel Joson
HAIR David Stanwell
PHOTO ASSISTANT Andrew Ryan
SHOT AT Miahaus Studios
Kim Kardashian wears one sided ruffle dress by George Hobeika
MAKEUP Rob Scheppy
HAIR Clyde Haygood
FASHION STYLIST Paris Libby
PHOTO ASSISTANT Andrew Ryan
RETOUCHING Kristen Lauber
SHOT AT www.concreteloft.com

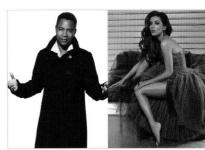

Cuba Gooding Jr wears trench coat by Armani
GROOMING Georgie Eisdell
PHOTO ASSISTANT Andrew Ryan
SHOT AT Smashbox Studios
Eva Longoria wears gray leotard gown by Georges Hobeoka, black diamond drop earrings & black diamond cross ring by Theodoros Savopoulos jeweler
MAKEUP Iris Moreau
HAIR Glenn Nutley
MANICURE Jenna Hipp
RETOUCHING Kristen Lauber

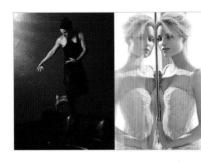

Channing Tatum wears lack jersey pant with leather cargo pocket by Skin Graft Black tank and boots-stylists own
GROOMING Glenn Nutley
PHOTO ASSISTANT Andrew Ryan
SHOT AT Miahaus Studios
Dianna Agron wears pale pink & blue lace gown by Suzie Turner Couture
MAKEUP Amy Oresman
HAIR Clyde Haygood
PHOTO ASSISTANT Andrew Ryan
RETOUCHING Kristen Lauber
SHOT AT www.concreteloft.com

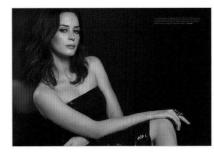

Emily Blunt wears navy rouched sequined tube dress by Nicole Miller
MAKEUP Matthew VanLeeuwen
HAIR Laini Reeves
MANICURE Jenna Hipp
PHOTO ASSISTANT Andrew Ryan
RETOUCHING Judith Caingat
SHOT AT Miauhaus Studios

Amy Adams wears Copper sequins dress by All Saints, Nude patent pumps by Jimmy Choo
MAKEUP Stephen Sollitto
HAIR Adir Abergel
PHOTO ASSISTANT Andrew Ryan
RETOUCHING Kristen Lauber
Taye Diggs wears cotton Shirt and charcoal herringbone blazer by H&M
GROOMING Garret Gervais
PHOTO ASSISTANT Andrew Ryan
SHOT AT www.concreteloft.com

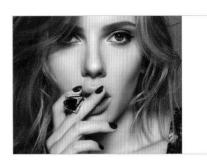

Scarlett Johansson wears black diamond ring by Azature
MAKEUP Mai Quynh
HAIR David Babaii
MANICURE Jenna Hipp
PHOTO ASSISTANT Andrew Ryan
SHOT AT www.concreteloft.com

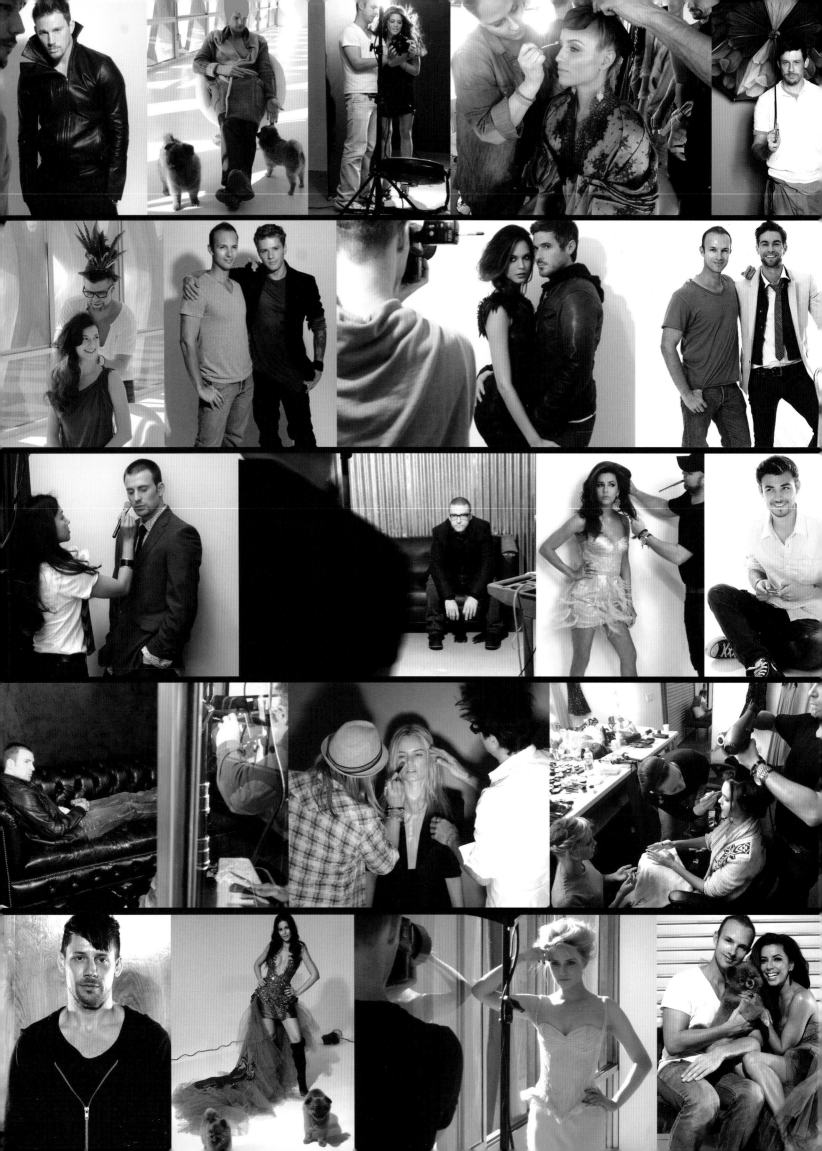

thank you

The Beauty Book would not have been possible without all the support I got from so many different people and companies. I'm so thankful for the generosity of all who got involved and supported this cause that is so personal to me.

Firstly, to all the amazing actors, actresses, musicians and models that shared their time to be photographed for this cause, it was truly an honor for me to photograph you all and I'm overwhelmed at your collective support, not to mention the star power that gives The Beauty Book for Brain Cancer a massive voice.

Secondly, to the amazing Douglas Vanlaningham who graciously donated more than 2 years of his life to style over 280 pages - your genius fashion instinct on a daily basis was so clever and you're the one person who was at every shoot with me and knows how important this project is to me.
Thirdly, to Leonardo Esposito who was married to the stunning Natalie Sattler-Esposito, who came along for the ride in LA, whilst trying to get perspective on his life without Natalie. Your help at every shoot day for the first year was invaluable and so greatly appreciated.

"Pantera" Sarah Uphoff where do I start with you, I'm so sorry for you and your family for the loss of your Mom who battled brain cancer. Meeting you and having you involved in this project has elevated it to another level. The Beauty Book now is how I always envisioned it to be. I cant put into words how thankful I am to you, all I can say is; thank you, thank you, thank you and lots of love to you.

Luis Rodriguez, thank you for supporting, I'll never forget your generosity towards this project and myself at the beginning and throughout this project. Glenn Nutley and Kat Andrews, both of you were on the first shoot day and both of you stayed very loyal to this cause, I'll always appreciate that. Glenn, you have been my friend for over 17 years and always stood by me and again this project cements what an amazing friend you are and what a talent you have in hair & makeup.

Thank you, Jane Negline for becoming my advisor and 'regulator' and for giving this project 200% all the time, your support is so generous to me as my friend and to The Beauty Book itself. Kim Kilbey, for always smiling and opening her home to me and using the power of the 'Aussie Mafia' to get us Sam Worthington, amazing (we will never underestimate the power of the 'Aussie Mafia')!!! Janelle and Laurence Hallier, thank you to both of you, "you don't get if you don't ask" and you know I will!! My longest standing friend, Jordan Roach thanks for always believing and your help along the way. I'm so grateful that we became friends at 13 years old, I'll always cherish our years with Natalie at school and into adulthood.

Thank you Georgie Eisdell for your support and helping me reach out to some of your clients, you're a talented makeup artist. Big thank you to Andrew Ryan for assisting me on the last year and half of this project, it's really kind of you to donate all those days to help us on every photo shoot, I'm glad to have you as a friend too. A massive thank you to Amy Oresman and Clyde Haygood, what a fabulous team you both are, the images we did are so beautiful. A big kiss and thanks to Jenna Hipp for the genius manicures and the use of your studio Space 905.

Samantha Bailey, thanks for being an amazing friend and strategizing our final plan to make this all happen, not to mention your creative skills for the Sydney event.

Thank you Siri Garber at Platform PR. Thank you to Manuel Villafania for designing the cover. Thank you Jack Ketsoyan for supporting me. Thanks to Pam Bailey for all your platters and for getting me will.i.am. The talented retouching team a big thank you to you all, Kristen Lauber, Judith Caingat and Grace Testa.

Special thank you to Alberto Tolot, Carlo Dalla Chiesa, Ed Canas, Veronica Hamburger, Martina Talot, Desmond Reich, Jacopo Campaiola & Daniele Colombera from Smashbox Digital, having the support of your equipment throughout the whole two years has made this project so exceptional, I'll be forever grateful.

I can't thank Paul Kim at Image locations + B Rolling enough for all the fabulous loft space you donated and the cool "behind the scenes" videos that we shot and your great staff, Alice Kim who did all of our bookings and Gerard Walsh & Vinny Pereira who filmed & edited the videos. You guys are truly amazing.

I have to thank the team at CPI in New York, Geoff Katz, Hugo Reyes, Danny Greer & Brittany Siegman for looking after me over the years and for coming on board to help raise more funds for this project, your support means the world to me.

Karen McHugh and Mike Kempler from Samys Camera for coming on board as a sponsor and giving me countless days of support. Thank you, Rinat Greenberg from Miauhaus Studios, we loved shooting at your space, Thanks to Steve Shaw and Rebecca Black at Smudge Studios. Adele, Stacia and Sarah at High Profile Productions you rock for the days of studio space you kindly donated. John at 5th & Sunset, Shaun at Milk LA and Rebecca, Greg & Donato at Smashbox Studios – thank you.

A big thank you to Marilyn Heston, Alexander & Katia at MHA for your divine fashion support. Chip, Mel, Anita & Frank at Celestine Agency, you guys have always supported me in Los Angeles with your talented roster. Darin, Jen and Claire at Exclusive Artists, Samer at Starworks, Jessica and Elizabeth at Tracey Mattingly, Alyssa at Solo Artists a massive thank you to you all. As you know a celebrity needs a strong team to make these shoots happen, the amount of talent involved is overwhelming, I'm so honored that everyone came together to support this project and me, its genius and it will never be forgotten.

Thank you to all the uber creative hair, makeup and stylists that all donated hours of your time to make all the celebrities look so stunning and glamorous.

Thank you to all my generous sponsors who supported The Beauty Book and made it come to life, without the all the generous donations and kind hearted people who believed in me and this cause, it would have not ever been possible, I'm truly touched and eternally grateful.

Lastly, if you're reading this, you have bought a copy of The Beauty Book, so thank you for supporting Brain Cancer and for giving it the voice it needs.

Darren Tieste